This book is dedicated to the ideals of excellence, to the concept that all of us in the photojournalism profession — no matter our skill level — need always to strive for higher levels of performance. We hope this book serves as an inspiration.

— Bob Lynn
Editor

D1299878

An annual based on the 45th Pictures of the Year competition sponsored by the National Press Photographers Association and the University of Missouri School of Journalism, supported by a grant to the University from Canon U.S.A., Inc.

Pictures of the Year

Photojournalism 13

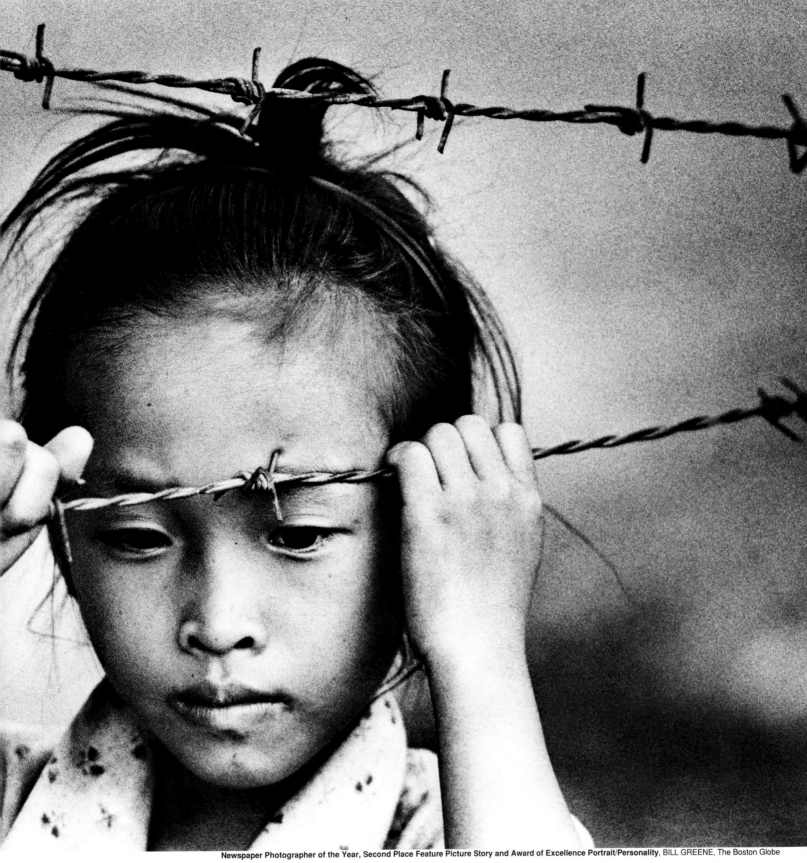

A Cambodian girl stares beyond a barbed-wire fence surrounding the refugee camp where she lives in Thailand.

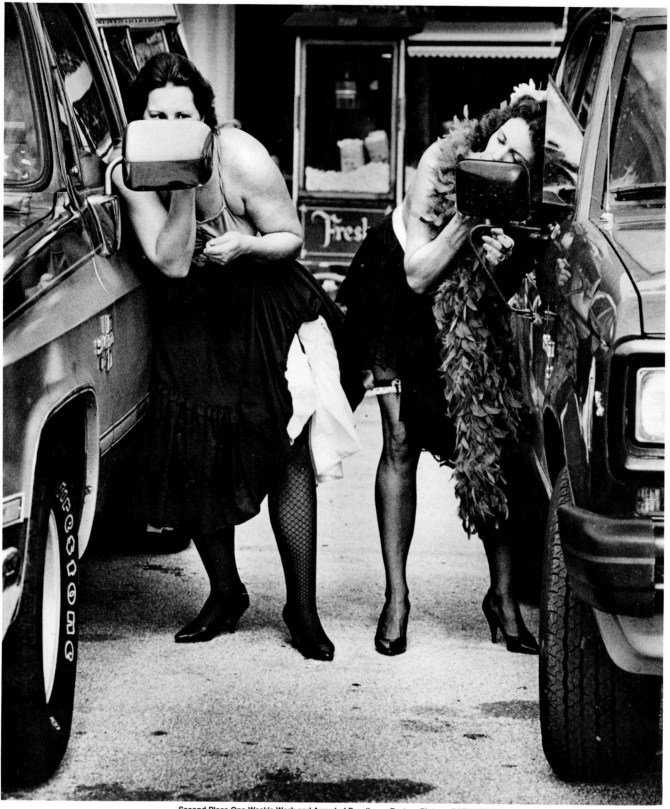

Second Place One Week's Work and Award of Excellence Feature Picture, CATHARINE KRUEGER, The Sun-Tattler (Hollywood, Fla.)

Lyn Hale, left, and Karen King put on makeup before performing with the New Frontier Gunfighter's Association during the 60th anniversary celebration for Hallandale, Fla., in October.

Bob Lynn: Editor/Designer

Pamela Smith-Rodden: Text Editor

Paul Bates: Coordinating and
 Computer-Systems Editor

Lois Bernstein: Coordinating Editor

Copyright © 1988
National Press Photographers Association
3200 Croasdaile Drive, Suite 306, Durham, NC 27705

Library of Congress Catalog Number: 77-81586
ISBN: 0-89471-629-8 (Paperback)
ISBN: 0-89471-630-1 (Library binding)
ISSN: 0161-4762

Printed and bound in the United States of America by
Jostens Printing and Publishing Division, Topeka, KS 66609

Cover design by Running Press

Contents

Canadian representatives: General Publishing Co., Ltd., 30 Lesmill Road., Don Mills, Ontario M3B 2T6

International representatives: Worldwide Media Services Inc., 115 East Twenty-third Street, New York, NY 10010

This book may be ordered by mail from the publisher. Please include $2 for postage and handling. But try your bookstore first. Running Press Book Publishers, 125 South Twenty-second Street, Philadelphia, PA 19103

For information concerning the Pictures of the Year competition, contact Director of POY, School of Journalism, University of Missouri, P.O. Box 838, Columbia, MO 65205.

1987

Heroes or villains

It depended on viewpoint

1987. The year of the hero. But one person's hero often was another person's villain.

Lt. Col. Oliver North. The ultimate patriot. Earnest. Sometimes boyish. For six days in July, North captured America's imagination during televised testimony before the joint House-Senate committees investigating the Iran-Contra affair.

North talked of selling arms to Iran in the hopes of bringing the U.S. hostages home from the Middle East. He talked of turning a profit on the arms sales and using it to finance the "freedom fighters" — the Nicaraguan Contras — in their fight for democracy against the communist Sandinistas.

President Reagan called North a hero. And North told the committee he had the complete support of his superiors, denying he did anything on his own. He also told of a plan to make him the scapegoat if word of the operation ever got out. He was the fall guy. A shield for his superiors and, North said, for President Reagan.

But some members of the Iran-Contra committee saw no hero in North. To the committee, North admitted he lied. Lied every time he met with the Iranians. Lied to investigators. Lied to Congress. He also admitted shredding key documents in the arms sales. He shredded documents the day he was dismissed from the National Security Council.

Senate committee chairman Daniel K. Inouye, in his final statement at the hearings, voiced concern about North's "ends justify the means" tactics, calling that philosophy one of the most important tenets of Communism and Marxism — the two philosophies North was fighting.

Gary Hart, white knight of the Democratic Party. The man to beat George Bush. An early front-runner. And an early dropout May 8 after the disclosure of a bit of monkey business with Miami model Donna Rice. "I am not a perfect man," Hart said. "I am a human. I commit sins. The Bible I read says we all commit sins. Mine happen to be pretty visible." Hart reentered the race in December. But not for long.

Jim Bakker disclosed a sexual encounter with church secretary Jessica Hahn and a subsequent payment to keep her quiet. The news of his tryst with Hahn, as well as other charges of sexual and financial misconduct, not only ended Bakker's career as an Assembly of God minister, but also rocked television evangelism and nearly toppled the PTL ministry. Said Bakker's wife Tammy Faye about Hahn, "That girl knew exactly what she was doing when she went down there. Besides it (the sexual encounter) only lasted 15 minutes."

Bernhard Goetz, the "Subway Vigilante," was acquitted June 16 of attempted murder in the shootings of four black teen-agers on a Manhattan subway in December 1984. Goetz claimed he had a right to defend himself on the subway when he allegedly was threatened by the teens. "I have $5 for you," Goetz reportedly said. He then fired five shots,

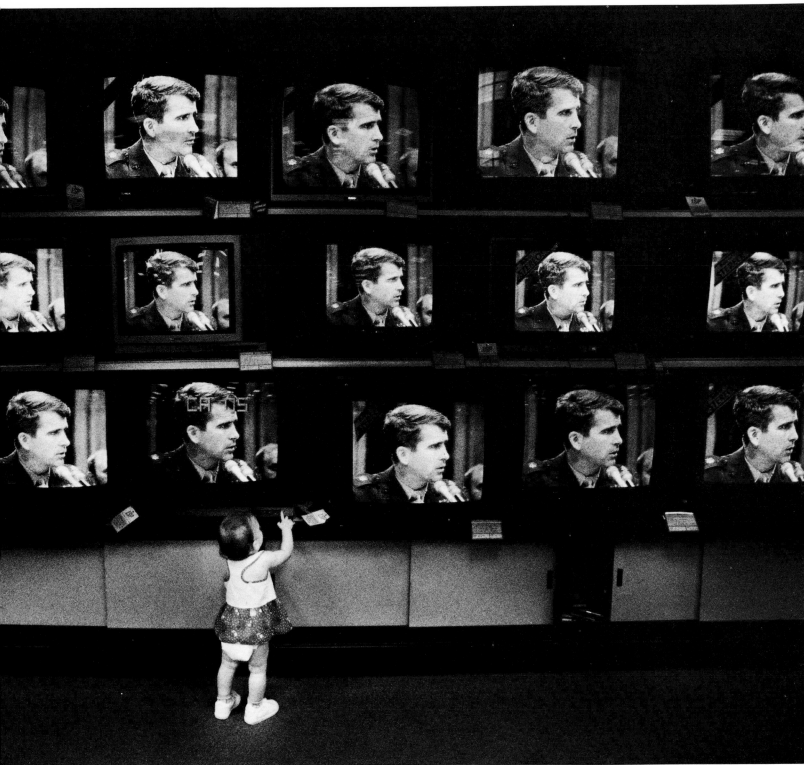

Newspaper Photographer of the Year,
BILL GREENE, The Boston Globe

During July's testimony on the Iran-Contra affair, the face of Lt. Col. Oliver North shone from television sets across America.

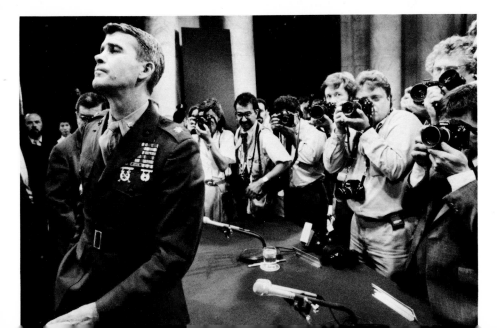

A favorite of many Americans and an enigma to the press corps, North ignores an array of cameras pointing at him during the hearings.

CHRIS WILKINS, Agence France-Presse

Heroes or villains

wounding all four. One teen remains in a wheelchair.

Edwin Meese III, close friend of President Reagan and attorney general of the United States. Questioned for his ties to the Wedtech Corp., a New York-based military contractor accused of attempting to bribe public officials in exchange for their assistance. Questioned for his investments with a California financial advisor who was a Wedtech consultant. Many feel the person holding the title of attorney general should be above reproach. But no wrongdoing has been proven. The investigation continues.

Robert Bork, nominee to the Supreme Court backed by Meese and Reagan, spent five days in televised hearings trying to convince the Senate Judiciary Committee — and the American public — to put him on the bench. The senators said no. After the vote, Sen. Edward M. Kennedy said, "If we receive a nominee who thinks like Judge Bork., who acts like Judge Bork ... he will be rejected like Judge Bork." Next on the list was Douglas Ginsburg, who quickly withdrew after the public learned of his marijuana use as a law school professor.

The stock market crash of Oct. 19 boasted no heroes. Only winners and losers — lots of them — as the Dow Jones industrial average plunged an astonishing 508.32 points in frantic trading. This marked an end of the bull market that saw the average climb from 776.92 in August 1982 to a high of 2722.42 in August 1987. It also sent world markets tumbling in reaction to the plunge.

And there were heroes for world peace.

Mathias Rust, a West German teen-ager became a hero for world peace. Rust piloted a Cessna 172 from

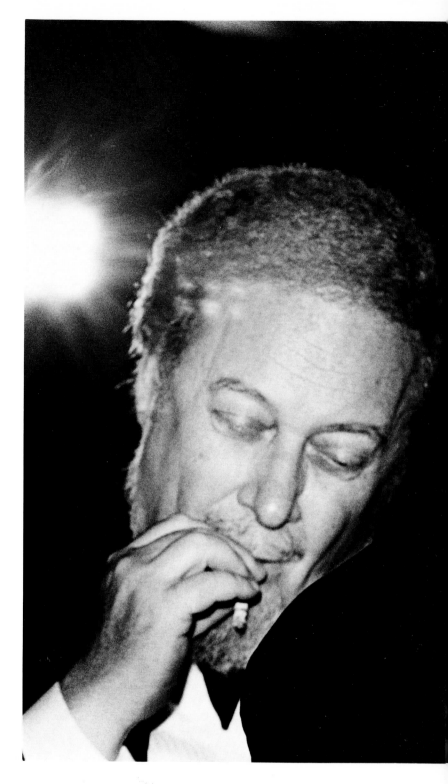

Controversial U.S. Court of Appeals Judge Robert Bork, turned down as a nominee to the Supreme Court by the U.S. Senate, and Attorney General Edwin Meese III listen to a speech by Vice President George Bush at the American Spectator Magazine's 20th anniversary party in November at the Omni Shoreham Hotel in Washington, D.C.

MANNY ROCCA, The Washington Times

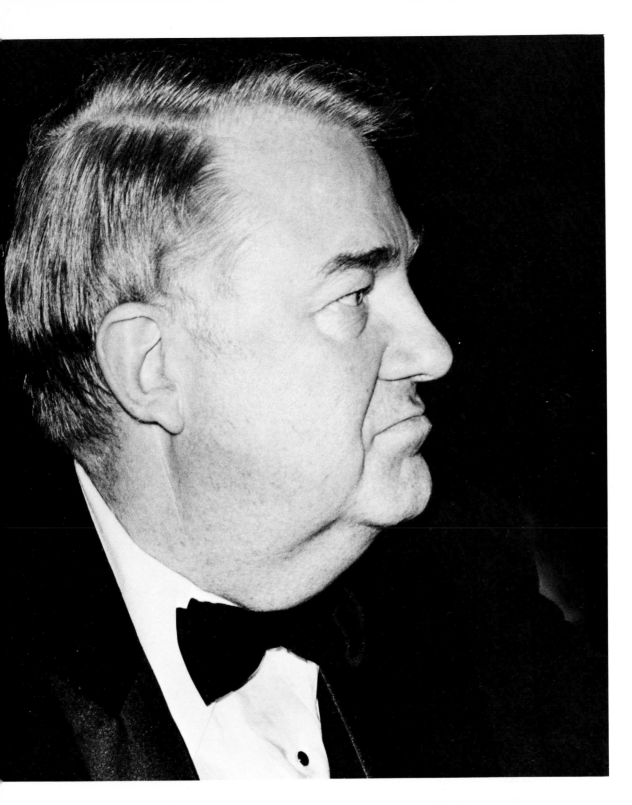

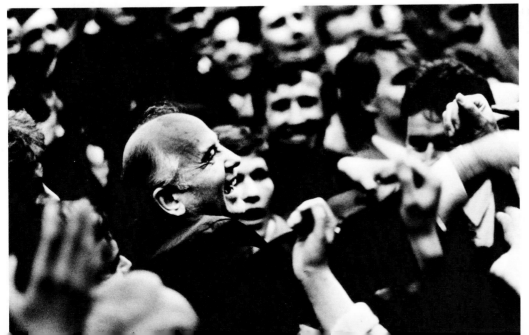

A new era opens for Eastern Bloc countries as Soviet leader Mikhail Gorbachev launches his strategy for perestroika — restructuring — which endorses a kind of restricted free market. But the people are wary, wondering if Gorbachev can control opposition within the Communist Party and stay in power.

PETER TURNLEY, Newsweek (original in color)

Heroes or villains

Helsinki to Moscow on May 29 — flying through 400 miles of Soviet airspace. The 19-year-old landed in Red Square. A hero to the adventurous at heart. An embarrassment to the Soviet Union, resulting in the dismissal of the Soviet defense minister. Despite rumors that Rust might be released unpunished, he was sentenced to four years in a labor camp. Rust was finally released Aug. 3, 1988.

The U.S. Navy launched itself as a protector of neutral shipping in the Persian Gulf, taking on the responsibility of escorting 11 reflagged Kuwaiti oil tankers. And it left heroes behind, including 37 sailors killed when two Iraqi missiles accidentally hit the guided-missile frigate Stark.

President Reagan and Soviet leader Mikhail S. Gorbachev agreed at a Washington summit to remove an entire class of nuclear weapons from Europe and Asia by signing a treaty to ban medium and short range nuclear missiles.

Costa Rican President Oscar Arias, Nobel laureate for trying to bring peace to a war-ravaged Central America.

Despite the magnitude of events in 1987, the world held its breath while a tiny girl wedged 22 feet underground in an abandoned well shaft in Midland, Texas, sang nursery rhymes in the dark and waited to be rescued. Workers spent 2 1/2 days digging, tunneling. And the world prayed. Then the cheers. The tears. And a heroic effort paid off to save one of the biggest little heroes of the year. Eighteen-month-old Jessica McClure.

A somber mood envelops sailors standing under the 16-inch guns of the Battleship Iowa as it eases from its Norfolk, Va., moorings in mid-September for a cruise to the Mediterranean and eventual duty in the Persian Gulf.

Judith and William Hansen grieve as a flag that covered their son's casket is folded by Navy pallbearers. William Hansen — who died doing "what he wanted to do and what he believed in doing" — was killed May 17 in the accidental Iraqi attack on the guided-missile frigate Stark. Hansen was buried in his hometown of Reading, Mass.

BRIAN WALSKI, The Boston Herald

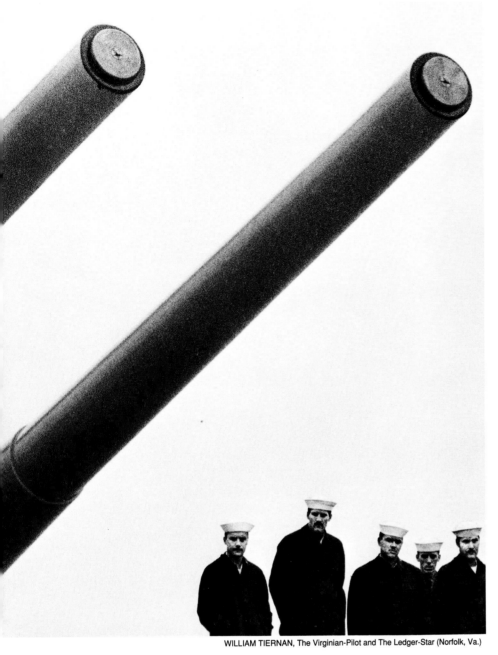

WILLIAM TIERNAN, The Virginian-Pilot and The Ledger-Star (Norfolk, Va.)

Defused mines on the deck of a captured Iranian ship provide the proof the United States was looking for. U.S. Army helicopters from the frigate Jarrett attacked and disabled the Iranian vessel caught sowing the mines in Persian Gulf shipping lanes in late September.

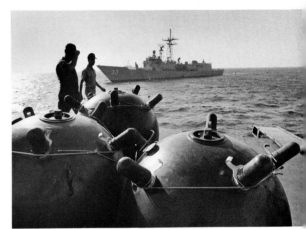

MARK DUNCAN, The Associated Press (original in color)

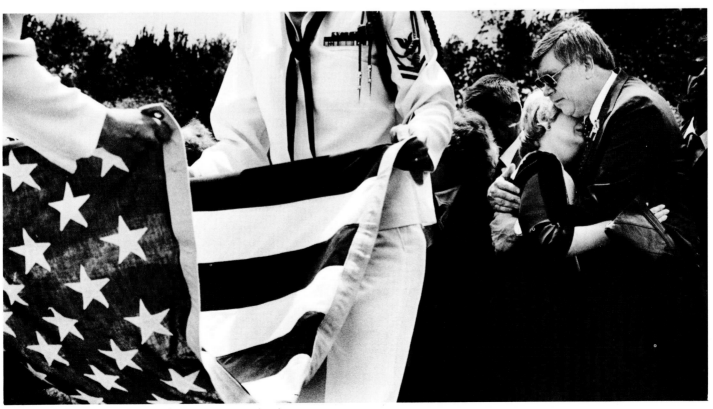

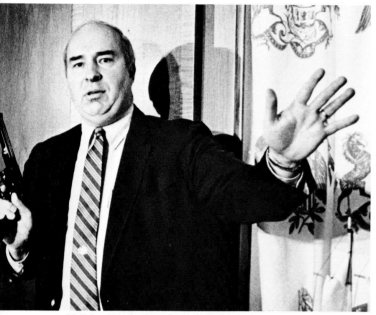

AE (*) Spot News and News Picture Story, TERRY L. WAY, United Press International

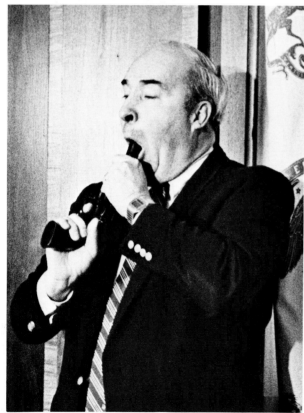

AE Spot News and News Picture Story, TERRY L. WAY, United Press International

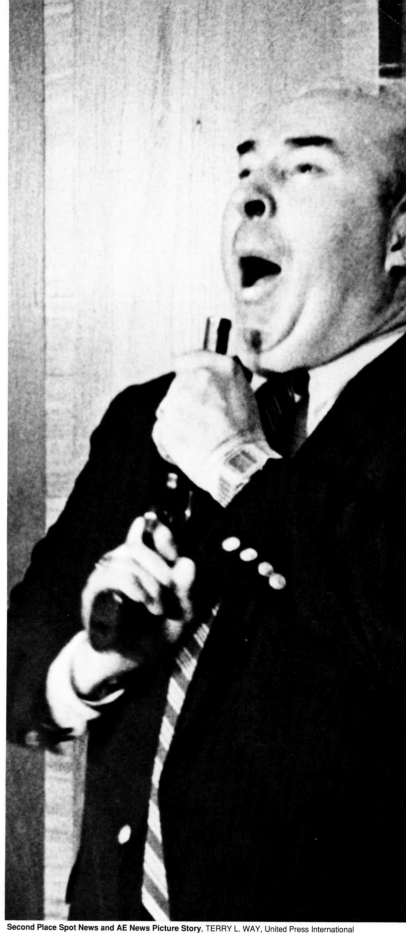

Second Place Spot News and AE News Picture Story, TERRY L. WAY, United Press International

Public suicide

Pennsylvania State Treasurer R. Budd Dwyer scheduled a press conference Jan. 22, one day before he was to be sentenced on a federal bribery conviction.

Everyone expected Dwyer to announce his resignation. In a packed office, Dwyer rambled for nearly an hour, reading a prepared script that blamed a number of people for his problems. Then he pulled a .44 magnum handgun from a large envelope and warned people to stay away or leave the room if they did not want to watch.

Dwyer stepped back against the wall, placed the gun in his mouth and, holding it with two hands, pulled the trigger.

* (Note: Because of space limitations, Award of Excellence credits will at times be noted--AE.)

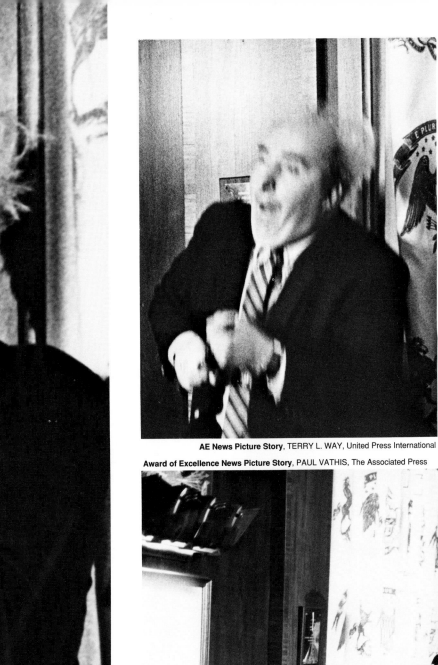

AE News Picture Story, TERRY L. WAY, United Press International

Award of Excellence News Picture Story, PAUL VATHIS, The Associated Press

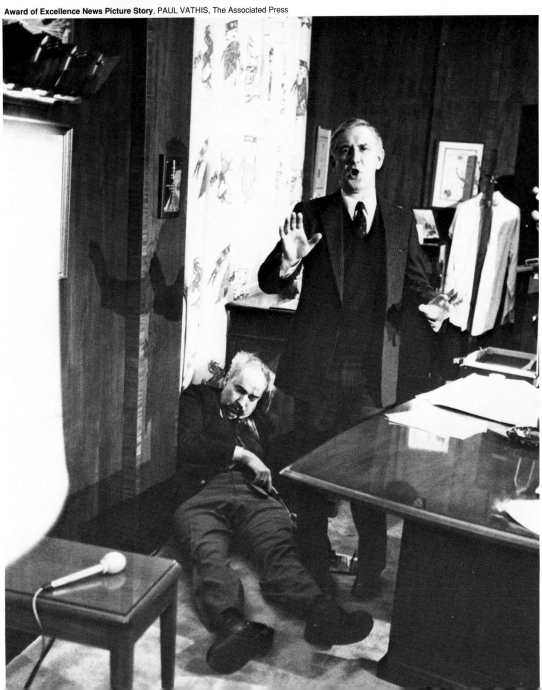

13

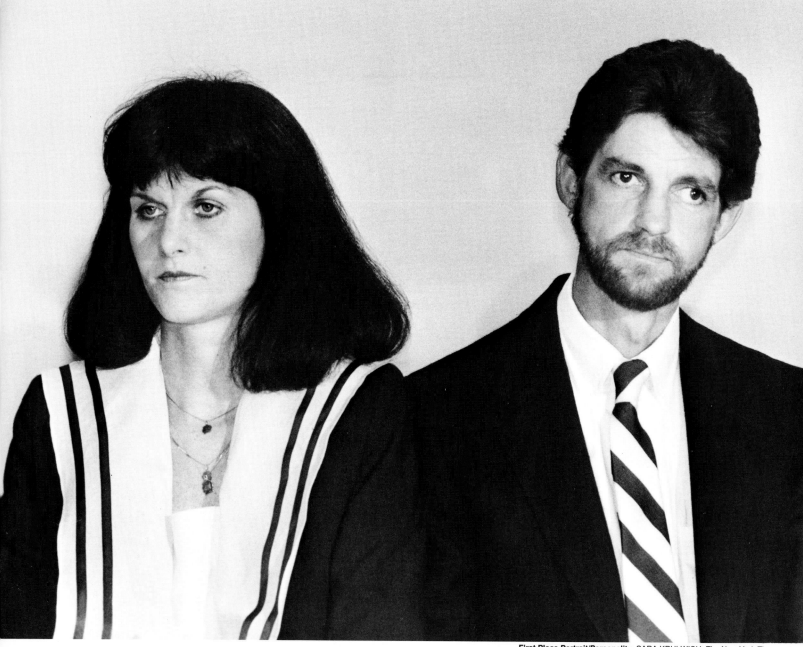

Mary Beth Whitehead and husband Richard await start of press conference the day following negative court ruling.

The Baby M case

Baby M. Also known as Sara. Also known as Melissa.

The prize in the first U.S. test of the legality of a surrogate mother contract. Mary Beth Whitehead agreed in 1985 to bear a child for William and Elizabeth Stern for $10,000.

William was born in Berlin at the end of World War II. All of his blood relatives were dead. Elizabeth put off having children and later developed a mild case of multiple sclerosis. She was afraid to have a child.

So Whitehead was hired to bear a child conceived by artificial insemination.

After the birth of the child later known as Baby M, Whitehead was unable to surrender the baby. She fled to Florida — with the child and without the money — but was apprehended at her mother's home.

"She's my flesh — my blood, and no judge that never gave me a chance is going to take that away from us," Whitehead said after a judge awarded custody to Stern on March 31.

Black Monday

Newspaper Photographer of the Year, BILL GREENE, The Boston Globe

Black Monday. Oct. 19. The day the Dow Jones industrials plunged 508.32 points in frenzied, often out-of-control computerized trading that left investors and brokers alike helpless.

This marked the end of America's bull market that saw the average climb from 776.92 in August 1982 to a high of 2722.42 in August 1987.

There were warning signs. On Oct.14, the Dow dropped 95.46 — its largest one-day drop in history. On Oct.16, the Friday before the crash, the Dow lost 108.36 — the first 100-point loss in a single session.

The drop also sent world markets into a tailspin, forcing countries to prop up a falling dollar. Analysts feared another Great Depression. None materialized.

Award of Excellence News Picture Story, STEVE RINGMAN, San Francisco Chronicle

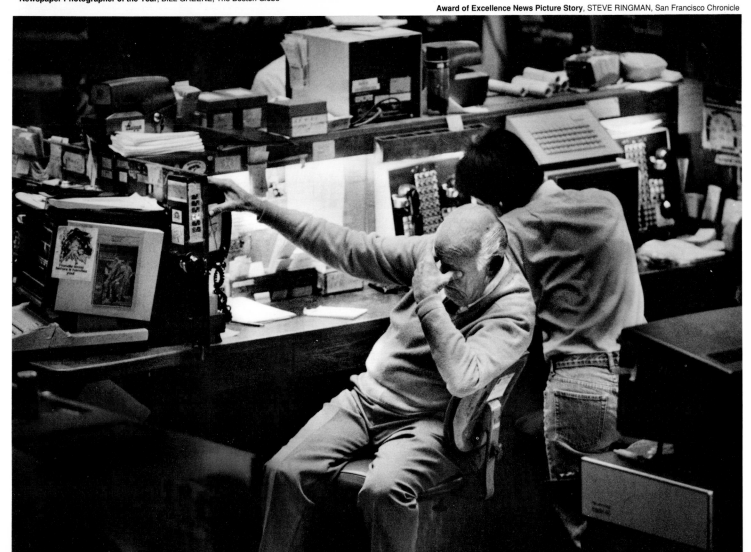

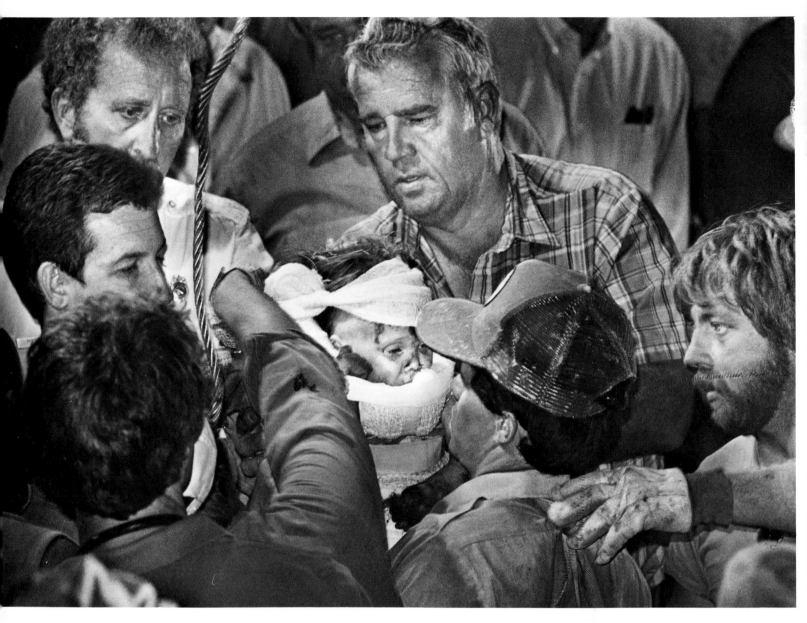

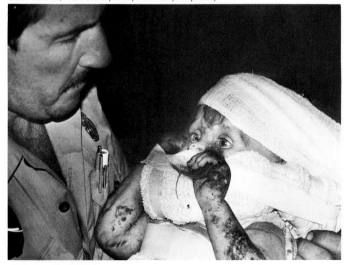

Baby Jessica's ordeal

Eighteen-month-old Jessica McClure became the focus of national and international attention when she spent 2 1/2 days trapped 22 feet underground in an abandoned well shaft. The financially-strapped oil town of Midland, Texas, rallied around Jessica and her frantic parents, tunneling day and night to rescue the tiny girl. The Oct. 16 rescue was televised live on all three U.S. television networks. The next day, Jessica underwent surgery on her right foot, which had been wedged under her during the ordeal, cutting off circulation. At first, it was feared she would lose her right foot. However, only the little toe was removed.

Pope visits America

Pope John Paul II launched a tour of the United States Sept. 10 in Miami, visiting nine cities in 10 days. The others included Columbia, S.C., New Orleans, San Antonio, Texas, Phoenix, Ariz., Los Angeles, Monterey, Calif., San Francisco and Detroit.

In Phoenix, the pope was blessed by Emmett White, a Pima Indian, in a special ceremony.

At one of his most emotional stops, John Paul embraces 5-year-old AIDS victim Brendan O'Rourke during a visit to Mission Dolores Basilica in San Francisco. The boy squealed with delight and tugged on the pontiff's ear. The youngster contracted AIDS from a blood transfusion during his premature birth.

As about 2,000 protesters demonstrated against the pontiff's teachings on homosexual behavior, the pope offered words of consolation and acceptance. "God loves you all, without distinction, without limit. He loves those of you who are sick, those who are suffering from AIDS and AIDS-related complex."

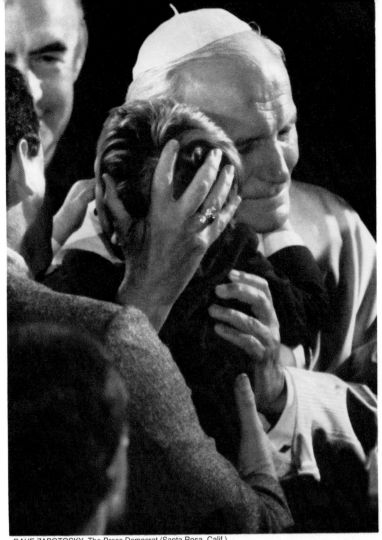

DAVE ZAPOTOSKY, The Press Democrat (Santa Rosa, Calif.)

VICKIE LEWIS, Albuquerque (N.M.) Tribune

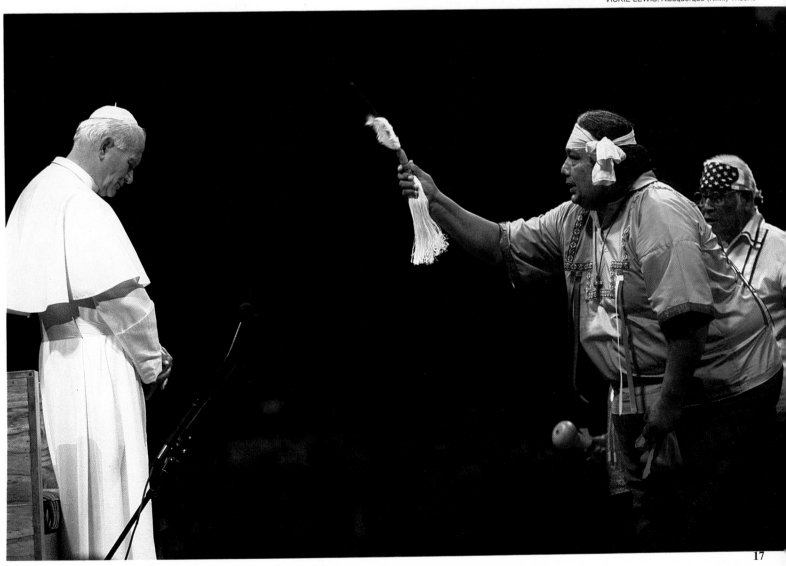

The family of Asson Vital mourn at his funeral in the national cemetery in Port-au-Prince. Vital was one of the 15 people slain at a school as a warning to the population not to vote in Haiti's first democratic elections in 30 years.

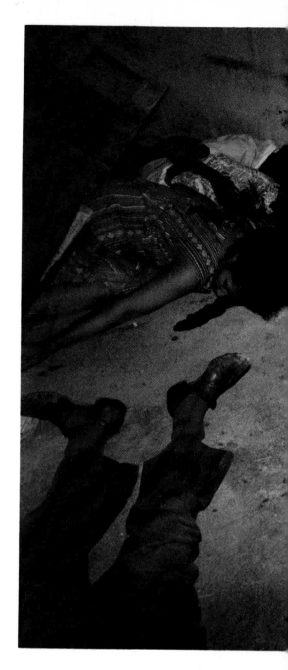

First Place Magazine News/Documentary, MAGGIE STEBER, J.B. Pictures for Newsweek

Haiti

Bloody election

Voting with blood. In Haiti, where the people were striving for democracy, that was the road to reform.

In June, provisional ministry ruler Lt. Gen. Henri Namphy voided plans by the Electoral Council to hold democratic presidential elections, choosing to place them under the control of his ministry of the interior.

Namphy led a provisional government since Jean-Claude "Baby Doc" Duvalier fled into exile in 1985, ending more than 29 years of family dictatorship.

Violent protests followed into July. The turmoil was

the worst threat to Haiti's stability since Duvalier's ouster.

Strikes and street protests paralyzed the capital and other cities. By the second day, there were deaths and injuries.

In the face of the violence, Namphy offered to restore control of the election to the provisional council.

But it was too late. Protests already had gone beyond the desire for free elections. Haitians wanted freedom from Namphy and his military government.

The United States warned both Namphy and the

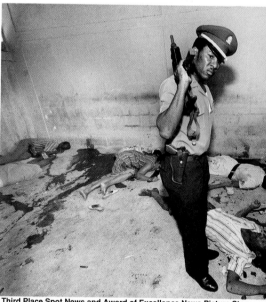

Third Place Spot News and Award of Excellence News Picture Story, VIOREL FLORESCU, New York Newsday

A uniformed police officer on the scene of an election day massacre in a school where 15 people were slain while trying to vote. Witnesses said they saw officers watching the massacres, but did nothing to stop them.

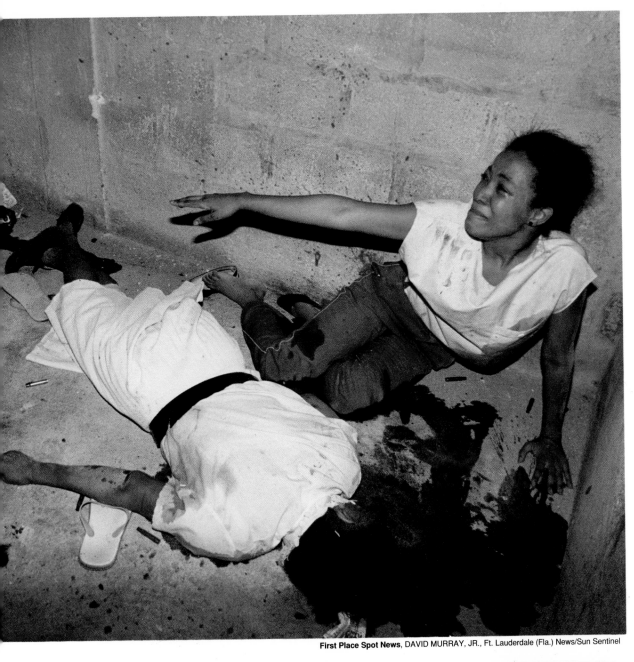

A wounded Haitian woman grieves over the body of her mother, foreground, and other relatives surrounding her. The family tried to vote in the Nov. 29 elections in Port-au-Prince, but became victims of the Tonton Macoute massacres.

First Place Spot News, DAVID MURRAY, JR., Ft. Lauderdale (Fla.) News/Sun Sentinel

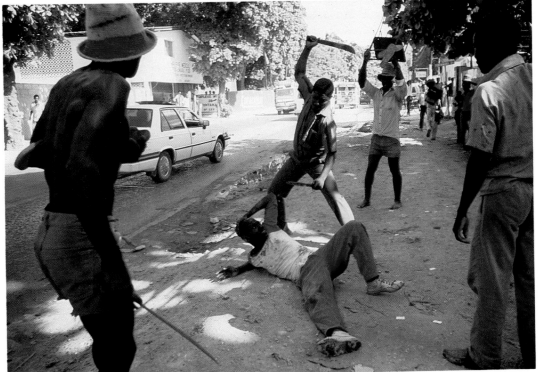

Four days before the Nov. 29 elections, a commando group formed to protect Haitians against pre-election violence hacked a man to death in the streets of Port-au-Prince. He was said to have been a relative of a close associate of the deposed Duvaliers and one of the 12 presidential candidates disqualified because of ties to the former dictator.

Award of Excellence News Picture Story, CAROL HALEBIAN, Gamma/Liaison

Haiti

Bloody election

opposition it would cut off aid if either side spoiled the democratic process. And the United States reiterated its support of Namphy, so long as the free elections went ahead as scheduled.

For months, Haiti was plagued with nighttime shootings that left bodies in the streets of the capital. On Oct.13, witnesses said plainclothes policemen beat a Haitian presidential candidate to death. The government came under immediate fire for failing to maintain security.

Political leaders blamed Duvalier loyalists for trying to intimidate the candidates and the voters.

But there would be no vote. As the long-suffering people of Haiti turned out for their first free election in 30 years — Nov. 29, 1987 — Duvalier still ruled in abstentia. His henchmen — the Tonton Macoute — silenced waiting voters with machetes and gunfire, leaving 34 people dead and more than 70 wounded.

The Provisional Electoral Council called off the elections in the wake of the bloodbath, rescheduling the vote in 1988.

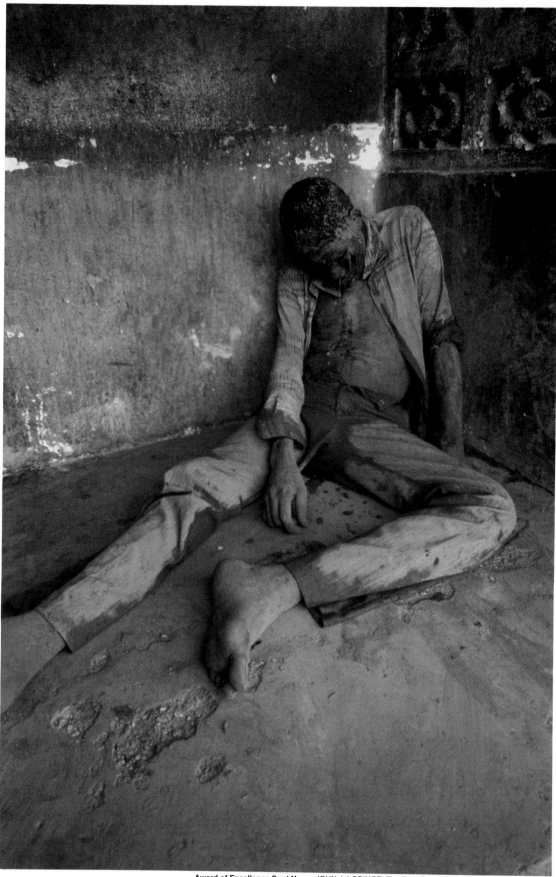

Award of Excellence Spot News, JOHN J. LOPINOT, The Palm Beach Post (West Palm Beach, Fla.)

Days before the election, a man lies slumped in a stairwell after being shot in the back by soldiers in a Port-au-Prince alley. The man, who had been taking a friend to the hospital on a motorcycle, was shot as he attempted to flee troops. He dragged himself through the mud to the doorstep of a woman's house and begged her to let him in. "I've been shot twice. I'm not a thief!" he shouted before dying. The woman was too frightened to help.

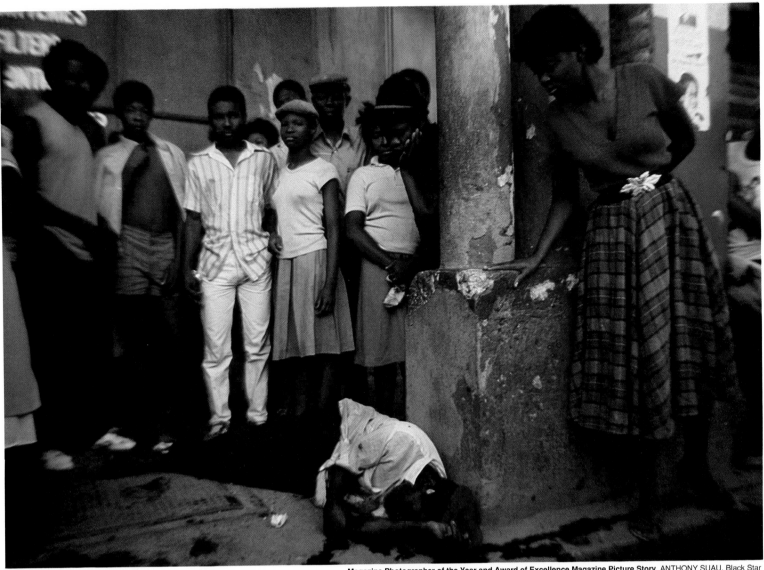

Haitians look in horror at a body in the street.

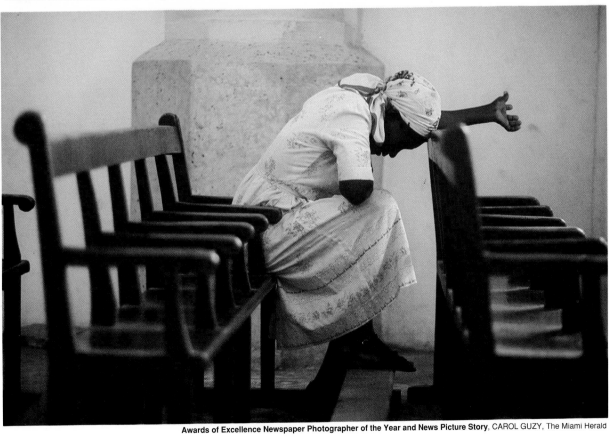

During the violent days before the election, a woman prays in the main Port-au-Prince cathedral.

Haiti

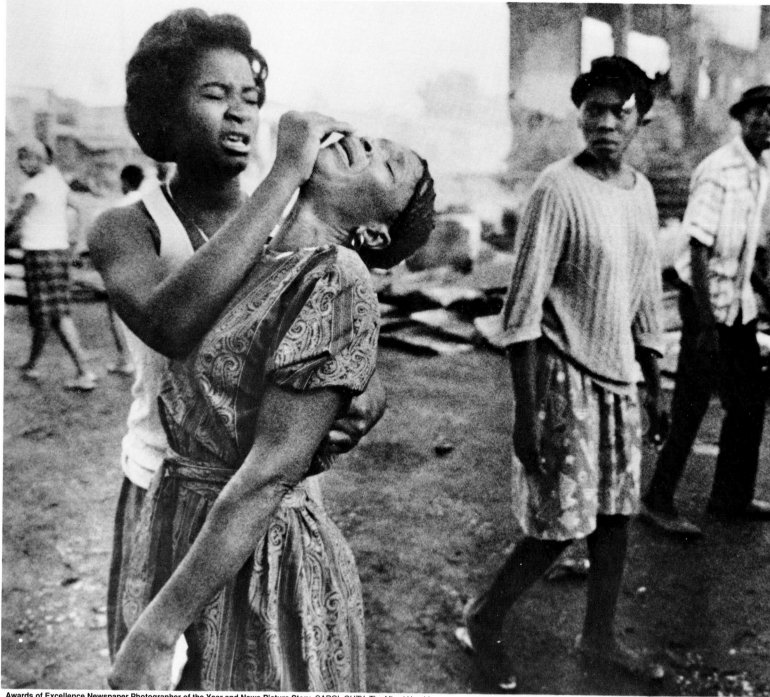

Peasant women weep when they arrive at the Marche Soloman and discover the marketplace has burned during the night. The Tonton Macoute were suspected in the blaze. The women lost all their belongings at the market, where they sold their wares.

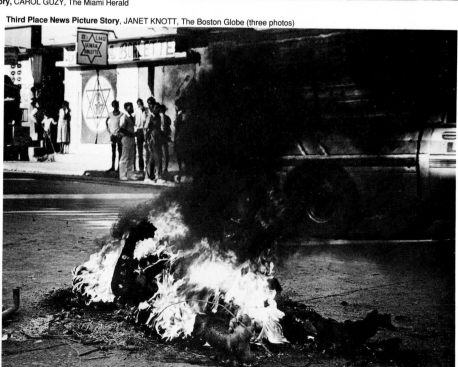

A body burns on the street in downtown Port-au-Prince during pre-election violence.

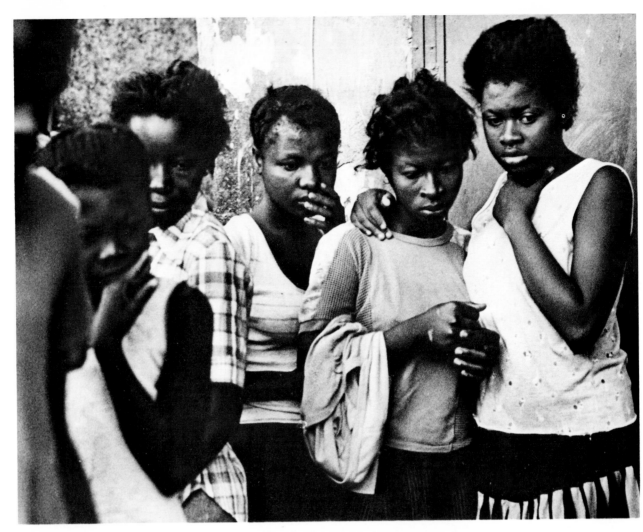

Women stare in silent terror at a body on the sidewalk in downtown Port-au-Prince.

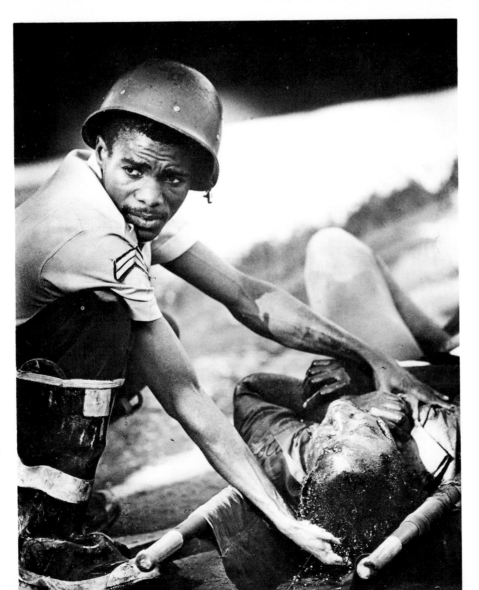

An ambulance worker waits for assistance and cradles a dying woman, a victim of violence at the polls on election day.

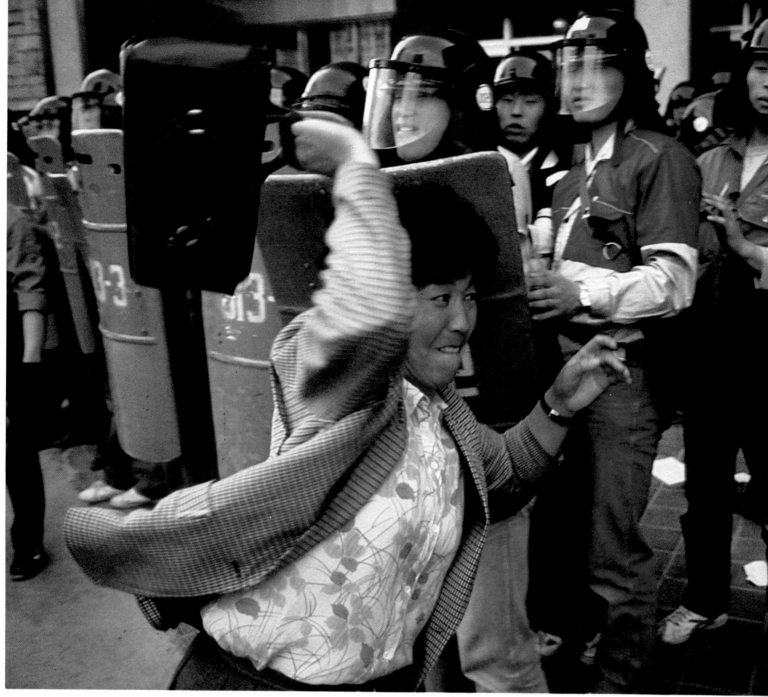

A woman attacks the line of riot police with her purse and is arrested in Seoul. The women who attack the police say they do it because they believe the police represent a new police state attitude by the government.

Korean politics

An all out protest

The Jan. 14 death of a 21-year-old Seoul National University student while undergoing interrogation by police helped the opposition close ranks against the government of President Chun Do Huan.

Although earlier protests were quashed, new demonstrations came 49 days after the student's death. In Buddhist belief, that is the day the soul entered the new world.

A massive display of police force, approximately 35,000 against 10,000 demonstrators in half a dozen cities,

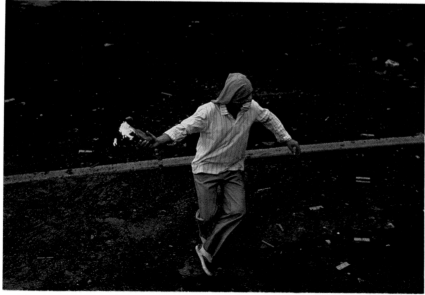

AE Magazine Photographer of the Year and Second Place Magazine Picture Story,
NATHAN BENN, National Geographic (above and below right)

A protester holds his position with a firebomb around the cathedral stronghold.

At Myongdon Cathedral in Seoul, school children walk by police as they return from demonstrations. Heavily guarded against tear gas used to disperse demonstrators, the police look like they have stepped out of the movie "Star Wars."

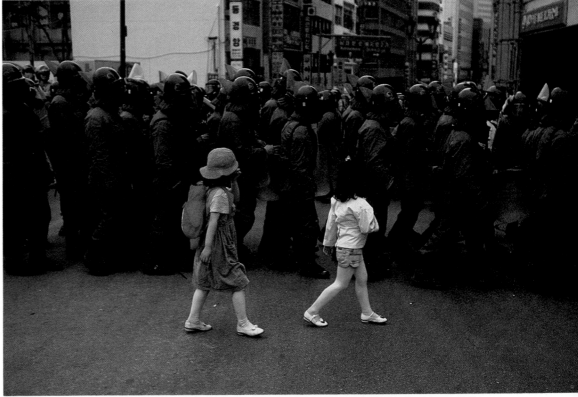

Magazine Photographer of the Year and Award of Excellence Magazine Picture Story, ANTHONY SUAU, Black Star (above and left)

quelled the uprising. In Seoul, 171 protesters were arrested. In other cities, the numbers hit 224. Police used massive amounts of tear gas, while demonstrators hurled only two bombs.

Opposition leaders Kim Dae Jung and Kim Young Sam praised the relative restraint of the demonstrators, saying nonviolence had "taken root." But Chun waved a red flag in the students' faces, announcing April 13 he was suspending debate on constitutional reforms.

On June 10, Chun named his own

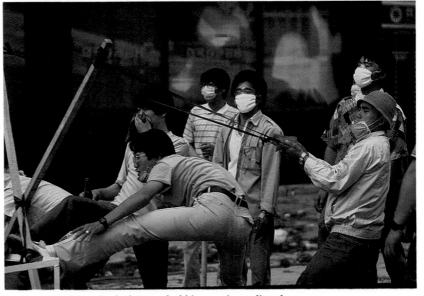

Students in the cathedral stronghold improvise a slingshot to propel rocks. Their efforts were unsuccessful.

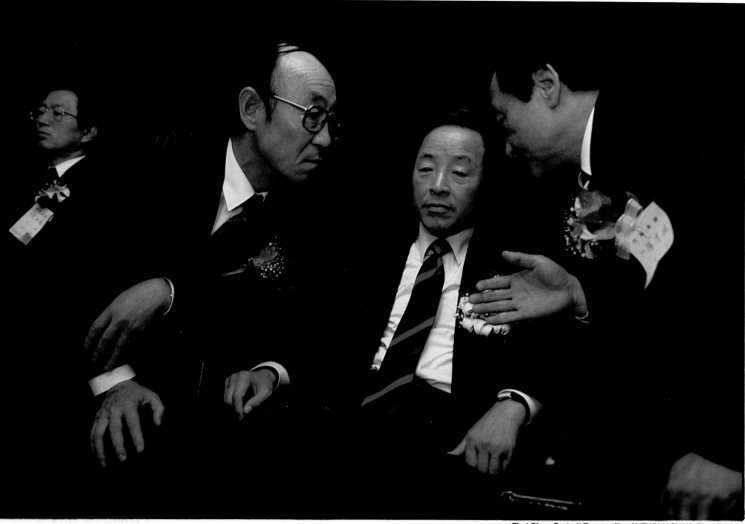

Kim Young Sam is named presidential candidate of South Korea's opposition party May 1, 1987.

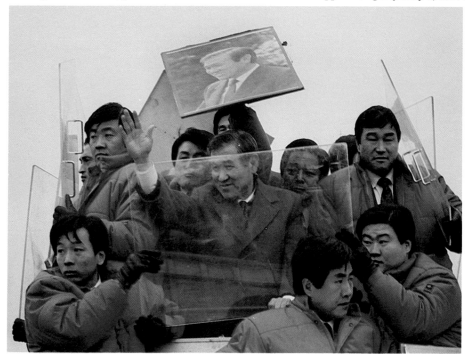

Roh Tae Woo, the president's hand-picked successor, parades through
Pusan, South Korea, protected by bullet-proof shields and bodyguards.

Korean politics

successor — Roh Tae Woo — chief of
the party and a close friend.

Days of street riots followed, which
included construction of barricades at
Myongdon Cathedral. The barricades
became the protesters' focal point with
as many as 400 students staging a sit-
in. Before it was over, the government
said it arrested 3,800 people in Seoul
and 10 other cities.

The violence continued. June 18, tens
of thousands of students rampaged,
breaking the military's hold on Seoul.
Police estimated 90,000 students at 59
campuses across the country rallied for
a chance at free elections.

As the demonstrations spread, so did
the use of tear gas. Everyone,
including children, was forced to don

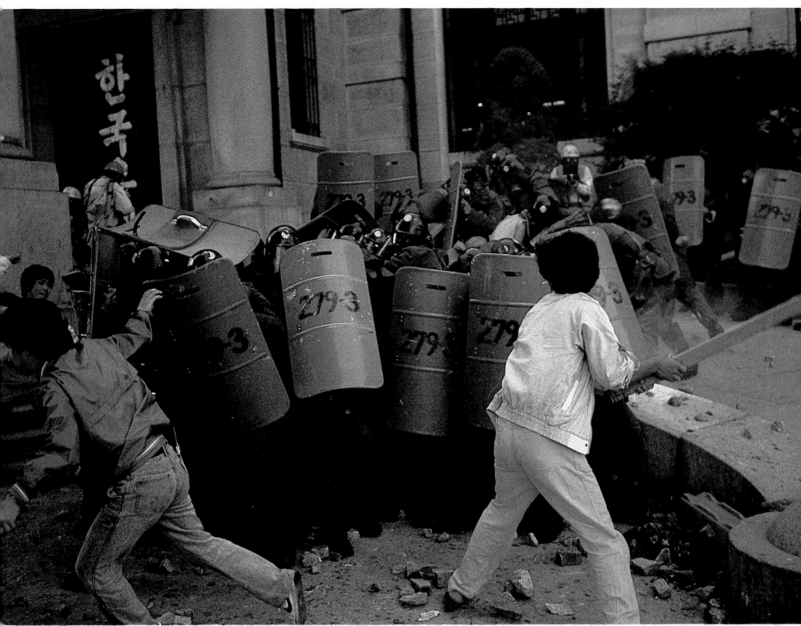

Demonstrators overwhelm police in downtown Seoul.

masks for protection. Angered, more South Koreans joined the protests.

In all, there were 2,154 demonstrations from June 10 to June 26. Police fired 351,200 tear gas canisters. Hundreds were injured, but only two died.

Chun's hand-picked successor stunned all sides June 29, announcing his backing for most of the opposition's reforms — including direct presidential elections.

On Dec. 16, the ruling party's candidate won South Korea's first direct presidential election in 16 years. The two main opposition leaders split the anti-government vote, leading to their defeat. Although the opposition claimed the vote was rigged, little evidence of fraud was found.

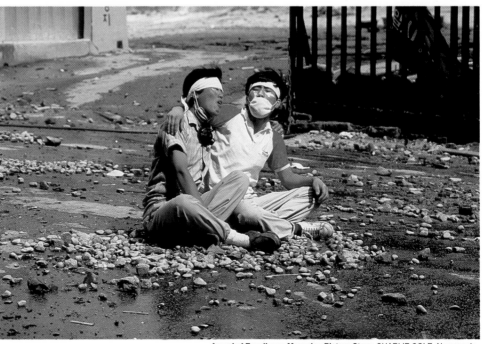

Student protesters at Seoul University.

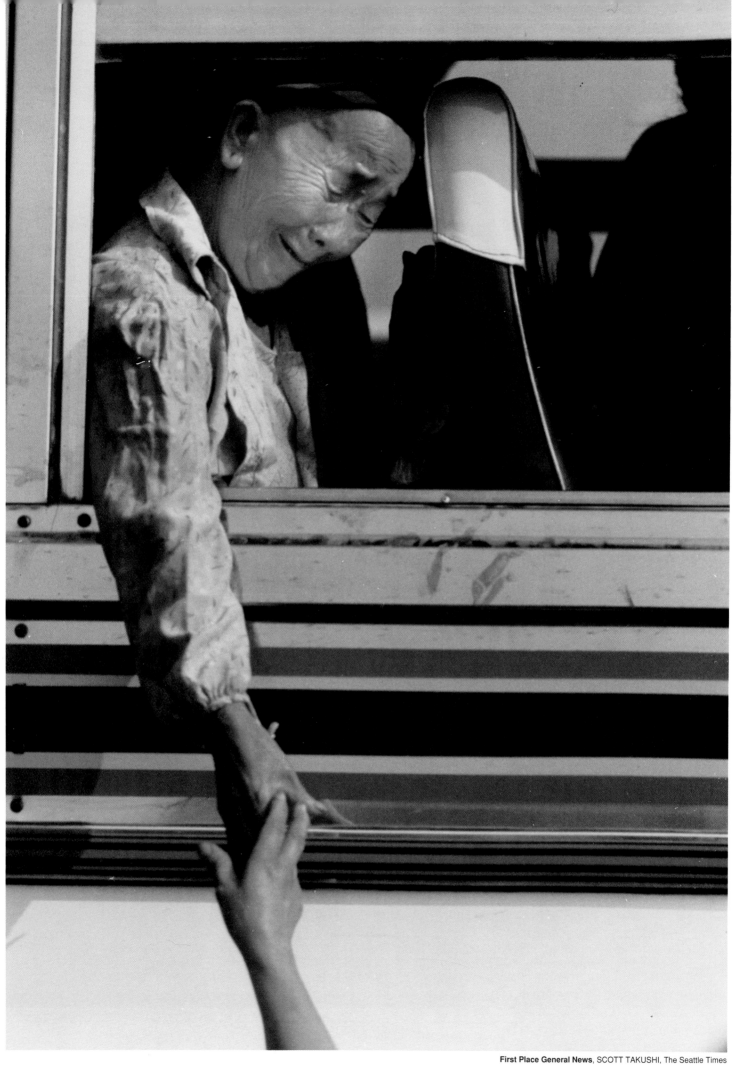

A Hmong woman sobs and clutches a relative's hand as she waits for a bus to leave the Ban Vinai refugee camp in northern Thailand. The woman is resettling in a western country and may never see her loved one again.

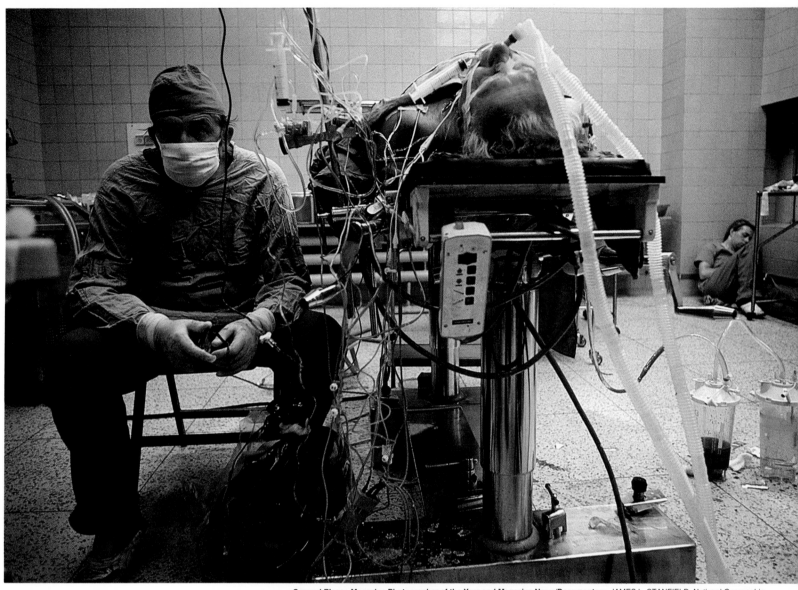

Second Places Magazine Photographer of the Year and Magazine News/Documentary, JAMES L. STANFIELD, National Geographic

The anxious eyes of Dr. Zbigniew Religa keep watch on a monitor tracking the vital signs of a heart-transplant patient at the Cardiology Clinic in Zabrze, Poland. An exhausted colleague who helped Religa perform two transplants in one all-night session rests in the corner.

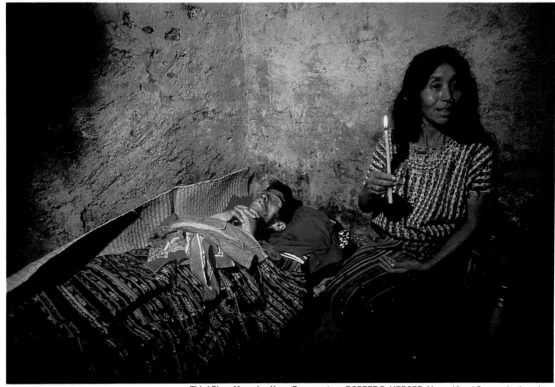

Third Place Magazine News/Documentary, ROBERT R. MERCER, Mercer Visual Communications, Inc.

A family in Santiago-Atitlan, Guatemala, waits for the pastor of the Catholic church, who was called out late to visit a family member they feared was dying.

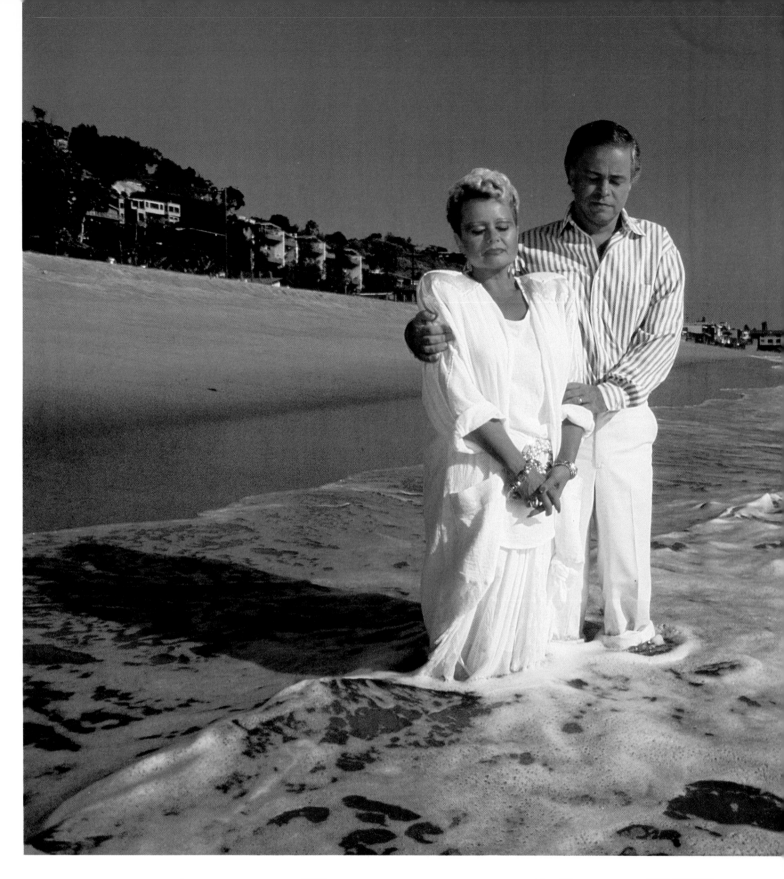

Jim and Tammy ousted from PTL

Praise The Lord. People That Love. Jim and Tammy Faye Bakker.

A holy war of adultery and blackmail marked the downfall of Bakker's PTL ministry. On March 19, Bakker resigned after admitting to a sexual encounter seven years earlier with then-church secretary Jessica Hahn. Revelations of a bribe for Hahn to keep quiet and other financial irregularities sealed his fate.

Bakker called the disclosures blackmail and accused fellow television evangelist Jimmy Swaggart of trying to take control of the $129 million-a-year PTL ministry.

Jerry Falwell was asked to step in as head of the ministry. But the stories continued. Another television evangelist, the Rev. John Ankerberg, spoke of evidence that Bakker was involved with prostitutes, homosexual

Third Place Magazine Portrait/Personality, HARRY BENSON, Freelance for LIFE

Falwell plunges in

The Rev. Jerry Falwell goes down the 68-foot "Typhoon" waterslide at PTL's Heritage USA theme park near Fort Mill, S.C. In July, Falwell promised to take the plunge if 1,000 people donated $1,000 each to the financially-strapped PTL ministry. Falwell took the plunge Sept. 10. He took another "plunge' in October, resigning as president of PTL.

ANDREW BURRISS, The Herald (Rock Hill, S.C.)

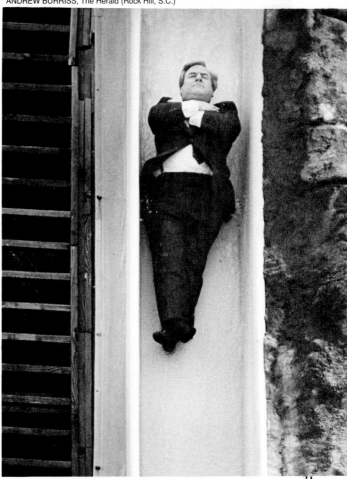

encounters and wife- swapping.

April 28, Falwell announced that Bakker's ministry at PTL was over. May 6, Bakker was defrocked by the Assemblies of God for "conduct unbecoming of a minister."

The Bakkers, facing a series of federal investigations, vowed that they would return to their ministry.

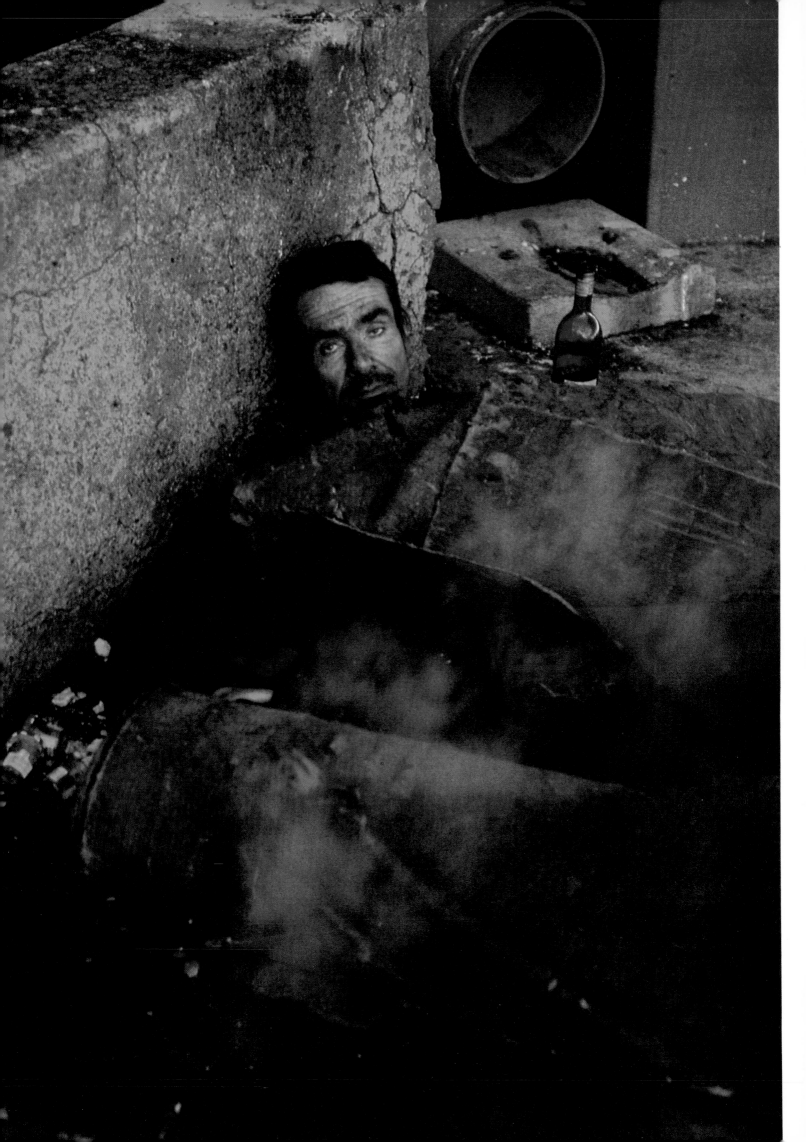

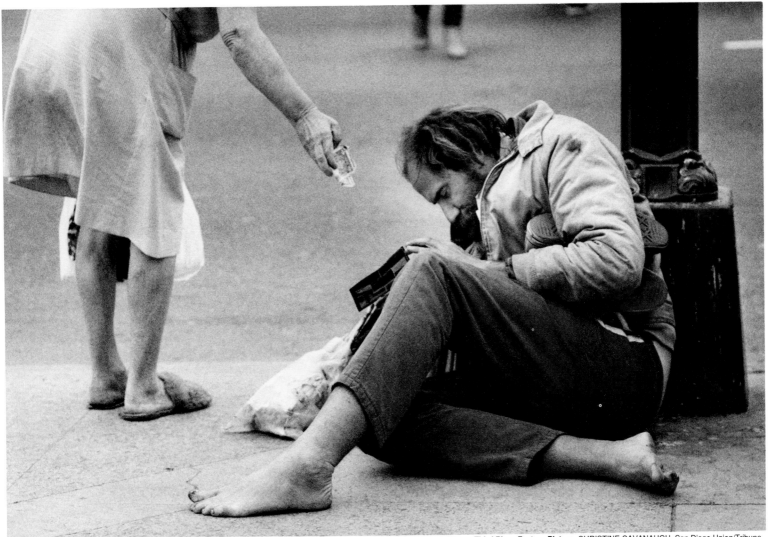

Robert Monaghan, reading a book on the streets of downtown San Diego, refuses money offered by a passer-by.

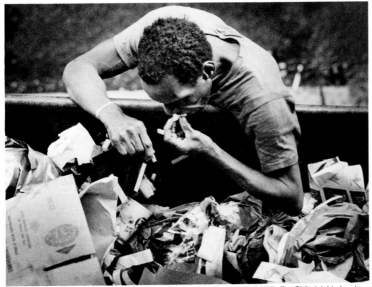

A man eats from a garbage bin in a Philadelphia alley.
He didn't seem to understand that a van with free food
for the homeless would be around the corner soon.

A homeless man keeps warm over a steam
vent on the streets of New York City.

Nation's homeless

Surviving on the streets

The year of the homeless. At least in the eyes of the
federal government. On Feb. 12, President Reagan
signed a bill providing $50 million in federal disaster
relief for the homeless. Millions more were included in
other bills before Congress. And still the need continues.

According to a survey, demand for emergency shelters
rose 21 percent and the demand for food assistance rose
18 percent. Estimates of the number of homeless in
America range from 250,000 to more than 3 million.

Many Americans believe people who live on the streets
are derelicts. Alcoholics. Drug addicts. And the mentally
ill do account for 25 percent of the homeless. But a 26
city survey by the U.S. Conference of Mayors showed
families with children made up one-third of the
homeless.

Nearly a quarter of the homeless held full or part-time
jobs, but weren't able to afford housing. The average wait
for subsidized housing – 22 months.

That left them – and their families – on the streets of
America.

Seattle's homeless

Lott, Berner spend six weeks on street

Photographers Jimi Lott and Alan Berner spent six weeks walking the streets of Seattle, taking more than 3,500 photographs for a six-part series on the homeless for The Seattle Times.

"I was very well received by 98.5 percent of the people I photographed," Lott said, "in part because I didn't go in blasting away. I carried one camera and a small bag, keeping it off to the side. I tried to engage them in conversation first, not so much to win their confidence, but to show them I really did care."

City and county officials estimate between 2,000 and 5,000 people have no permanent place to live. And up to 90 percent of King County's homeless live in Seattle. Lott and Berner looked behind the statistics.

"A lot of them are good people," Lott said. "What hurts me the most are the old men — the broken spirits. They have nothing to hold on to except dreams. They would try to outdo each other with stories of heroic deeds." One of those heroic deeds included rescuing Lott.

"I had these street people sticking up for me on a couple of occasions. Belligerent drunks started flexing their anger and were squelched immediately by my street friends."

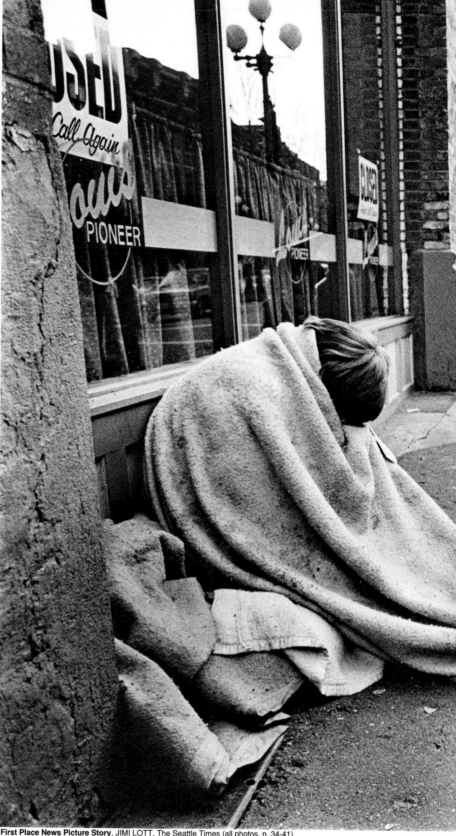

First Place News Picture Story, JIMI LOTT, The Seattle Times (all photos, p. 34-41)

Despite comfort from a friend, tears well in the eyes of a man whose life has lost all meaning.

Days are spent collecting change for the usual bottle of street elixir, trying to numb the pain of a troubled existence.

A native American still lives on the land of his forefathers, but this time it is under a freeway ramp.

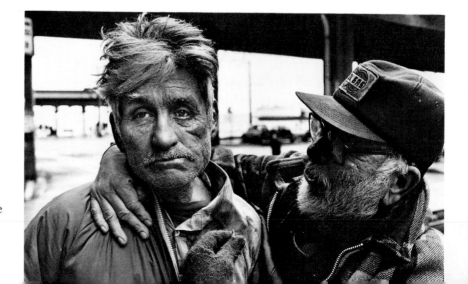

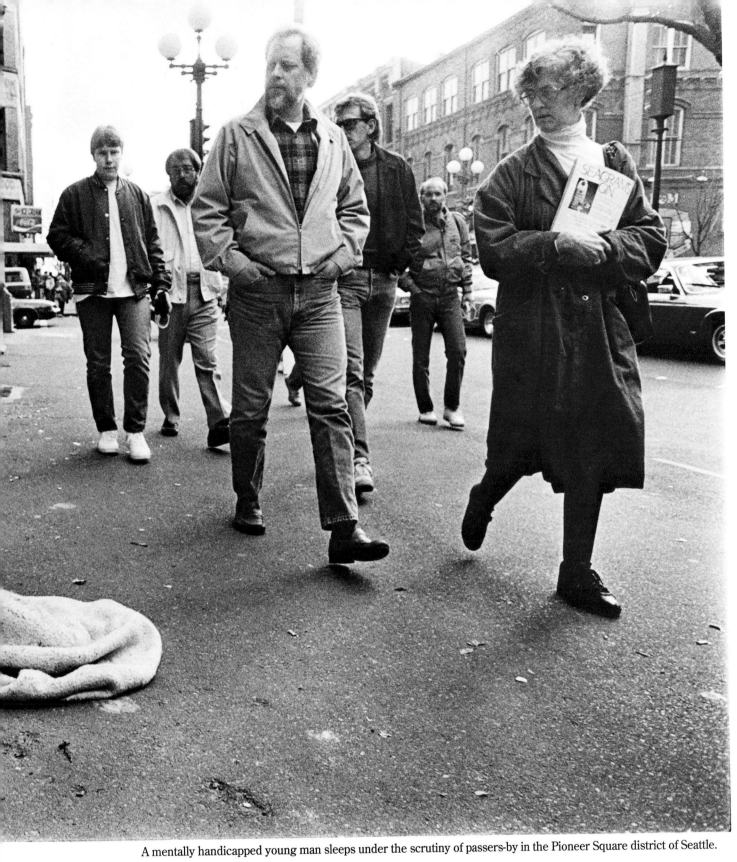

A mentally handicapped young man sleeps under the scrutiny of passers-by in the Pioneer Square district of Seattle.

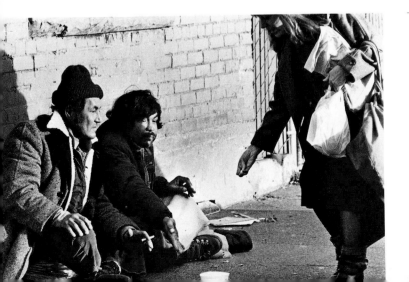

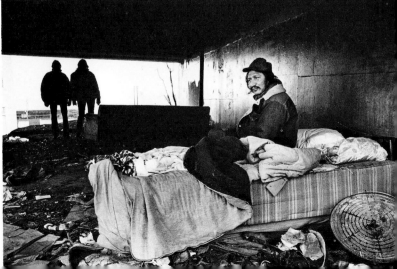

Seattle's homeless

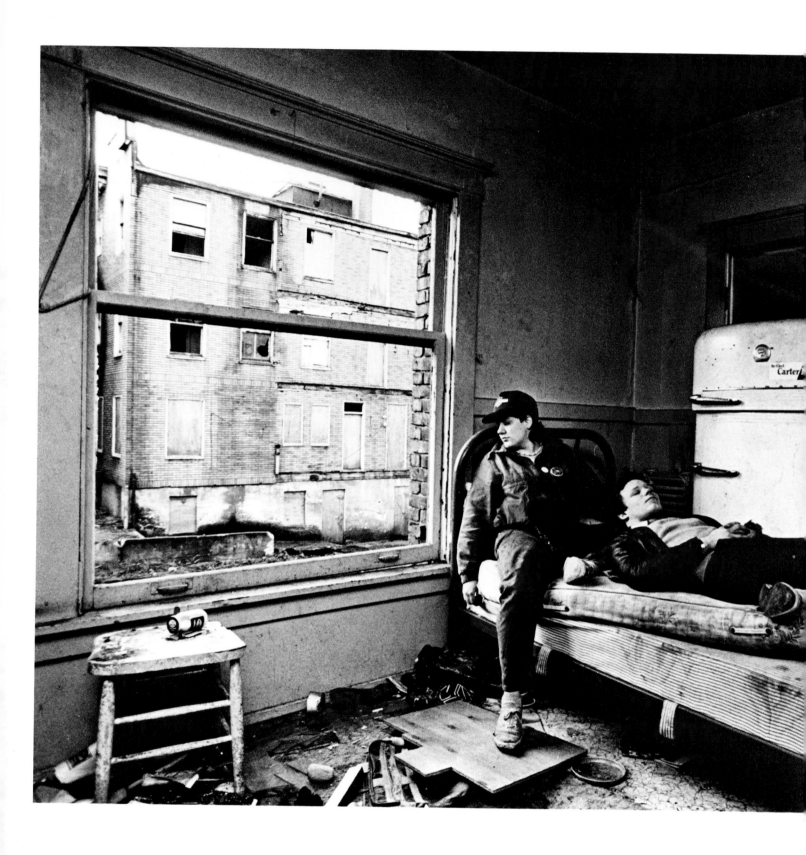

"The streets are just as tough as prison. There are animals out there. They will eat you alive if you are out here after 2 o'clock in the morning."

-- Doyle O'Neal, homeless Vietnam veteran

She's 15 and he's 17. They love each other, but dreams of the future are clouded by the reality of living in an abandoned apartment building. For money, she panhandles. He is an expert at stealing from parking meters.

Rules are rules. If you want to sleep at the emergency shelter during the day, you do it on the floor. The mats can be used only at night.

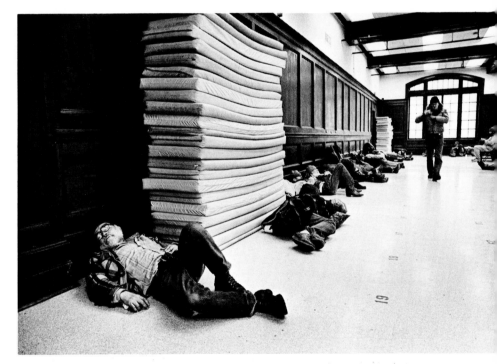

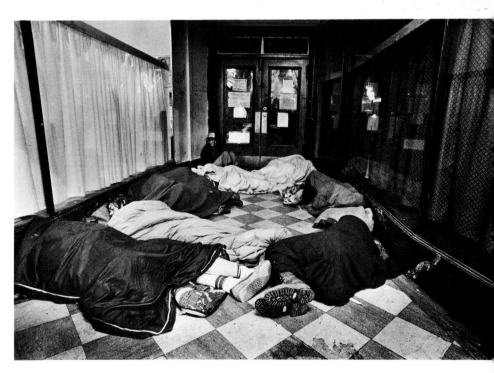

A dozen homeless, mostly teen-agers, sleep in the doorway of a youth center in downtown Seattle. Because of a lack of funds, the center — one of the last places young people go during the harsh winter — closed its doors.

Seattle's homeless

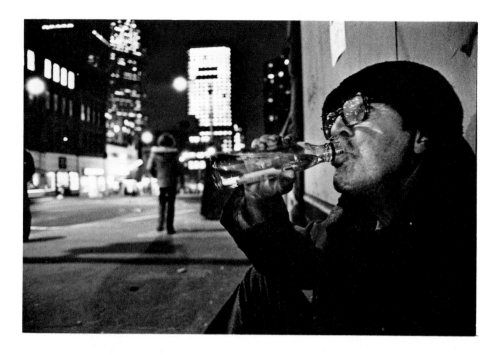

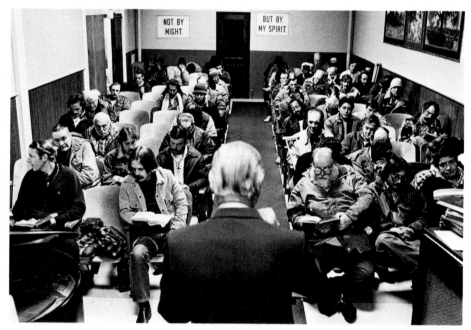

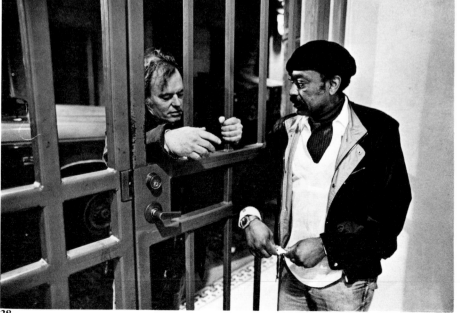

The first thing this road-beaten man asked was "Why don't you use a Leica?" He further explained some technical reasons for using the lightweight, quiet piece of camera equipment.

With every free meal at the Bread of Life mission comes a half-hour sermon. Attend or go hungry.

A drunken man creating a disturbance after hours is denied a bed at the emergency shelter. He'll have to find a place on the street for the night. The rule is simple: You can sleep or you can drink. It's your choice.

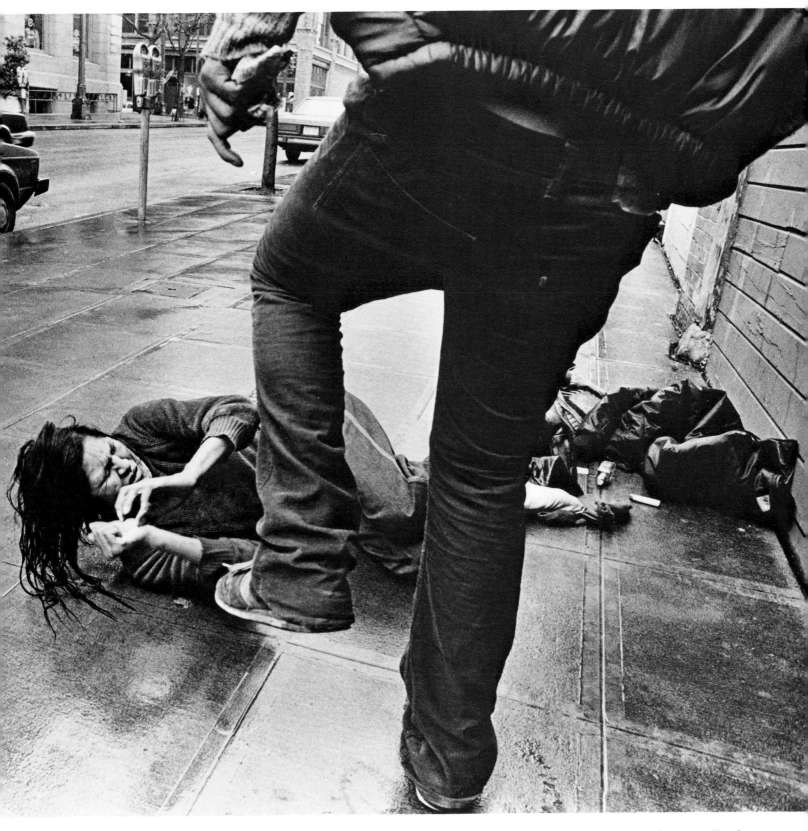

An intoxicated man attempts to kick his sister in the face because of a $10 debt. The photographer who came upon the scene offered what money he had — $3 — and promised to make up the difference within 10 minutes. Taking the money, the brother vowed to kick her anyway. The brother also emptied the contents of his sister's purse and removed her shoes, looking for hidden money.

Overleaf:

Firefighters face a dilemma of what to do with a slightly injured man found drunk in an alley late at night. With the detox center full, they could only place him in a doorway out of the rain to sober him up.

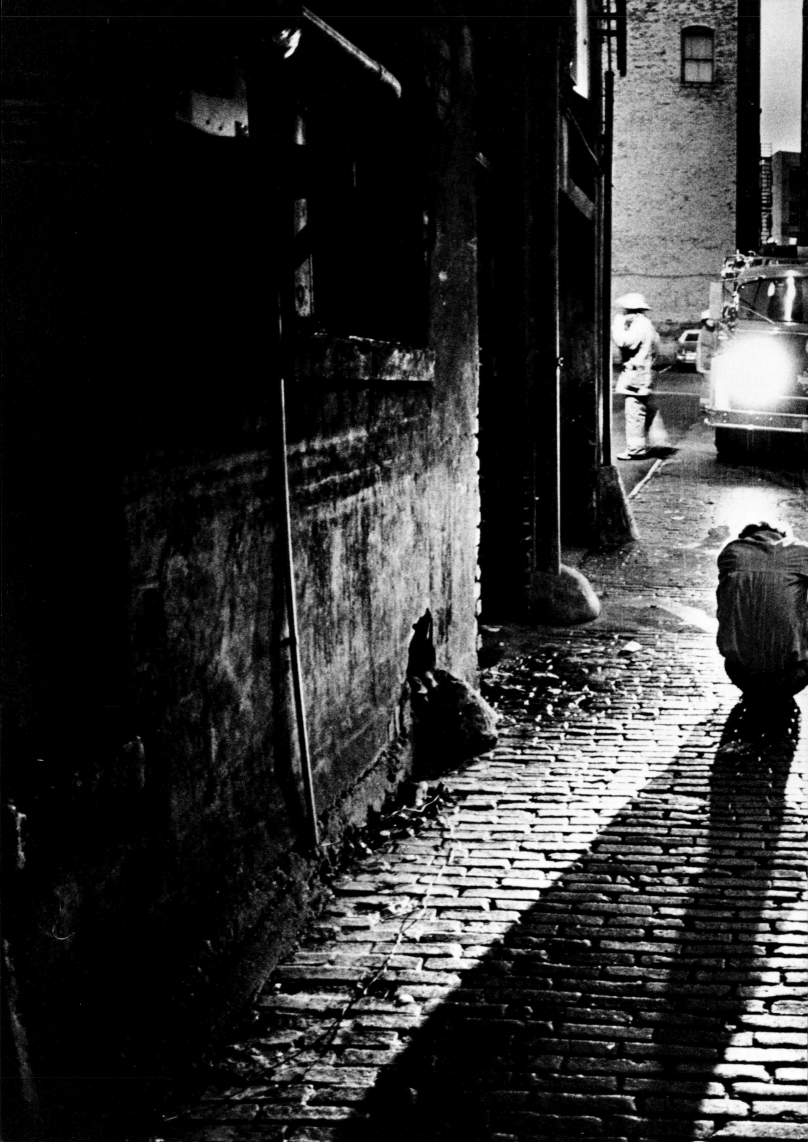

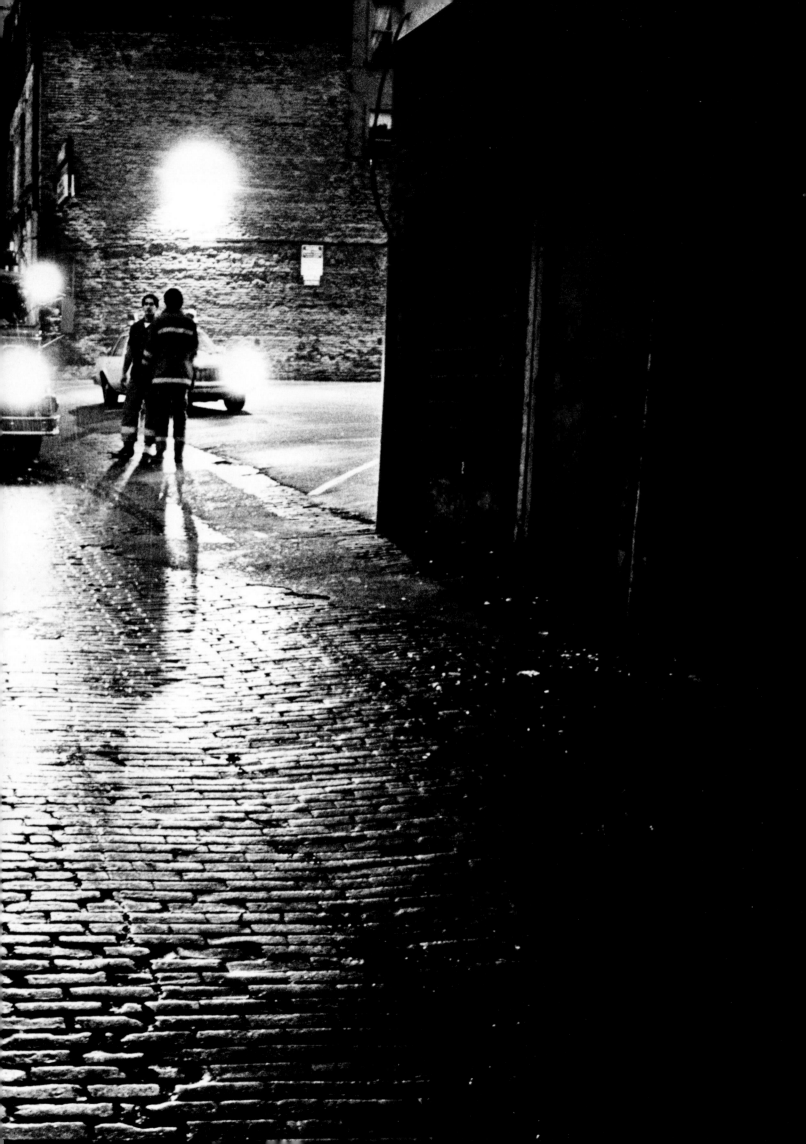

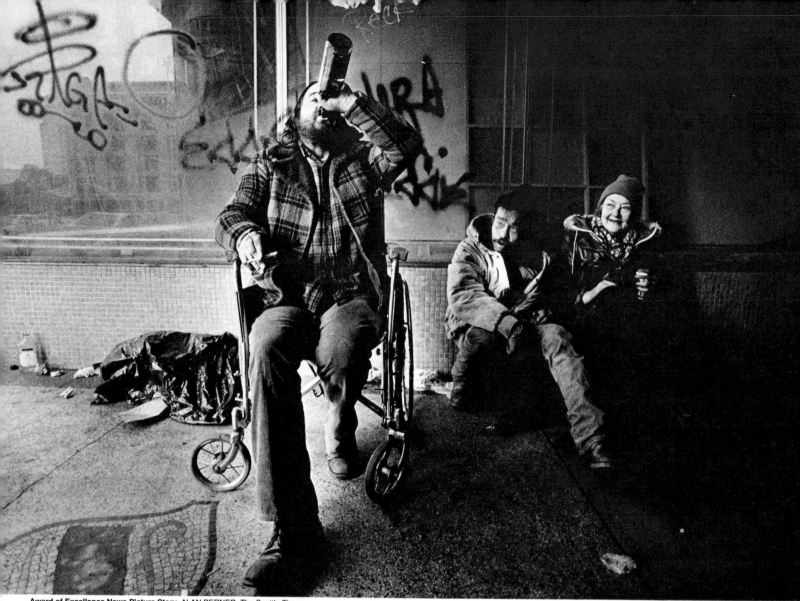

Award of Excellence News Picture Story, ALAN BERNER, The Seattle Times

Wheelchair-bound Mike Haven has his morning "wake up" in the Second Avenue Seattle storefront that he often calls home. Irene Hogan and a man known only as Nat keep him company.

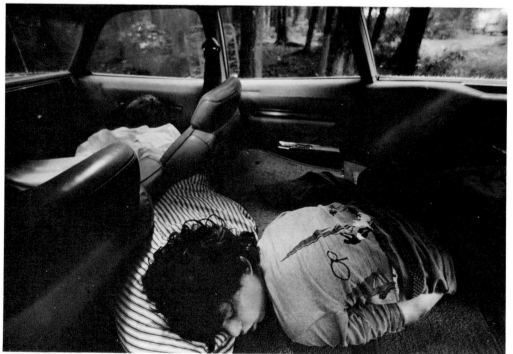

Award of Excellence News Picture Story, STEPHEN SHAMES, The Philadelphia Inquirer

Eleven-year-old Tony Beck sleeps in the car after a September storm washed out his family's tent — their home — in Bucks County, Pa.

Two days after Christmas, 23-year-old Barbara Trango changes her daughter's diapers on the floor of a public rest room in the Travelers Aid offices in Jacksonville, Fla. The agency, which receives some federal funds, gave Trango money for a small hotel room. The baby is sick with diarrhea caused by an improper street diet.

RON BELL, The Florida Times-Union (Jacksonville, Fla.)

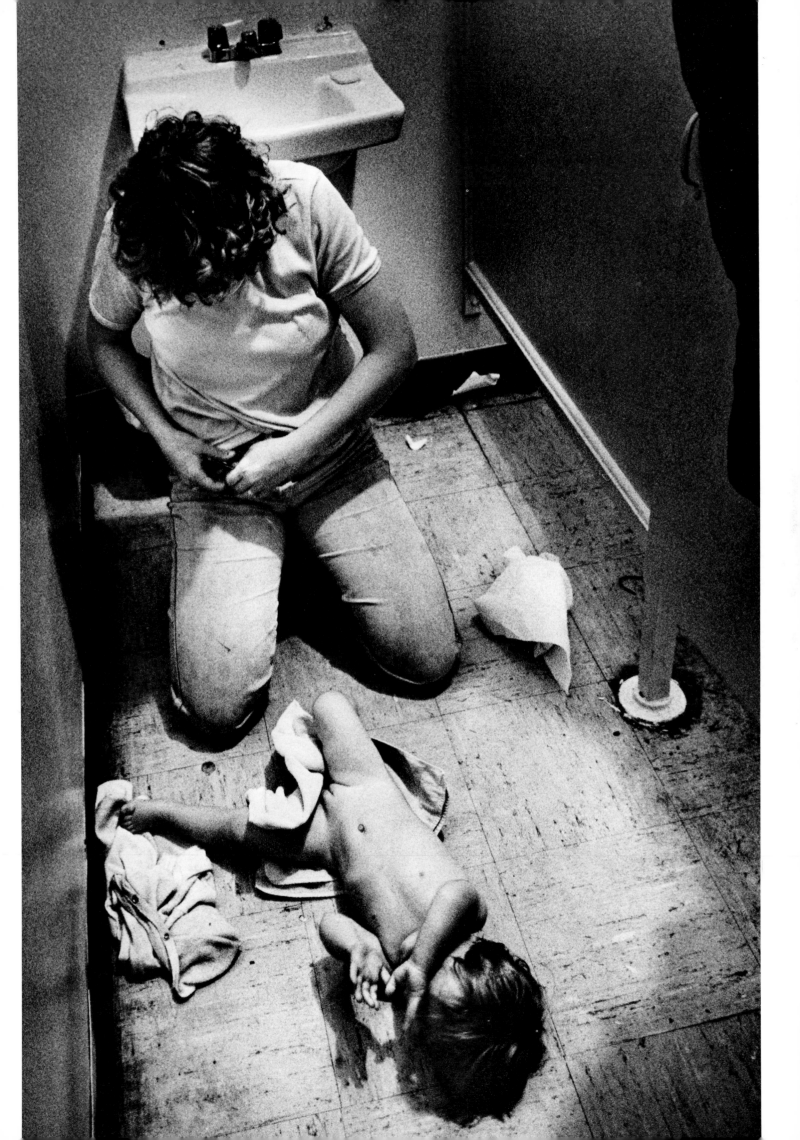

Time is running out for 23-year-old Brenda Young and her 7-year-old son, Renard. They are one of 424 families that received lease terminations for their Lafayette Shores apartment. Lafayette Shores is the second-largest privately owned apartment complex for the poor in Norfolk, Va. It will be torn down to make way for higher-income homes.

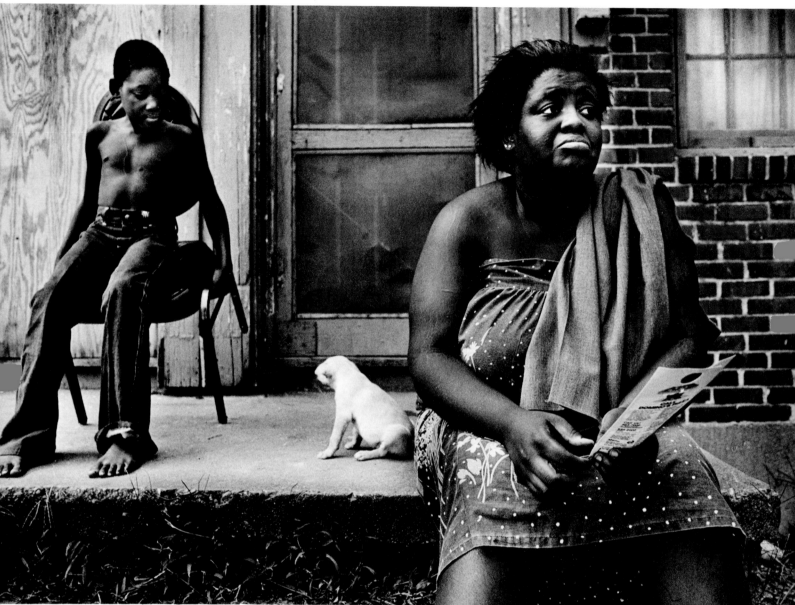

"My boy is learning about the Constitution this month in school--about justice, you know--but for us out here, there ain't no justice at all."

--Brenda Young

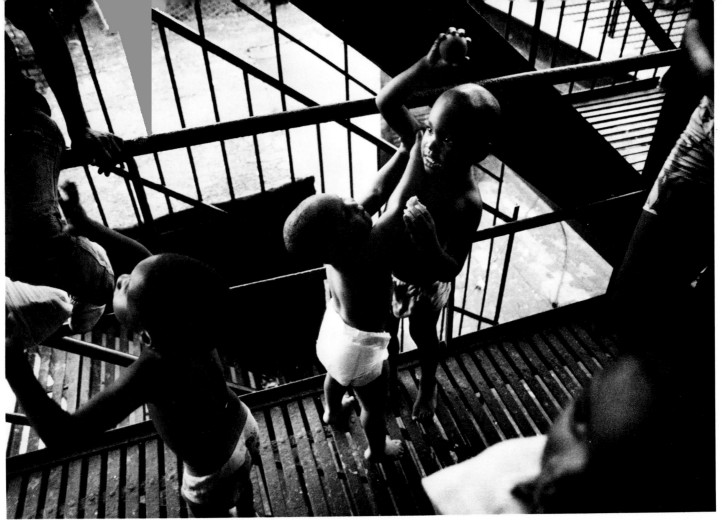

The Davis brothers fight over a ball on their fourth-floor fire escape playground.

The Holland Hotel

Danger in high places

New York City has 63 hotels for the homeless. The Holland Hotel is considered one of the worst. Photographer Nicole Bengiveno went under cover to expose how the residents were being taken advantage of. Residents told of a rash of violence, but police said most incidents go unreported. Bengiveno also found a hotel full of children. Authorities estimate 70 percent of the 300 children living in the hotel do not go to school – lost in the Holland Hotel.

Third Place Feature Picture Story, NICOLE BENGIVENO, New York Daily News (all photos)

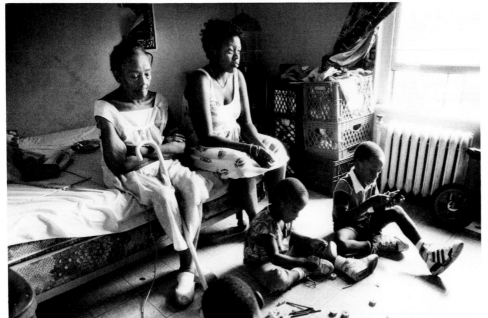

Daphne Pratt, who is pregnant, sits on her bed at the Holland Hotel with her mother, D'Lornia, and her three sons. "They know stuff they shouldn't know, even the 4-year-old," she says. "They know what crack is, what a pipe is, what a stem is and how much it cost. They see it all in the halls."

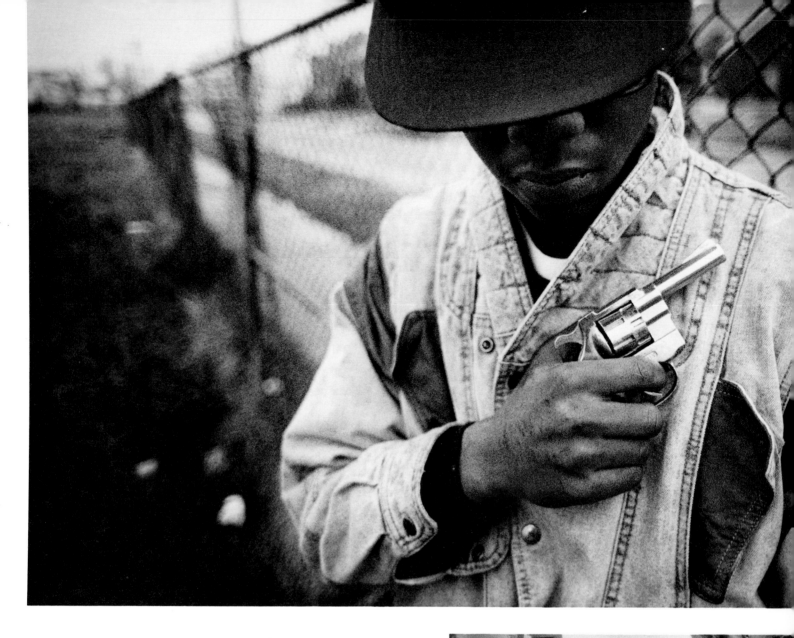

Kids, guns and blood

With 11,419 legally licensed firearms dealers in Michigan, and an infinite number of street-corner dealers, the supply of guns in Detroit is staggering. During the first 10 months of 1987, police confiscated 68 percent more guns from juveniles than they did in a similar period the year before. In the past two years, 690 youngsters were shot. Seventy-seven died.

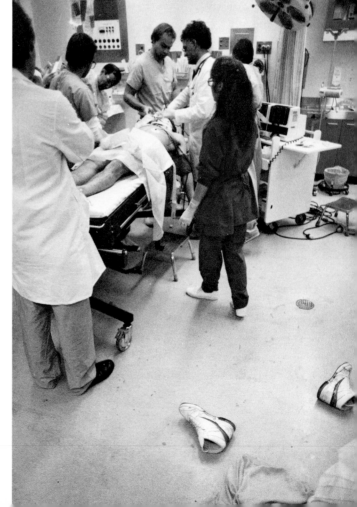

The sight is all too common on a Saturday night. Doctors and paramedics fight to save a teen-age shooting victim.

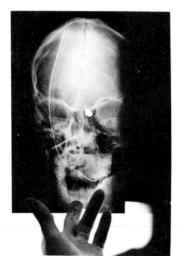

An emergency room physician looks over an X-ray showing a bullet hole in the middle of a teen-ager's head. The youth did not survive the apparently self-inflicted gunshot wound.

Frisked and arrested, a 14-year-old was one of three people taken into custody during a raid on an abandoned house in Detroit. Police said it was a crack house. "In Detroit, almost all the homicides are narcotics-related in one way or another," a DEA agent said.

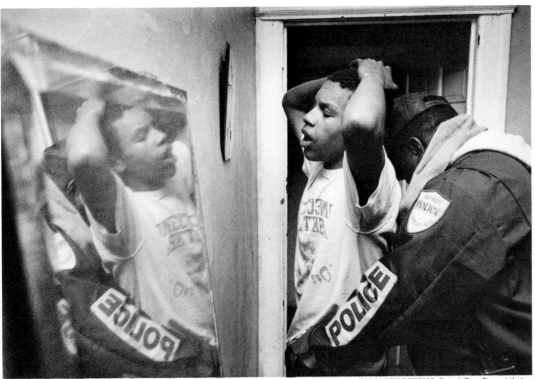

Second Place News Picture Story, MANNY CRISOSTOMO, Detroit Free Press (all photos)

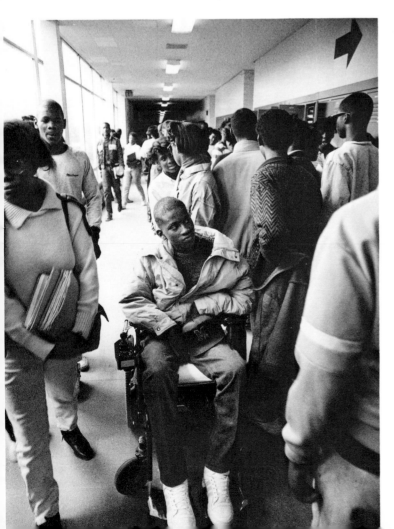

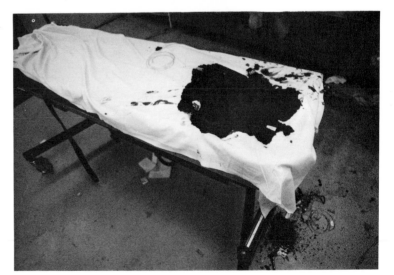

A blood-stained hospital stretcher is a gruesome reminder of the futile struggle to undo the damage of guns in Detroit.

Julius Jones survived being shot by another teen-ager on a Detroit sidewalk, but is confined to a wheelchair. Jones doesn't remember what their fight was about, "but it wasn't nothing to get shot over."

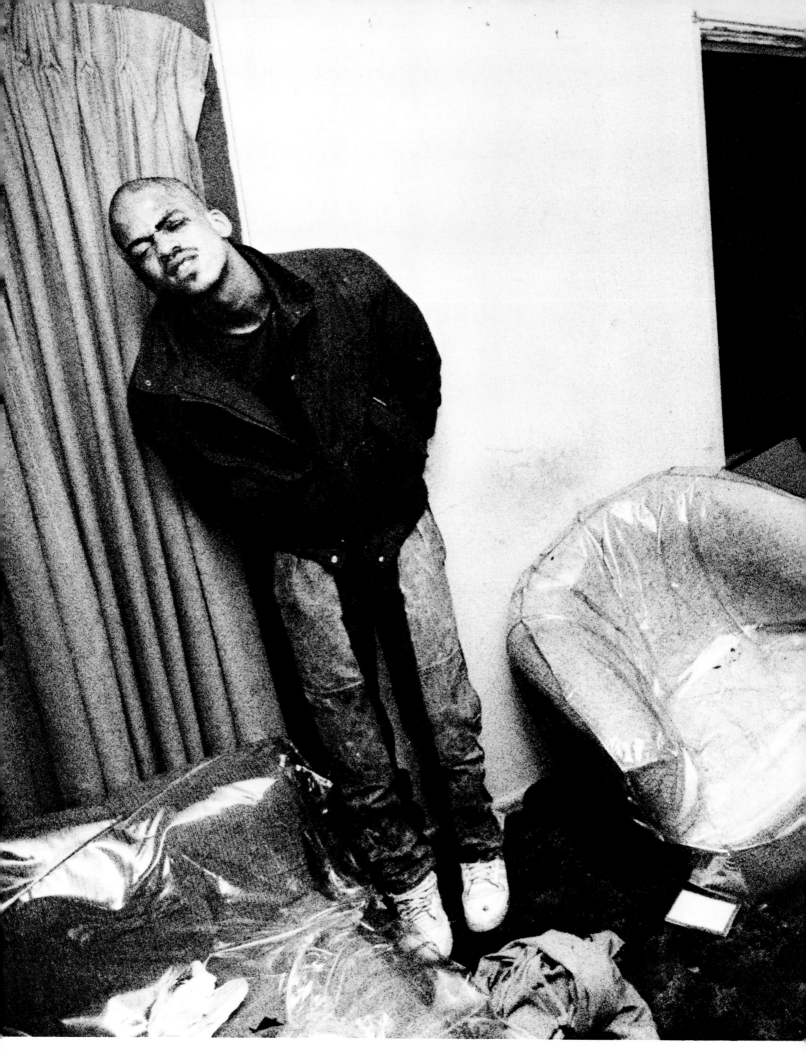

Walter Murphy, 22, arrested during the first night of Detroit's crackdown on cocaine trafficking, stands apart from the others after a scuffle with police. Murphy was arraigned on charges of possession with intent to deliver cocaine, carrying a concealed weapon and possession of a firearm in the commission of a felony.

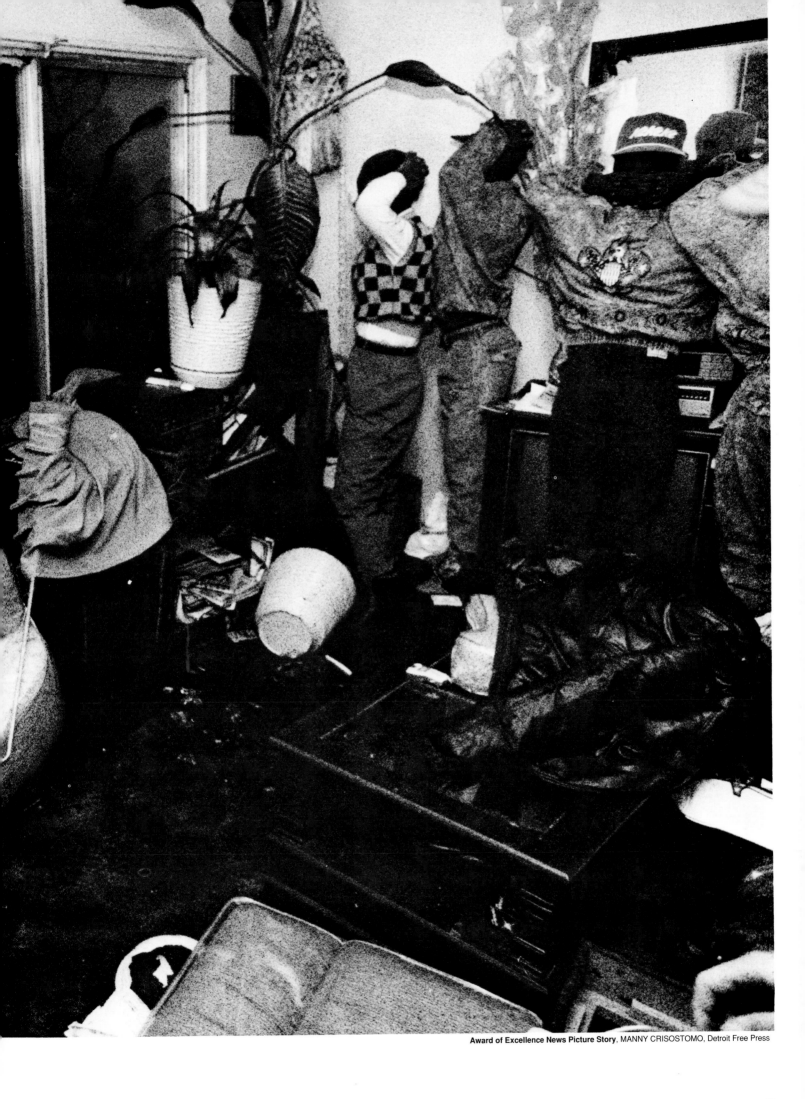

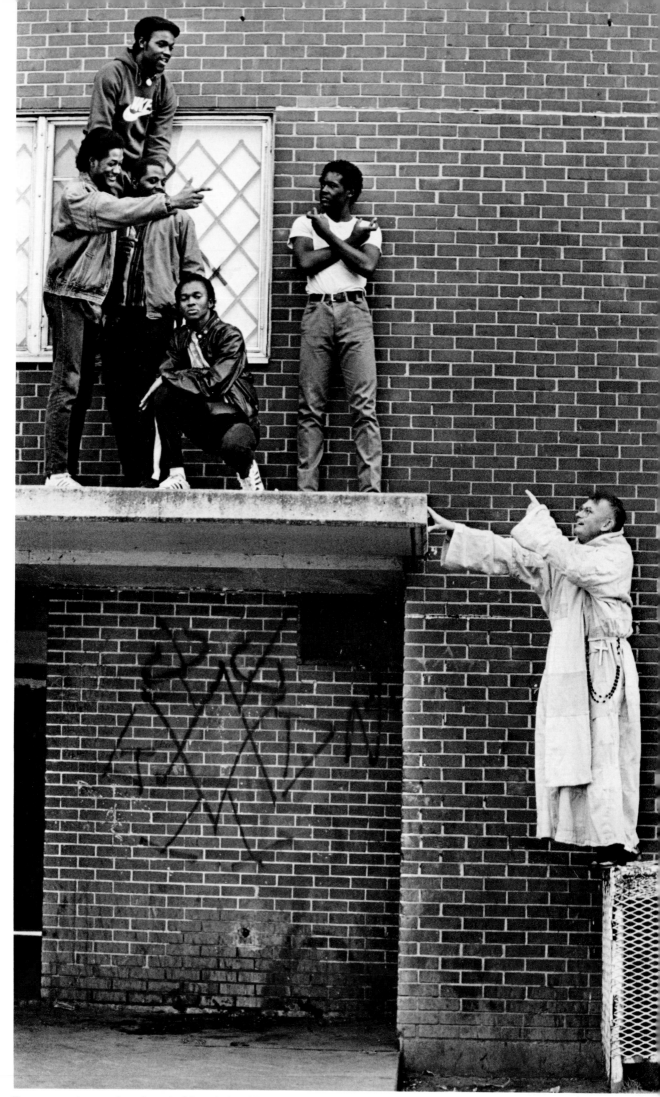

Tomes goes to great lengths to build a relationship.

Brotherly love in Chicago projects

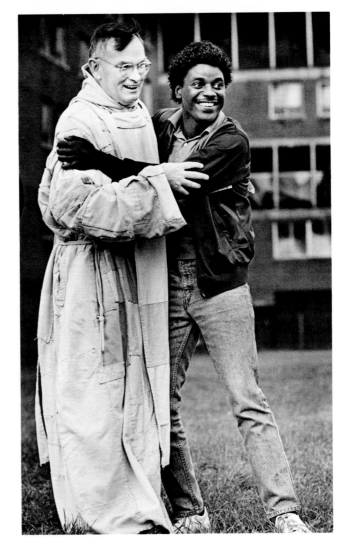

Brother Bill is William W. Tomes, a familiar figure in the Chicago housing projects. During the past four years, the denim-clad lay consultant to Catholic Charities has built a rapport with the gang members, giving them rides, buying them burgers and sodas at McDonald's, visiting the wounded and grieving with the survivors.

Jobs are needed to get the young away from the gangs, Tomes says. "I talk with gang members as brothers and sisters. I love them a lot. People should understand them as persons. Sometimes they do things wrong, but everybody does things wrong sometimes."

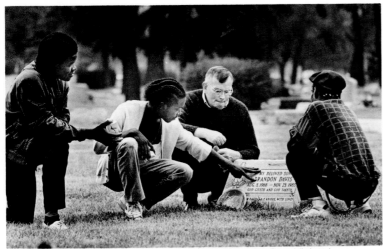

Award of Excellence News Picture Story, AL PODGORSKI, Chicago Sun-Times (all photos)

Death is a part of Tomes' life. He has been to 56 funerals in four years, with victims ranging in age from 5 to 25.

Tomes jokes with his godson, Demetrius Ford, who helps "bring about constructive things."

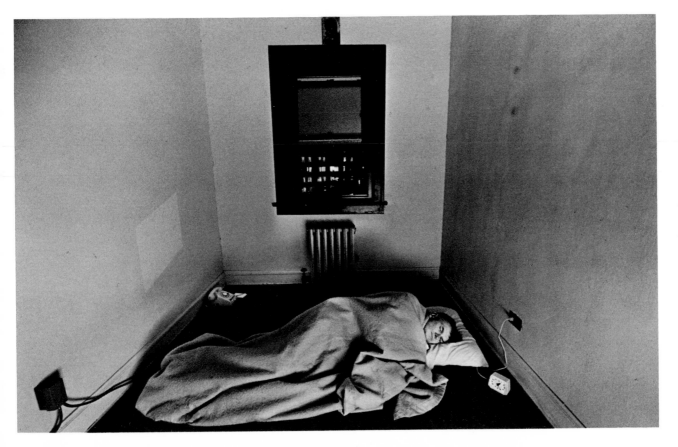

The small, bare room where Tomes sleeps on a blanket on the floor overlooks the Henry Horner development. Tomes keeps his window cracked so he can hear any sound of trouble.

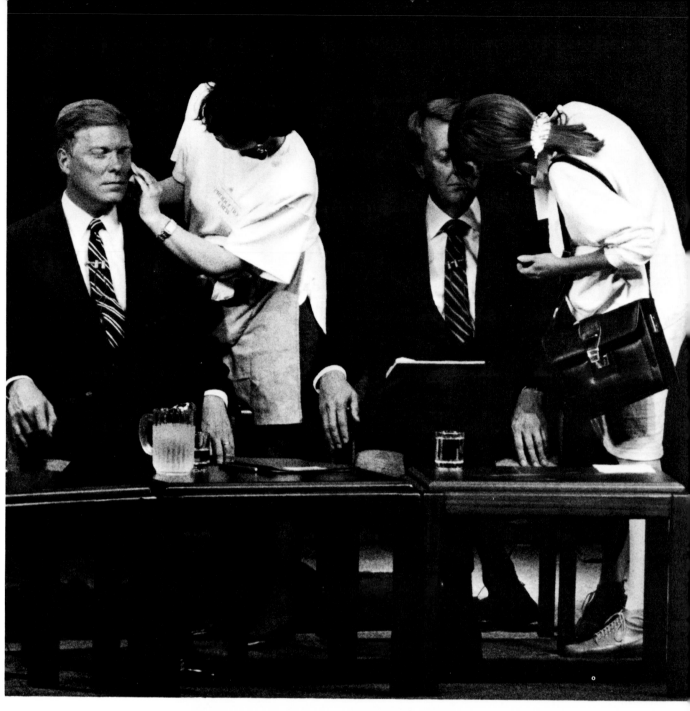

Democratic presidential hopefuls Richard Gephardt, Bruce Babbitt and Jesse Jackson get a few finishing touches on their makeup as Paul Simon waits his turn before a debate in New Orleans.

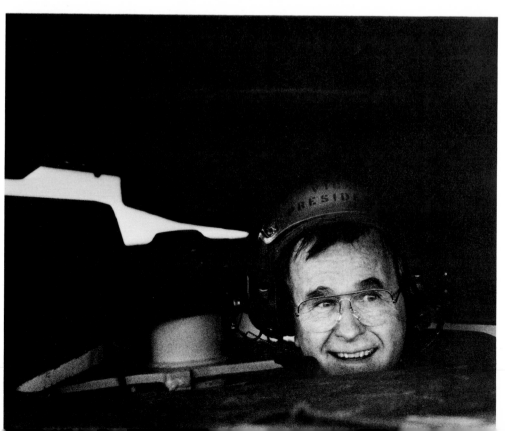

Vice President George Bush, wearing a personalized helmet, checks out the army's M-1 tank at Fort Knox, Ky.

BEN VAN HOOK, The Courier-Journal and Louisville (Ky.) Times

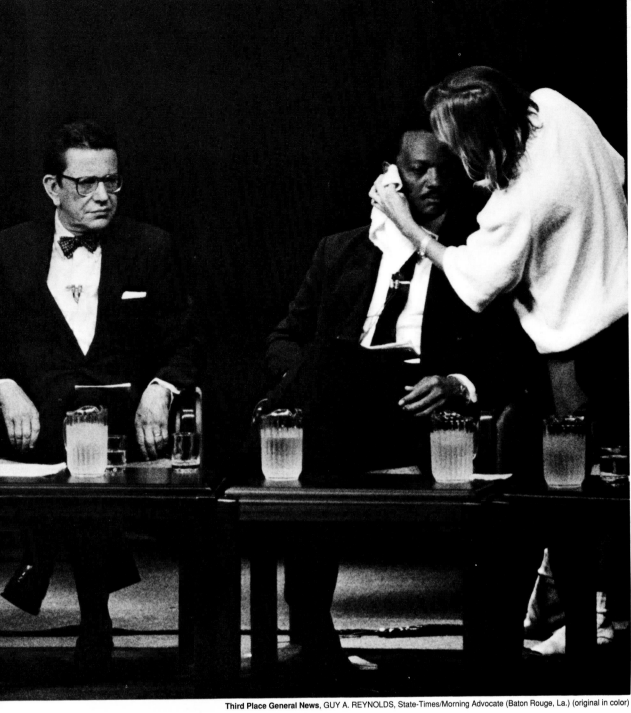

Third Place General News, GUY A. REYNOLDS, State-Times/Morning Advocate (Baton Rouge, La.) (original in color)

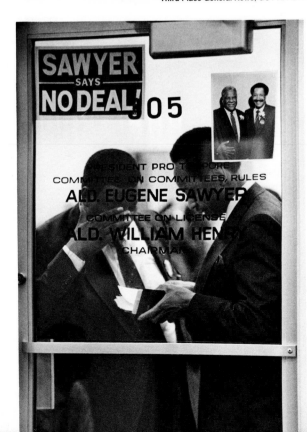

Politics

Chicago's first black mayor, Harold Washington, collapsed in his office and died of a heart attack Nov. 25.
As his admirers wept over their loss, the political repercussions were just beginning.

The day after Washington's death, names already were circulating among the aldermen, who would select the interim mayor.

Before the vote, there was a lot of wheeling and dealing. Much of it took place in the office of Alderman Eugene Sawyer, who later was elected mayor.

AE News Picture Story, JUDY FIDKOWSKI, The Daily Southtown Economist (Chicago)

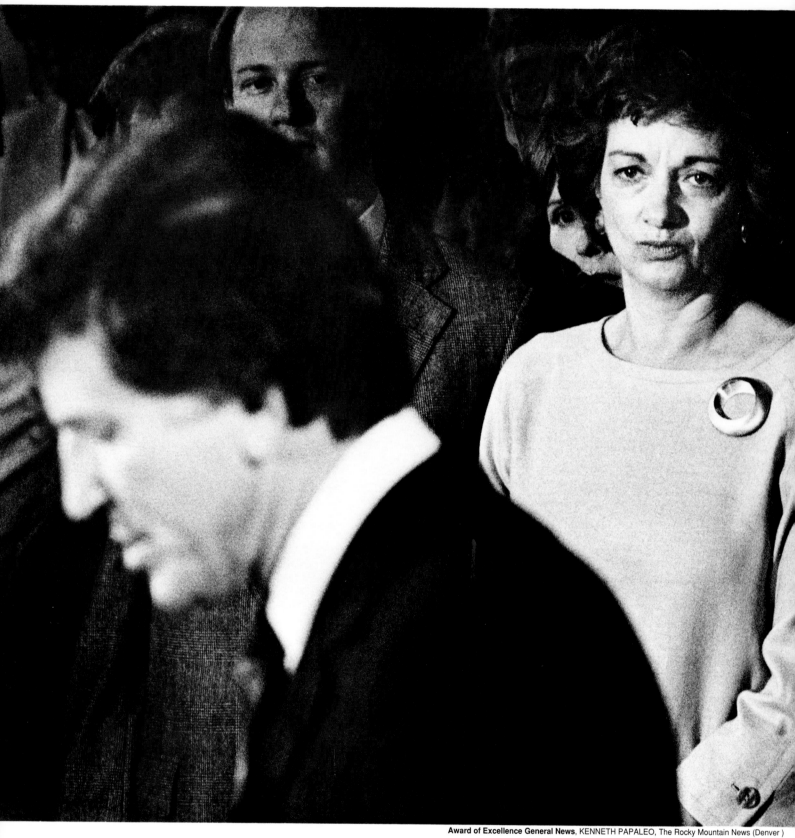

Award of Excellence General News, KENNETH PAPALEO, The Rocky Mountain News (Denver)

Lee Hart watches her husband, Gary, tell a crowd he is giving up his campaign for the Democratic presidential nomination. Hart faced a public scandal when his relationship with Miami model Donna Rice was revealed by articles in The Miami Herald.

Politics

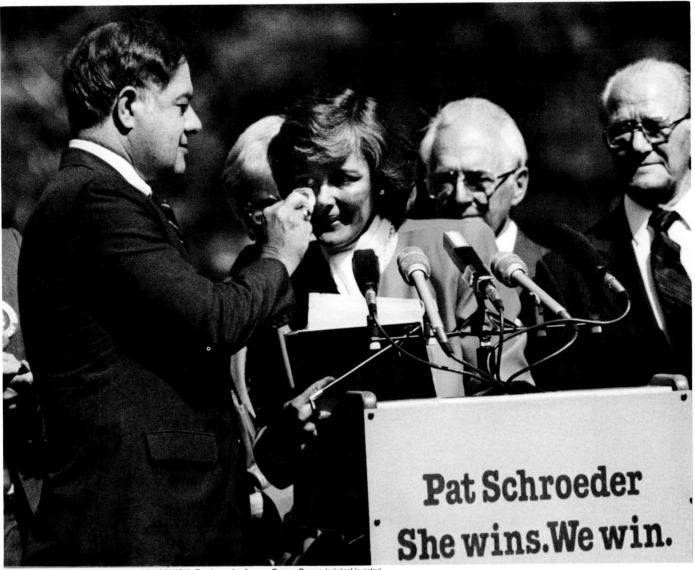

Award of Excellence General News, ED KOSMICKI, Freelance for Agence France-Presse (original in color)

U.S. Congresswoman Pat Schroeder gets a tear wiped away by her husband, Jim, just after she announced she would not be running for the Democratic nomination for president.

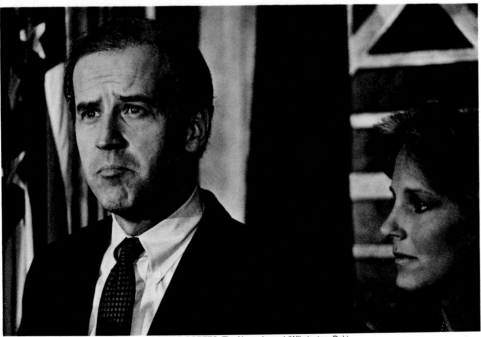

Award of Excellence One Week's Work, RONALD CORTES, The News-Journal (Wilmington, Del.)

Admitting he made mistakes, U.S. Sen. Joseph R. Biden Jr. announces he is dropping out of the race for the Democratic nomination for president. Biden is joined by his wife, Jill.

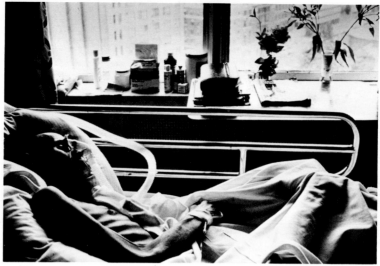

Thomas Ramos, 30, died of AIDS in August in New York City. His sister said Ramos was not a homosexual or intravenous drug user.

AE Magazine Picture Story, ALON REININGER, Contact Press Images (both photos; originals in color)

AIDS: the continuing tragedy

By the end of the year, nearly 50,000 cases of Acquired Immune Deficiency Syndrome had been reported. Almost half of those people had died.

While prospects for a vaccine against AIDS were dim, the government approved the first drug in the fight against the disease — AZT. Not a cure, the drug extends and improved the quality of life for some AIDS sufferers. For others, the drug either did not work or its side effects were too severe.

Much has been learned about the virus — an amazing amount since its discovery in 1981. However, the work is slow. The AIDS virus apparently mutates at a faster rate than the flu virus, making work on a vaccine more difficult than anyone first believed.

In August, approval came for the first human testing of an experimental vaccine. Scientists believe it is only the first of many such tests.

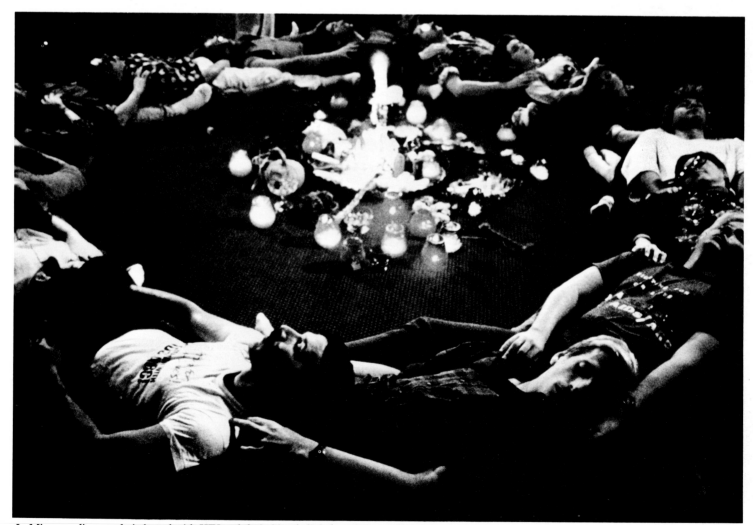

In Minneapolis, people infected with HIV and their friends link in a chain and laugh in sequence — one of the many unconventional therapies that have sprung up as medicine fails.

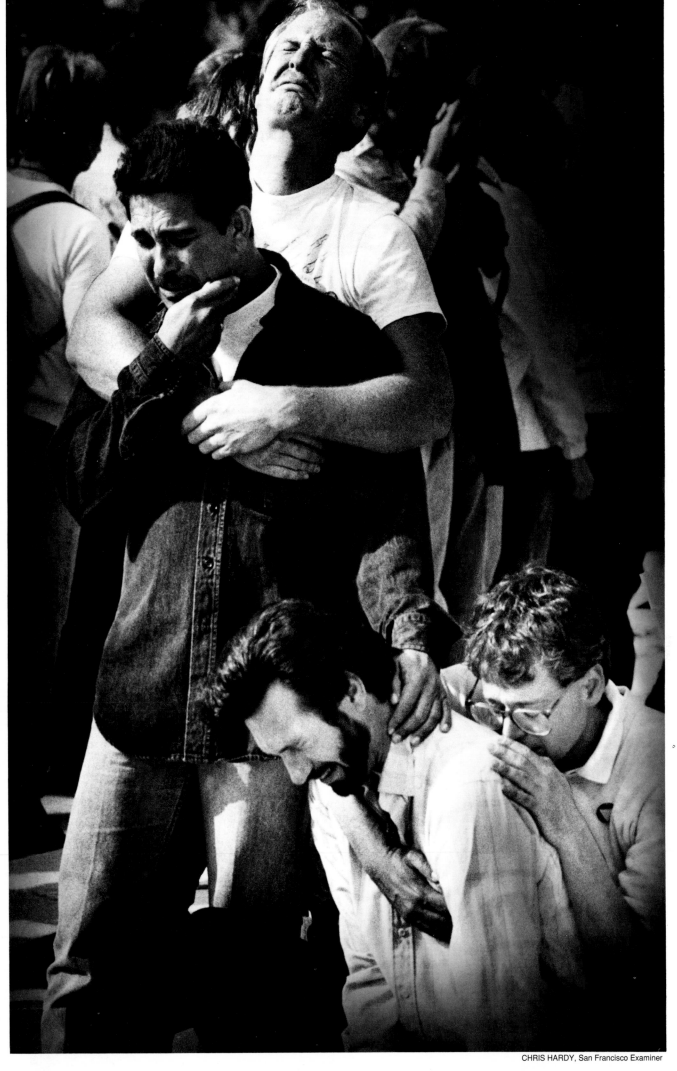

Founders of an AIDS quilt project grieve at the loss of friends whose names are added to the commemorative quilt. Some panels of the quilt include favorite poems, T-shirts, teddy bears or other keepsakes of people who died of AIDS.

AIDS: the continuing tragedy

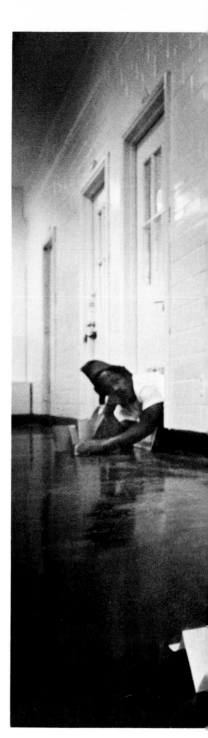

Award of Excellence Newspaper Photographer of the Year, CAROL GUZY, The Miami Herald

Wendy Blankenship, a 19-year-old prostitute with AIDS, is sentenced to one year at the Miami Women's Detention Center. Wendy, a repeat offender, was arrested for practicing her trade even though she knew she had AIDS.

HIV carriers at the Missouri State Penitentiary were isolated virtually 24 hours a day until late April. They were reduced to talking through food slots in the doors. Officials said the AIDS carriers were isolated for testing, as well as for protection from infections.

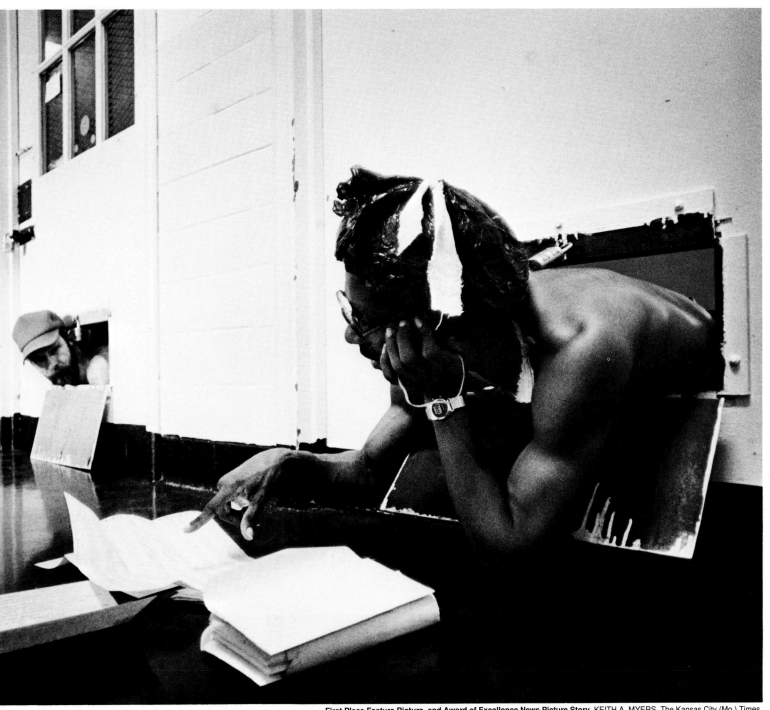

First Place Feature Picture, and Award of Excellence News Picture Story, KEITH A. MYERS, The Kansas City (Mo.) Times

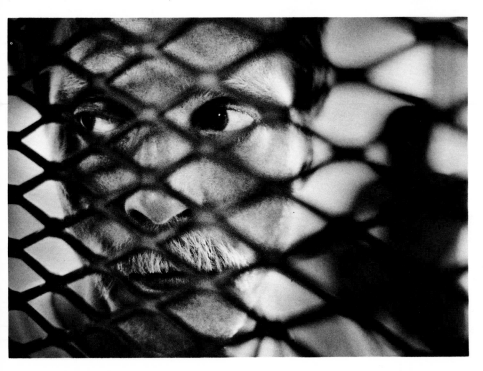

AIDS-infected inmates such as Gary Brown are isolated on one floor of the Missouri State Penitentiary prison hospital.

Award of Excellence News Picture Story,
KEITH A. MYERS, The Kansas City (Mo.) Times

AIDS: the continuing tragedy

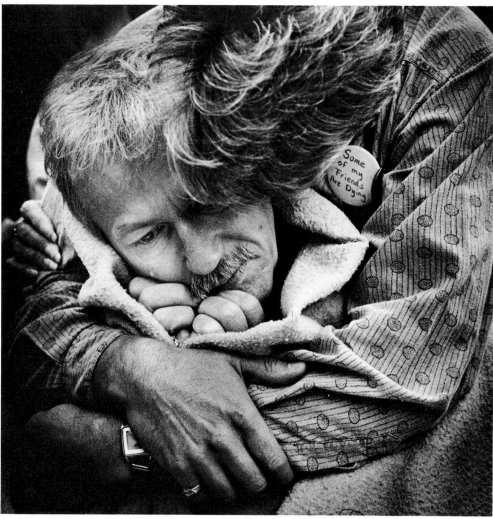

TIMOTHY C. BARMANN, Daily Kent (Ohio) Stater

Dan Webber, an AIDS victim, is comforted by Rick Holderman during an October gay rights march in Washington D.C. Webber, in a wheelchair, was among 3,000 people with AIDS in the march. More than 200,000 people gathered for the demonstration.

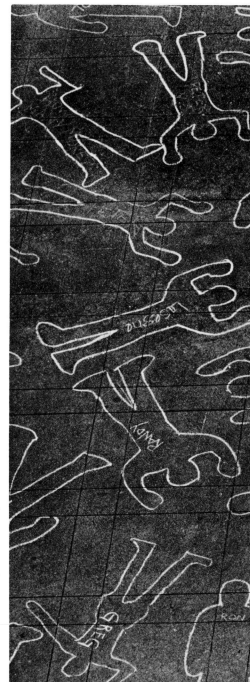

A passer-by strolls over the outlines of 610 Dallas AIDS victims who have died since December 1987. The outlines were drawn near City Hall to dramatize AIDS deaths in the Dallas area.

Award of Excellence General News, LOUIS DeLUCA, Dallas Times Herald

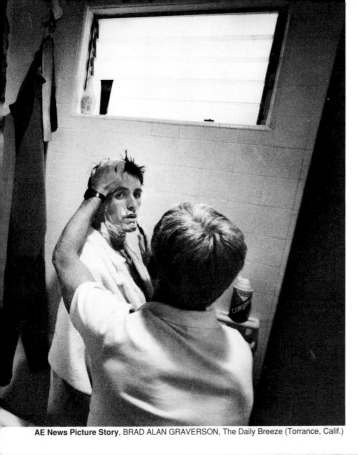

Ray Gubser, who admitted having problems dealing with his son's impending death, took part in Paul's care, including shaving and showering. "I'll take him any way. The way he is now."

AE News Picture Story, BRAD ALAN GRAVERSON, The Daily Breeze (Torrance, Calif.)

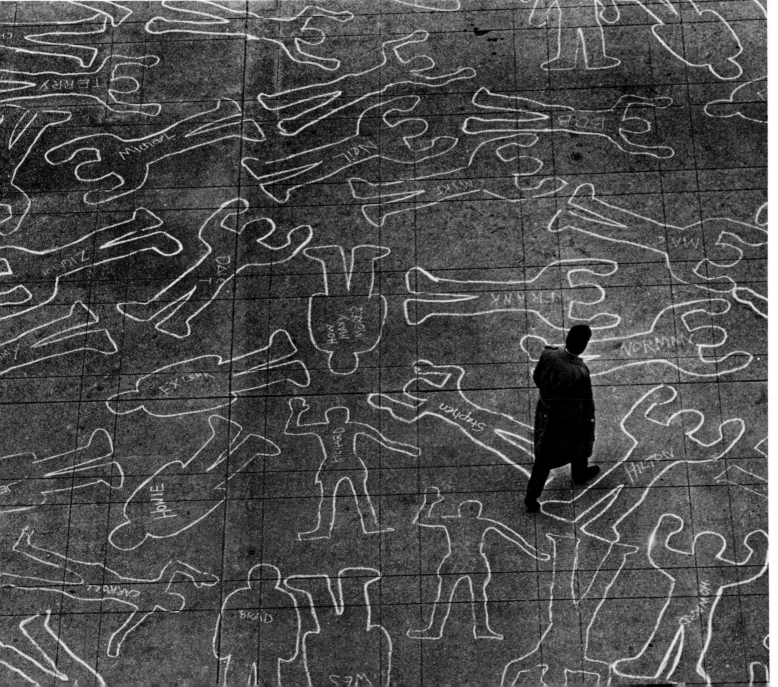

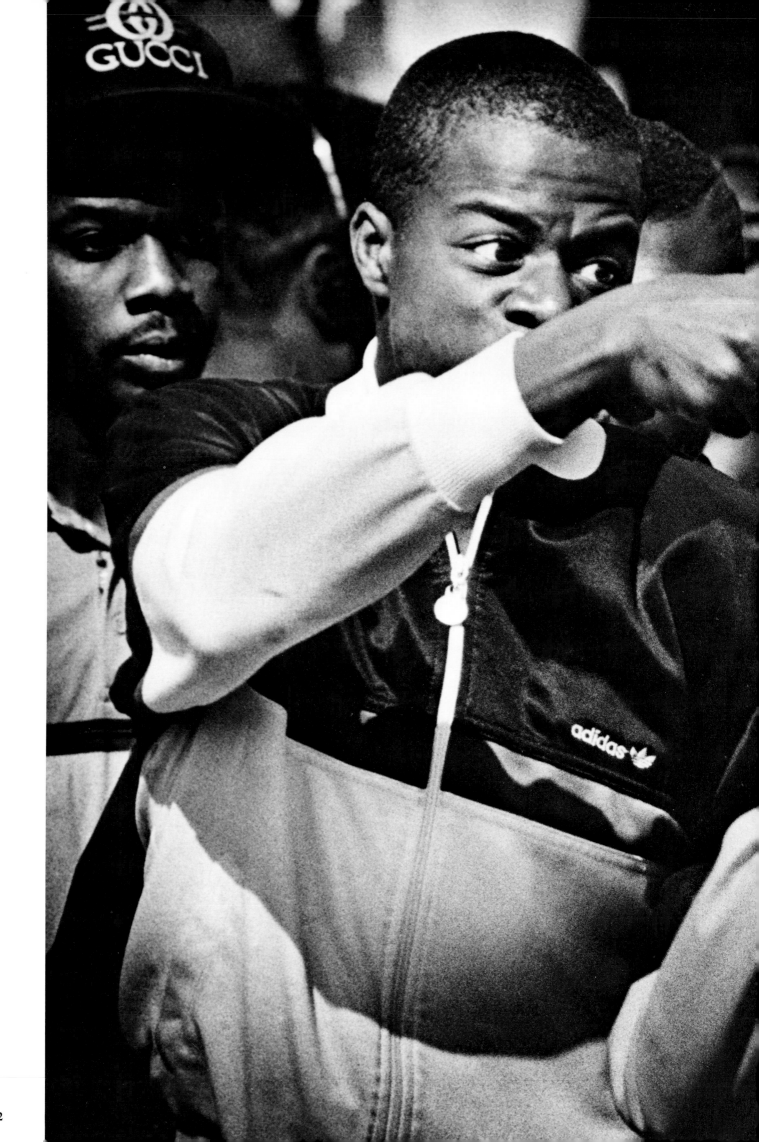

On the spot

An unidentified man wields a knife in a photo that convinced police that an additional man should have been arrested after a dispute erupted at a high school track meet in Virginia Beach, Va. The man in the photo was not arrested.

Award of Excellence Spot News,
PAUL AIKEN, The Virginian-Pilot and
The Ledger-Star (Norfolk, Va.)

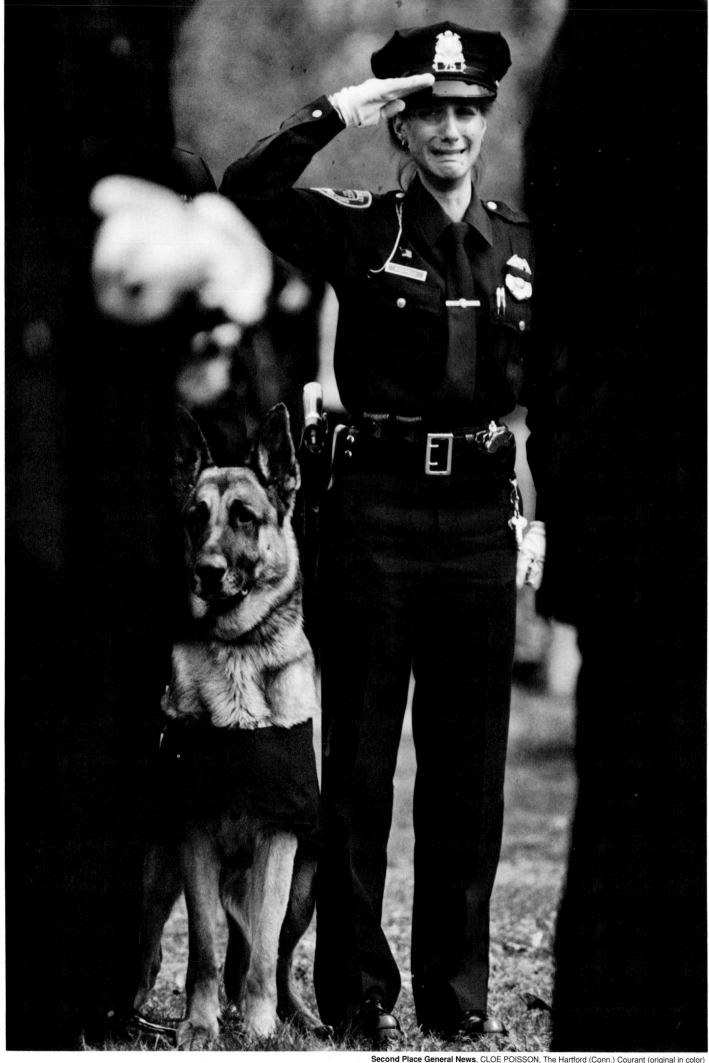

Officer Melissa Piscatelli salutes the coffin holding the body of her fiance, Milford Patrolman Daniel Scott Wason. At her side is Wason's police dog. The 25-year-old Wason was the first Milford, Conn., officer killed in the line of duty.

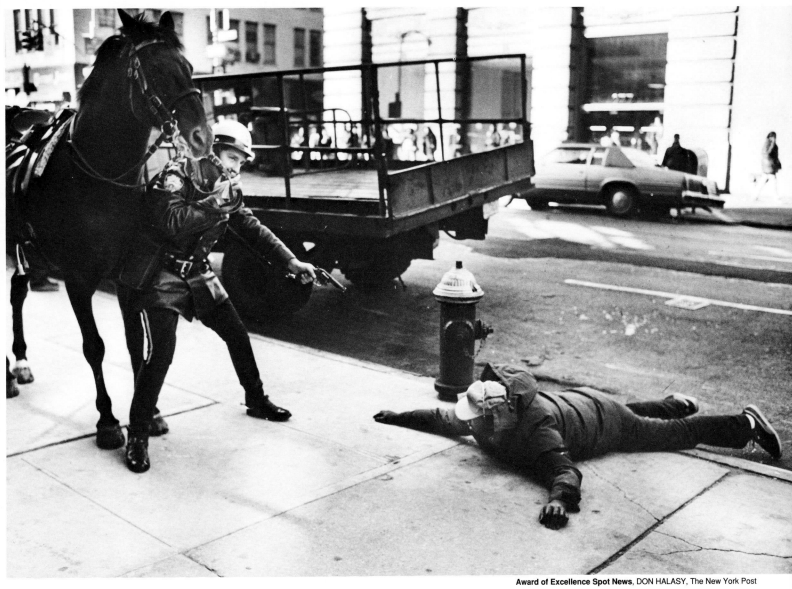

Award of Excellence Spot News, DON HALASY, The New York Post

A mounted police officer orders a murder suspect to freeze just moments after witnesses saw a security guard stabbed to death in lower Manhattan.

Children return to their Gary, Ind., home to find their parents handcuffed in the front yard, arrested on drug charges. Huge garbage bags of marijuana were found in the house, along with several stashes of cash.

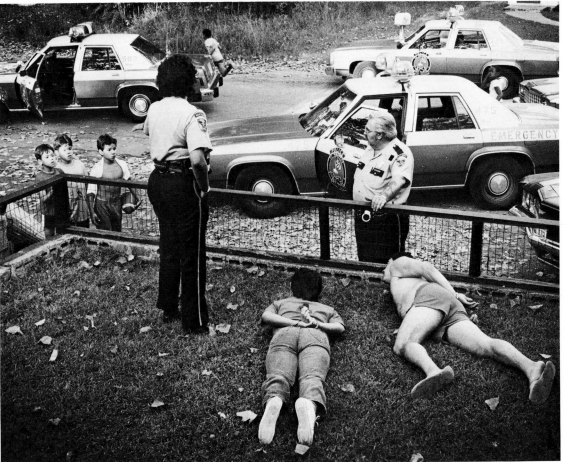

KAREN PULFER, The Post-Tribune (Gary, Ind.)

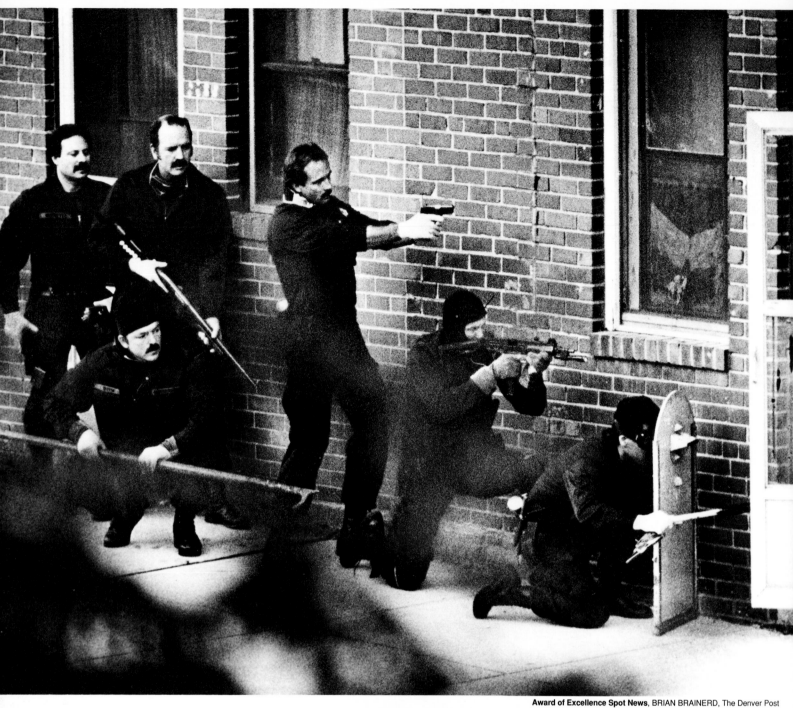

A Denver SWAT team approaches the apartment of a man after a shootout with police. The lead officer uses a shield and mirror to peer into the apartment, discovering the gunman had been killed in the shootout.

Ron Bratt is a Dallas cop. He walks the walk. He talks the talk. But Bratt is different. Before he carried a badge, he carried a Bible. Bratt was a Roman Catholic Priest.

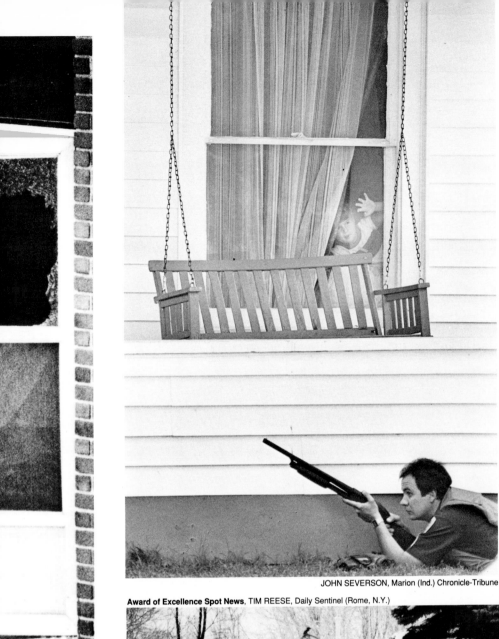

Five-year-old Ryan Borders peers out a front porch window while he, his younger brother and a woman are held hostage by a Marion, Ind., gunman Sept. 6. The gunman, father of the children and despondent over the living arrangements with the mother, barricaded himself and his hostages inside the house for seven hours. No one was injured. The gunman surrendered to police.

Robert Groth swings his father's mailbox during a scuffle with deputies and their dog. Groth's father died in a fire at the house earlier in the day in Oneida County, N.Y.

JOHN SEVERSON, Marion (Ind.) Chronicle-Tribune

Award of Excellence Spot News, TIM REESE, Daily Sentinel (Rome, N.Y.)

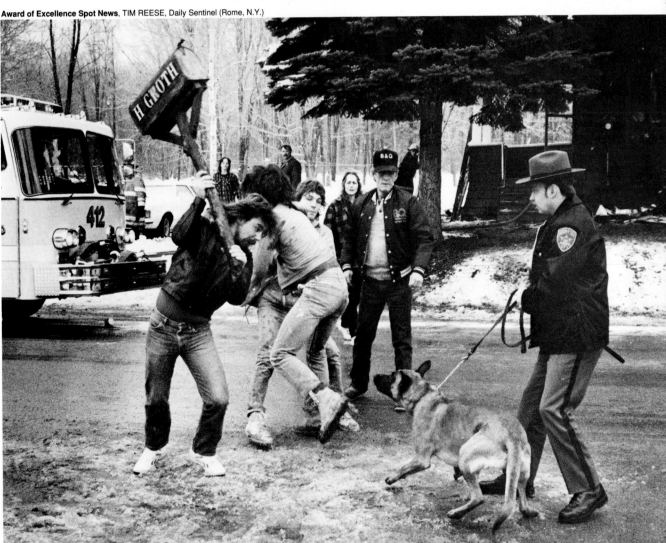

MICHAEL SCHWARZ, Atlanta Journal and Constitution

Business declined at Midtown Plaza in Rochester, N.Y., because kids would loiter in the plaza, often harassing shoppers. Fights like these were an everyday occurrence.

KENNY KEMP, Charleston (W.Va.) Gazette

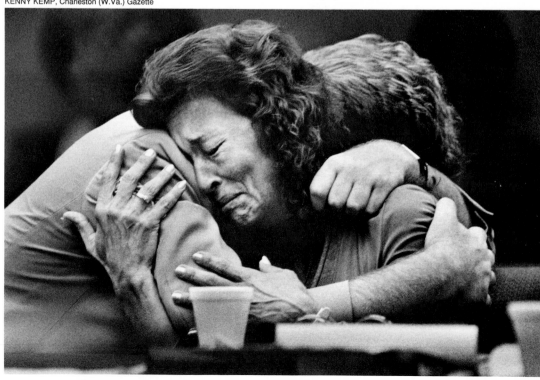

It was a highly charged murder trial in Charleston, W. Va. Linda Ankeney never denied shooting her husband, but her lawyer maintained that she was a battered wife acting in self-defense. After four hours of deliberation, Circuit Judge Margaret Workman emerged from her chambers with a verdict. For the first time in her judicial career, she directed a verdict of acquittal in a murder case. Ankeney and her lawyer, Ed Rebrook, embraced at the news.

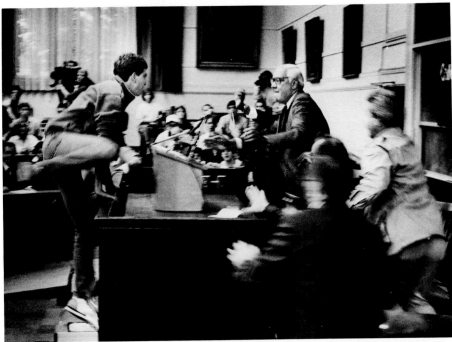

Desk top protest

Tufts University student Joshua Laub rushes at Contra leader Aldolfo Calero during a speech at the Harvard Law School in October. Police shielded Calero from the attack and he was not injured.

Award of Excellence Spot News, JOE WRINN, Harvard University News Office (Cambridge, Mass.) (both photos)

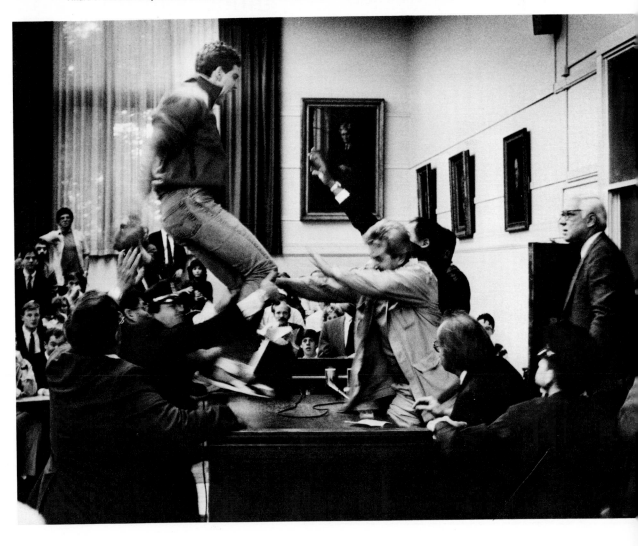

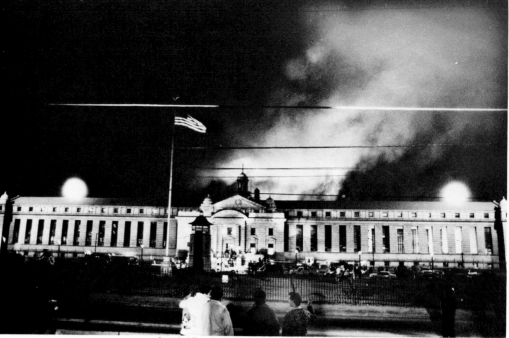

Seized by 1,400 Cuban inmates in November, the Atlanta Federal Penitentiary burns on the first night of the takeover.

A guard from the Atlanta prison comforts a hostage's family outside the prison walls.

Atlanta prison riot

Inmates fear forced return to Cuba

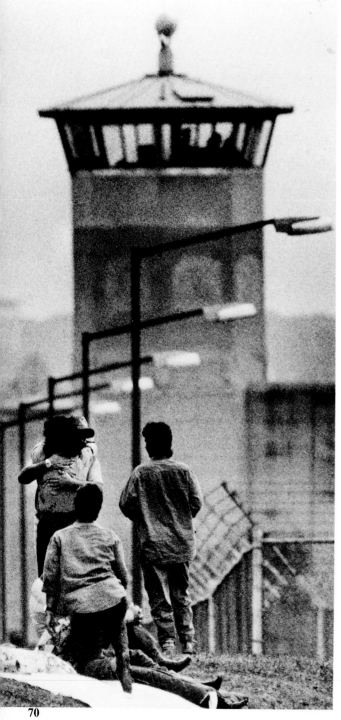

Cuba agreed in November to accept the return of more than 2,000 "undesirables" who came to the United States during the 1980 boatlift, sparking riots at two U.S. detention centers.

In Oakdale, La., 1,000 imnates held for deportation seized 30 hostages and set fires, destroying most of the facility.

Tensions were higher in Atlanta, where inmates generally had been accused of more serious crimes. Initially, 75 hostages were taken, but another 25 were seized from the prison hospital. One inmate was killed and several staff members injured.

Inmates at both centers threatened to kill the hostages if any rescue attempts were made. The Oakdale standoff

An inmate's wife is consoled by her children and a friend outside the penitentiary.

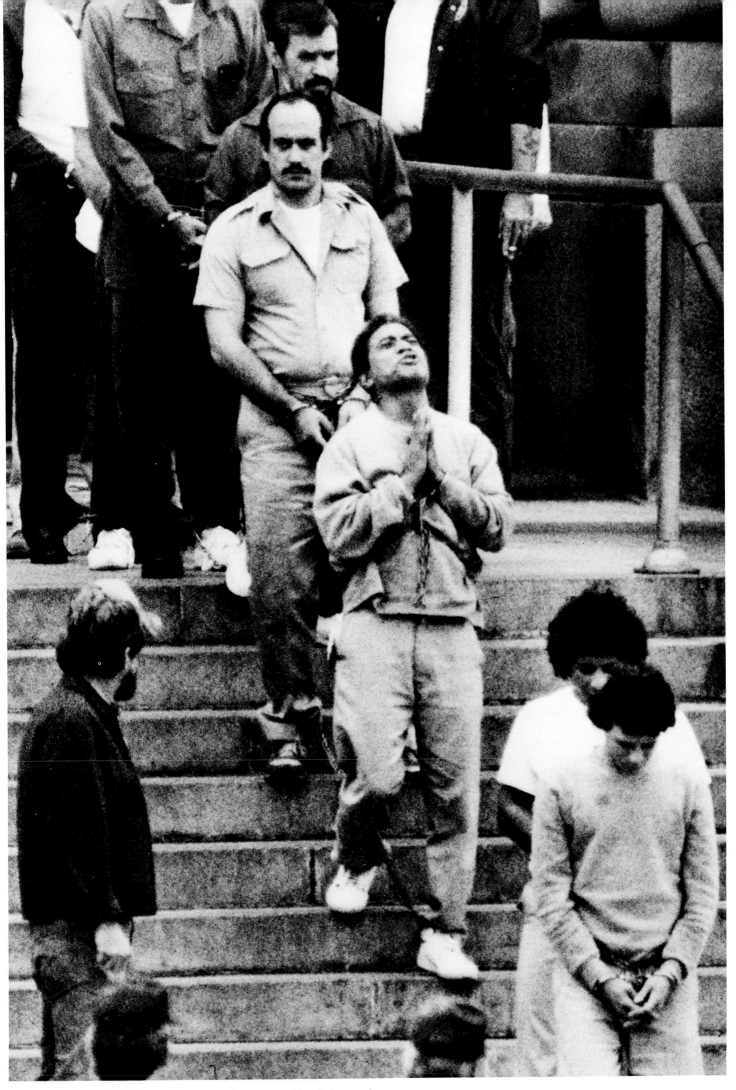

After surrendering, an inmate prays while being escorted in chains to a bus.

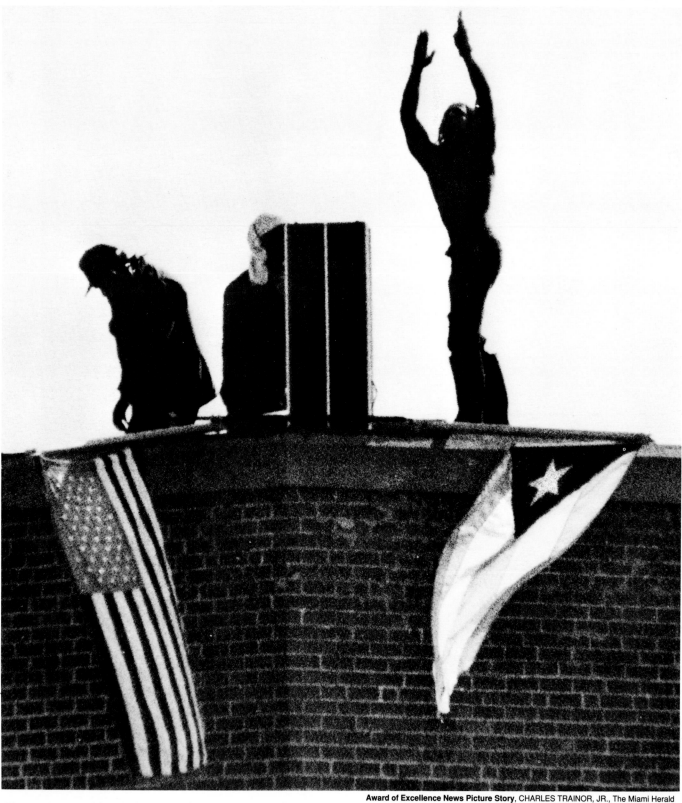

Three prisoners (above) place a speaker on the roof of the Atlanta prison. After the siege (right), the word "liberty" scrawled on a prison walkway is a reminder of the Cuban detainees' dreams.

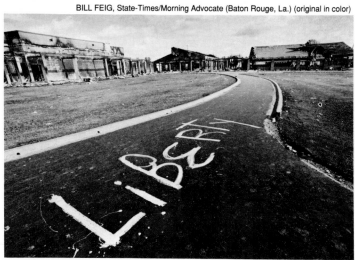

Atlanta prison riot

standoff lasted eight days, and ended after Auxiliary Bishop Agustin A. Roman of Miami endorsed a settlement with federal negotiators for reviews of the inmates' cases.

Three days later, the Atlanta inmates also surrendered.

The agreements included allowing inmates to be deported to other countries, guaranteed medical attention and immunity for damage done to the prisons during the riots.

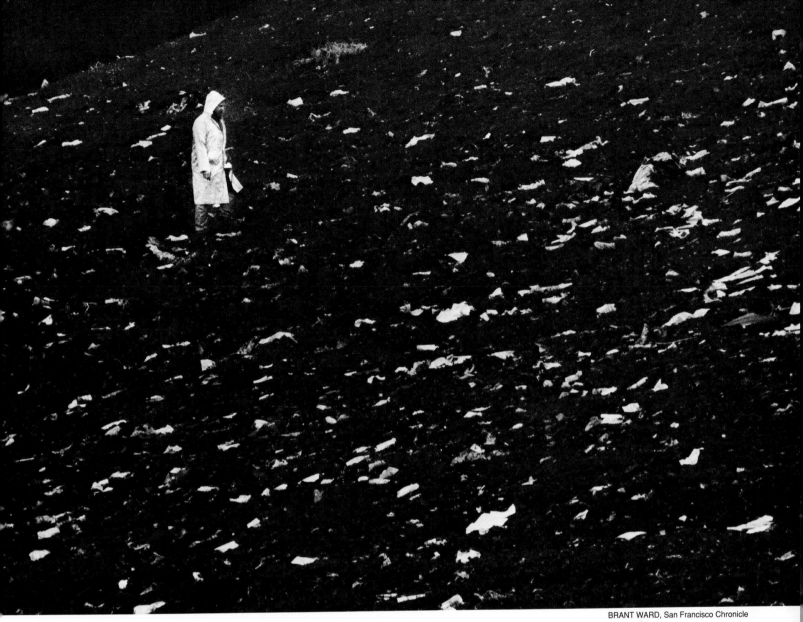

A coroner's deputy surveys the wreckage of a PSA jet that crashed in December. The FBI linked the accident to a disgruntled ticket agent who fired a .44 Magnum pistol aboard the Los Angeles to San Francisco flight.

Out of the sky

Plane disasters

There were miracles and horrors in this year's plane crashes, which killed more than 250 people in the United States.

During a heavy November snowstorm, a Continental DC-9 jet slammed onto the runway and flipped at Denver's Stapleton International Airport, killing more than two dozen people.

One child, 4-year-old Cecilia Cichan, was the only survivor of the August crash of a Northwest Airlines jet leaving Detroit. At least 156 people died – the second deadliest crash in the United States.

Revenge was the motive in the December crash of a PSA jet traveling from Los Angeles to San Francisco. All 47 people on board died when the jet crashed just moments after the crew reported gunshots. The FBI linked the accident to a disgruntled airline ticket agent.

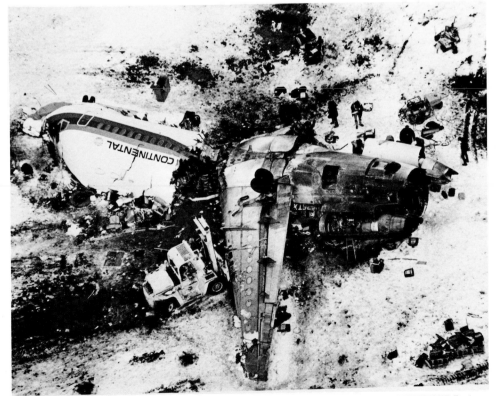

After taking off in near blizzard conditions, Continental Flight 1713 slammed back to the runway and flipped over at Denver's Stapleton Airport in November.

73

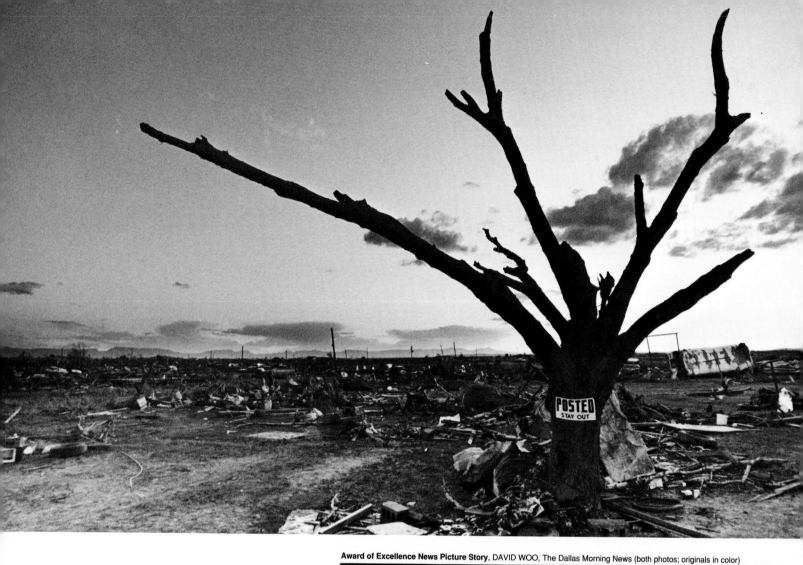

Award of Excellence News Picture Story, DAVID WOO, The Dallas Morning News (both photos; originals in color)

Twister
Texas town destroyed

Once it was known as Saragosa, a little West Texas farming community of 250 residents.

But Saragosa was reduced to a pile of rubble on May 22 when a tornado flattened the town, killing 30 and injuring 170. Hardest hit was the Saragosa Community Hall, where a preschool graduation was under way when the twister ripped the town apart.

Splintered houses, scattered belongings, leafless trees and crumpled cars were all that remained.

More than 2,000 mourners turned out for the first funeral Mass. They mourned the loss of relatives, the loss of friends, the loss of an entire town.

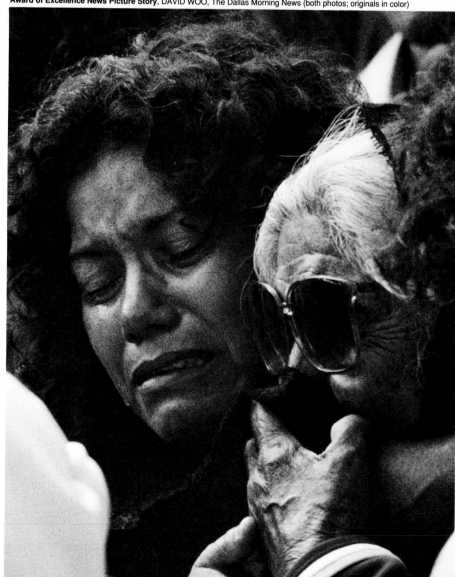

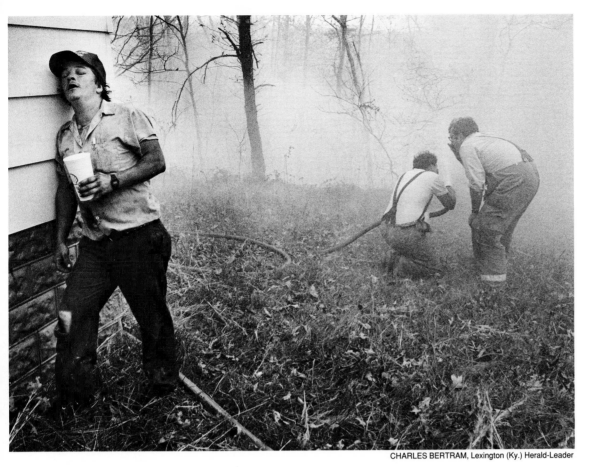

Volunteer firefighter Sammy Holland takes a break during a forest fire in Lee County, Ky. The blaze, one of many burning across the southern states during the fall, was halted just a few feet from the church Holland is leaning against.

Forest fires

It was a long, hot summer for much of the United States as forest fires rampaged through the West. The U.S. Forest Fire Service estimates 1,200 fires destroyed 800,000 acres in California alone. Other western states were hard hit, with Oregon losing 200,000 to 300,000 acres. November was a hot month for the southern and mid-Atlantic states, where 200,000 acres were lost.

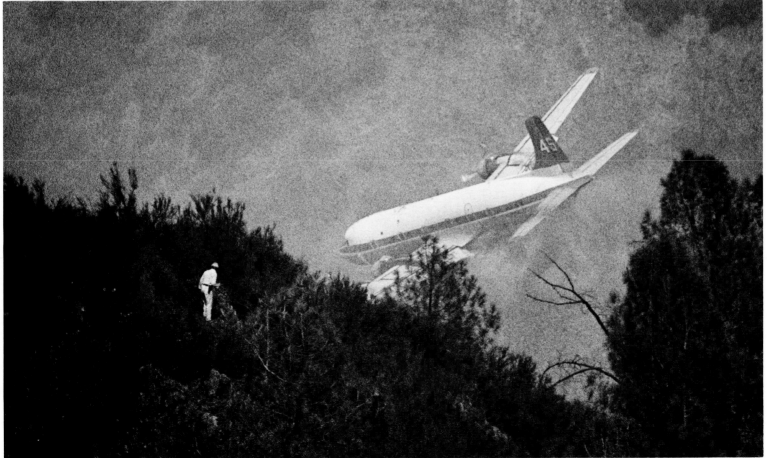

A DC-6 dives into a canyon at Yosemite National Park to fight a huge forest fire that threatened the park. On this pass, the plane's wing tips cleared the trees by only a few feet. Firefighters were successful and stopped the inferno here.

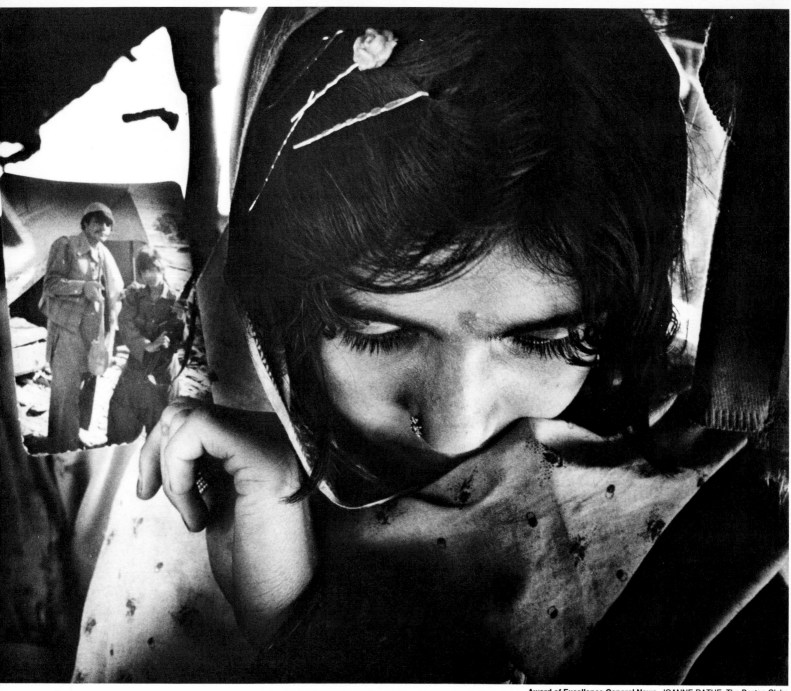

Mira Khila, a young Afghan refugee, holds a picture of her 17-year-old husband who was killed in the holy war against the Afghanistan government.

Near the Nicaraguan-Honduran border, Sandinista counter-insurgence troops cover hills and jungles looking for Contra rebels. The soldiers, many of them barely 17, quickly become experienced fighters.

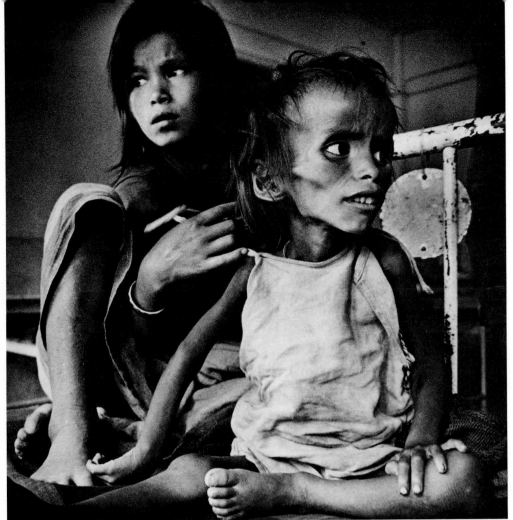

Overleaf:
Outside a five-star hotel in Bombay, India, children work as beggars for a syndicate run by adults. In return for the money they bring in, the children get a space to sleep on the floor and a bite to eat.

Award of Excellence Feature Picture, MELANIE STETSON FREEMAN, The Christian Science Monitor

This 3-year-old boy arrived at a hospital in Katmandu, Nepal, on his sister's back. The boy, severely dehydrated from diarrhea, cried but had no tears. Diarrhea is one of the leading causes of death in Third World countries in children under the age of five.

As a thunderstorm approaches, Ugandan refugees wait for the French Red Cross to test them for sleeping sickness.

Award of Excellence Feature Picture Story, GARY PORTER, The Milwaukee Journal

Second Place Newspaper Photographer of the Year, AE General News and AE News Picture Story, JOHN TLUMACKI, The Boston Globe

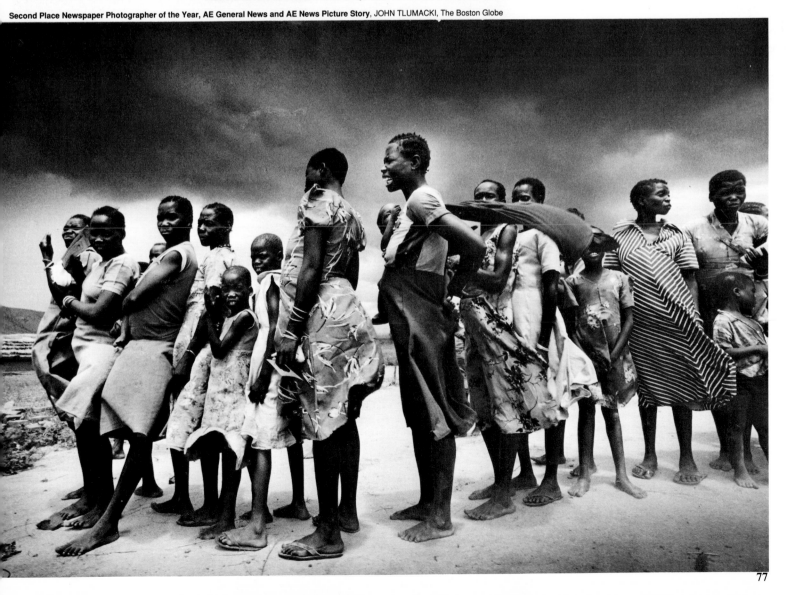

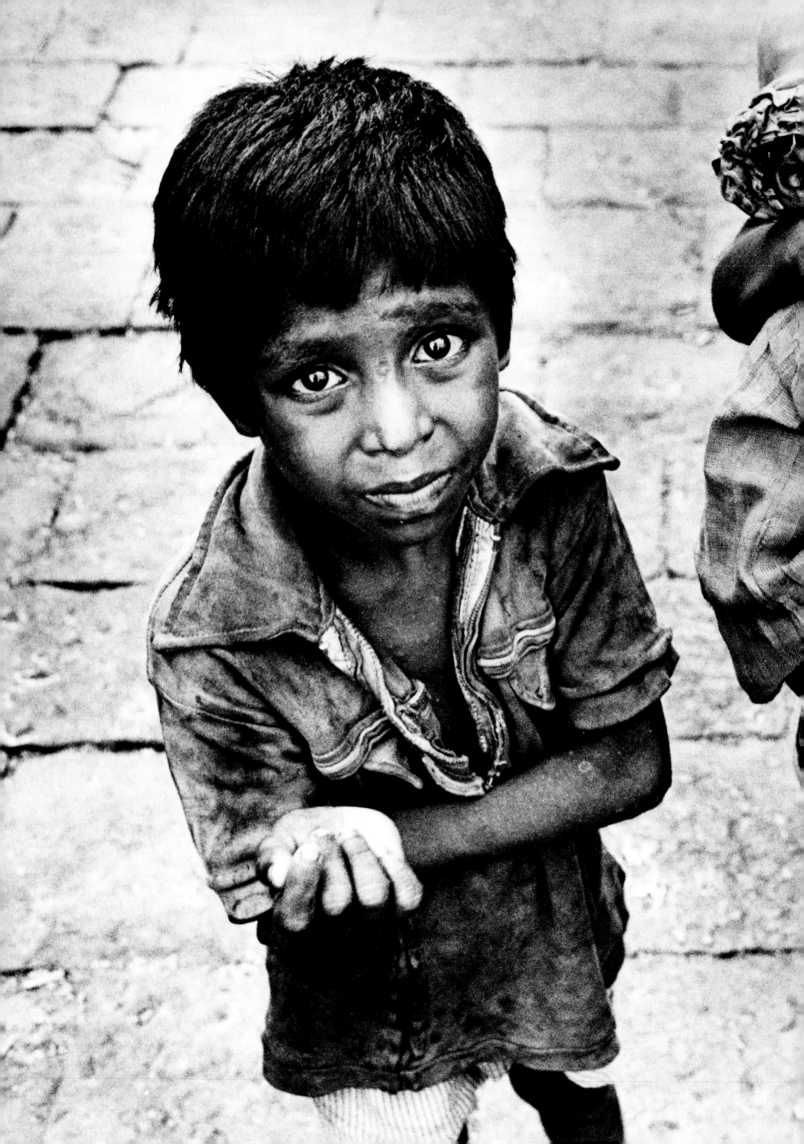

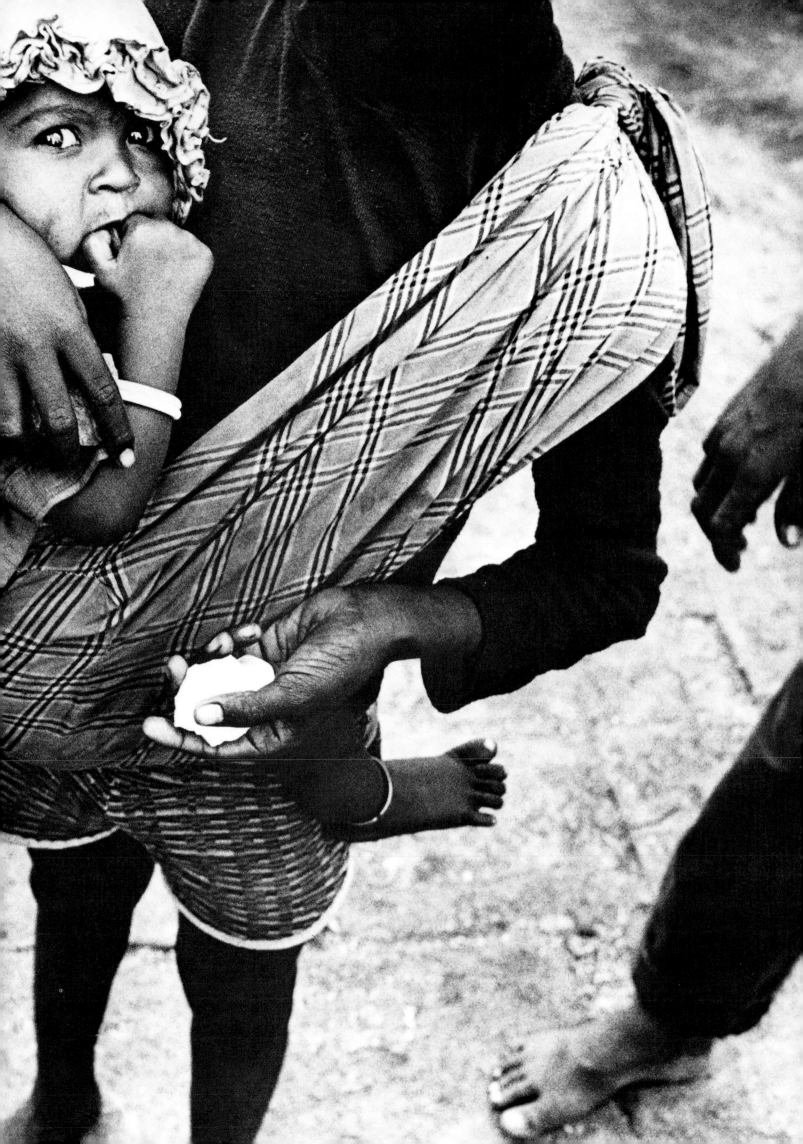

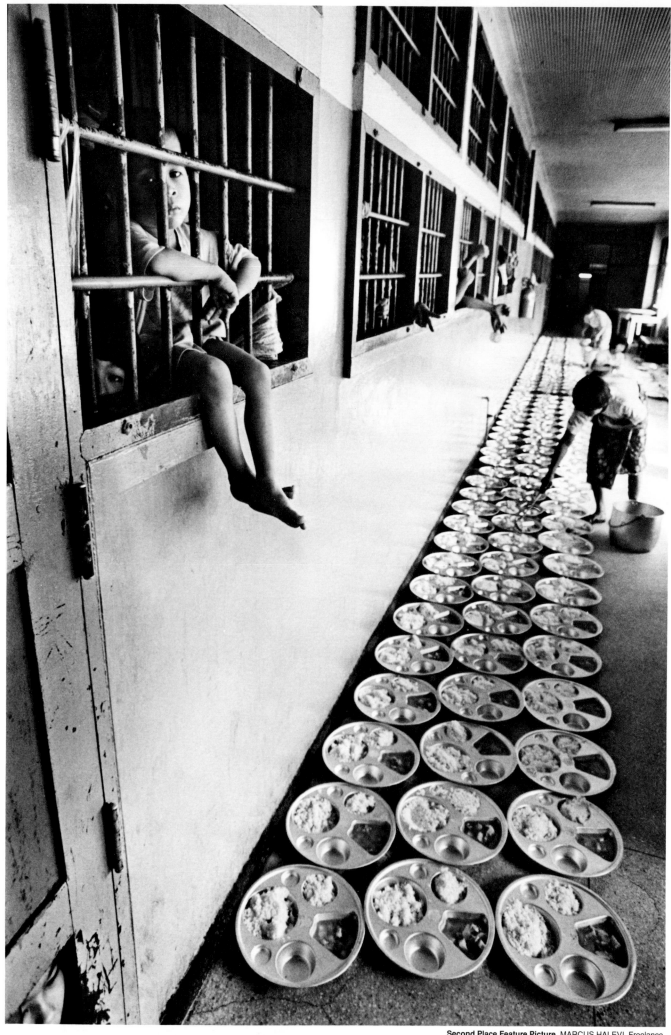

Behind bars, a 6-year-old boy waits for lunch in a Southeast Asia prison. The child is serving a
four-month term with his father for an immigration violation. The crowded prison has no beds.

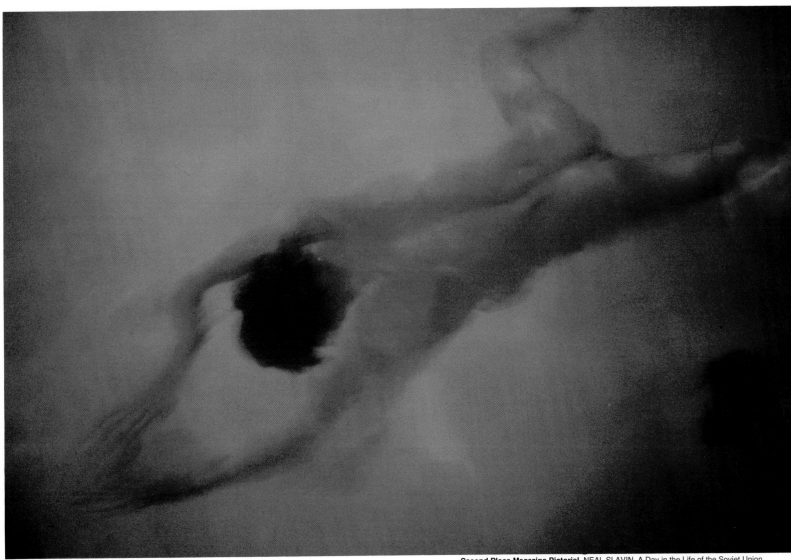

Second Place Magazine Pictorial, NEAL SLAVIN, A Day in the Life of the Soviet Union

The bathhouse is a steamy place of rejuvenation — a constant of daily Soviet life for hundreds of years. At its heart is the steam room, where bathers bask in an inferno of steam, only to plunge into the icy waters of the pool.

A spinner porpoise surfaces in Turquoise Lagoon, Midway Atoll.

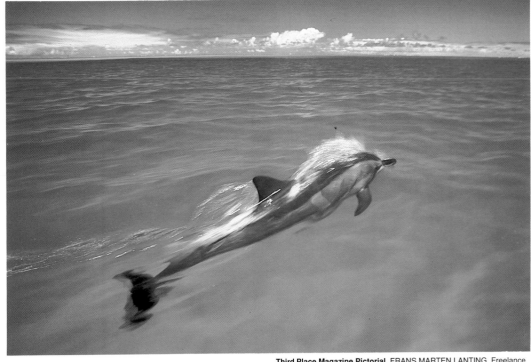

Third Place Magazine Pictorial, FRANS MARTEN LANTING, Freelance

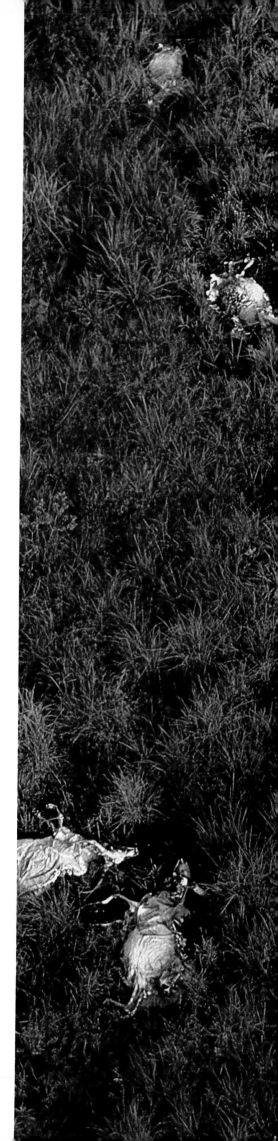

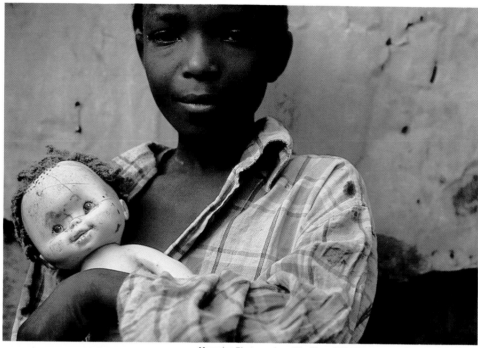

A child clutches a doll in the slums of Port-au-Prince, Haiti.

Anthony Suau

Magazine Photographer of the Year

Anthony Suau has been on a fast road to recognition for his photography since 1979, the year he graduated with honors from Rochester Institute of Technology with a bachelor's degree in photojournalism.

Suau joined the staff of the Chicago Sun-Times in 1979 and was named Illinois Photographer of the Year in 1980. He joined The Denver Post in 1981, working under Rich Clarkson. In 1984 he received an honorable mention in POY's Photographer of the Year category.

He won the 1984 Pulitzer Prize in feature photography for a single picture of a widow embracing her husband's tombstone at a cemetery in Denver and for a series of photographs of mass starvation in Ethiopia.

Since late 1984 , Suau has continued his award winning work through Black Star photographic agency, covering the political crises in the Philippines, South Korea, Pakistan, Israel and Afganistan. He also covered Ethiopia and Cameroon for National Geographic Magazine.

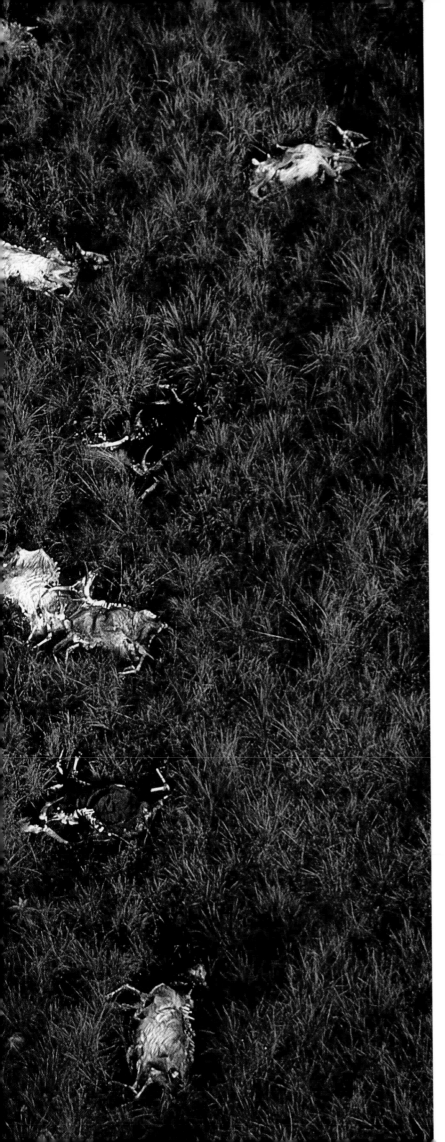

More than 3,000 head of cattle died August 21, 1986, when a lethal jet of carbon dioxide spewed from Lake Nyos in West Africa. As many as 1,700 Cameroon villagers also were smothered by the cloud of death.

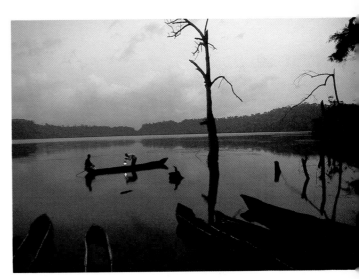

Fishermen float along on Lake Barombi.

Anthony Suau

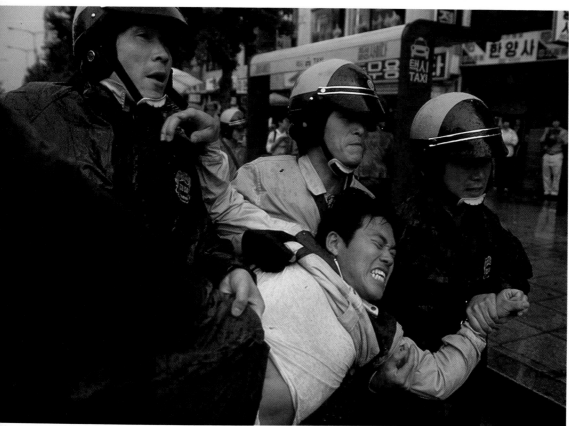

Magazine Photographer of the Year and Award of Excellence Magazine News/Documentary, ANTHONY SUAU, Black Star

South Korean riot police arrest a student protester during May demonstrations in Central Seoul.

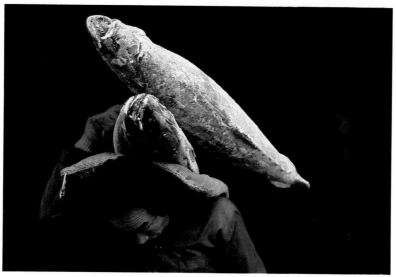

Magazine Photographer of the Year, ANTHONY SUAU, Black Star

A fisherman carries frozen fish to market in South Korea.

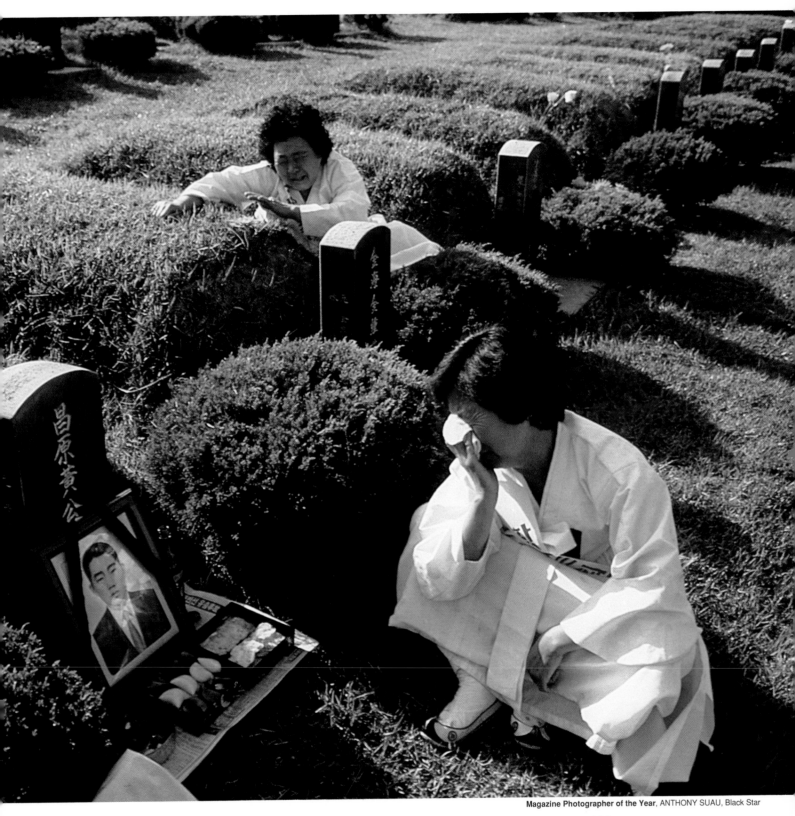

Mothers of students killed in the 1980 Kwangju, South Korea, uprising mourn their loss on the anniversary of the massacre.

Arctic wolves

Brandenburg and biologist share lives with pack

"Did you find the wolves?" photographer Jim Brandenburg asked.

"You'll never believe it. Den ... pups ... ten feet away ... chance of a lifetime!" babbled wolf biologist L. David Mech.

Seven Arctic wolves and their six pups, little harassed by hunters, allowed these two patient men to meet the family and see their home hundreds of miles north of Hudson Bay, in the heart of Ellesmere Island.

The pair tried different ways to approach the pack, including sprawling on the ground and whining loudly like seals.

And their patience paid off when the leader, the alpha male, and the other adults left the pups unattended in the den, despite the two men's human company.

From then on, Brandenburg (who has photographed wolves for 20 years) and Mech enjoyed watching every aspect of the wolves' lives — hunting, playing, sleeping. They truly shared their lives with Arctic wolves.

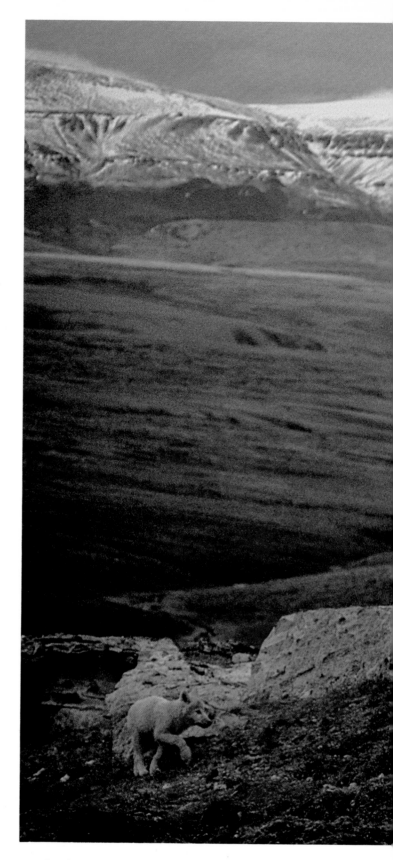

Inquisitive pups frolic beside the den with a yearling male named Scruffy, who served as babysitter while the pack hunted.

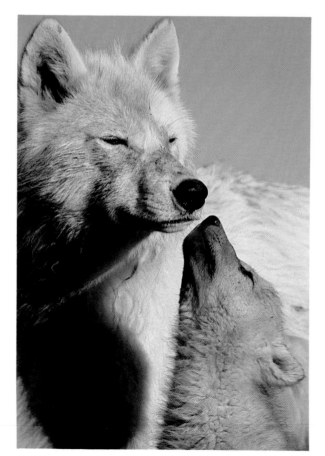

Bared teeth mean dinner — not danger — for pups when they beg for food.

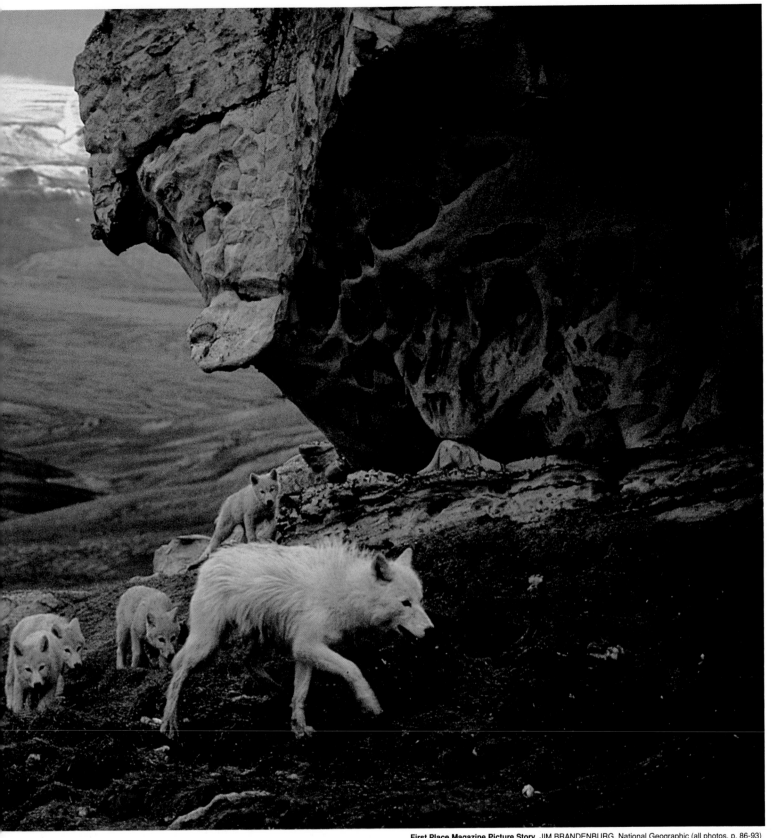

"Wolves will take anything they can get. If they are too good at it, there won't be anything left. If they aren't good at it, they starve."

--Jim Brandenburg

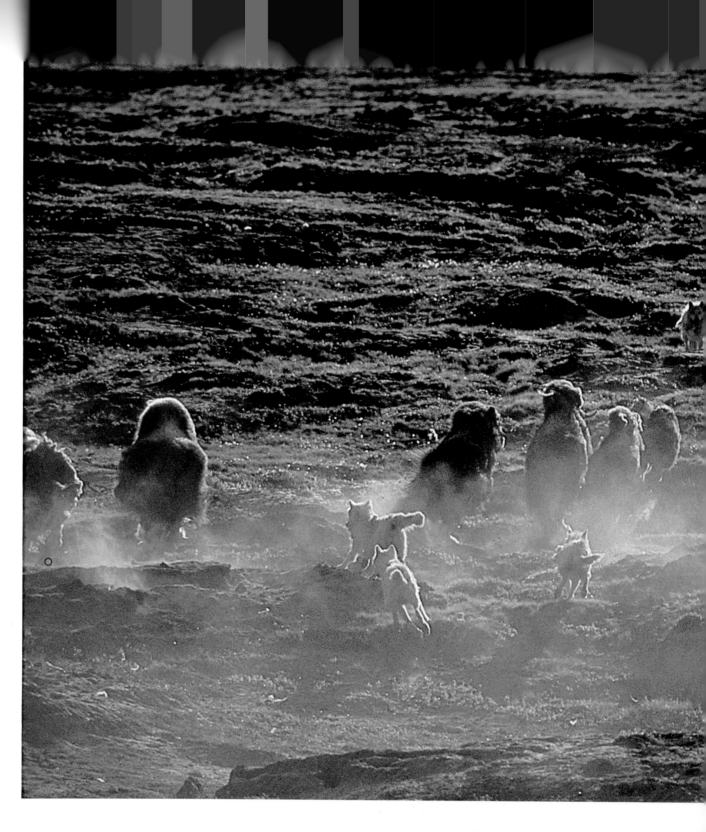

Arctic wolves

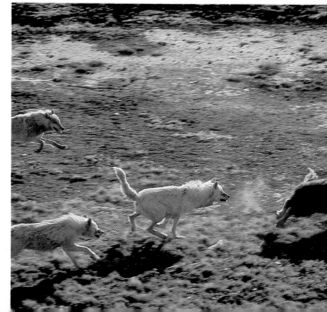

Soon, the alpha male wolf moves in, with the others close behind.

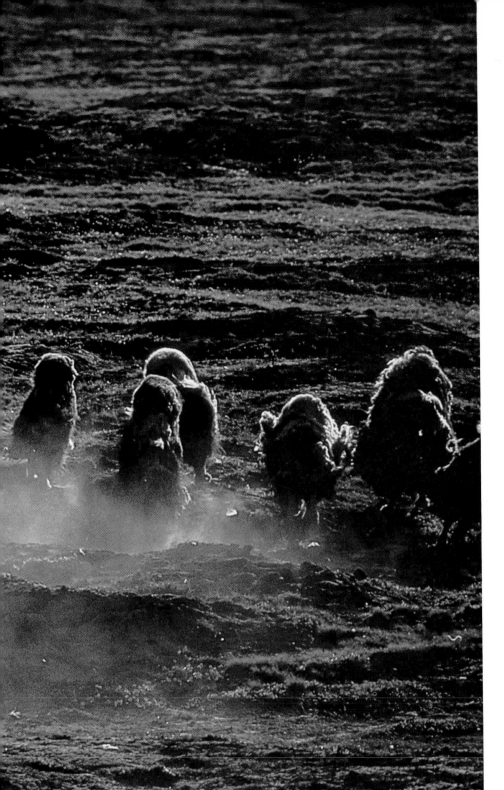

Overleaf:

The alpha male patrols the edges of his territory, about three miles from the den at a fjord. Pack members often bathe in the shallows after they make a kill.

First Places Magazine Picture Story and MagazineScience/Natural History, JIM BRANDENBURG, National Geographic

Seven wolves target three musk-oxen calves guarded by 11 adults whose hooves could crack a wolf's skull. A long standoff deteriorated when a single ox broke ranks and the herd scattered — with the wolves in hot pursuit.

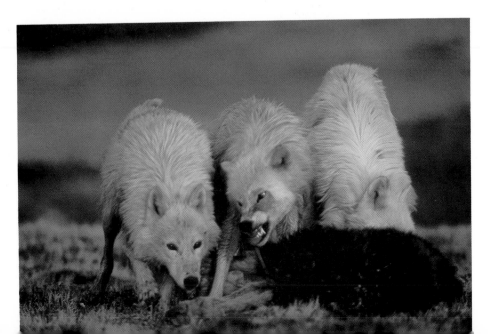

Within a few furious moments, the pack caught and killed all three calves and began devouring their prey.

89

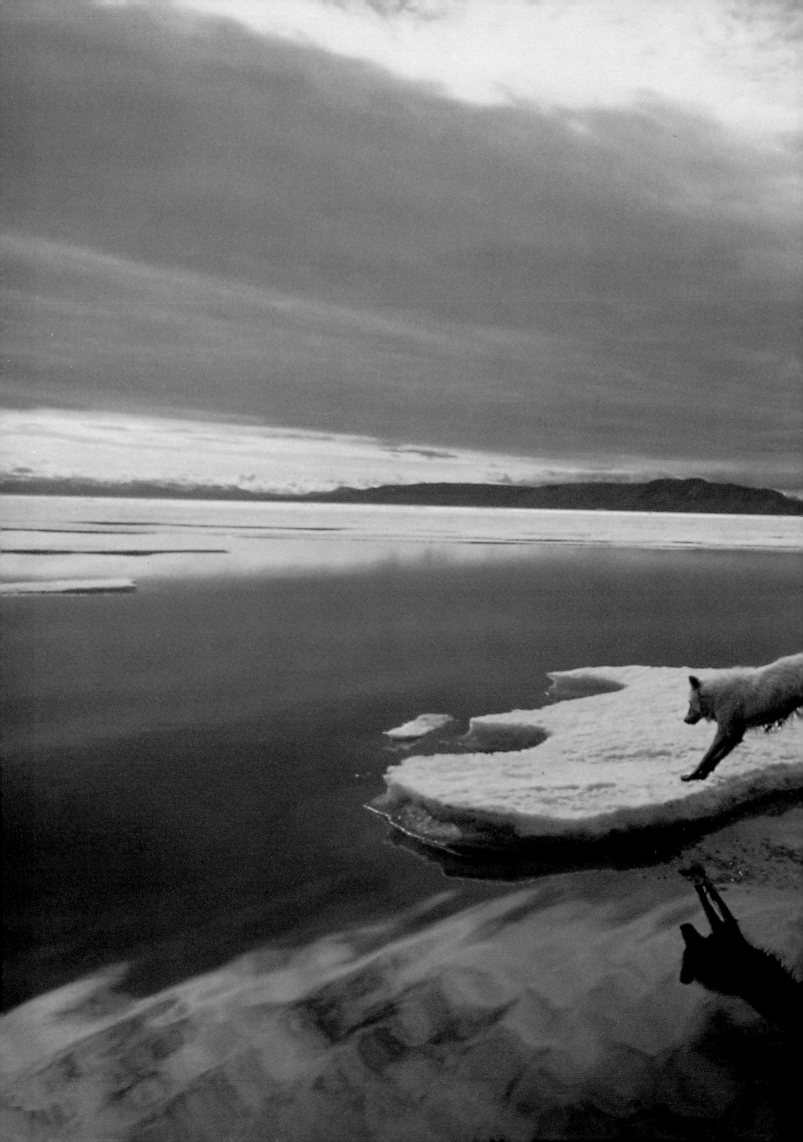

Arctic
wolves

A gull feather acts as an after-dinner toy and teacher for a pup. Such play familiarizes the pups with the kinds of prey they will stalk.

Wolves work hard on the hunt and sleep about 12 hours a day.

A lone sentinel surveys its territory, which extends more than 1,000 square miles, from atop an iceberg. It takes that much land to support prey for the wolves to hunt.

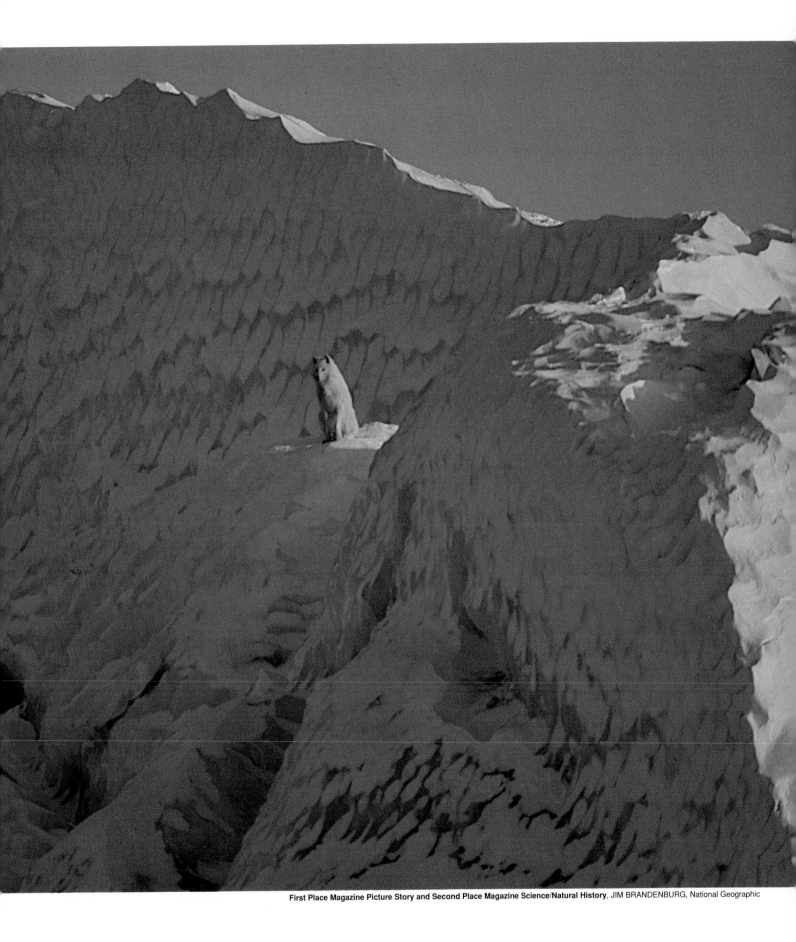

*"Wolves have been wolves a lot longer
than humans have been humans."*

-- Jim Brandenburg

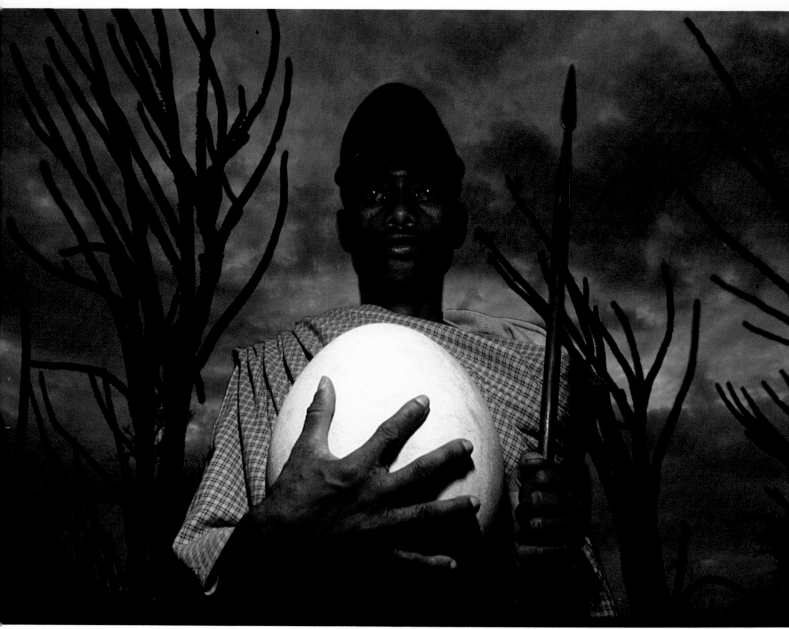

Award of Excellence Magazine Picture Story, FRANS MARTEN LANTING, Freelance for National Geographic

Many of the Island of Madagascar's larger animals, such as the Aepyornis — the world's largest known bird — disappeared in a wave of extinctions ending 500 years ago. Elephant bird eggs still are found occasionally along stream beds after heavy rains.

A curious skua hovers in front of the camera in the Falkland Islands.

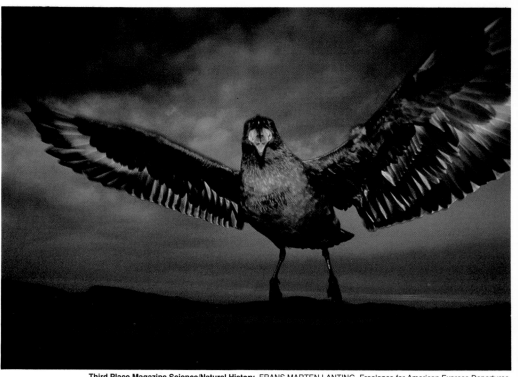

Third Place Magazine Science/Natural History, FRANS MARTEN LANTING, Freelance for American Express Departures

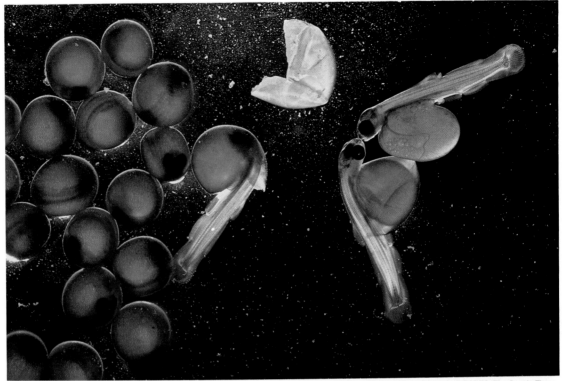

A shoot on salmon eggs —
part of a Pacific salmon photo
project — took an unexpected
turn when the eggs hatched
into alevins (larvae).

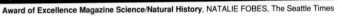

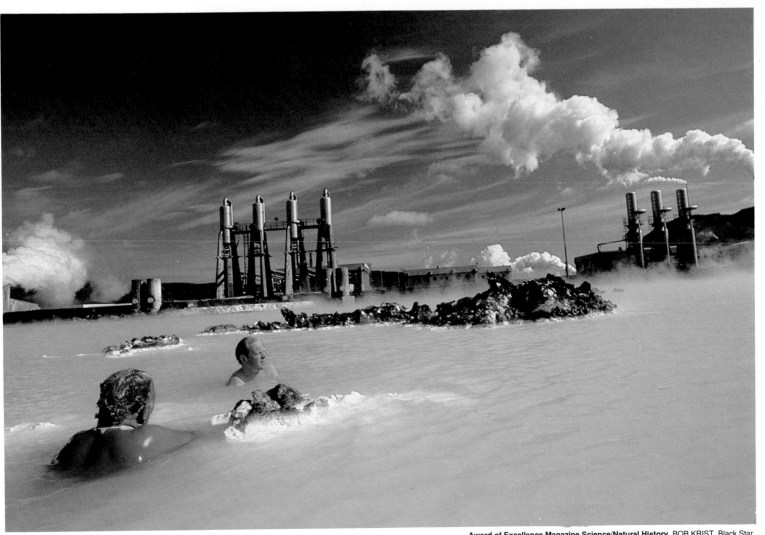

In a land of volcanoes, earthquakes and glaciers, Icelanders learn to survive — and prosper. The Svartsengi geothermal plant harnesses the
earth's energy to heat Iceland's homes, while runoff waters warm bathers.

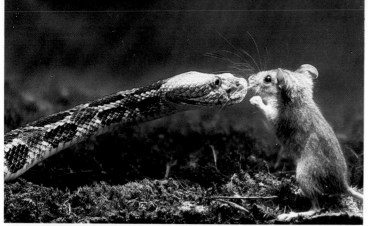

AE **Magazine Science/Natural History**, BIANCA LAVIES, Freelance for National Geographic

How sweet it is

Nature's balance is kept in check as a black timber rattlesnake strikes a white-footed mouse. The snake's jaws spread to swallow a kill that may take four days to digest. This predator vs. prey episode took place in captivity. In the wild, the snakes eat between six and 20 meals a year.

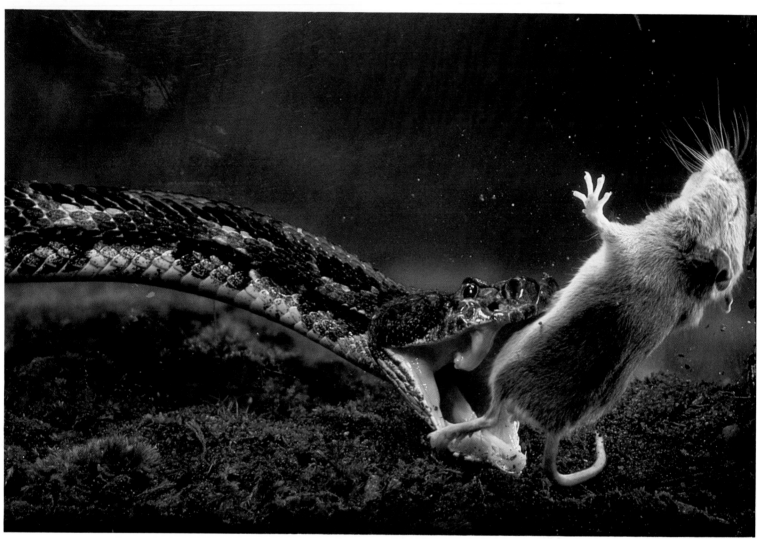

BIANCA LAVIES, Freelance for National Geographic

AE **Magazine Science/Natural History and AE Magazine Picture Story**, FRANS MARTEN LANTING, Freelance

Survivors from the age of dinosaurs, chameleons abound in Madagascar, where half the world's species are found. A Brevicornis captures prey from a body length away with its tongue.

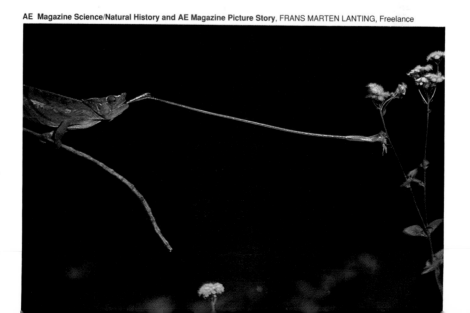

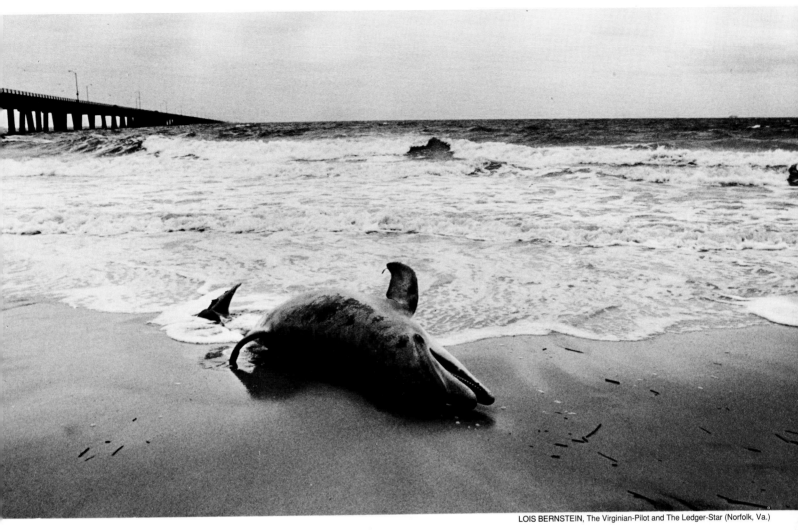

LOIS BERNSTEIN, The Virginian-Pilot and The Ledger-Star (Norfolk, Va.)

As tourists swamped the summer shores, dead dolphins began washing up on beaches from New Jersey to North Carolina. By Labor Day, more than 300 dolphins died. During the height of tourist season, renowned marine biologist Dr. Joseph Geraci set up a "dolphin response team" in Virginia Beach, Va., to look for the mysterious dolphin killer. No cause has been found.

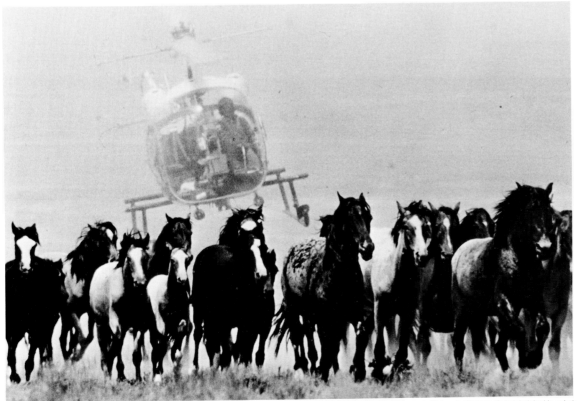

Award of Excellence General News, CHUCK BIGGER, Gazette Telegraph (Colorado Springs, Colo.) (original in color)

Flying less than 50 feet above the Nevada desert, pilot Jim Hicks herds a group of wild mustangs toward a corral trap set by the Bureau of Land Management. More than 90,000 wild horses have been removed from open rangeland in six western states since federal legislation protecting the mustangs passed in 1971.

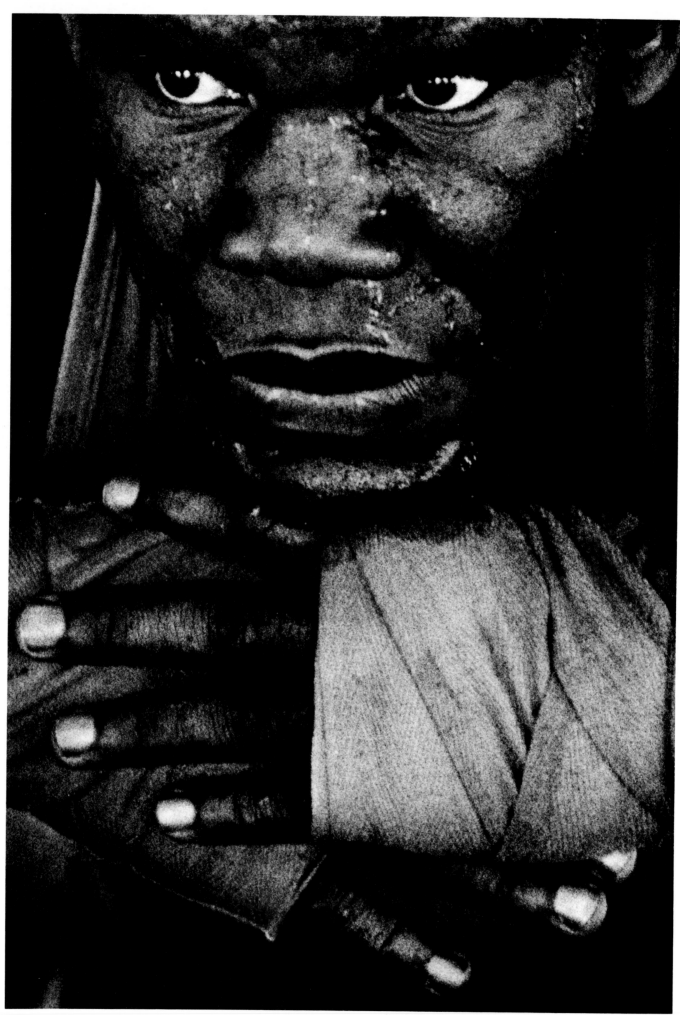

Award of Excellence Portrait/Personality, ANDREW ITKOFF, The Miami Herald

After a spar and a workout, a fighter takes a breather on the ropes at the 5th Street gym in Miami Beach, Fla.

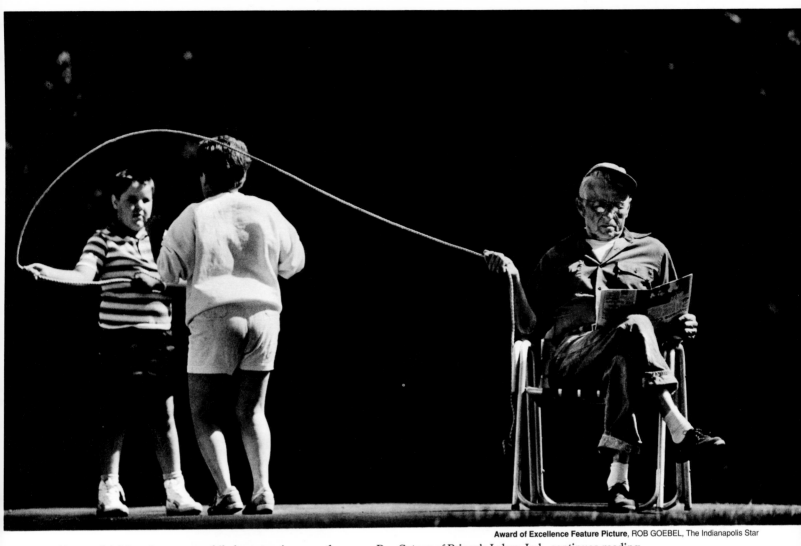

Helping his grandchildren jump rope while he gets a jump on the news, Ray Catron of Prince's Lakes, Ind., continues reading.

A blissful Ratutow village carpenter enjoys life along the Polish-Czechoslovakian mountain border.

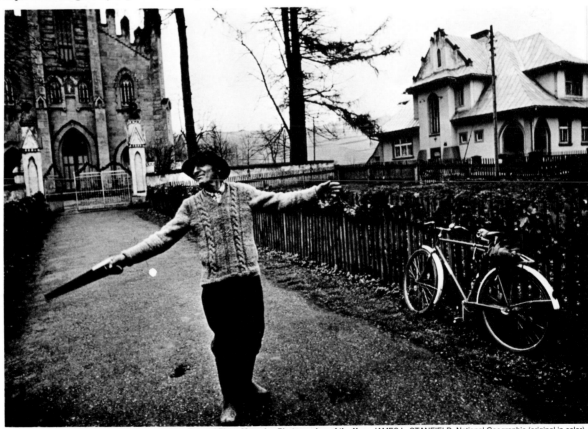

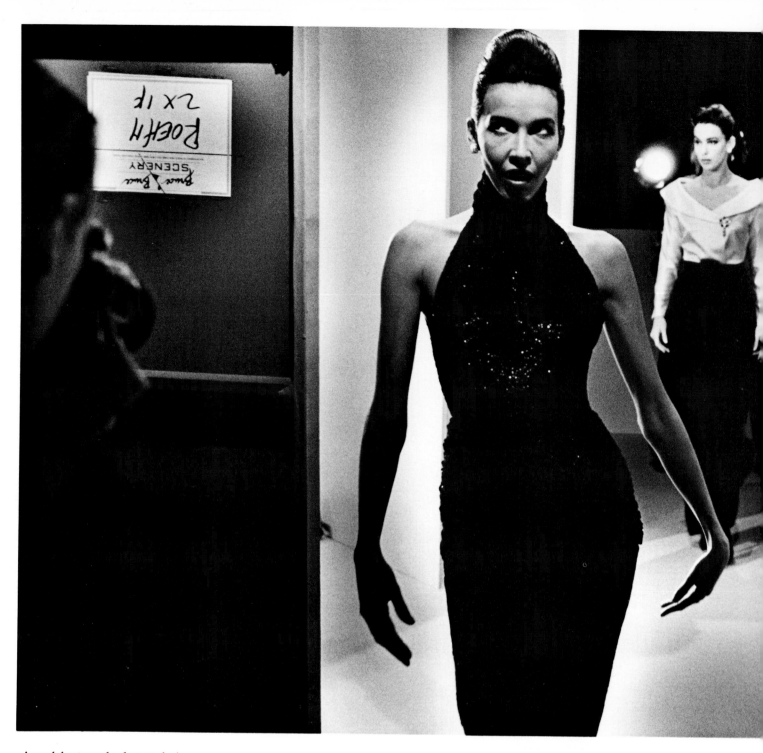

A model returns backstage during a
New York spring fashion show for
designer Carolyn Roehm.

LUCIAN PERKINS, The Washington Post (both photos)

President Reagan and Elizabeth
Taylor exchange a few words
during an AIDS benefit in
Washington, D.C., in May.

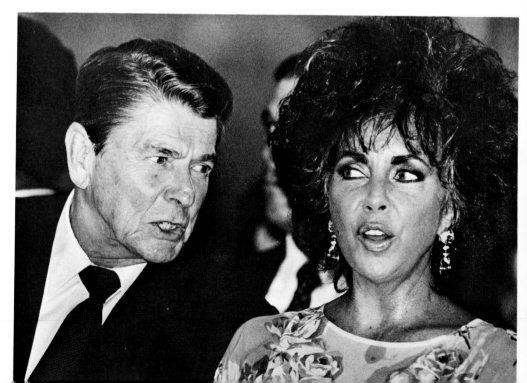

Award of Excellence General News, ROBERT A. MARTIN, The Freelance-Star (Fredericksburg, Va.)

LOIS BERNSTEIN, The Virginian-Pilot and The Ledger-Star (Norfolk, Va.)

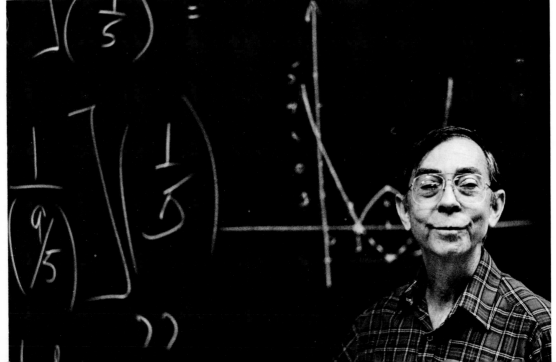

Caroline County, Va., supervisors Robert Doswell, left, and Lorenzo Boxley are on opposite sides of a water and sewer bond referendum.

Professor James Louis Hatfield confronts freshmen at Old Dominion University in Norfolk, Va., with every student's nightmare: calculus.

Overleaf:

During a police department walkout in Tampa, Fla., one man arrested during a crack bust answers questions from inside a paddy wagon.

Second Place Pictorial, CHARLES LEDFORD, The St. Petersburg (Fla.) Times

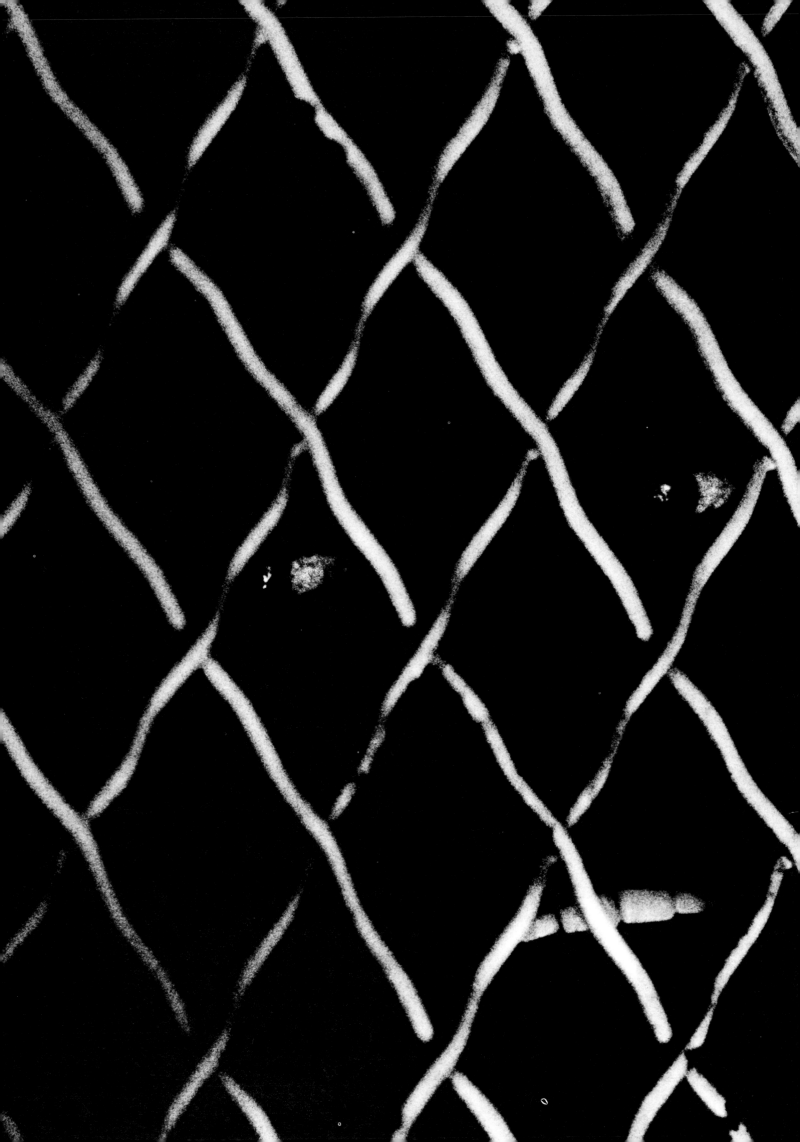

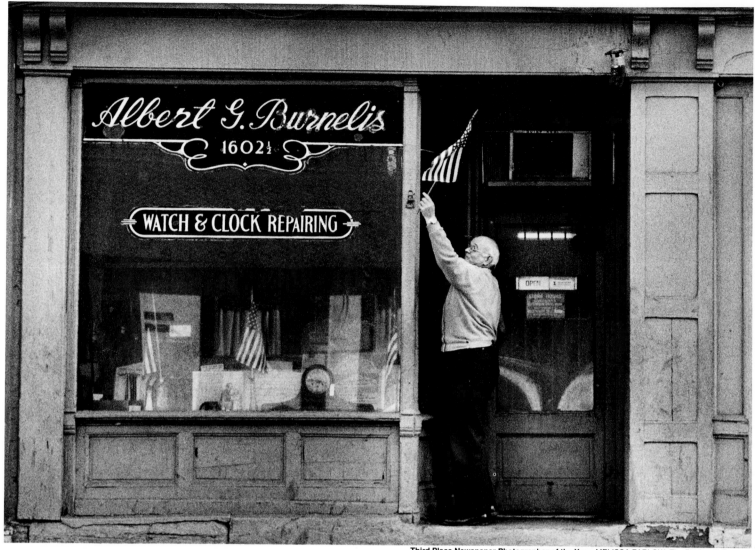

A master watch repairman takes down the flag outside his shop on the South Side of Pittsburgh at the end of his workday to signal he is closed.

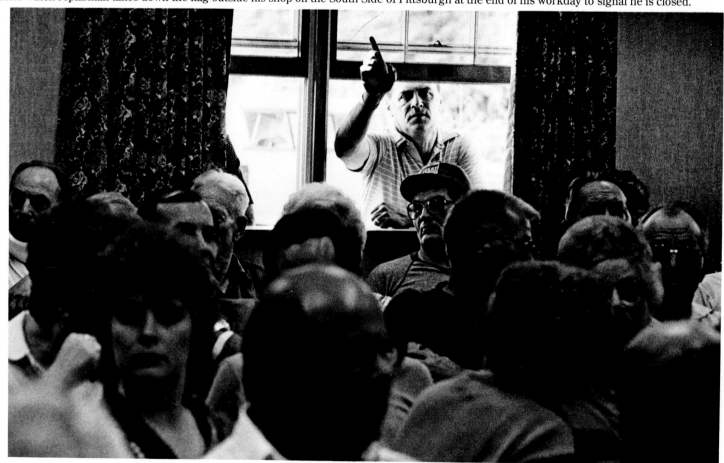

There is room for questions — but none for questioners — at an overcrowded supervisor's meeting in Shenango Township, Pa., where George Albertini asks why he is not allowed to tap into the new sewer system. Most residents were upset by the tap-in fee of $600.

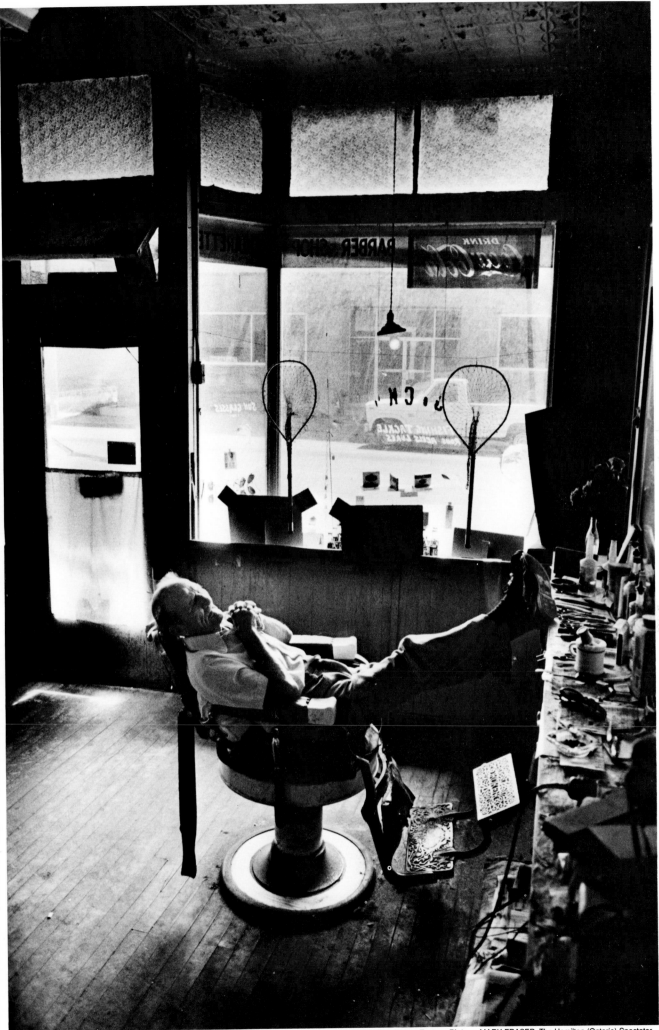

On a slow day, barber Jack McGleish of Cayuga, Ontario, stretches out in his favorite chair for a snooze. The 89-year-old has been at the same location for 65 years and still is cutting hair for $2.

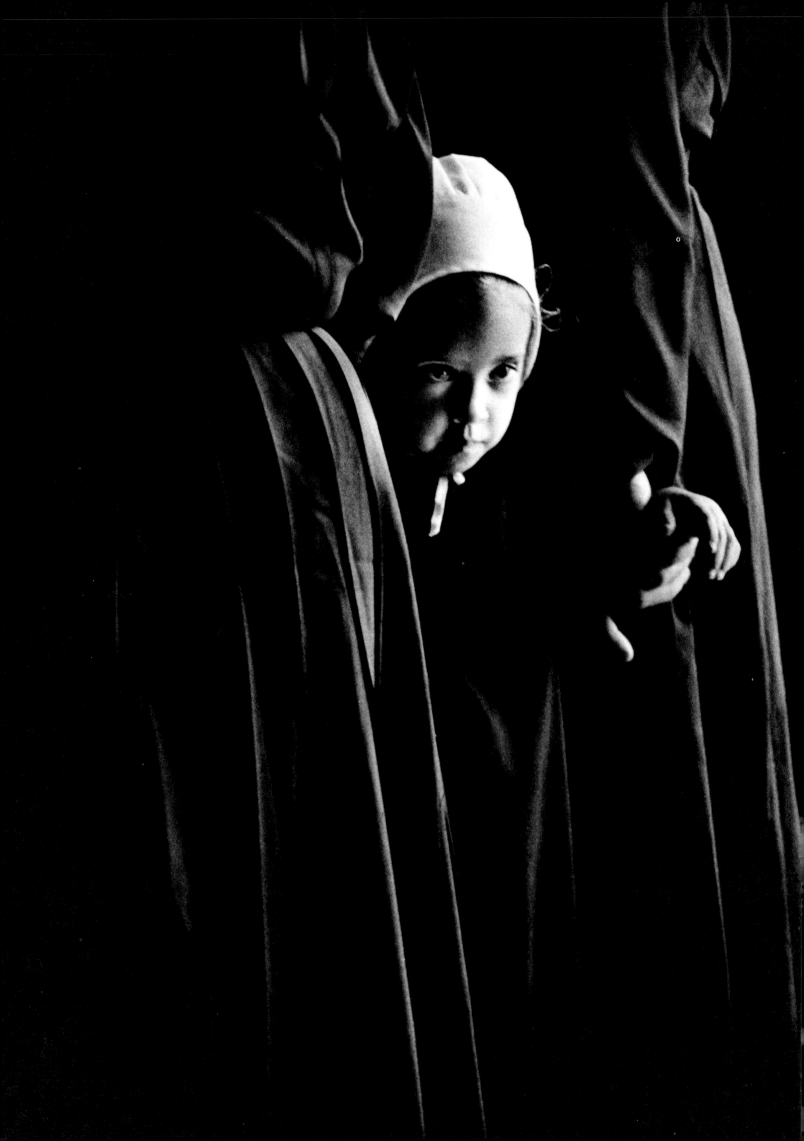

A young Amish girl
watches an auction on the
outskirts of Dover, Del.

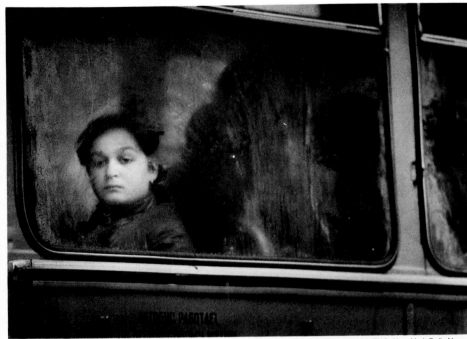

A girl looks out a
bus window on a
rainy May day in
Moscow.

NICOLE BENGIVENO, New York Daily News

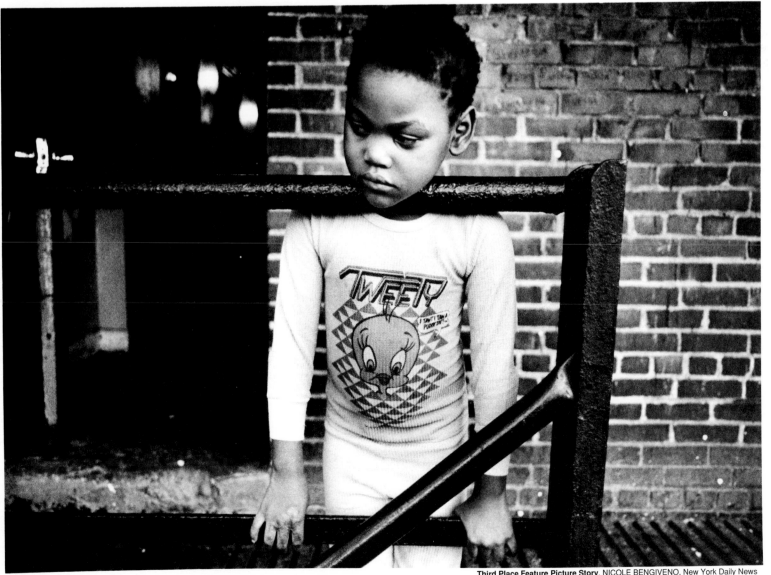

Third Place Feature Picture Story, NICOLE BENGIVENO, New York Daily News

Resting her chin on the fire escape rail, 5-year-old La Tasha Davis watches other children playing four stories below.

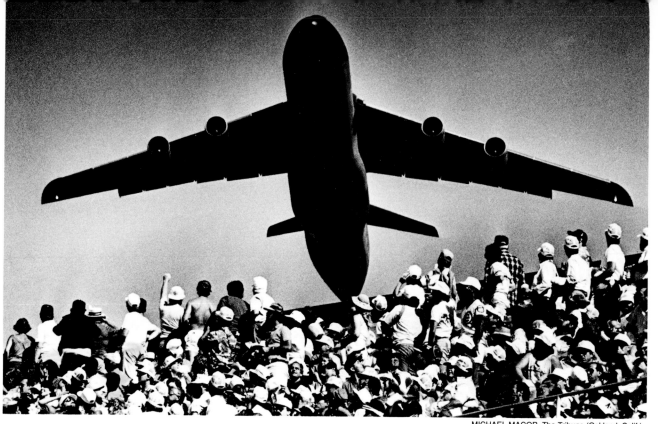

An Air Force plane makes a low pass over the rim of Oakland Coliseum during pregame activities at the baseball All-Star game in California.

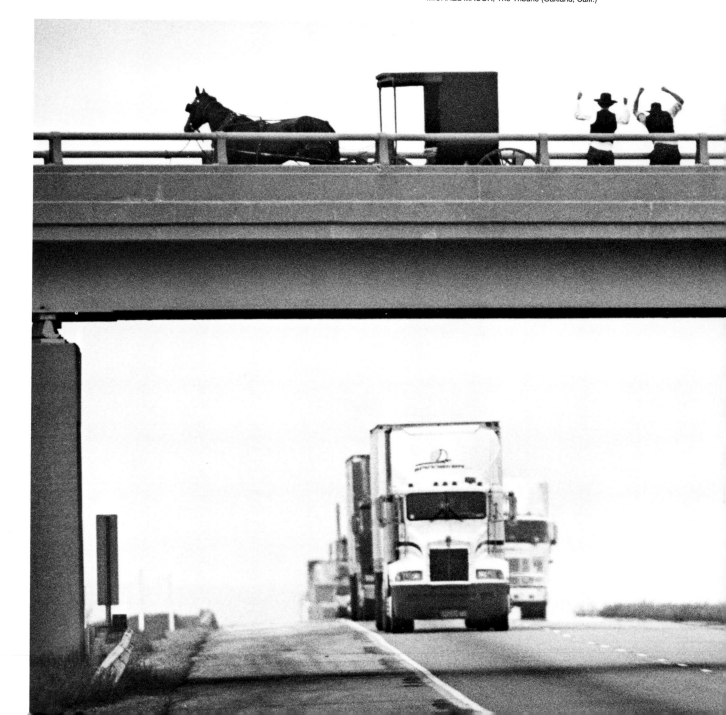

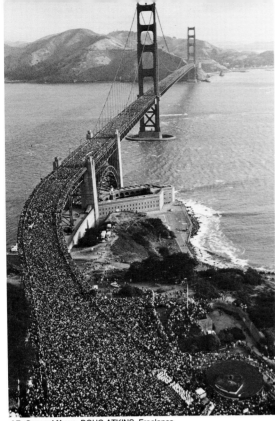

More than 800,000 people flocked to the 50th anniversary of San Francisco's Golden Gate Bridge, which was closed to automobiles for several hours on the morning of May 24.

AE General News, DOUG ATKINS, Freelance for The Associated Press (original in color)

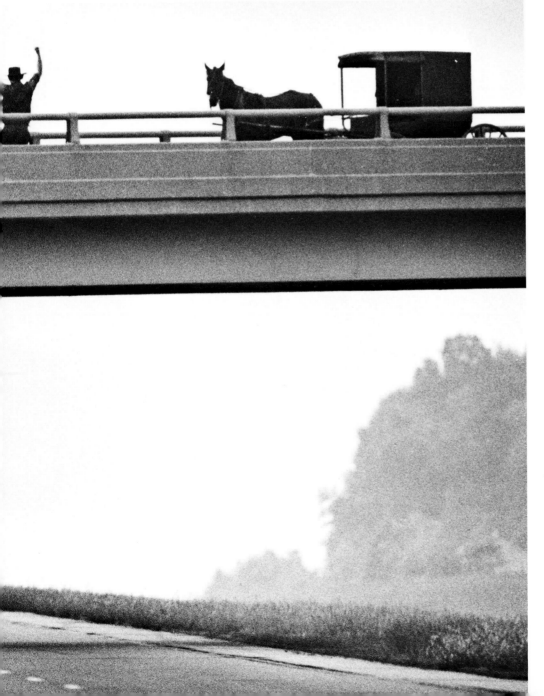

Three Amish youths urge oncoming truckers to blast their horns while passing at an overpass south of Mansfield, Ohio.

Award of Excellence Feature Picture, CURT CHANDLER, The (Cleveland) Plain Dealer

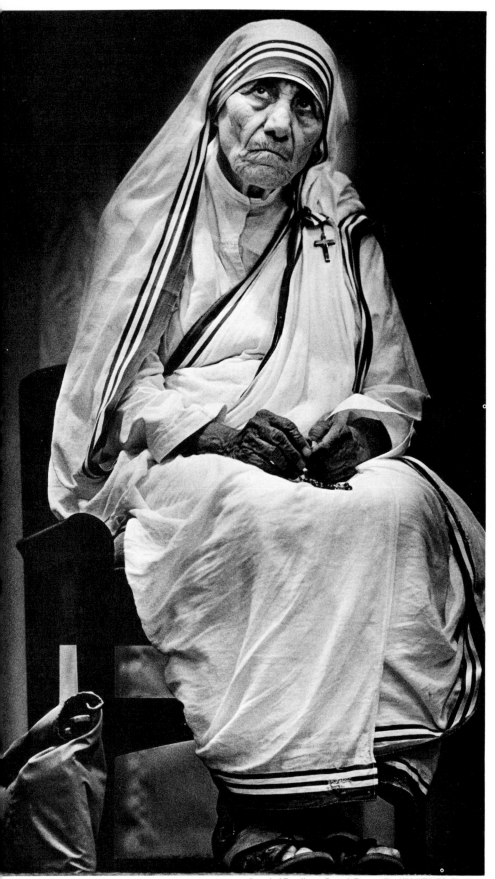

Award of Excellence Portrait/Personality, KIM WEIMER, Freelance

Mother Teresa offers up a prayer before addressing a crowd in Scranton, Pa.

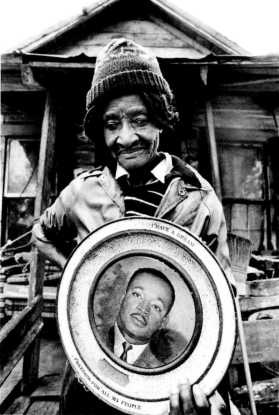

AE Portrait/Personality, MICHAEL EWEN, The Tallahassee (Fla.) Democrat

Eighty-year-old Rosie Mabry, whose dilapidated home in Gretna, Fla., was to be demolished, had a dream that finally came true. A new home was built for her with all the modern conveniences past homes lacked — indoor plumbing, electricity, running water. For Mabry, the legacy of Martin Luther King Jr. kept her dreams for a better life alive.

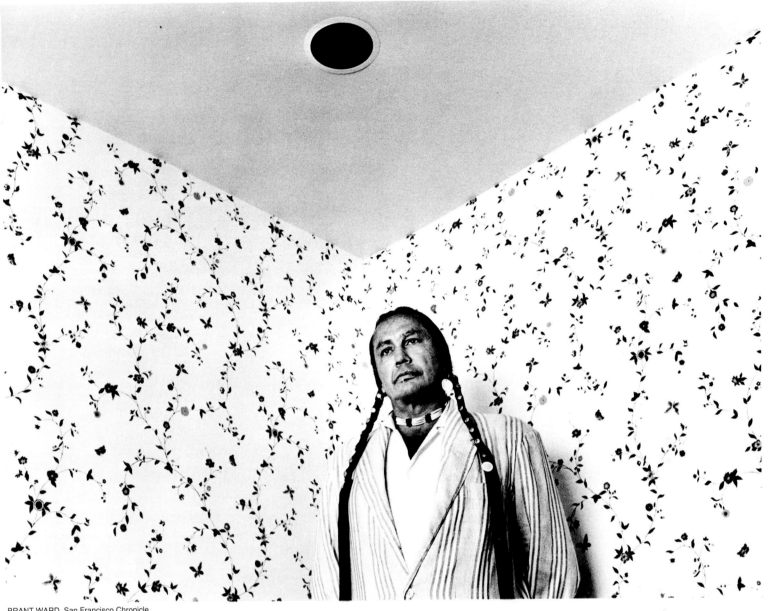

Indian activist Dennis Banks announces in California that he plans to run for president of the United States.

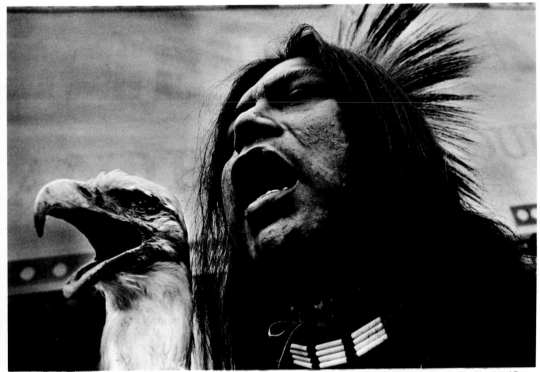

Kootenai Indian tribe member Virgil Mathias raises his Bald Eagle staff while singing traditional songs during a celebration of the Hellgate Treaty. The treaty, signed in 1855 by the Confederated Salish and Kootenai tribes and the U.S. government, is celebrated annually in Missoula, Mont., with singing, dancing and a feast of buffalo burgers and potato salad.

A sudden downpour fails to dampen the patriotic spirit of flag-waving Chris Grisham at a May welcome home rally in Houston for Vietnam War veterans. At the center of the celebration was a touring replica of the Vietnam War memorial wall. Many used the wall to pay tribute or say goodbye. Others learned the fate of comrades left behind as they searched for names they hoped they wouldn't find.

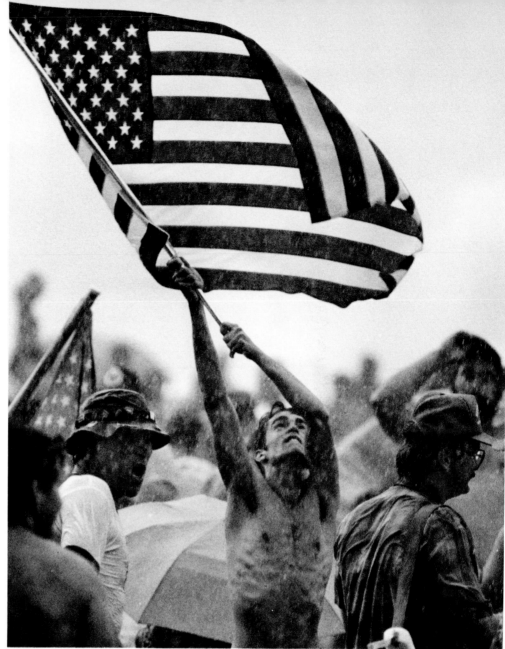

Award of Excellence News Picture Story, STEVE CAMPBELL, The Houston Chronicle (original in color)

Award of Excellence Portrait/Personality, JIM PRESTON, The Philadelphia Inquirer

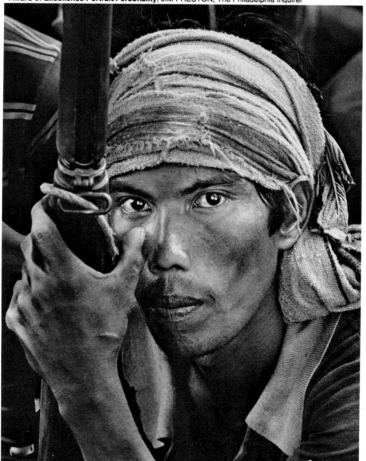

A young Philippine farmer learns how to defend his home and protect his freedom from Communist guerrillas during a formal government training program.

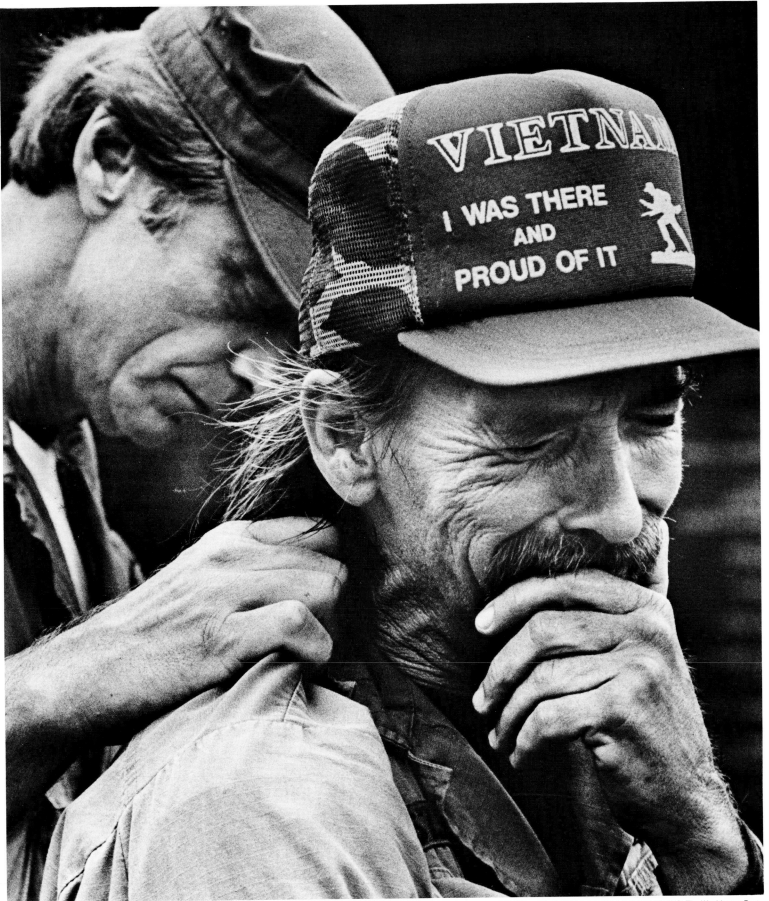

VIETNAM
I WAS THERE
AND
PROUD OF IT

After his first visit to the Vietnam War Memorial — on Memorial Day — Peter Kelsch of Miami is comforted by Alan Pitts.

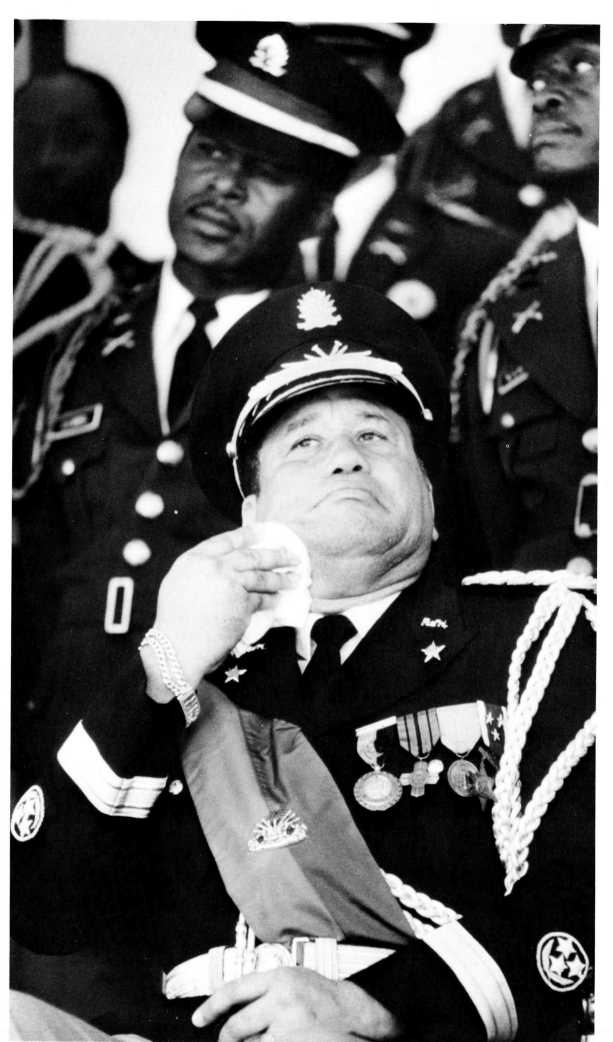

Although Haiti's junta leader, Lt. Gen. Henri Namphy, pledged to safeguard the elections, things turned bloody when henchmen of deposed dictator Jean-Claude Duvalier started burning electoral offices, scattering ballots in the streets and gunning down voters.

Award of Excellence Newspaper Photographer of the Year and Second Place Portrait/Personality, CAROL GUZY, The Miami Herald (original in color)

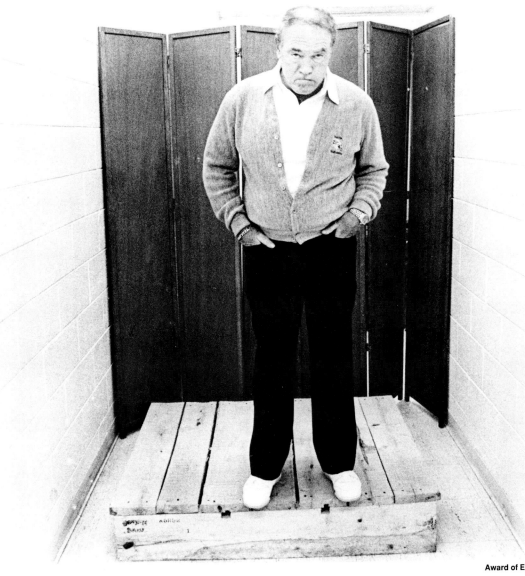

Award of Excellence Sports Portfolio, HARLEY SOLTES, The Seattle Times

Seattle Seahawks head coach Chuck Knox prepares for his not-so-favorite event — the post-game press conference.

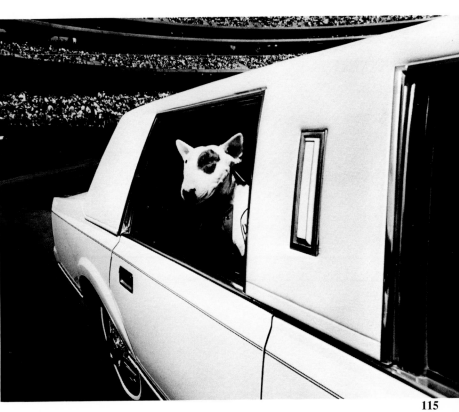

So much for a dog's life. Spuds MacKenzie takes a limousine into the Oakland-Alameda County Coliseum in California before an Oakland A's-N.Y. Yankees game. Spuds, the black-eyed mascot for Bud Light beer, was present for the first pitch.

ANGELA PANCRAZIO,
The Tribune (Oakland, Ca.)

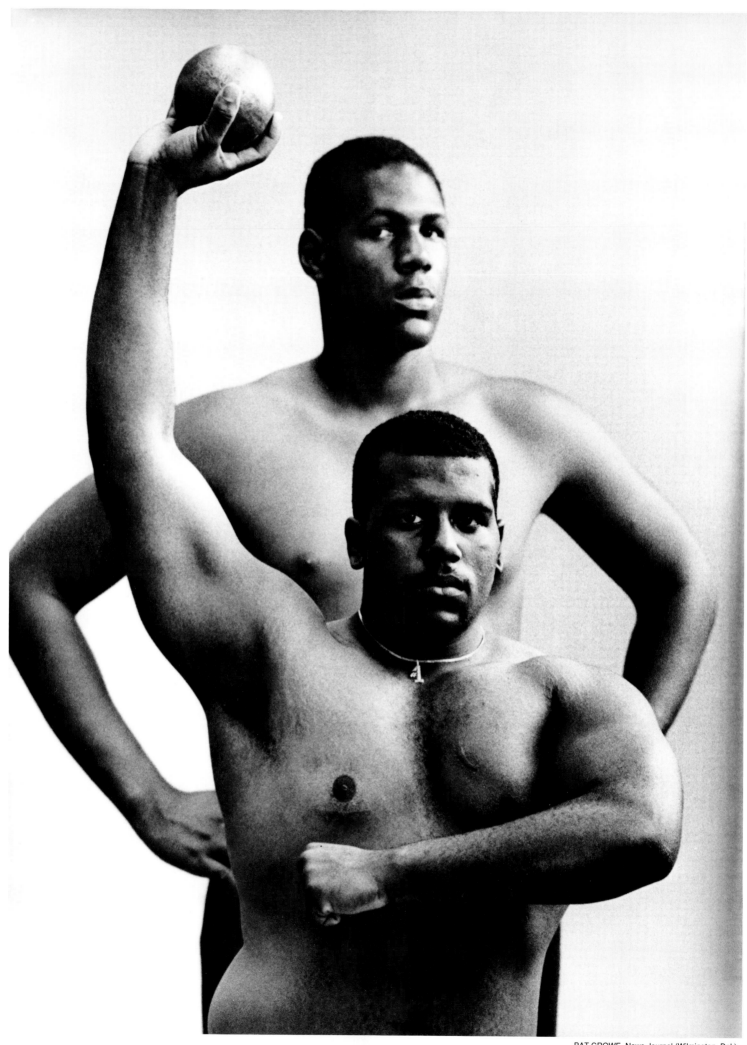

Shot put teammates Jim Croner (front) and Eric Edwards push each other to greater heights at Wilmington High in Delaware.

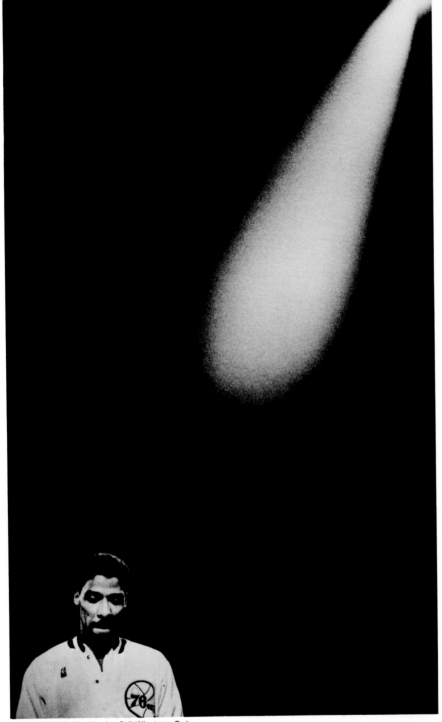

Philadelphia 76er Julius "Dr. J." Erving, making his final house call April 17, fights his emotions during a ceremony honoring him at his last regular season home game.

CHUCK ZOVKO, The Morning Call (Allentown, Pa.)

RICHARD HARBUS, United Press International

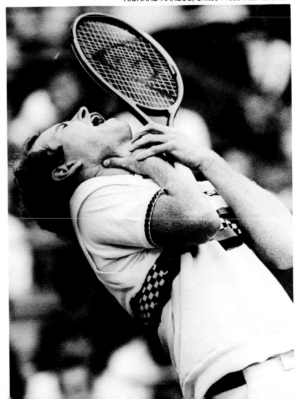

Eighth-seed John McEnroe "chokes" and loses a game, but rallied to defeat Yugoslavian Slobodan Zivojinovic at Louis Armstrong Stadium Sept. 5.

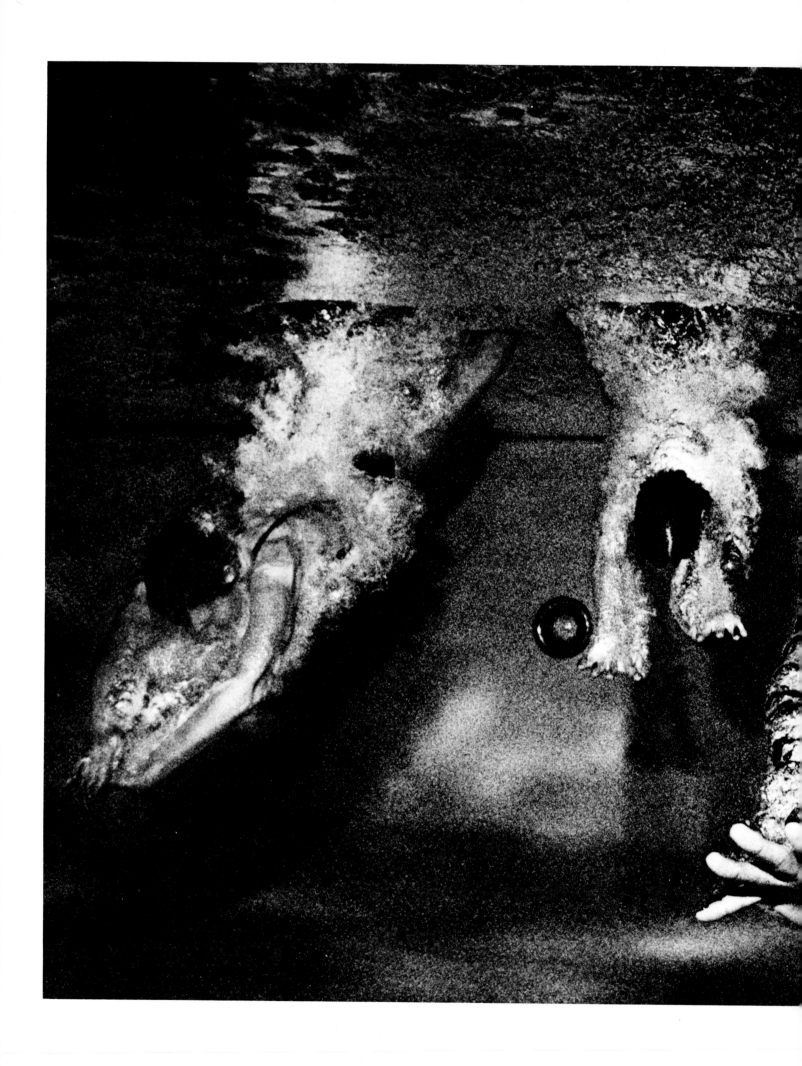

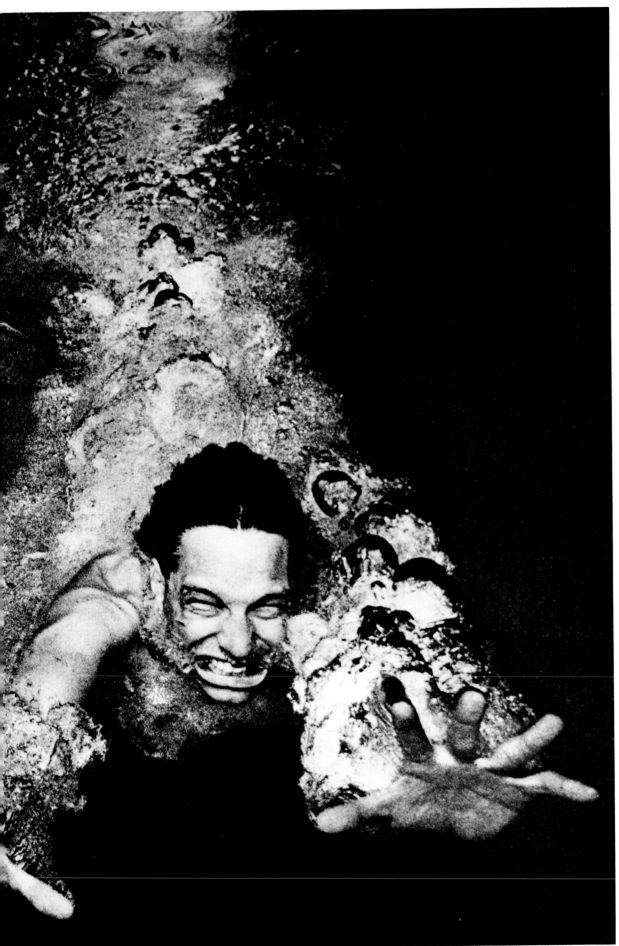

What better way for visitors from up north to cool off on a hot Florida night than with a dip in the neighborhood pool in Boca Raton, Fla.?

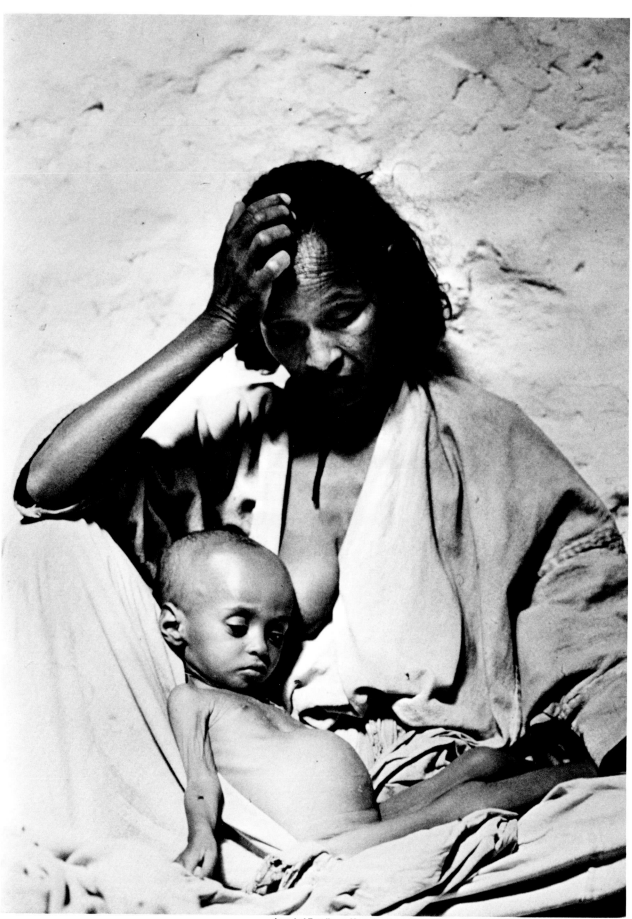

An Ethiopian mother holds her malnourished son at a Belgian medical station in northern Ethiopia. Once again, rains have failed and foreign government relief workers are trying to prevent a repeat of the mass starvation of 1984, but civil war is making their task almost impossible.

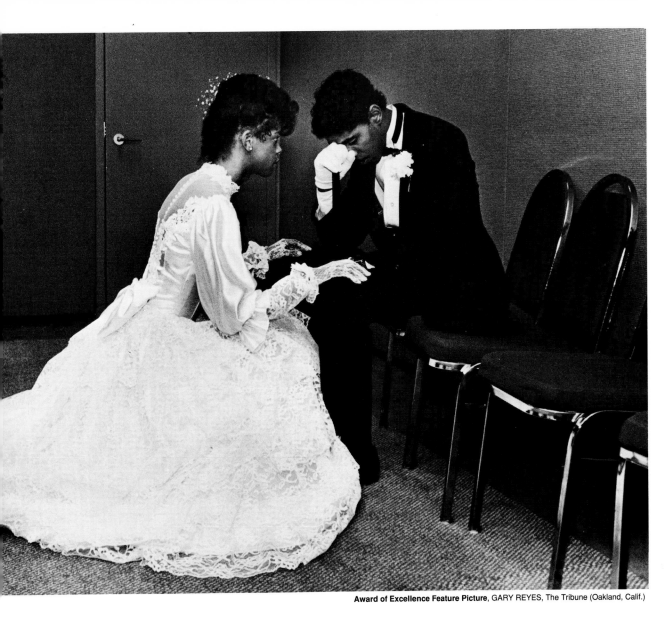

Antoinette Lee helps her escort, Marcel Dawson, overcome a little stage fright before the annual Beta Pi Sigma Debutante Ball in Oakland, Calif.

Award of Excellence Feature Picture, GARY REYES, The Tribune (Oakland, Calif.)

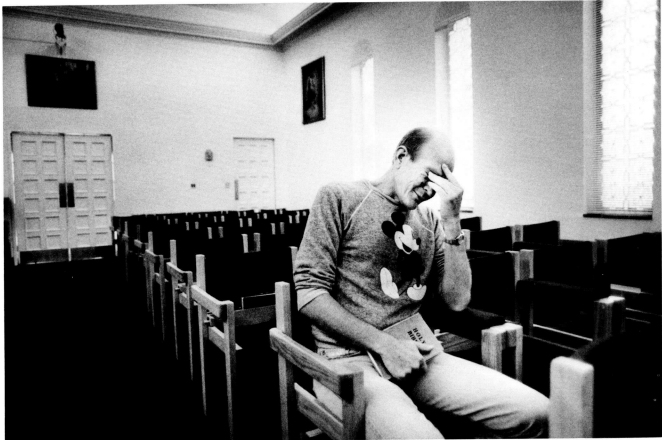

Award of Excellence Newspaper Photographer of the Year, CAROL GUZY, The Miami Herald

Following radiation therapy, Dan Bradley cries in a Miami hospital chapel after reading the 23rd Psalm, the passage he chose to have read at his funeral. Bradley has AIDS.

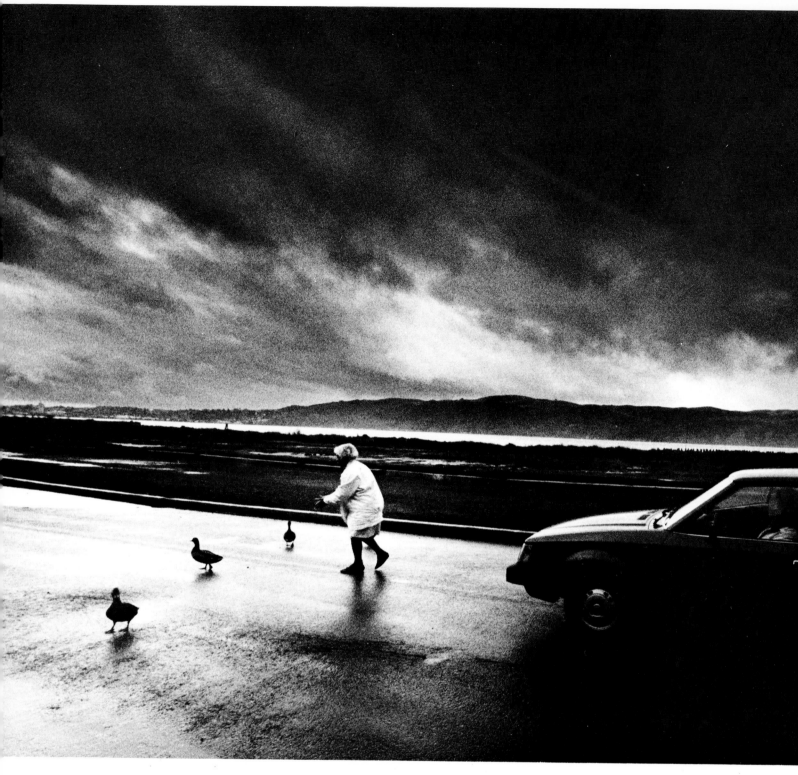

Ducks startled by a severe fall storm run out in front of a motorist, who jumps out of the car to shoo them away along a California road.

Elementary school children take notes on a field trip at a local nature preserve in Claremont, Calif.

Third Place One Week's Work,
LELAND HOLDER, The Claremont (Calif.) Courier

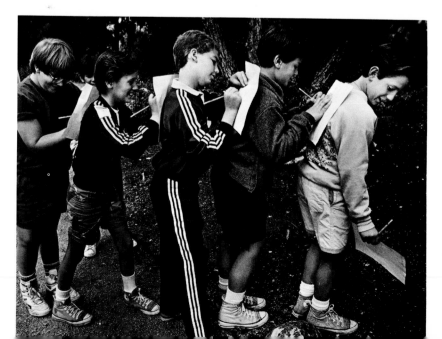

BRANT WARD, San Francisco Chronicle

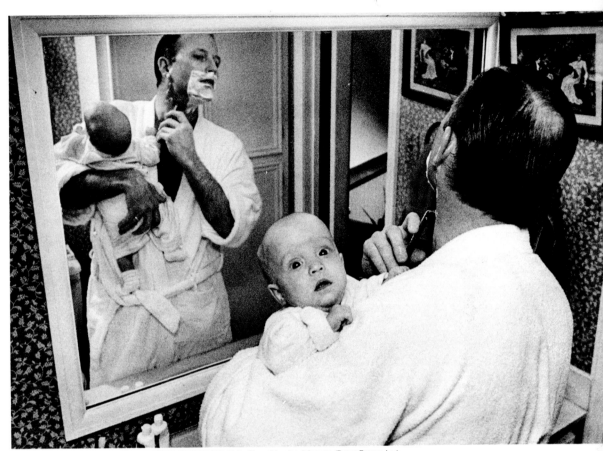

Award of Excellence Feature Picture, GUY A. REYNOLDS, State-Times/Morning Advocate (Baton Rouge, La.)

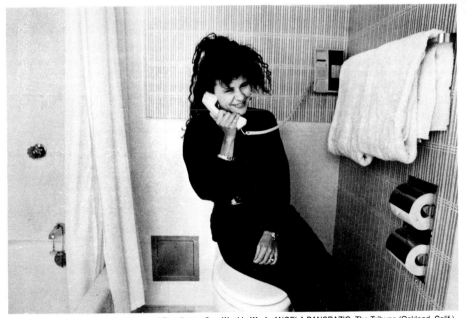

Award of Excellence One Week's Work, ANGELA PANCRAZIO, The Tribune (Oakland, Calif.)

With an extra little shaver in hand, Jim Roland continues his morning routine. Roland and his wife have quadruplets, so when a baby cries at the Roland house in Baton Rouge, La., you pick it up and continue with what you were doing.

Comic actress Tracey Ullman stoops to bathroom humor with a telephone in a San Francisco hotel.

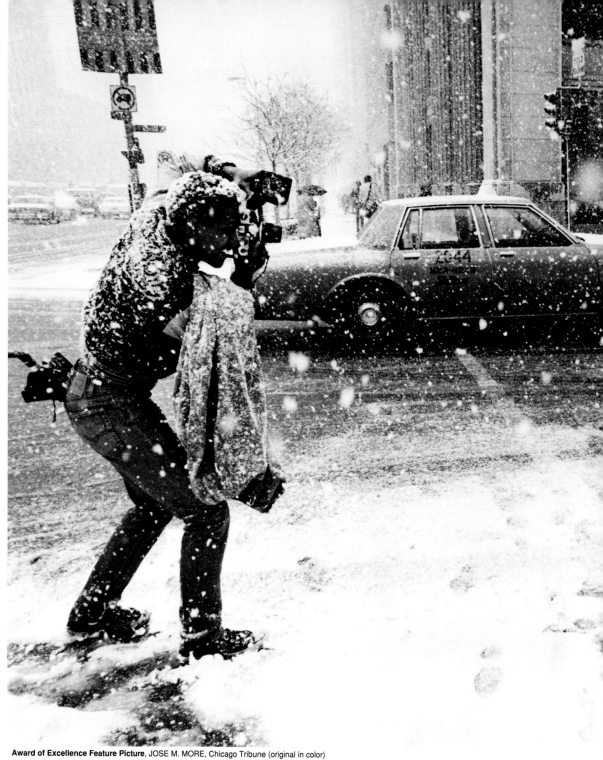

Award of Excellence Feature Picture, JOSE M. MORE, Chicago Tribune (original in color)

As umbrellas collapse, a crowd races for the Connecticut state capitol in Hartford during an April storm that dumped up to 5 inches of rain on the area.

Award of Excellence Feature Picture,
TONY BACEWICZ, The Hartford (Conn.) Courant

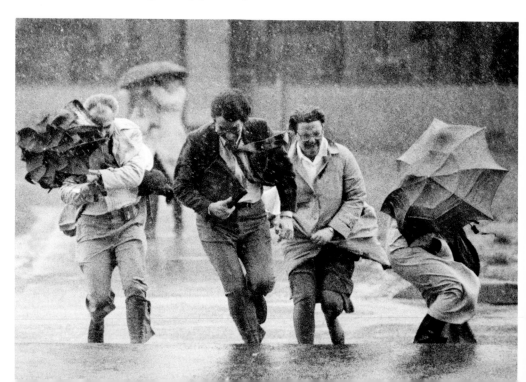

On a spring day in Chicago, a freelance photographer is startled to find his fashion shoot snowed in by a lake-effect snow — a mini-snowstorm that comes in off the lake and stays within a few blocks of the water.

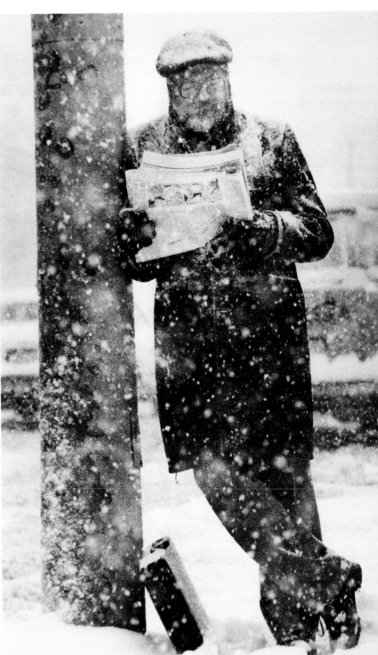

Award of Excellence Feature Picture, BARRY GRAY, The Burlington (Ontario) Spectator

Foul weather doesn't stop avid reader Harold Wells of Burlington, Ontario, as he waits for a bus during a spring snowstorm.

Weather or not

Weather. People love to love it. They love to hate it. They love to talk about it. Rarely do they ignore it. Same goes for the people who make a living shooting pictures for newspapers. The familiar call in newsrooms across the nation: "Can you get us a weather shot?" So out they go. Neither rain, nor sleet, nor snow keeps the photographers from their appointed task.

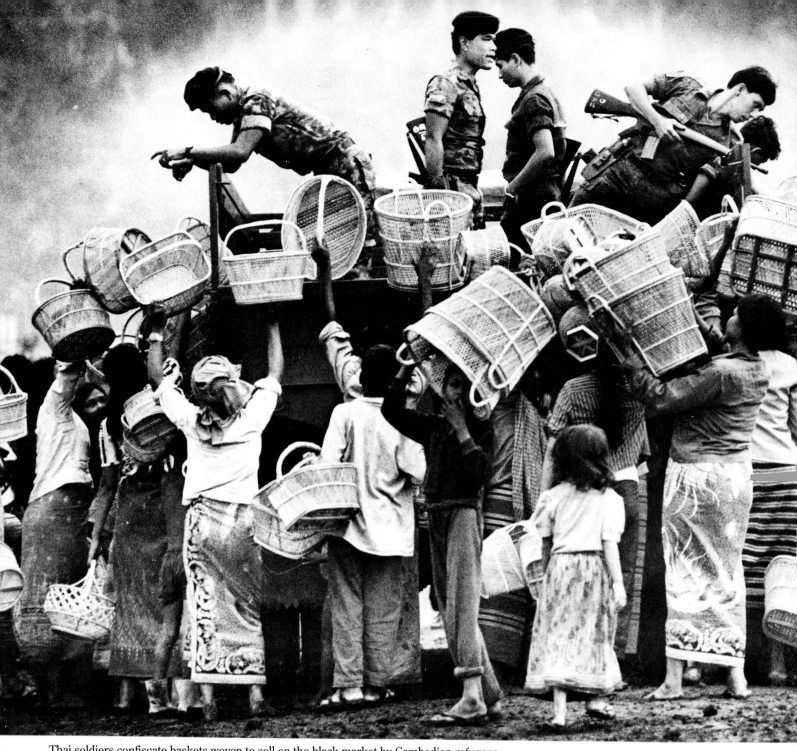

Thai soldiers confiscate baskets woven to sell on the black market by Cambodian refugees.

Bill Greene

Newspaper Photographer of the Year

In early 1987, The Boston Globe committed itself to a major project documenting the worldwide refugee problem. Teams of photographers and reporters were sent to five countries: Africa, Mexico, Thailand, Jordan and Pakistan.

Photographer Bill Greene was sent to document Cambodians living along the Thailand-Cambodian border.

Fleeing their homeland, which has been involved in a bitter war with Vietnam, the Cambodians have been largely rejected by the Thais and forced to live just inside the border in refugee camps. They live in simple straw huts and are prone to abuse from the Thai soldiers.

Primitive hospitals have been set up in each camp to treat the diseases that flourish in

Newspaper Photographer of the Year and Second Place Feature Picture Story, BILL GREENE, The Boston Globe (all photos)

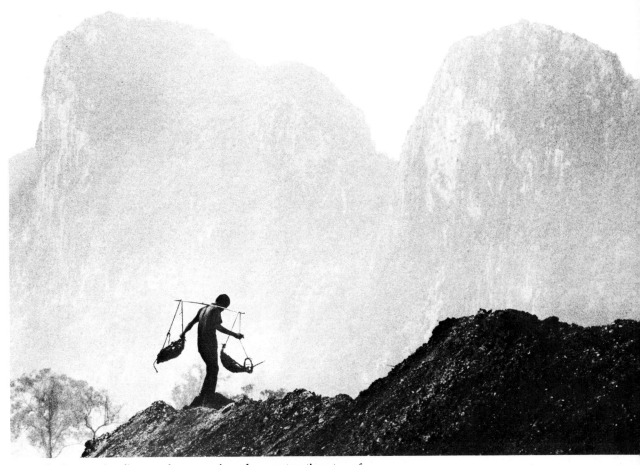

A Cambodian carries dirt out of a reservoir under construction at a refugee camp.

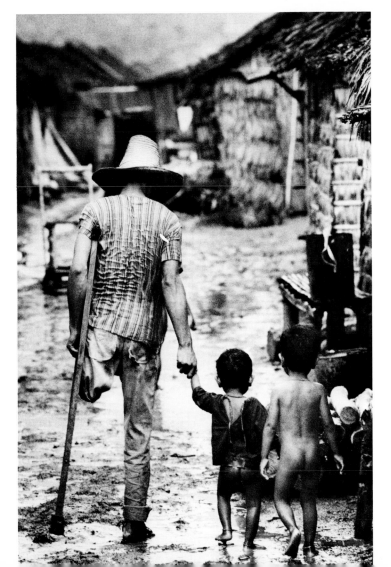

A Cambodian who lost his leg in the war with Vietnam walks with his sons inside a refugee camp.

A lesion is removed from the head of a boy at a refugee camp hospital on the Thai-Cambodian border.

127

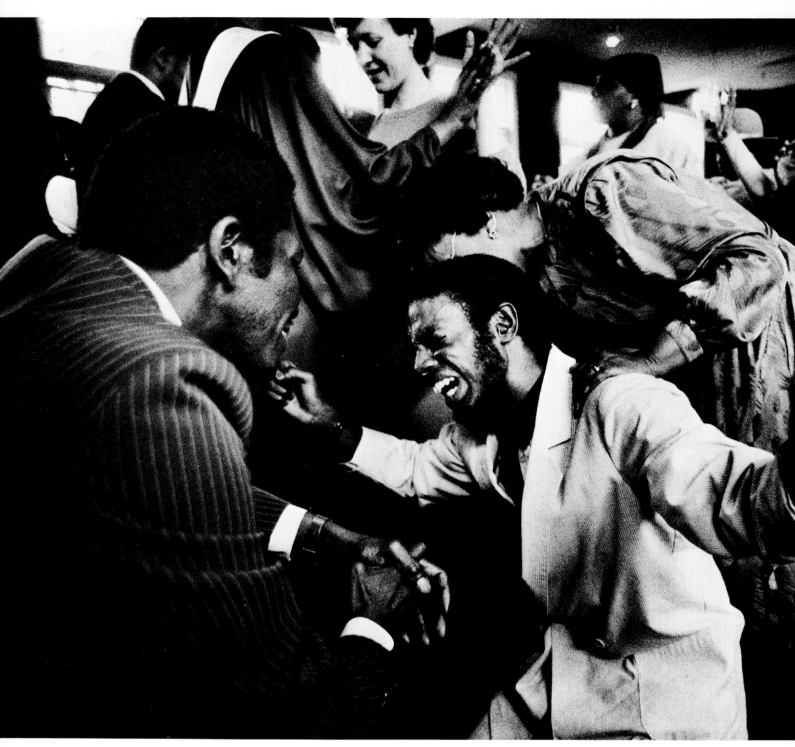

Newspaper Photographer of the Year, BILL GREENE, The Boston Globe (all photos)

As he receives the spirit of the Lord at a church altar, a worshipper falls to his knees.

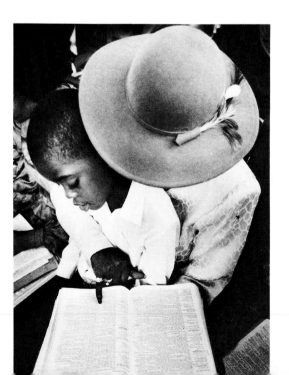

A young boy receives some help reading the Bible from his mother inside Grace Community Church in Dorchester, Pa.

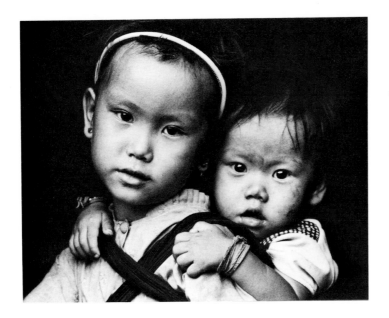

Two Hmong children, a brother and sister, pose inside Phanat Nikom refugee camp near Bangkok, Thailand.

Bill Greene

the camps: malaria, typhoid, meningitis, hepatitis and tuberculosis.

The vast majority are stuck, having left their homeland only to find an unreceptive country at the border.

"I was lucky enough to get that good overseas trip," Greene said about his portfolio.

"In putting a portfolio together, I think it is maturity. You learn to look at the whole picture. I did a lot of editing ... worked with a lot of photo editors and the portfolio changed a lot."

"I was after versatility. That was in the rules. And I had it: news, features, pictorial, graphics, sports ... I think I had some strong sports, which really helped."

"And I always like humor. I tend to lean toward something funny, something emotional."

Greene has been with The Boston Globe since 1985. He was named New England Photographer of the Year for four years by the Boston Press Photographers Association. He also has been named the National Press Photographer Association's Regional Photographer of the Year four times.

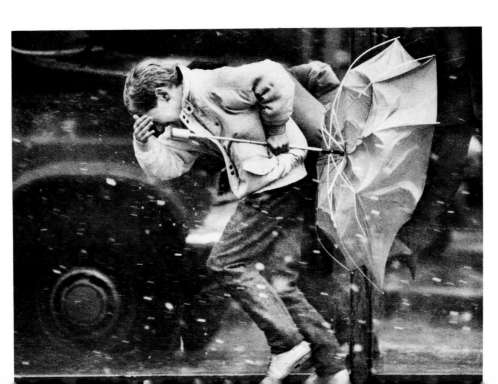

His umbrella a victim of the wind, a pedestrian braves the elements in downtown Boston.

Three die-hard fans stay dry during an NFL replacement game at Sullivan Stadium in Foxboro, Mass.

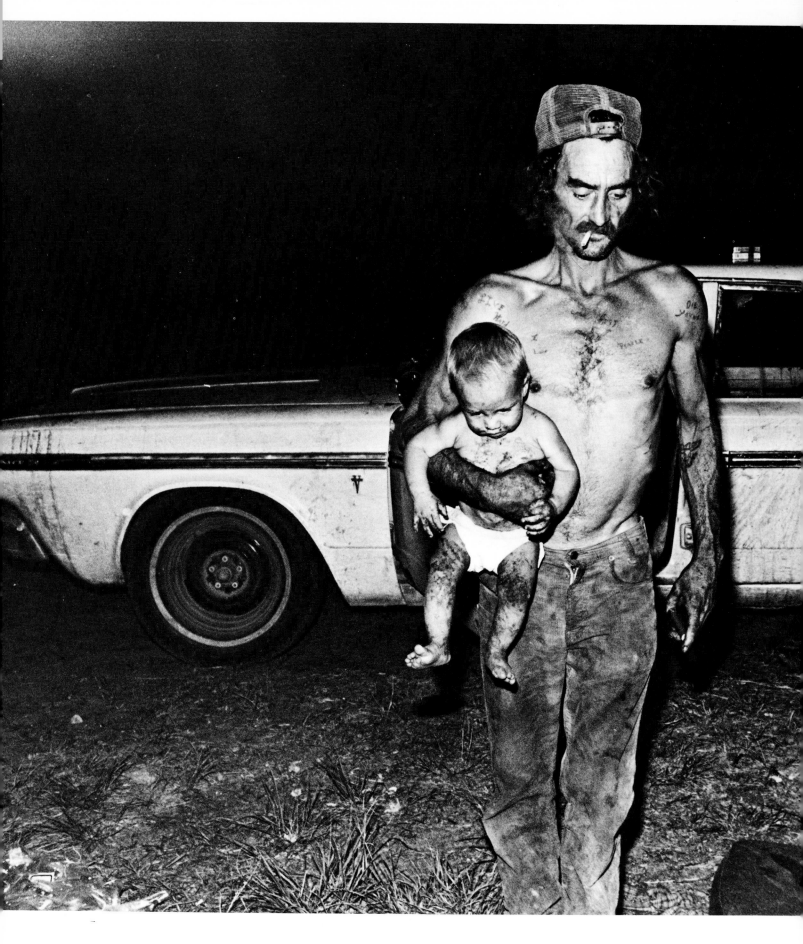

No water, no shelter, no shower, no toilet.

– Mirgrant camp, Loxahatchee, Fla., 1981

L.H. Tindal carries his 1-year-old son, Shannon Dewayne, from a jalopy to the family's migrant tent where the family lived in a citrus grove on the edge of the Everglades in total isolation. Loxahatchee, Fla. 1981.

Herman LeRoy Emmet

Canon Photo Essayist

"True blue." That was how L.H. Tindal and his family wanted their story told. The story of migrant workers.

And the only way to do that?

Work with them. Hour by hour. Sleep with them. Day by day. Move with them. Month by month. Feel with them. Year by year.

So for seven years, photographer Herman LeRoy Emmet looked from the inside out at a family of migrant farm workers.

It was L.H. Tindal's family.

L.H. and his wife, Linda, were born into migrant work. Neither had the education to escape the hard, wandering life. They held other jobs — construction, brick laying, housekeeping. But they didn't have the skills to move out of the migrant life.

They always ended up back in the field.

Emmet joined them, working side-by-side. Accepted as a photographer. As a co-worker.

Photographs were slipped in between picking. Emmet kept his camera in a sack with the crop. When he saw a moment, he would grab the camera and shoot.

Then it was back to picking. Back to the fields with L.H. and Linda.

And the children.

Realizing the migrant life was taking its toll on their children, L.H. and Linda are trying to settle down. They are looking to education to open the doors. To give their children the options they never had.

Herman LeRoy Emmet

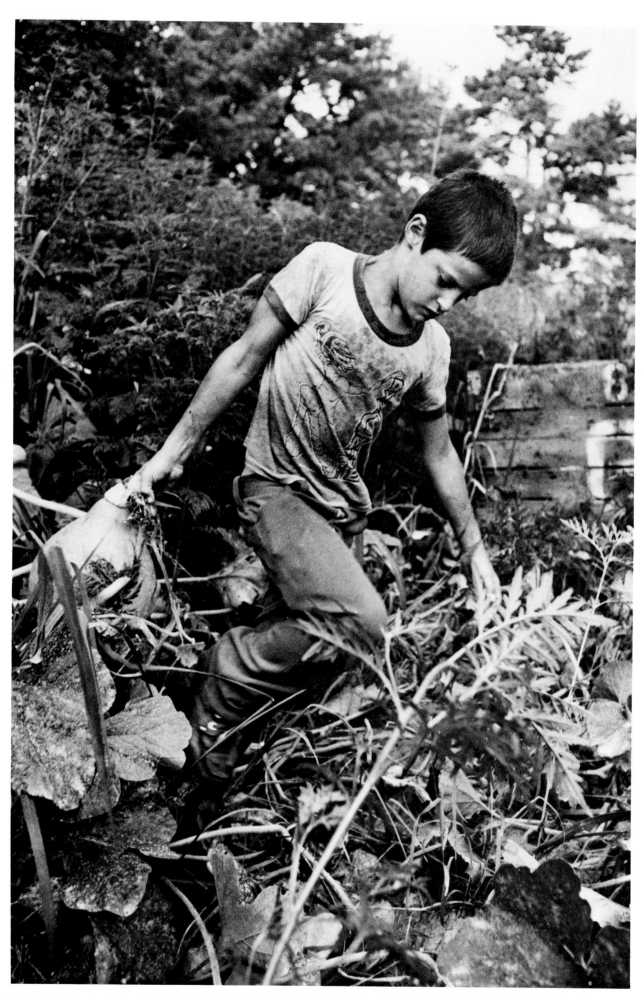

Ten-year-old "Monkey" Tindal (L.H. Jr.), working for a man's wage harvesting large orange "Gerber" or "punkin" squash weighing 15-20 pounds. Dana, N.C. 1979.

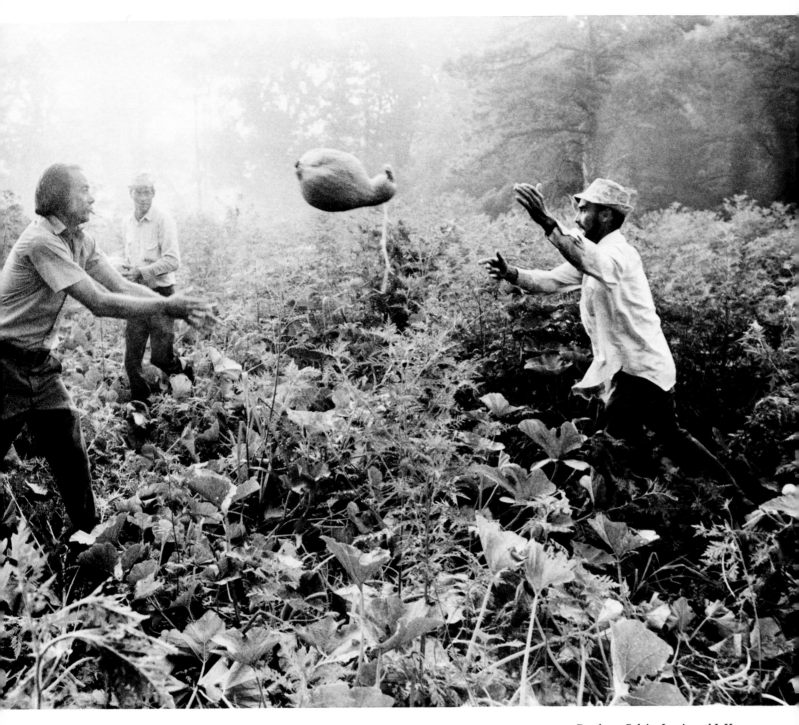

Brothers Calvin, Lewis and L.H. Tindal harvest large orange squash in the early morning as ground fog burns off. Dana, N.C. 1979.

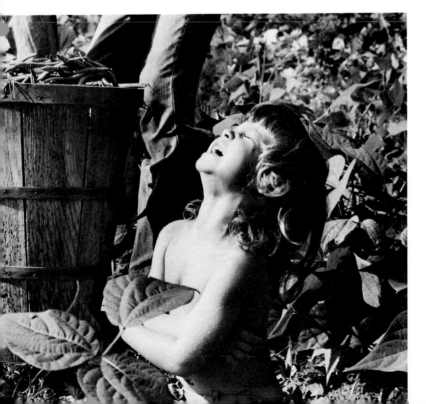

Three-year-old Tina Michelle Tindal cries after a long, hot day of working in the bean field with her family. Edneyville, N.C. 1979.

Herman LeRoy Emmet

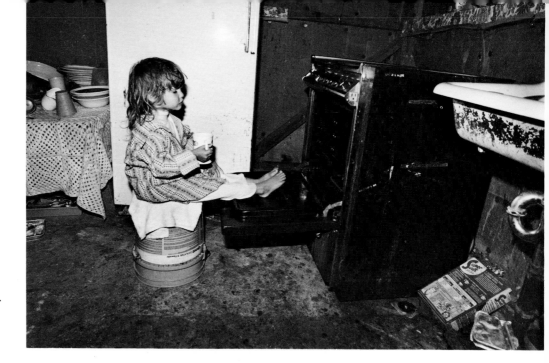

Tina Michelle Tindal sits on an herbicide bucket and warms her feet at the oven, surrounded by the cardboard walls of a migrant labor cabin. Edneyville, N.C. 1979.

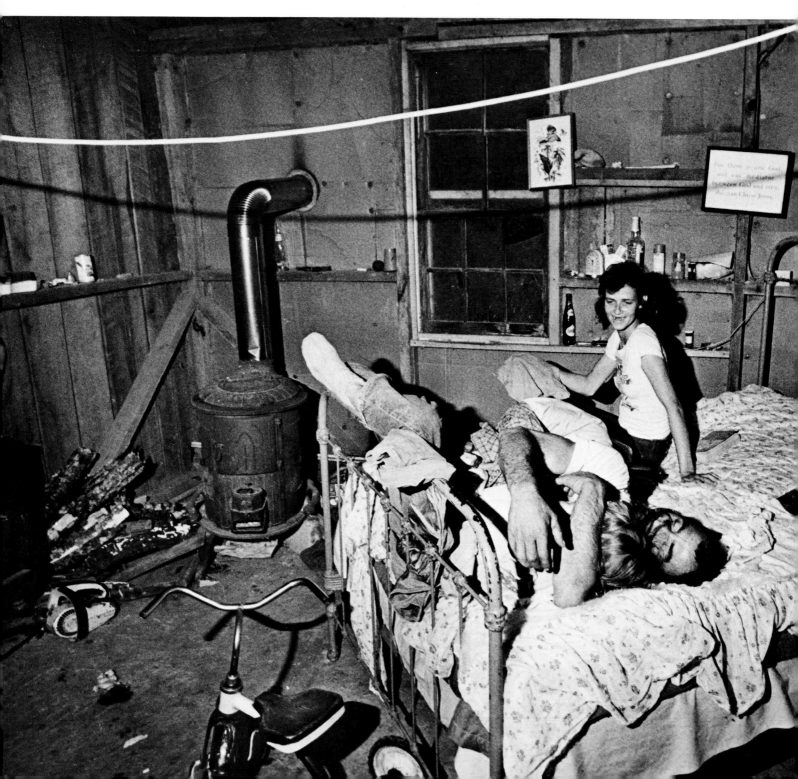

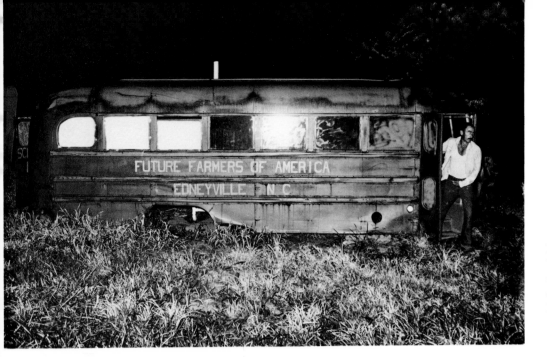

Tina Michelle, caught by the wind at the foot of an ancient Southern pine, watches her parents and their friends play poker. Dana, N.C. 1981.

L.H. Tindal leaves a school bus converted into a toilet/shower in a migrant labor camp early in the morning. Edneyville, N.C. 1979.

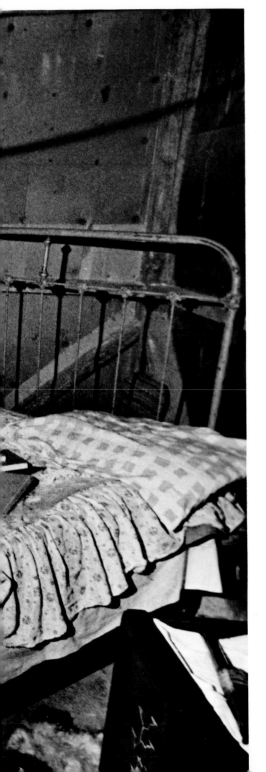

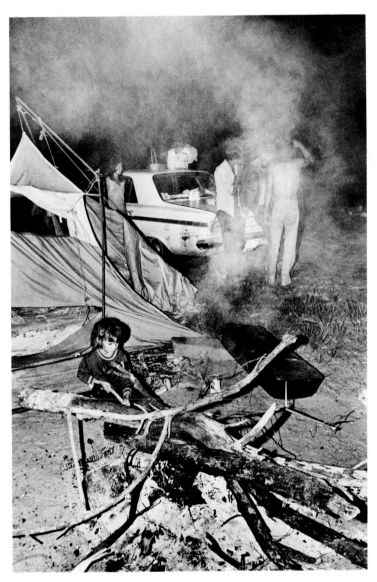

The Tindal family is forced to live in a tent among the citrus groves. Loxahatchee, Fla. 1981.

Linda, L.H. and Tina Michelle take time out for a family romp inside their migrant labor camp shack. The sign above the bed reads "For there is one God, and one mediator between God and men, the man Christ Jesus." Edneyville, N.C. 1979.

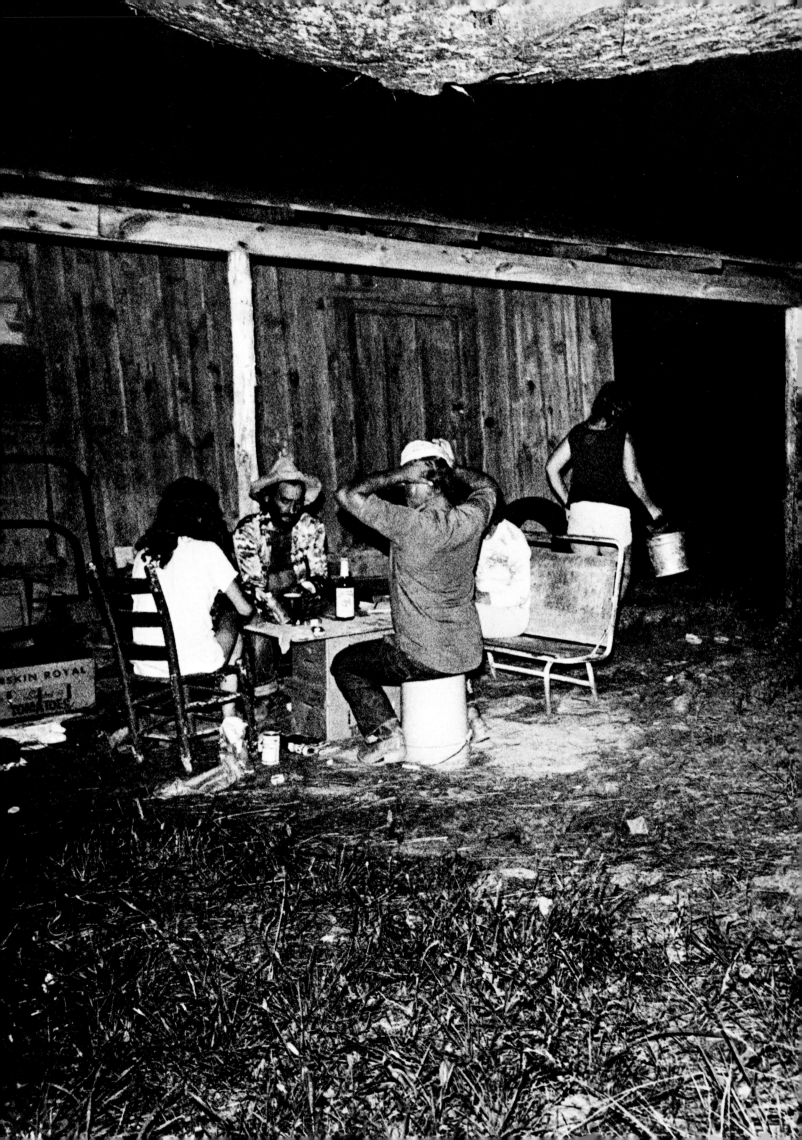

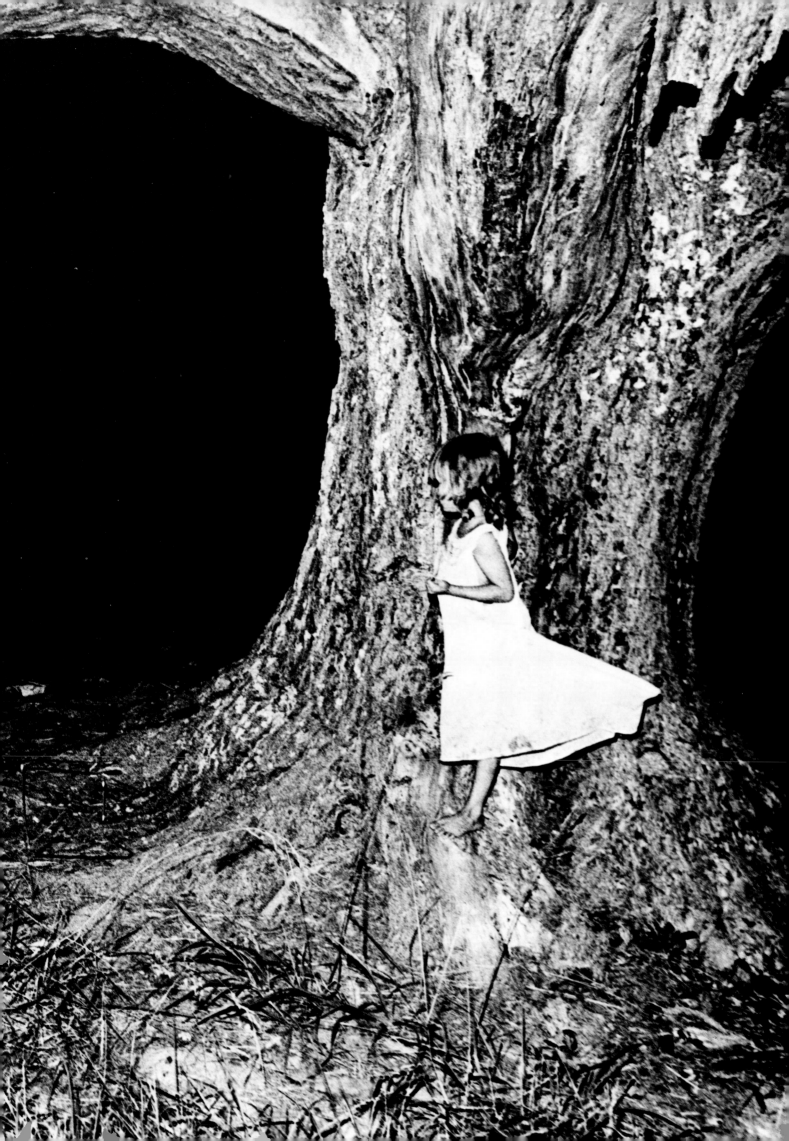

Herman
LeRoy
Emmet

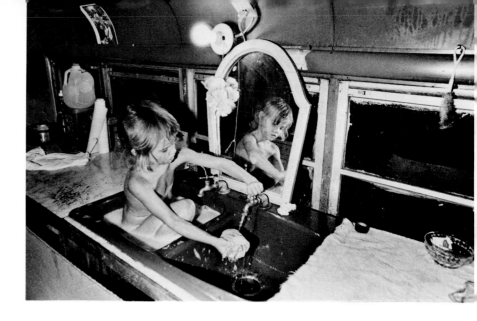

A 5-year-old Tina Michelle bathes in the sink of a converted school bus. Edneyville, N.C. 1981

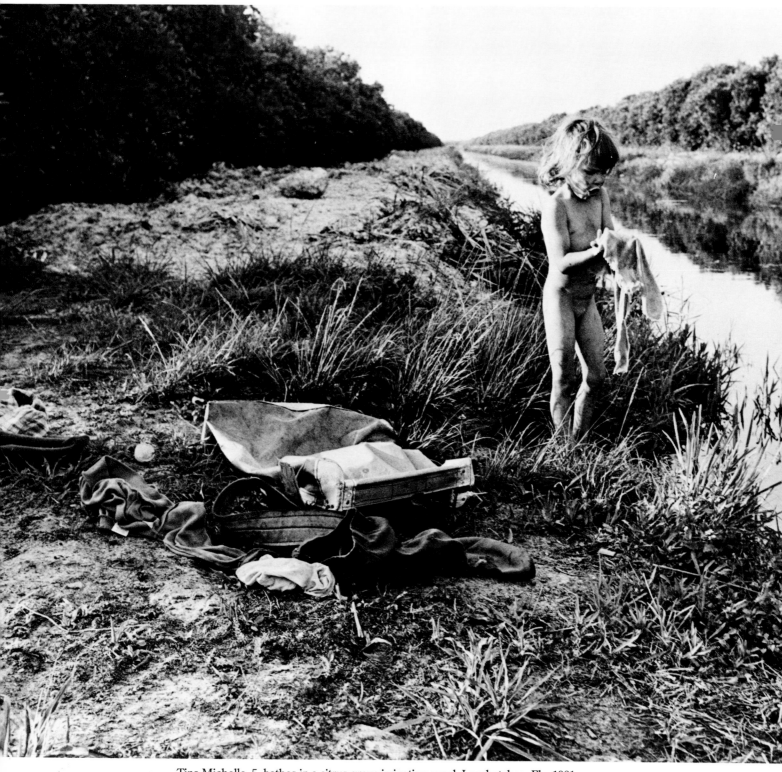

Tina Michelle, 5, bathes in a citrus grove irrigation canal. Loxahatchee, Fla. 1981.

Linda Tindal cuts through the woods with her 1-year-old son, Shannon Dewayne, followed by family and friends. Hendersonville, N.C. 1982.

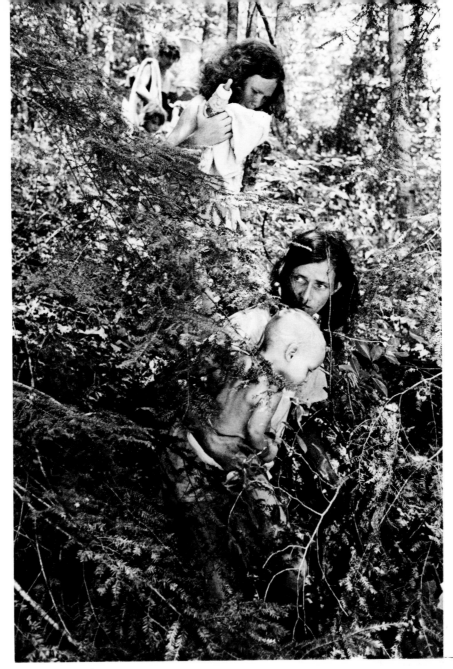

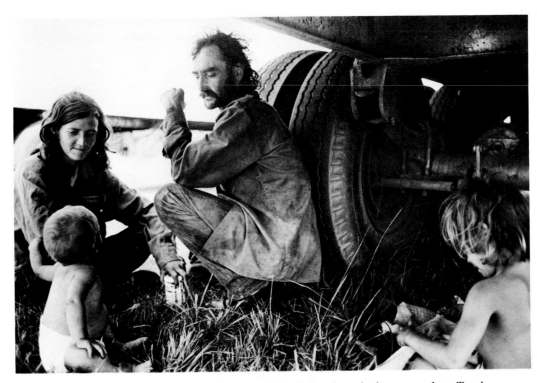

Tina Michelle, L.H., Linda and Shannon Dewayne take shelter from the hot sun under a Tropicana citrus loading truck during a break from picking oranges. Near St. Lucie Locks, Fla. 1981.

Herman LeRoy Emmet

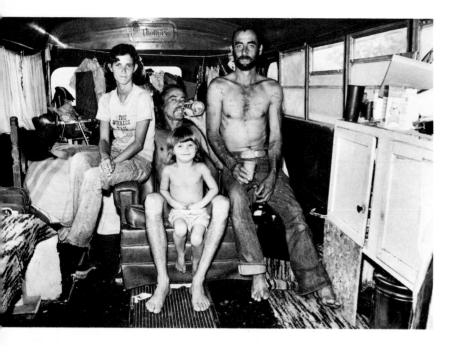

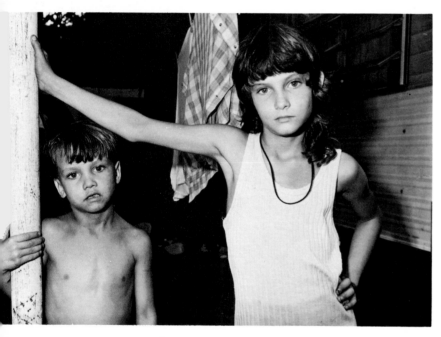

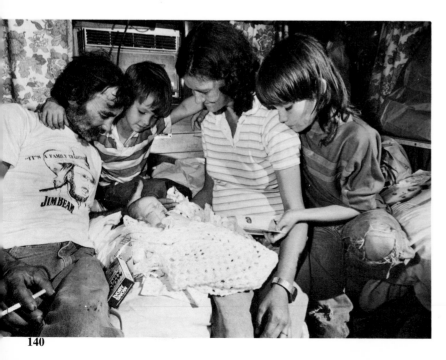

Linda, Calvin, Tina and L.H. Tindal pose for a family portrait in their migrant camp home, a converted school bus. Calvin and L.H. are brothers. Edneyville, N.C. 1979.

Shannon Dewayne and Tina Michelle pose for a portrait next to the family trailer. Ft. Pierce, Fla. 1986.

L.H., Shannon Dewayne, Linda and Tina Michelle admire 2-week-old Nikki Nicole inside their one-room trailer. Ft. Pierce, Fla. 1986.

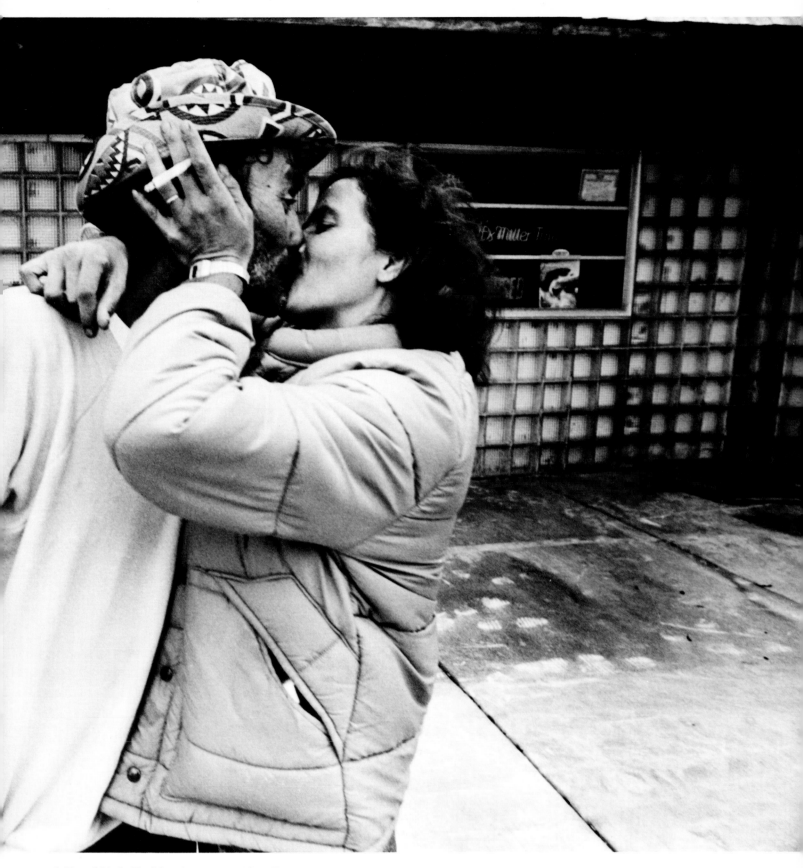

L.H. and Linda Tindal embrace on a sidewalk in Olcott, N.Y. 1984.

<u>1987</u> L.H. and Linda are trying to settle down. They
are looking to education to open the doors. To
give their children the options they never had.

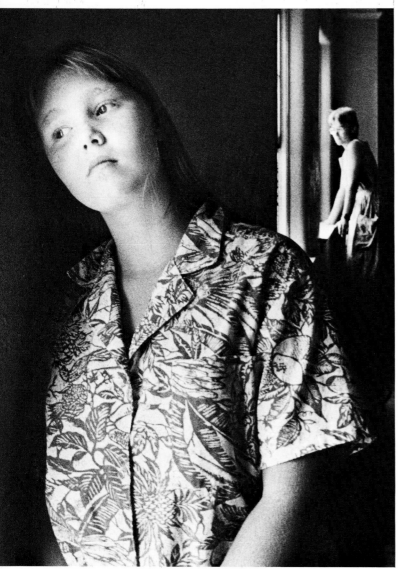

First Place Editorial Illustration, V. JANE WINDSOR, University of Florida (Gainesville, Fla.)

A mother-daughter modeling team illustrates the communication problems between teen-agers and their parents.

Editorial illustration

Judges debate approach

Only three of the 324 pictures entered in the editorial illustration category received recognition by the judges. And one of those was cause for debate.

Some judges were concerned that the picture awarded first place — a posed illustration — looked too documentary and would hurt the credibility of actual documentary photographs.

"It's really quite believable," one judge said.

"It's so believable, it's almost scary ... because people can think it was a found situation," another judge noted.

The photo, made by a photo student, had never been published.

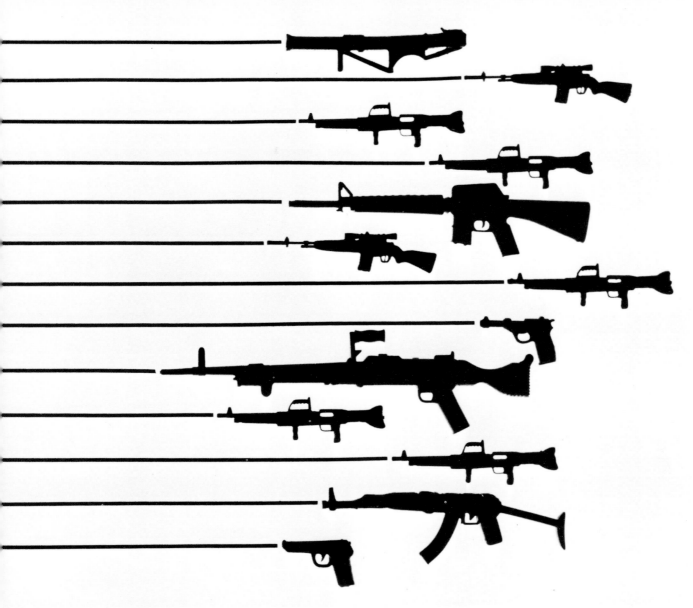

Second Place Editorial Illustration, SIG BOKALDERS, Freelance for Ft. Lauderdale (Fla.) News/Sun-Sentinel

This bullet-spangled banner takes aim at America's love affair with weapons. The set was assembled on a light box using small plastic toy guns and newspaper border tape.

Fatigue flattens millions of people every year. One survey found fatigue to be the seventh most frequent complaint at doctors' offices.

Third Place Editorial Illustration, GEFF HINDS, The News Tribune (Tacoma, Wash.)

The metamorphosis of
Wendy Fraser

Wendy Fraser was 21 years old when she had surgery to reduce her stomach's capacity to one ounce of food. The decision was a last resort for a woman from Monaco, Pa., who had never had a date and tried to eat away her problems — until she weighed 265 pounds. To qualify for the surgery — a near-total gastric diversion — Wendy had to be 100 pounds overweight. Doctors refer to the condition as "morbidly obese" because of the health hazards accompanying the extra weight. Her drastic and permanent surgery and the weight loss were recorded over a year and a half while she lost more than 100 pounds.

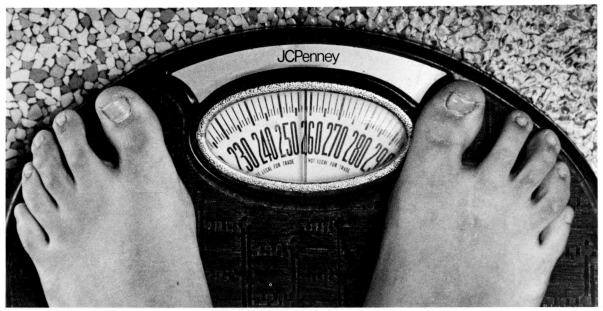

Before her surgery, Wendy weighed in a little below 260 pounds on a home scale. The last week before surgery, she binged on her favorite foods. She remembers her top weight — 270 pounds.

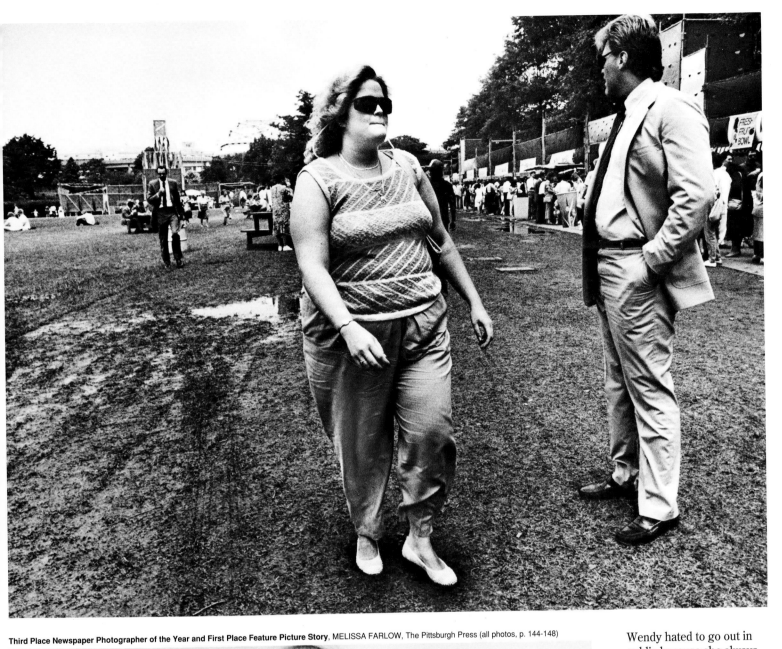

Third Place Newspaper Photographer of the Year and First Place Feature Picture Story, MELISSA FARLOW, The Pittsburgh Press (all photos, p. 144-148)

Wendy hated to go out in public because she always felt as if people were laughing at her. Awkward and uncomfortable, she walks past food booths at the Three Rivers Arts Festival after a doctor's appointment about her surgery.

Hours before surgery, Wendy's mother flagged down a volunteer pushing a snack cart and bought the hungry patient a lollipop.

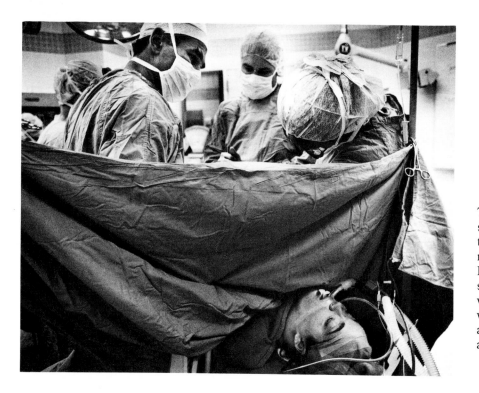

Wendy's surgery lasted four hours and cost about $25,000, which included an eight-day hospital stay. Most of her expenses were covered by health insurance.

Wendy
Fraser

The incision was stapled shut and a temporary tube that relieved gas was removed a week later. Recovery from the major surgery took several weeks. However, there were complications — anemia, hair loss, nausea and fatigue.

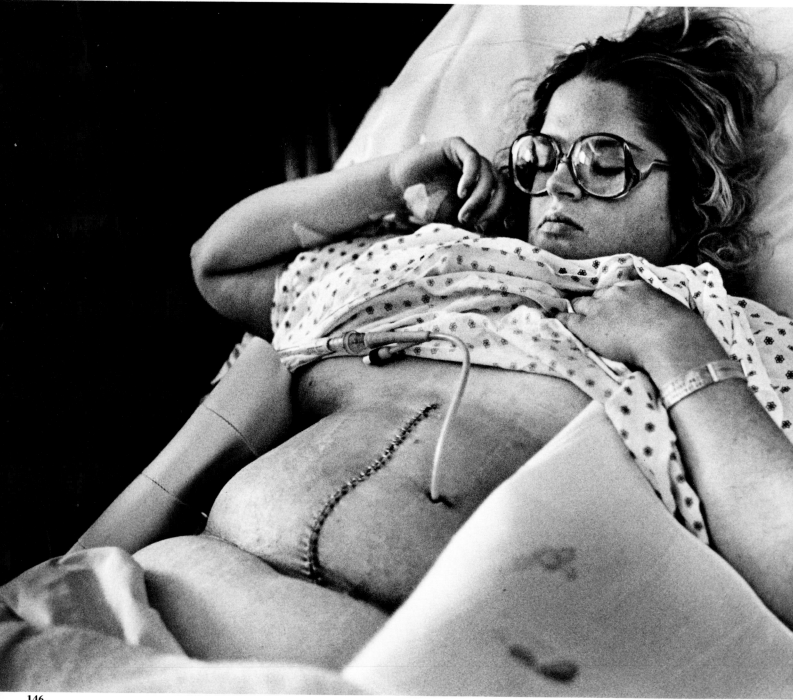

After several months, Wendy tried on her old nursing uniform. There was room to spare.

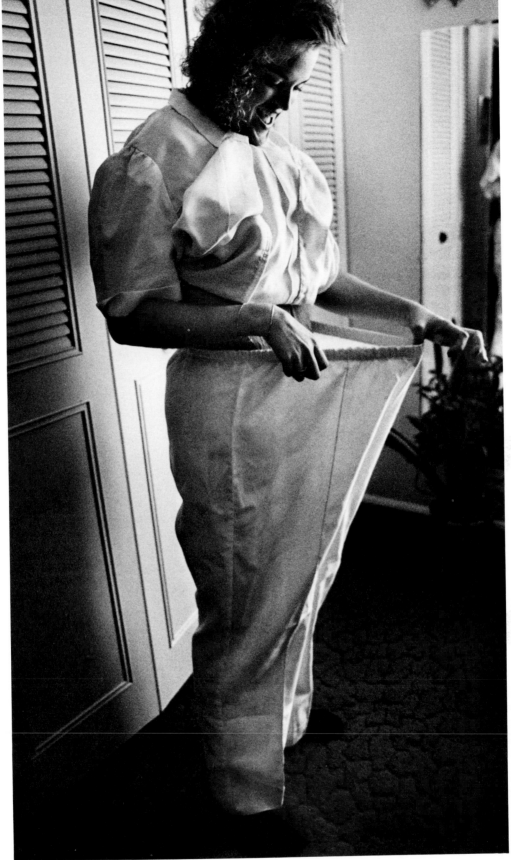

Back at home, Wendy's meals basically were two bites of real food accompanied by supplementary vitamin pills.

Wendy
Fraser

As Wendy's weight fell, her confidence — and her social life — improved. She went to Heartbeat, a local disco, and danced the night away with her girlfriends. Judy, a co-worker, was Wendy's inspiration for the surgery. She once weighed more than Wendy.

On her 23rd birthday, Wendy put on her sexiest black dress and pearls, said goodbye to her mother, and headed out to celebrate with a dinner date.

Wendy began dating men she met in bars. Her mother was worried she would be hurt because of her inexperience. Wendy was worried, too. Was she winning friends because of her good looks? Did people really like her for herself? Wendy began dating a man with similar interests and the relationship turned serious. Wendy was engaged in November.

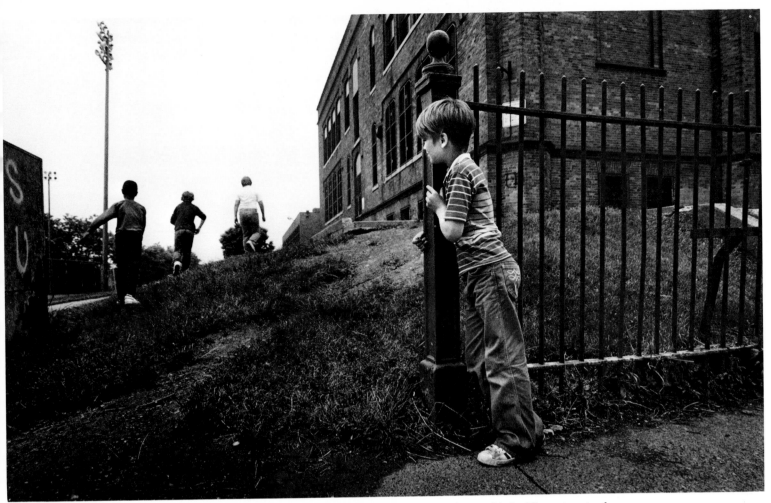

Suspended from Fort Pitt Elementary School for fighting, Jimmy Thornton "hangs out" alone as his buddies return to class.

Why won't Jimmy go to school?

Jimmy Thornton is an 11-year-old truant. His parents are divorced. His mother has custody, but isn't in the courtroom with her son, one of eight children.

District Justice John R. DeAngelis, at a truancy hearing in East Liberty, Pa., tells Jimmy's father and grandmother that Jimmy will have to spend the summer in the Allegheny County juvenile jail.

It is a bluff.

"I want him to be afraid of me. I pray that this kid believes I can lock him up and throw away the key if he doesn't go to school. I pray that he does that before he finds out that I can't really do anything to him at all," DeAngelis says.

The family swallows the bluff. The judge awards custody to Jimmy's grandmother, and offers to suspend the sentence if Jimmy and his family promise there will be no unexcused absences — including suspensions — in the last month of school.

Less than two weeks later, Jimmy is suspended from school for fighting. By the end of the month, he has been suspended a total of three times.

Jimmy and his father at a shoplifting hearing.

Third Place Magazine Picture Story, RANDY OLSON, The Pittsburgh Press (all photos, p. 149-151)

Why won't Jimmy go to school?

Jimmy scuffles with another student in the cafeteria. He went unpunished because he wasn't caught. Another time, Jimmy was suspended for back talk and spent the night at a friend's house.

Met by his mother and sisters after school, Jimmy — carrying an art class project — is taunted by a classmate.

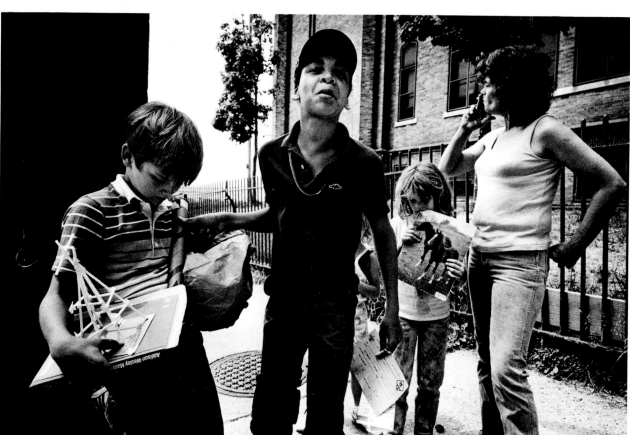

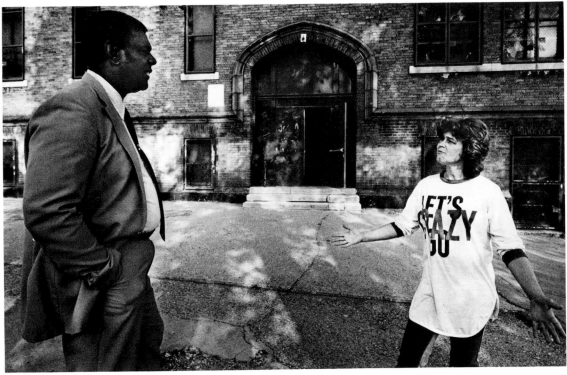

Outside Fort Pitt Elementary school, Carol Thornton and Principal Joseph Hightower talk about Jimmy's truancy.

Waiting out a boring suspension at his grandmother's home, Jimmy half-heartedly watches television.

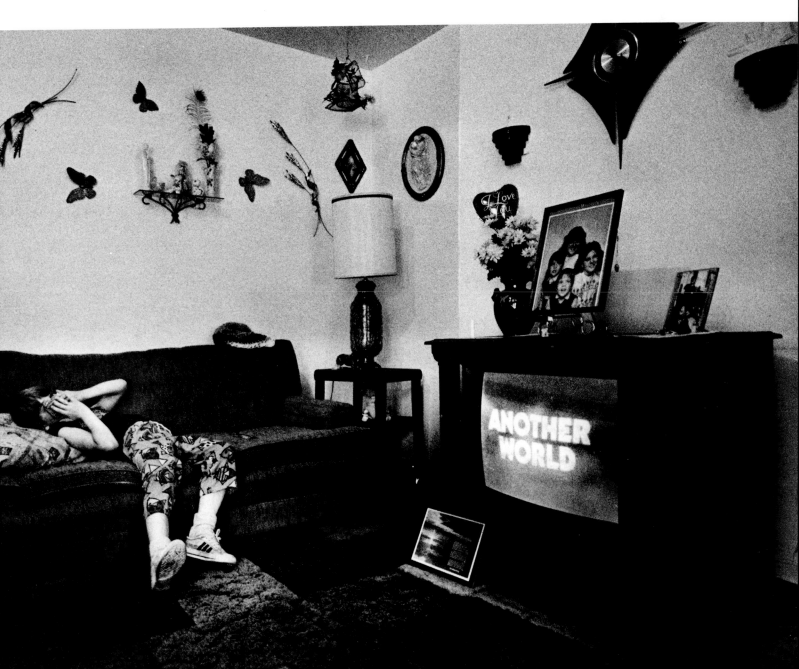

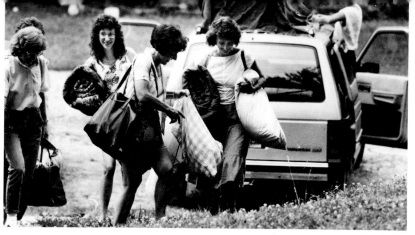

Five graduate school nurses from Pittsburgh piled out of a van to begin a week of home health-care visits to residents in Stinking Creek, Ky. The women grew close to the Appalachian people, offering medical care while gathering information for research.

Home health care on Stinking Creek

It starts with a narrow plank bridge. Watch out for your tires on the railings. It's pretty tight. And watch out for the drop — it's 40 feet down to Stinking Creek.

Stinking Creek, named for the sulfurous runoff from coal, is the home of the Lend-A-Hand Center, which has opened its doors to thousands of volunteers seeking a taste of Appalachian life.

In June, five graduate nursing students from the University of Pittsburgh crossed the bridge as part of a kind of working pilgrimage to help the people of Knox County, Ky.

They went to Stinking Creek to research and write papers on topics ranging from folk medicine to attitudes about breast self-examination. The five spent their days visiting patients and compiling health histories of school children.

It was a week of learning through "transcultural nursing."

Upon completing their program, they will join Pennsylvania's 1,075 licensed nurse practitioners.

Third Place Newspaper Photographer of the Year, MELISSA FARLOW, The Pittsburgh Press (all photos)

Nurse Peggy Kemner checks the blood pressure of a rural woman as a graduate school nurse observes on the front porch of a home up the holler from Stinking Creek.

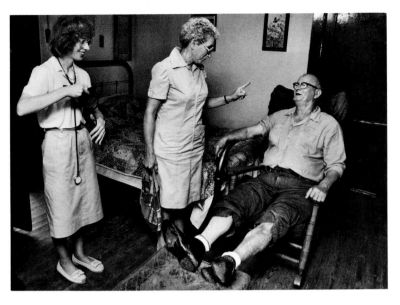

Nurse Peggy Kemner warns a patient about eating habits that aggravate his blood disorder.

Two nurses concerned about the condition of cancer patient Hobart Bargo wait for a call from the family doctor. The man died the next day.

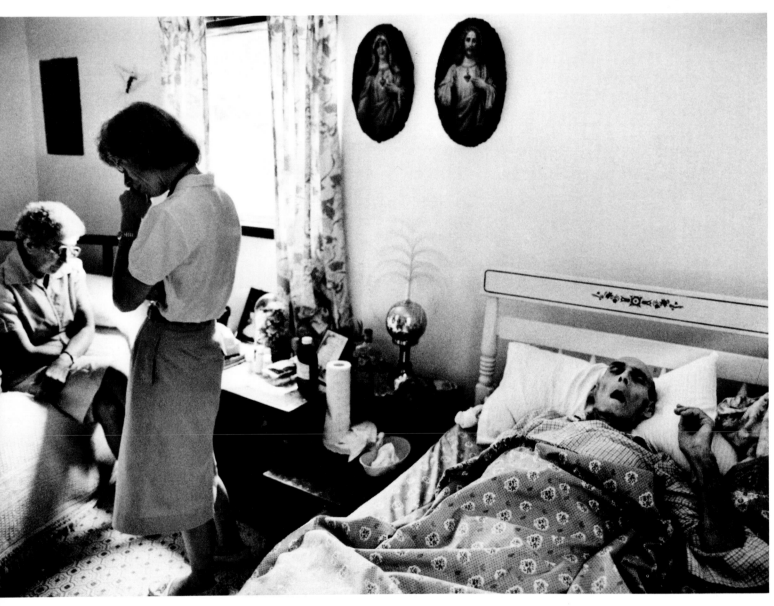

Nurse practitioners measure a child's head during a physical.

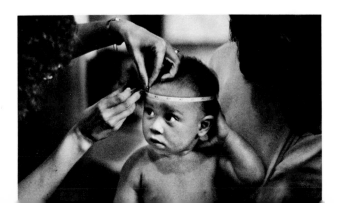

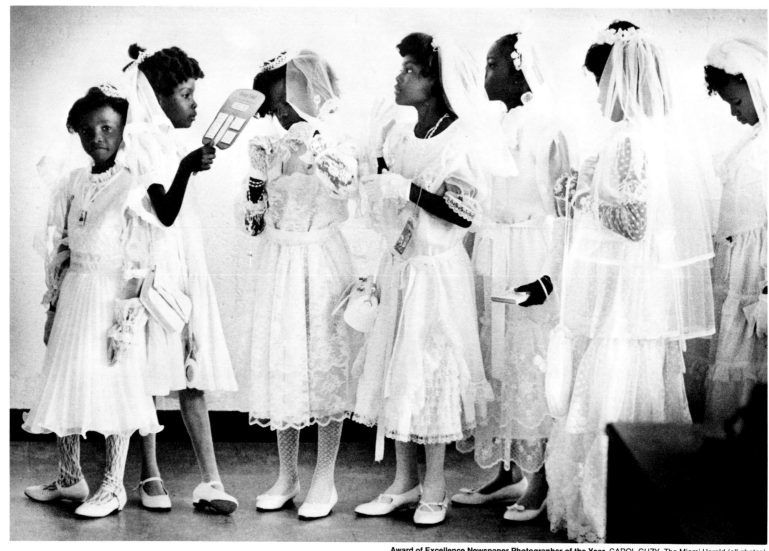

First communion

Dressed in white finery, girls line up in a classroom at Notre Dame de Haiti Mission. They are some of the nearly 300 children who will make their First Communion — to receive the spirit of God in his faith.

This is a family affair in Little Haiti, the north-central Dade County, Fla., neighborhood where 30,000 Haitians live. Almost everyone has a friend or family member making First Communion.

Anna Saintil, 11, was too excited to sleep the night before her First Communion. She awakened at 6:30 a.m., put on "the prettiest dress I've ever had" and went to the mission. Her brother Lincol, 3, is at her left.

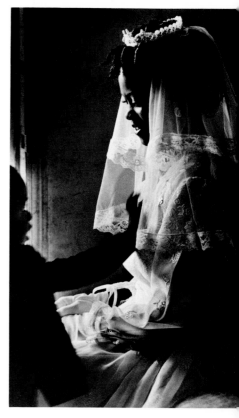

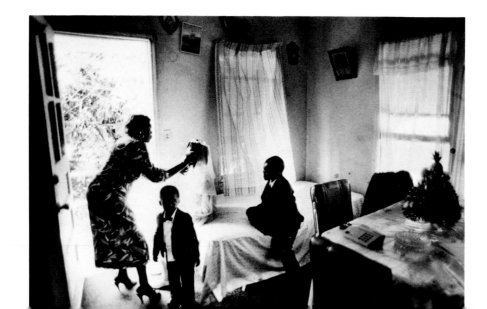

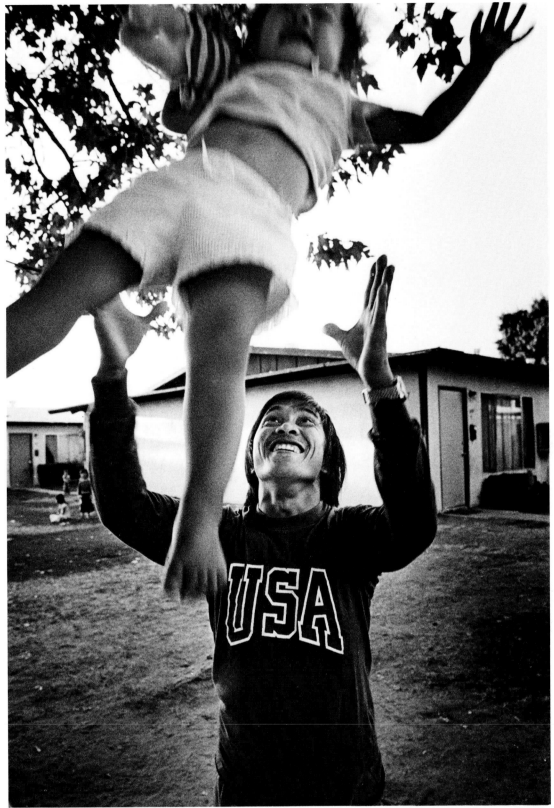

Award of Excellence Magazine Picture Story, APRIL SAUL, NPPA/Nikon Documentary Sabbatical Grant (all photos, p. 155-157)

Chao Yang plays with one of his three children outside his Fresno apartment. Many of the 20,000 Hmong in Fresno live in sprawling, all-Asian apartment complexes. Nearly all the refugees are unemployed.

In America: Hmong mix old and new

"Somebody said, 'Put up a sign on Highway 5 that says don't come to Fresno.' But this is freedom here. You can go anywhere you please," Hmong leader Tony Vang said. Indeed, if there is a mecca for the Hmong in America, it is Fresno, Calif. Lured by the promise of farming, family, English classes and welfare, more than half of America's Hmong live in California. Fresno has 20,000. In reality, land is too expensive for farming. Jobs are scarce. Many are confused by a welfare system that pays more to stay at home. Some believe the money is payment for helping the United States fight in Laos. But still they stay, in dingy apartments with their flush toilets and television sets, trying to mesh their culture with that of America's culture.

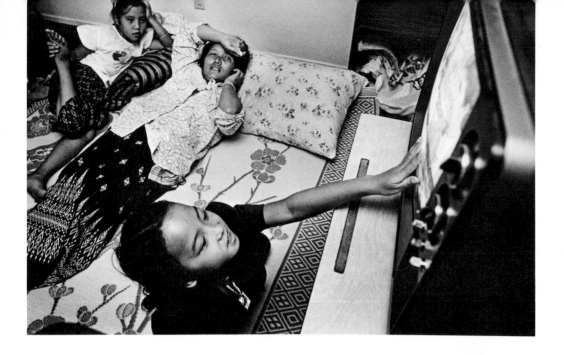

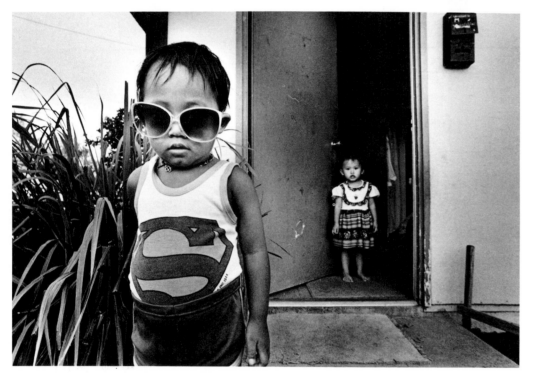

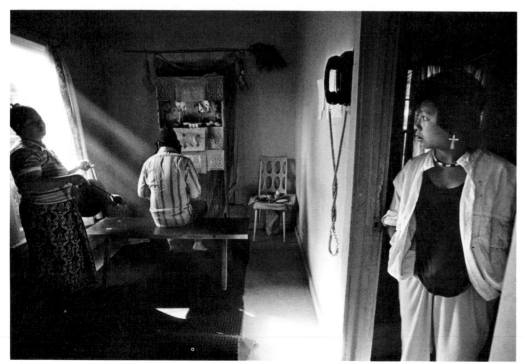

On her first day in America, Mao Lee watches television for the first time with her sister and mother. The children's father elected to remain in a Thai refugee camp with his other wife. Polygamy is not uncommon among the Hmong.

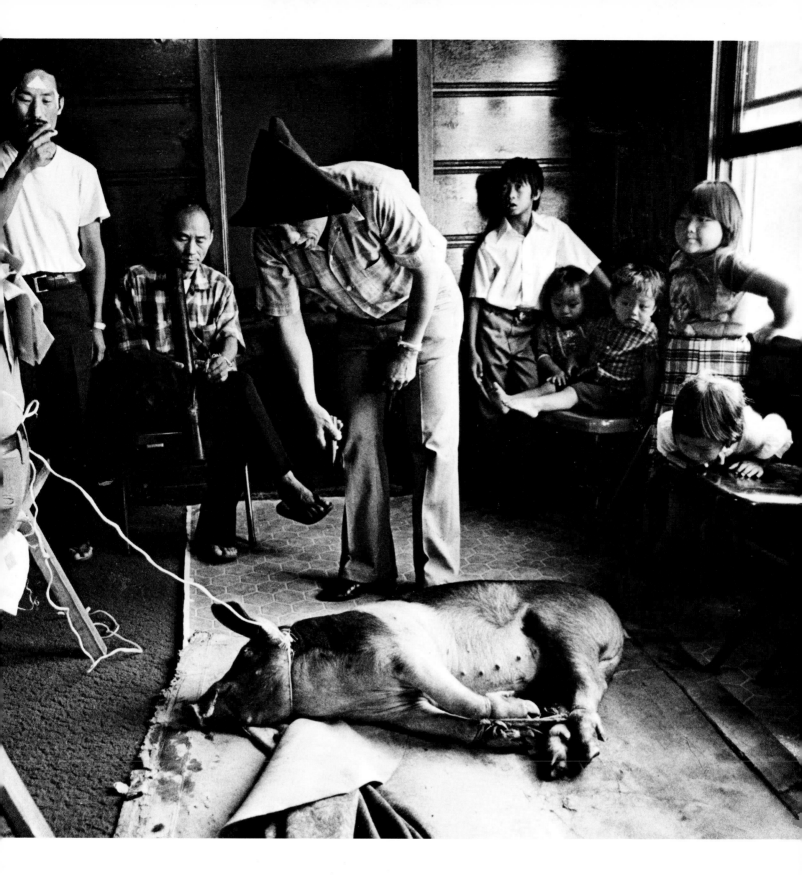

In America: Hmong mix old and new

Three-year-old Neng Vang and his cousin, Na Her, at their Fresno apartment complex. "He likes Superman and Thunder-kid very much," his mother says. "He puts the clothes on and says 'Superman fly!' He likes to use his father's glasses. He was born in Las Vegas."

Fourteen-year-old Xong Vang, dressed like her idol, Madonna, watches her parents perform a health ritual for their infant granddaughter in Fresno. Her father, Koua Pao Vang, is a shaman — a healer who chants, dances and sacrifices animals as part of his medical and spiritual calling. She and her siblings help in the rituals, but do not expect to inherit their father's calling.

Fresno shaman Fai Dang Vang tries to cure Nhia Vang's backache. During a long ceremony, the Hmong believe the malady is transferred through the rope from the patient to the animal and excised when the pig's throat is cut.

157

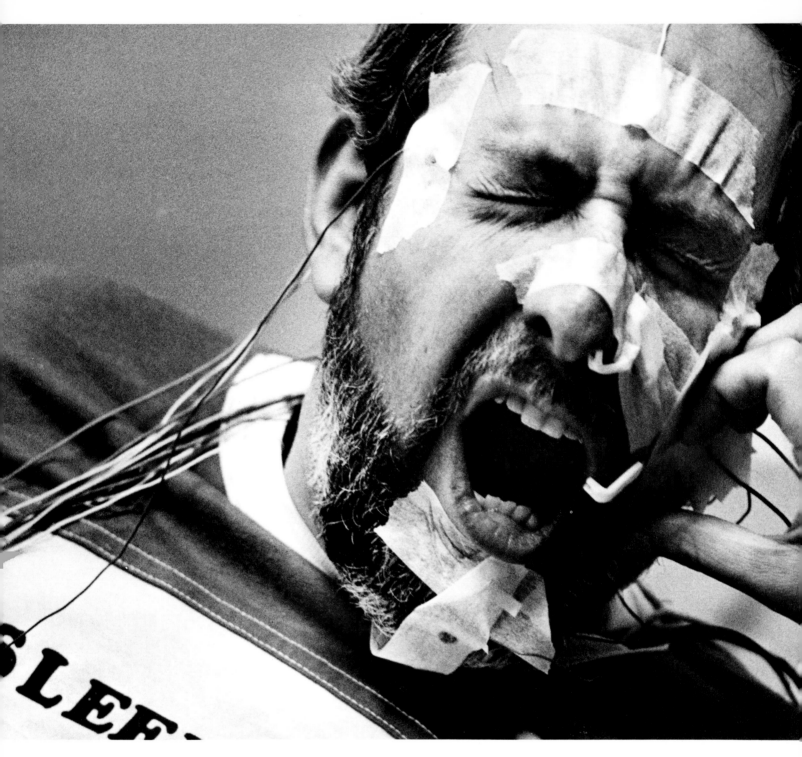

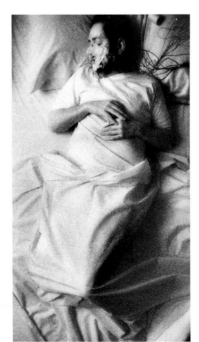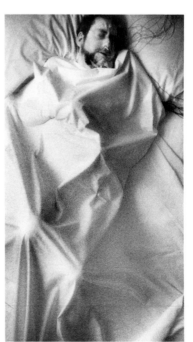

Yawn: Just a good night's sleep

West Penn Hospital in Pittsburgh opened a sleep disorder clinic to study sleep patterns of patients who may have serious problems. Hooked up to 27 wires, the patient didn't think he could sleep. He did.

Sleep is recorded by remote camera and infrared film throughout the night.

Eating a hearty breakfast before he left for work, the patient reported he had a normal night's sleep in spite of all the wires and being watched all night.

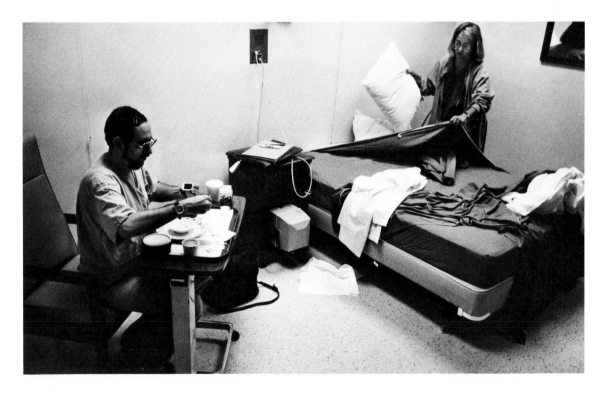

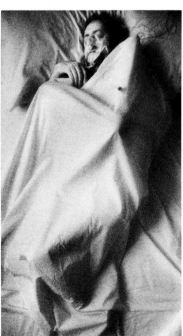
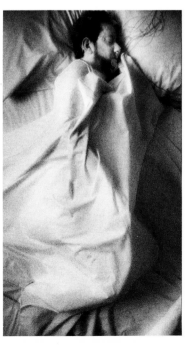

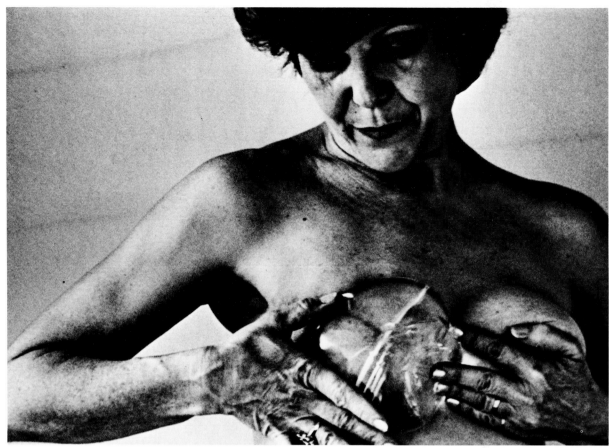

Breast reconstruction

"It was important for me to feel whole again..."

Like millions of women throughout the world, 44-year-old Peggy McCann underwent a radical mastectomy for breast cancer.

Her decision to undergo breast reconstruction reflected her desire to recover her sense of self — physically and psychologically.

A few months before surgery, Peggy's doctor gave her a pouch filled with silicone gel similar to the implant she would receive.

Nurses played an important role during Peggy's surgery, as doctors consulted with them during the six-hour operation to shape and match the new breast.

Nearly 100,000 American women have undertaken this cosmetic procedure after mastectomies.

"We each have to decide what's truly important," Peggy says. "It was important for me to feel whole again, and I do."

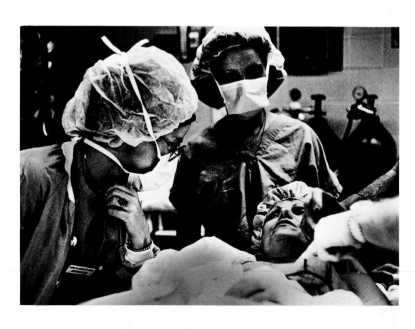

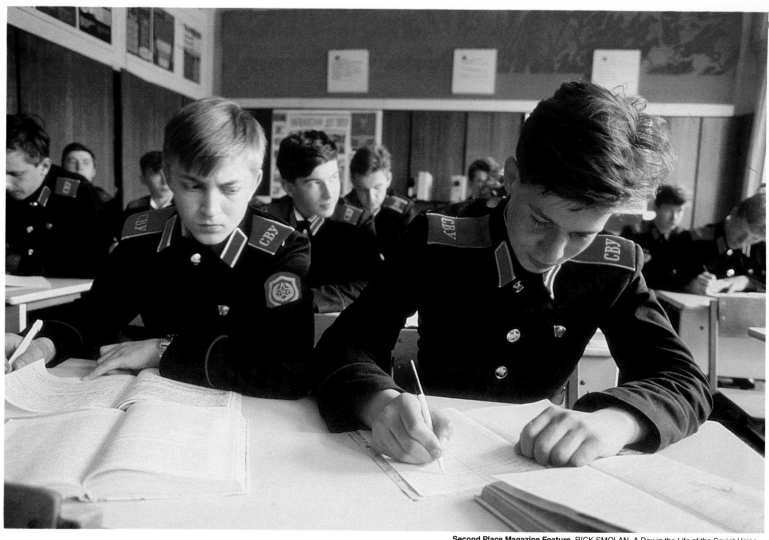

At Moscow's Suvorov Military Academy, a cadet gets by with a little help from his friend.

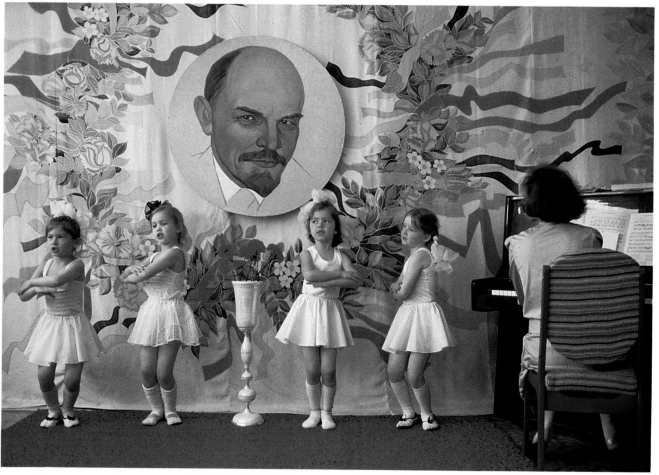

Preschoolers at Khabarovsk's kindergarten rehearse for a pageant under the watchful eyes of "Uncle Lenin."
From the time they enter school, Soviet children are taught to revere the founder of their nation.

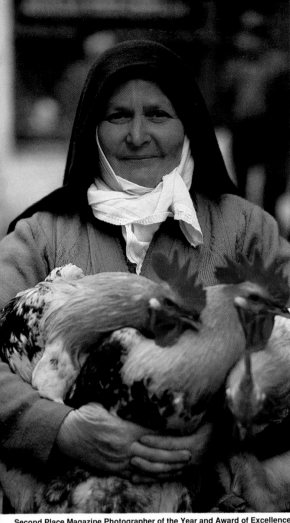

Like her ancestors nearly five centuries ago, a northern Anatolian woman delivers chickens to the Safronbolu Saturday morning market in Turkey.

Second Place Magazine Photographer of the Year and Award of Excellence Magazine Portrait/Personality, JAMES L. STANFIELD, National Geographic

"I stay right here," proclaims 85-year-old Virginia Bennett of Hilton Head Island, off the South Carolina coast. Five years ago, a condo pushed up behind the acre plot she has lived on for 40 years. The land could bring a relative fortune, but she won't sell. "If she moved, she'd die the next day," a friend says.

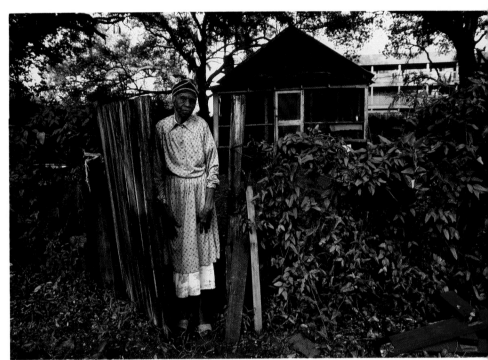

Award of Excellence Magazine Picture Story, KAREN KASMAUSKI, Freelance for National Geographic

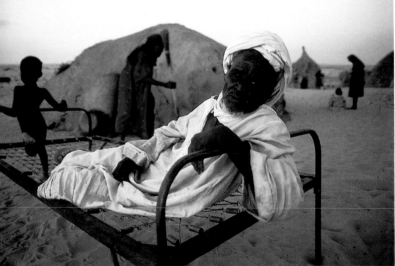

Award of Excellence Magazine Picture Story, STEVE McCURRY, National Geographic

A farmer waits for rain in the heat of the afternoon outside his home near Lake Chad. Without rain, he has no hope of planting his crops.

It's a dirty job, but gold ore at the huge federally operated Serra Pelada mine in Para, Brazil, still is hauled from the pits by hand. Faced with the threat of mechanization, some 60,000 workers are fighting for their jobs.

Award of Excellence Magazine Portrait/Personality, STEPHANIE MAZE, Freelance for National Geographic

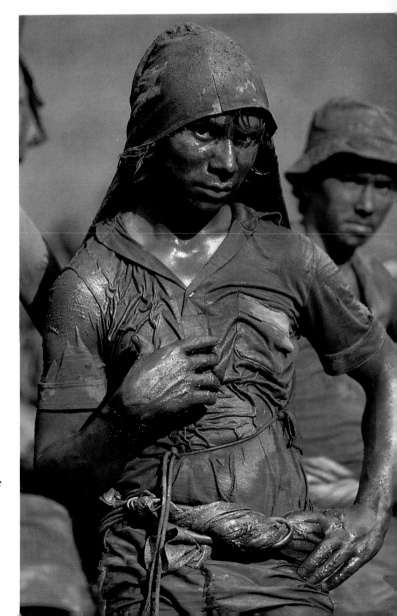

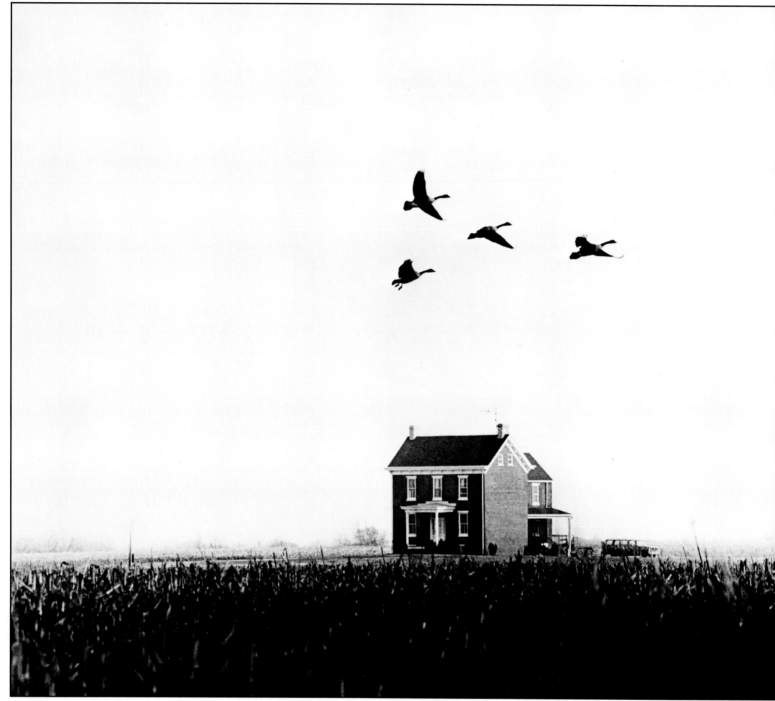

Geese by the gaggle fly past a house near Bombay Hook Wildlife Refuge in Delaware.

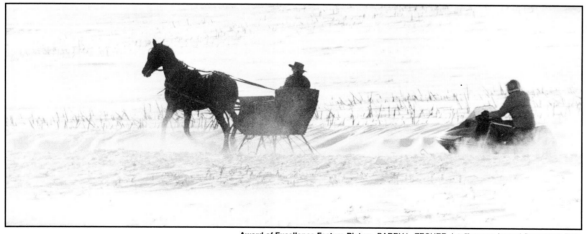

Old and new sometimes travel the same road as an Amish man in a
horse-drawn sleigh is followed by a snowmobile rider near Leola, Pa.

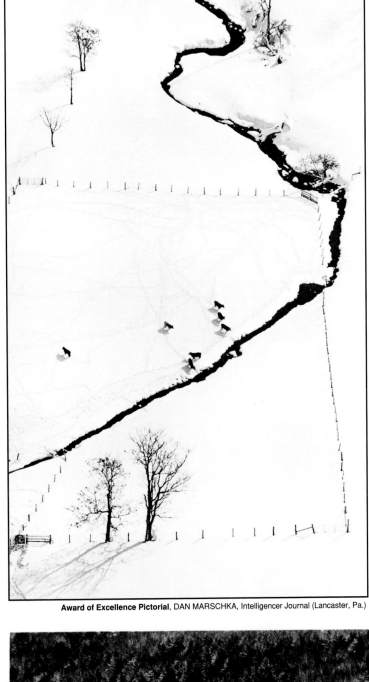

Cattle weave patterns of hoof prints in deep snow on a Pennsylvania farm.

Award of Excellence Pictorial, DAN MARSCHKA, Intelligencer Journal (Lancaster, Pa.)

Snow dusts the Anderson Memorial Church in Webster, N.H., on a frosty January morning.

GARO LACHINIAN,
Concord (N.H.) Monitor

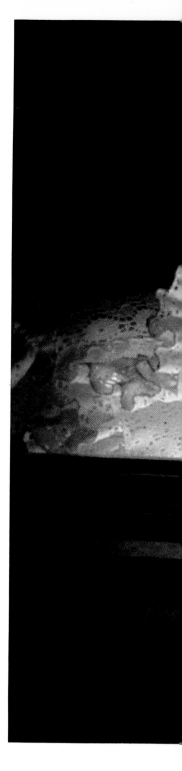

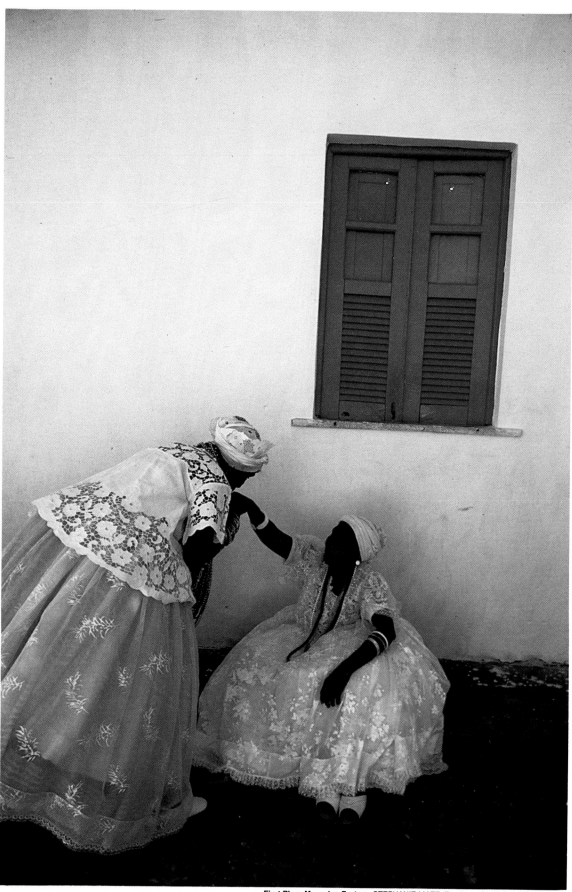

The Candomble priestesses of Brazil, in traditional ceremonial gowns, are part of a cult that originated in West Africa and includes animist gods and Catholic saints. The Candomble cult appeals to all races and classes of the world's largest Roman Catholic nation — Brazil.

First Place Magazine Feature, STEPHANIE MAZE, Freelance for National Geographic

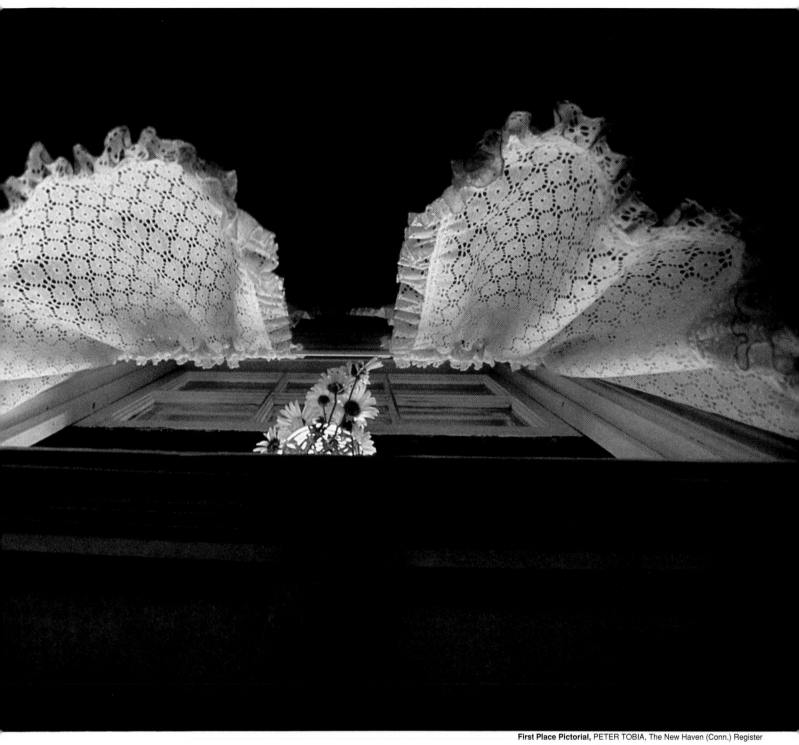

Spring breezes fill billowing curtains as flowers rest on a windowsill in New Haven, Conn.

Carmen Sotelo, a laundress at the Masso fish cannery in Cangas, Galicia, hangs towels to dry in the early morning. The fish-canning business in this northwest region of Spain is more than a century old.

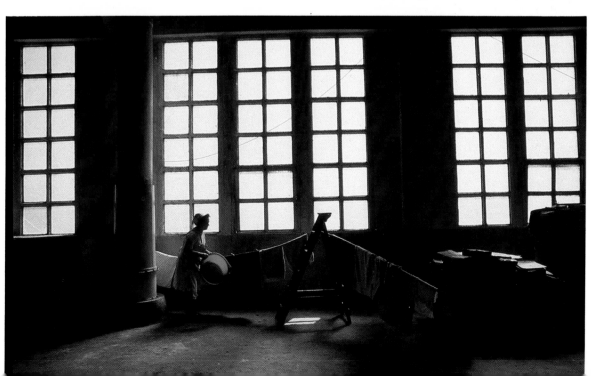

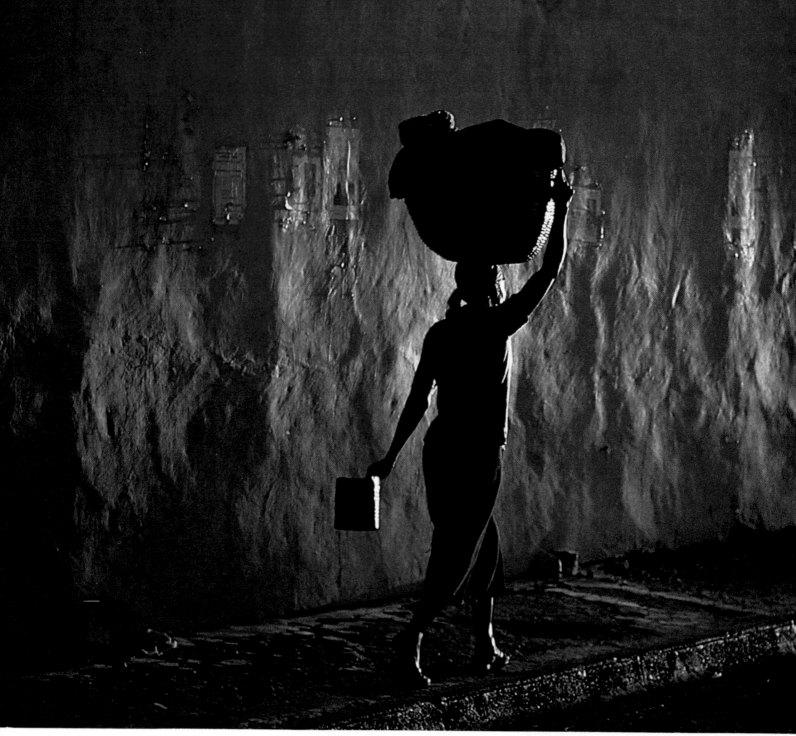

Award of Excellence Pictorial, DON PREISLER, The Washington Times

A Haitian woman carries a basket on her head in the early morning as she walks downtown in Port-au-Prince.

Award of Excellence Magazine Pictorial, BUCK MILLER, Sports Illustrated

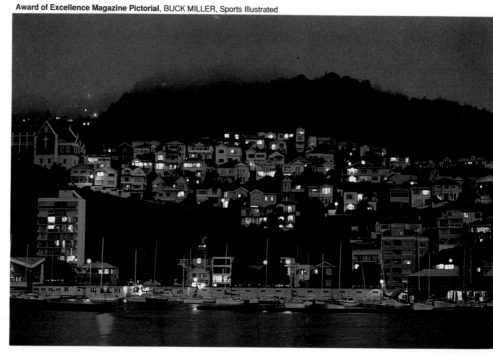

Wellington is the home of the New Zealand Yacht Club, which took part in the race for the America's Cup.

Overleaf:

Wild geese weather a snowstorm in Portsmouth, R.I.

First Place Magazine Pictorial, BOB THAYER, The Providence (R.I.) Journal-Bulletin

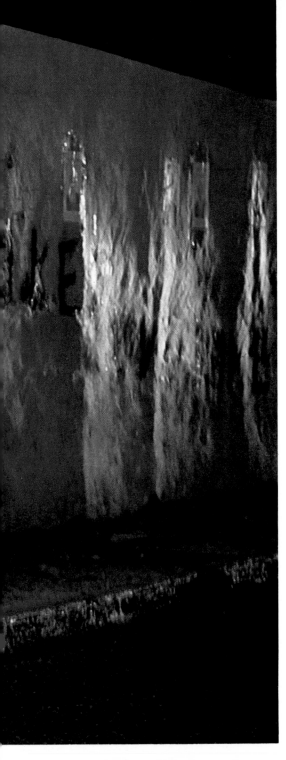

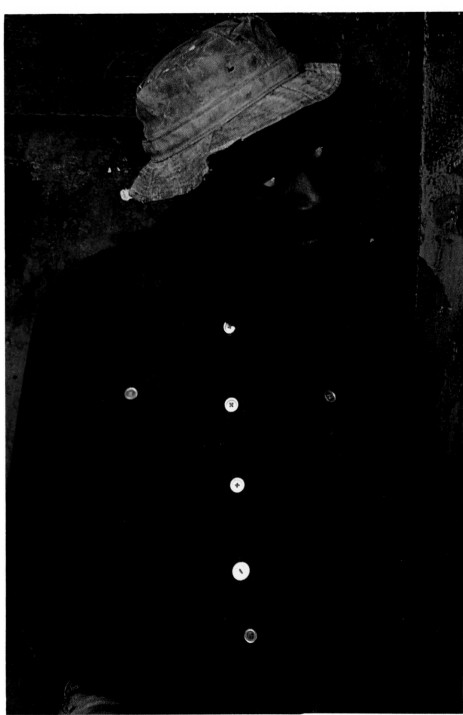

MAGGIE STEBER, J.B. Pictures

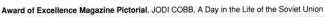

An unemployed Haitian sits in his corner of the worst of the nation's slums, La Saline, in Port-au-Prince. The man, considered mad, spends the day talking, yelling and waving his arms.

In the Armenian village of Voskevaz, a doll keeps an eye on the day's wash.

171

Chief Illiniwik (Mike Rose of Tulsa, Okla.) pulls his thoughts together as he prepares to perform his halftime routine for a University of Illinois basketball game. Rose uses the towel on the floor to dry his feet after frenzied dancing for the Illini.

HERB SLODOUNIK, Decatur (Ill.) Herald Review

Third Place Pictorial, WALLY EMERSON, Freelance for The Kansas City (Mo.) Times

Cars carve an oval path through a snowy downtown parking lot in Kansas City, Mo.

Award of Excellence Feature Picture, GARY LAWSON, The News Press (Stillwater, Okla.)

A Stillwater motorist exits his snow-covered car near the Oklahoma State University campus during a fierce storm that dumped 10 inches of snow in one day.

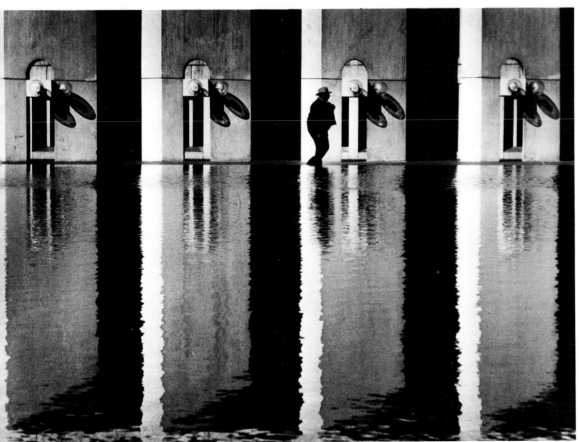

An elderly man passes the reflecting pool of the Christian Science Center in Boston's Back Bay.

Second Place Newspaper Photographer of the Year, JOHN TLUMACKI, The Boston Globe

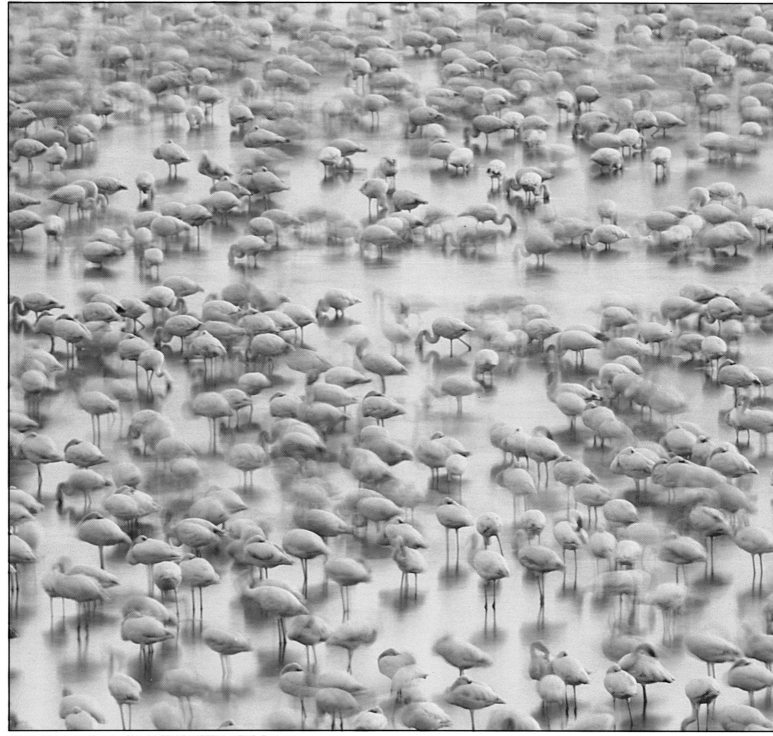

Award of Excellence Magazine Pictorial, FRANS MARTEN LANTING, Freelance

Lesser flamingos gather at dawn at Lake Nakuru, Kenya.

A pair of black-browed albatross court in the Falkland Islands.

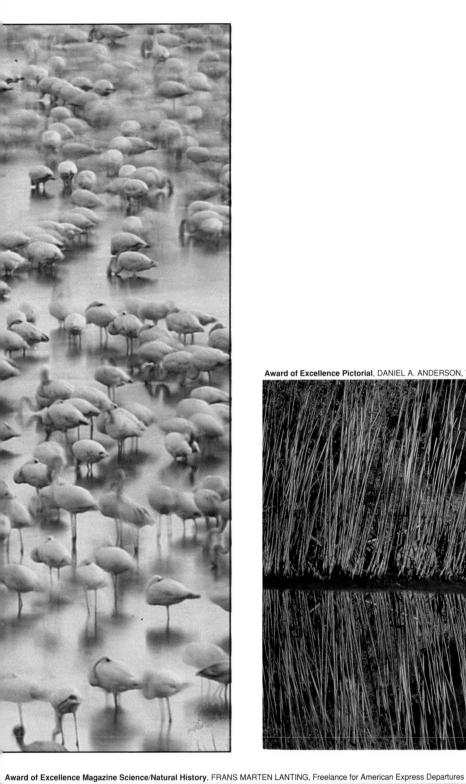

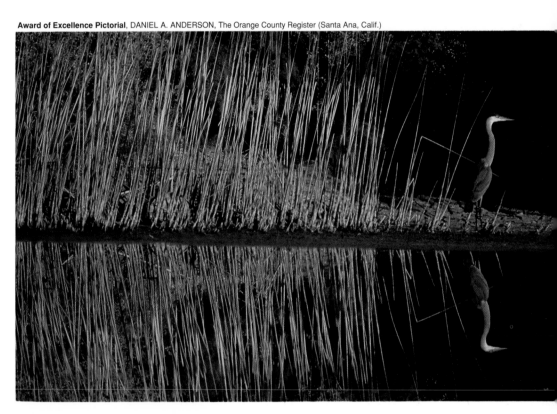

A great blue heron finds refuge from the California desert at a watering hole in Baker, Calif. Surface water is extremely scarce in the desert, making such spots critical to wildlife.

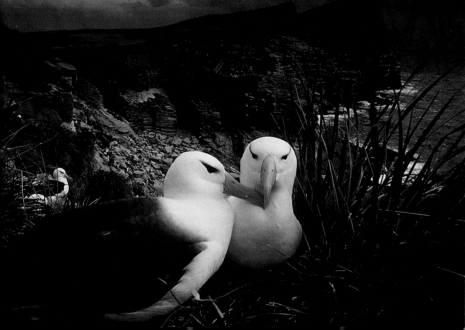

PAUL BROWN, The Dallas Morning News (original in color)

A traditional merry-go-round spins at the foot of the Cathedral of Sacre Coeur (Sacred Heart), which stands on a hill overlooking Paris.

Award of Excellence Pictorial, RUBEN W. PEREZ, The Providence (R.I.) Journal-Bulletin

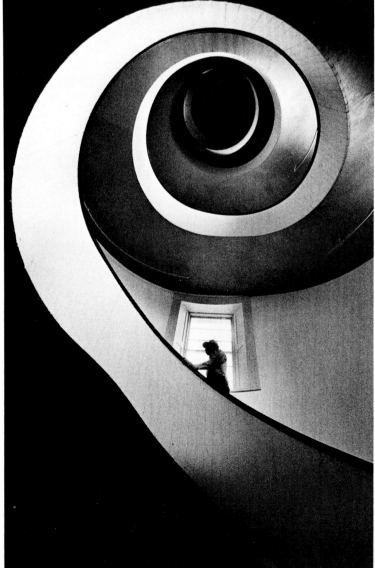

A security guard at the Springfield Armory Museum in Massachusetts walks up the spiral staircase during a routine check of the building.

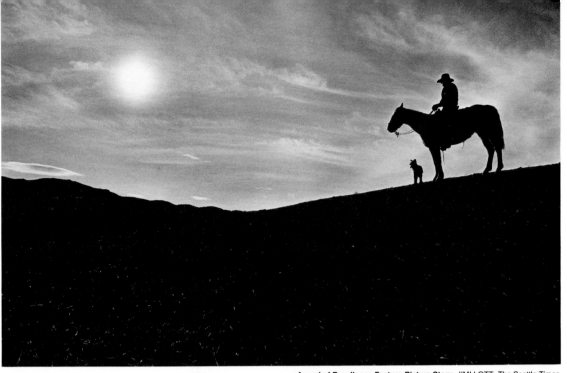

Gary McClure, eldest son of the McClure family of Nespelem, Wash., looks over the land where he carries on the tradition of his great-grandfather — being a cowboy.

During hot August weather, two young deer seek shade under a weeping willow in Laguna Canyon, Calif.

Award of Excellence Feature Picture Story, JIMI LOTT, The Seattle Times

Award of Excellence Pictorial, CHARLAINE BROWN, The Orange County Register (Santa Ana, Calif.)

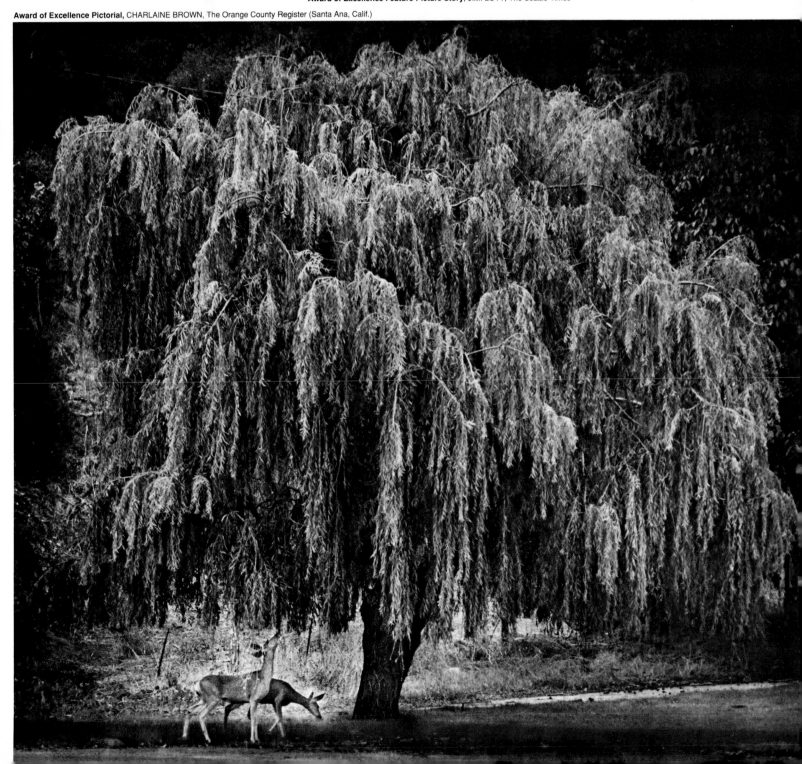

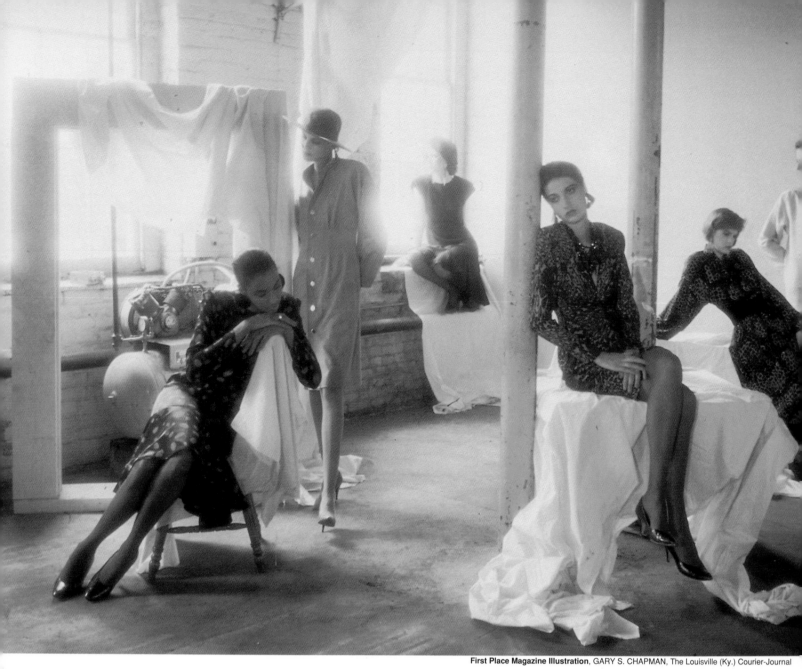

First Place Magazine Illustration, GARY S. CHAPMAN, The Louisville (Ky.) Courier-Journal

Several yards of cheap muslin and seven well-paid models show the season's new dress shapes.

Bulletproof sunglasses cross the line from high-tech to high fashion. The shatterproof shades are popular with bicyclists and skiers.

Award of Excellence Fashion Illustration, STEVEN ZERBY, Star Tribune (Minneapolis)

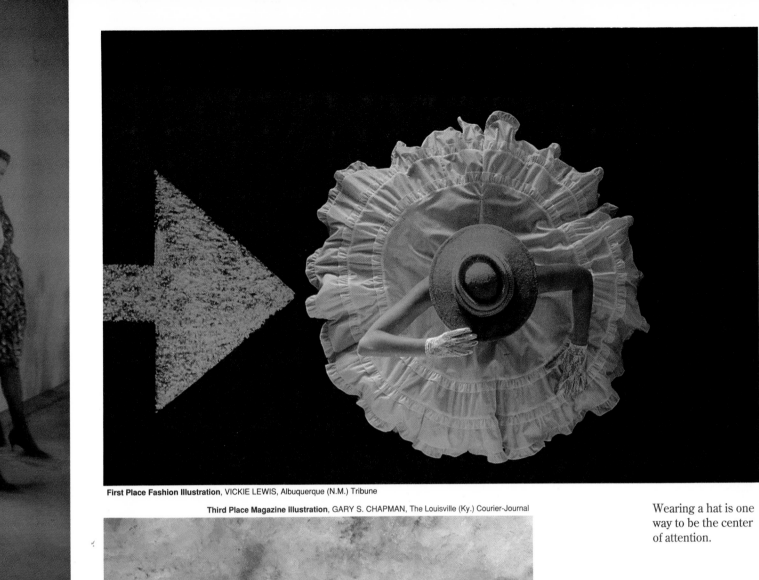

First Place Fashion Illustration, VICKIE LEWIS, Albuquerque (N.M.) Tribune

Third Place Magazine Illustration, GARY S. CHAPMAN, The Louisville (Ky.) Courier-Journal

Wearing a hat is one way to be the center of attention.

Hand-painted backgrounds, hand-colored prints and period props highlight a fashion series on the look that's new — deja vu.

To emphasize a return to the look of the early 1900s, Steve Harper used ambient light as his only source of illumination. The model worked with Harper for two days to create a feeling and mood evoking the turn of the century.

Second Place Fashion Illustration, STEVE HARPER, The Wichita (Kan.) Eagle-Beacon

Interior designer Michael McQuiston's dalmation-spotted shoes are enough to make you beg for more.

ALAN BERNER, The Seattle Times

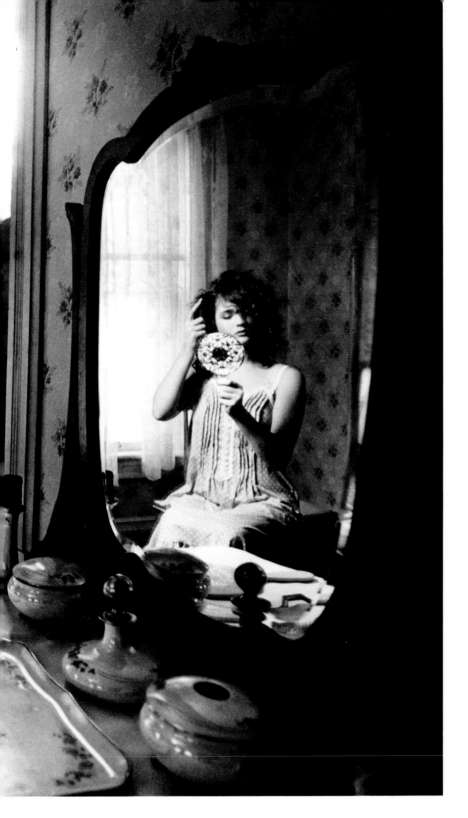

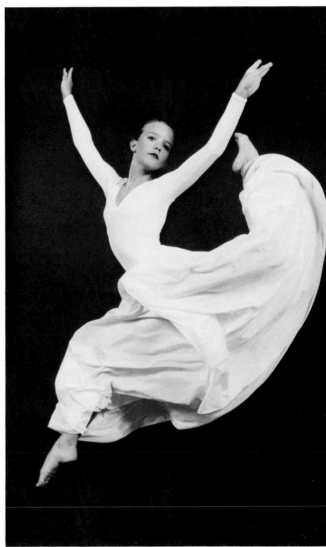

It took 10 jumps to capture the perfect moment in a preview illustration for a dance theater performance in Denton, Texas.

Third Place Fashion Illustration,
DAVID J. PHILLIP, The Denton (Texas)
Record-Chronicle (original in color)

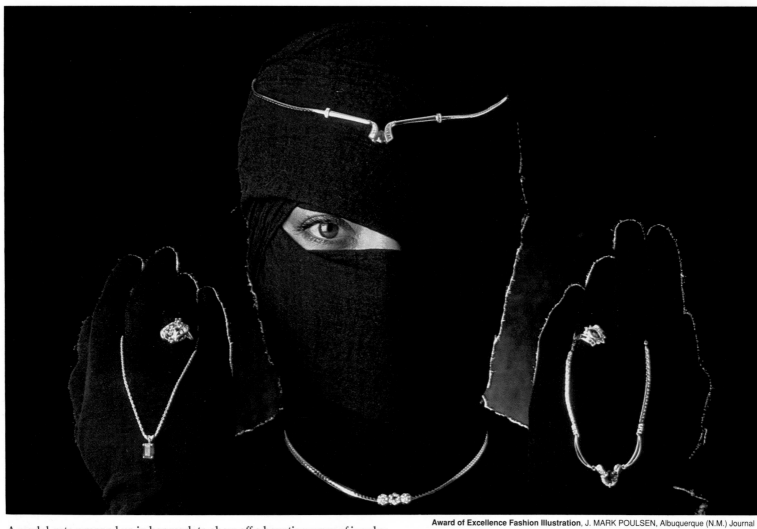

A model gets wrapped up in her work to show off a haunting array of jewelry.

Award of Excellence Fashion Illustration, J. MARK POULSEN, Albuquerque (N.M.) Journal

Award of Excellence Fashion Illustration, NAN WINTERSTELLER, Ohio University (Athens, Ohio)

The shades of summer offer a look at what's new in eyewear.

Award of Excellence Fashion Illustration, DON IPOCK, The Kansas City (Mo.) Star

For a walk on the wild side, leopard trim complements an elegant suit.

Award of Excellence Fashion Illustration, JIM SULLEY, The Staten Island (N.Y.) Advance

If you're a red socks fan, this combination may be a shoe-in.

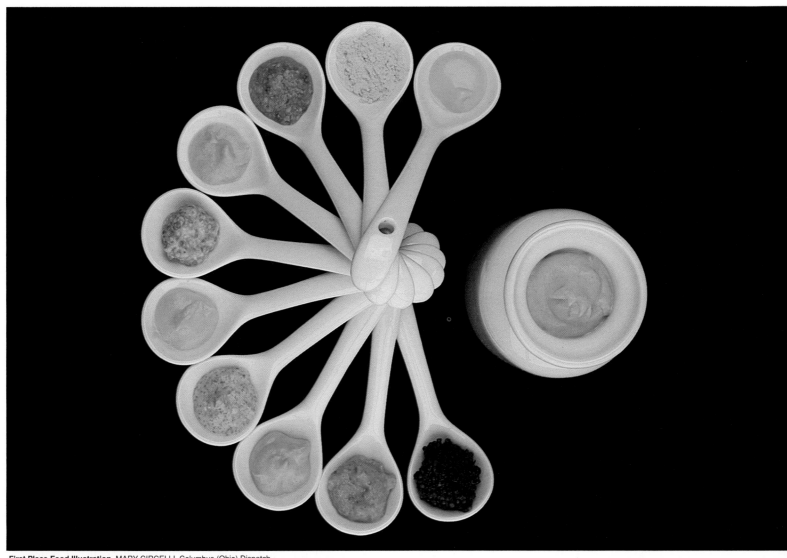

First Place Food Illustration, MARY CIRCELLI, Columbus (Ohio) Dispatch

For a saucy change of pace, mustard comes in a variety of flavors.

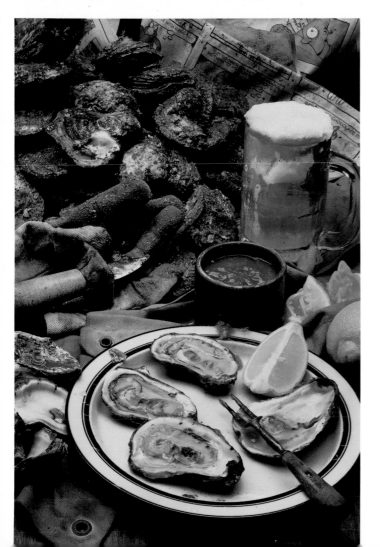

Aw shucks. There's nothing wrong with a little raw pleasure — especially when it comes to oysters.

Third Place Food Illustration, MARK B. SLUDER, The Charlotte (N.C.) Observer

To tame wild blackberries, all you need is a spoon and some cream.

Award of Excellence Food Illustration, NANCY N. ANDREWS, The Freelance-Star (Fredericksburg, Va.)

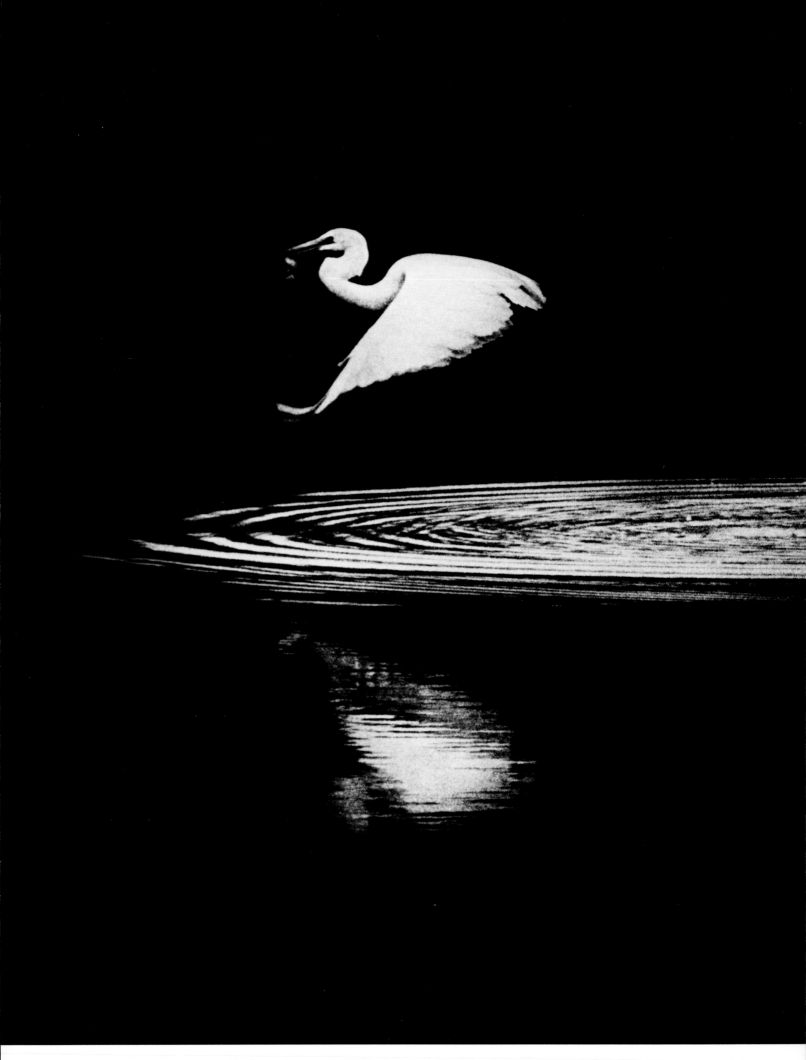

The laws of nature are black and white in the early morning stillness as a water
bird captures its breakfast and skims Lake Sherwood in Ventura County, Calif.

Award of Excellence Food Illustration, DAVID WOO, The Dallas Morning News

Well-schooled fish know that citrus imparts a piquant treat to the palate.

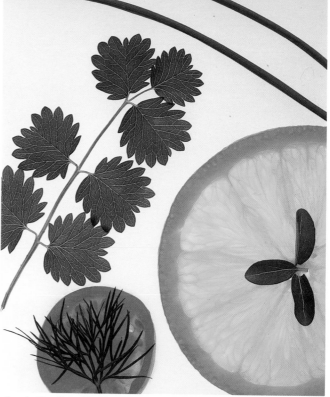

Award of Excellence Food Illustration, MARY KELLEY, The Kansas City (Mo.) Times

Cooks with good taste turn to fresh herbs for unmatched, just-picked flavor and fragrance.

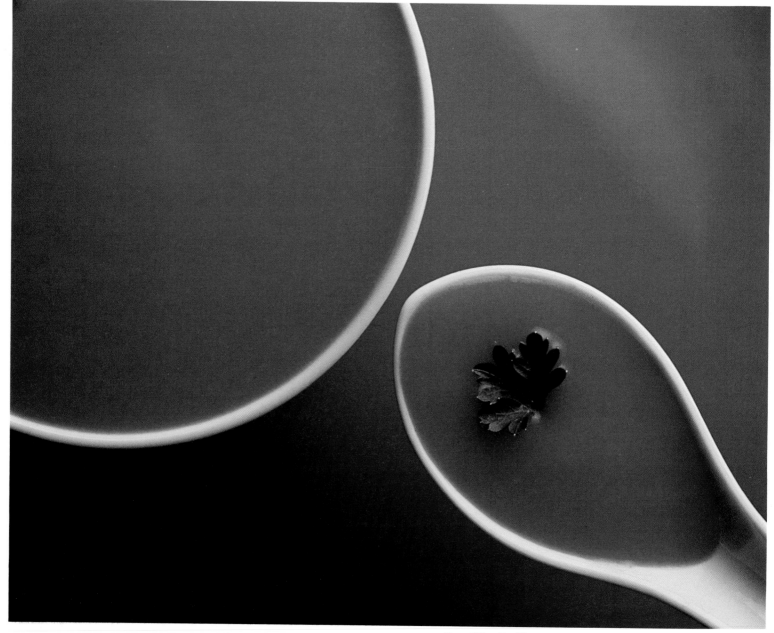

Second Place Food Illustration, CRAIG TRUMBO, The Providence (R.I.) Journal-Bulletin

No matter how you dish it out, tomato soup is ripe for any occasion.

Award of Excellence Food Illustration, LOIS BERNSTEIN, The Virginian-Pilot and The Ledger-Star (Norfolk, Va.)

Award of Excellence Food Illustration, J. MARK POULSEN, Albuquerque (N.M.) Journal

Pearl onions make a fashion statement at any dinner party.

Have a heart for the lowly thistle, the artichoke, which is pushing for mainstream acceptance.

Looking like extraterrestrials heading home, four artists ride a "Bubbleheads" sculpture toward Baltimore's Inner Harbor to promote an exhibit at the Maryland Institute of Art.

First Place One Week's Work, AMY DAVIS, The Baltimore Sun (all photos; originals, above and below, in color)

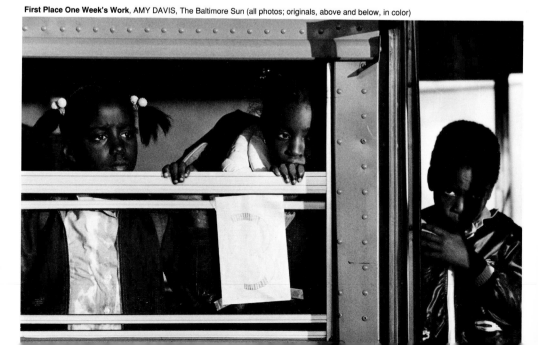

An accident involving two Baltimore school buses frightened some children and their mothers, but resulted only in minor damage and no serious injuries.

"Antique Row" merchants spruce up their storefronts for a reopening celebration after road construction hurt their businesses in Baltimore.

Amy Davis

First One Week's Work

"It wasn't an extraordinary week," Amy Davis said. "There weren't any real plums if you looked at the assignments, but it turned out better than I expected."

"I guess what happened was I had one unusual day. My assignments started me thinking that this is what I like about being a newspaper photographer. The bizarre contrasts. It is very stimulating."

"First I was sent to the art school to shoot the Bubbleheads exhibit. The assignment sounded really static. But when they decided to go out into the city, I got to take it a step further. I dropped the film by the paper and headed to do a portrait of the mayor's wife. On the way back, I was called on the radio to cover a spot news event.

"That combo of assignments was like the mixture of assignments for a week compressed into one day."

"When I read the contest information, that day kind of stuck in my head. I went back into the files to see what I had shot six days before and six days after ... I ended up going backward, digging into the previous six days and pulling out what I could for the entry."

Davis has been with The Baltimore Sun since 1987.

The clown prince of baseball, Max Patkin, throws dirt in his face to get a laugh during a minor-league game in Bristol, Va. The 67-year-old Philadelphia native, with nearly 5,000 games to his credit over four decades, is the last of a breed of baseball comics. Patkin does slapstick routines while coaching third base during live games.

J. KYLE KEENER, The Philadelphia Inquirer

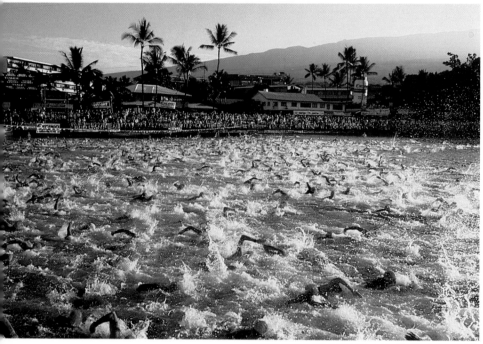

CHRIS COVATTA, The Orange County Register (Santa Ana, Calif.)

More than 1,300 men and women from around the world compete in the Ironman Triathlon, which includes a 2.4-mile swim, a 112-mile bike race and a 26.2-mile run near Kailua-Kona, Hawaii.

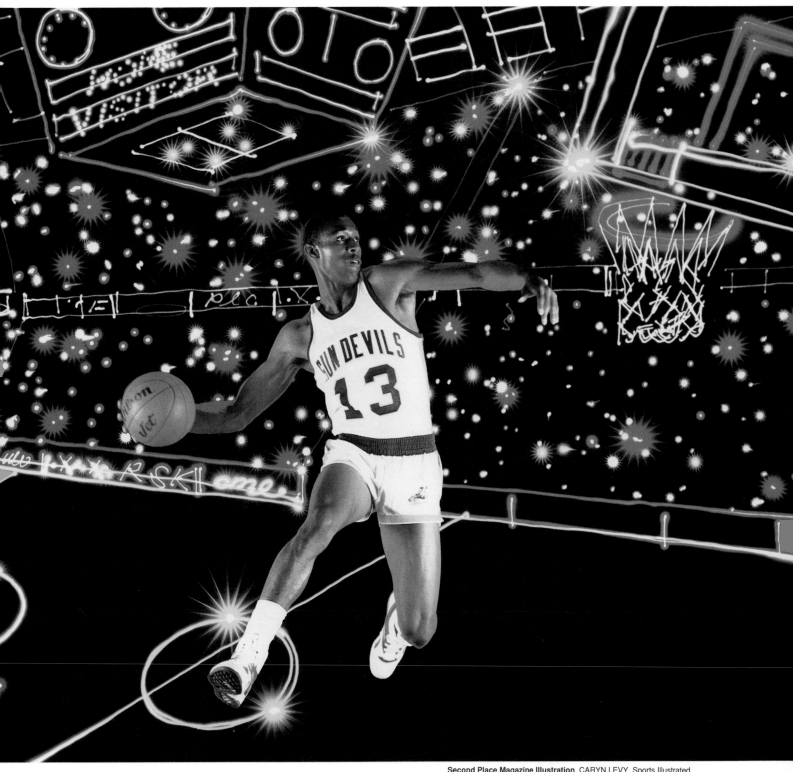

Second Place Magazine Illustration, CARYN LEVY, Sports Illustrated

With his amazing 50" vertical leap, Joey Johnson should light up the court at Arizona State University. The background illustration was produced using flashlights shown through colored gels. The exposure took 2 1/2 hours.

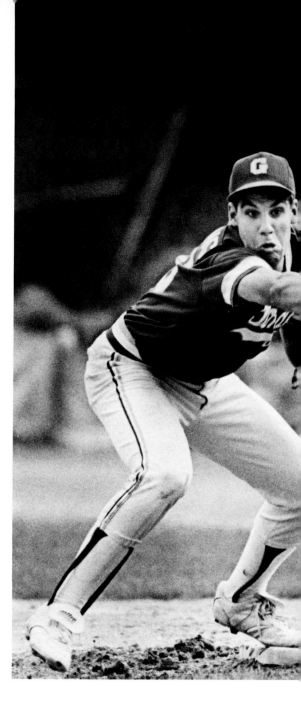

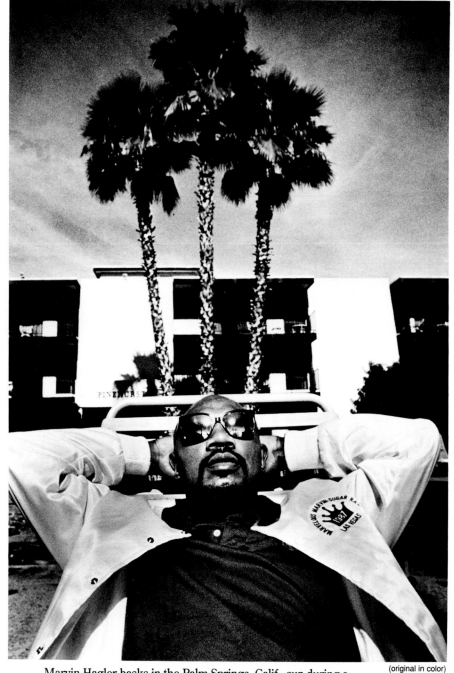

Marvin Hagler basks in the Palm Springs, Calif., sun during a break in training for his April 6 fight with Sugar Ray Leonard. (original in color)

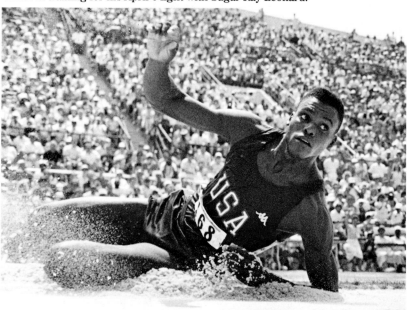

U.S. long-jumper Carl Lewis checks his distance during the Pan Am Games. He broke a Pan Am Games record, but not the world's. (original in color)

Gary Cameron

First Place Sports Portfolio

"While I was shooting sports, I felt like I was really on," Gary Cameron said. "Shooting sports just really sharpens your timing."

During 1987, Cameron was assigned to the Washington Post's sports photographer beat, a position that has since been eliminated.

"When I went back to shooting general assignment, I had to clear those cobwebs out. I had to be able to go into a boring office situation and make something out of it.

"But I really miss sports. At a paper like The Post, in a city like Washington, sports is one of the few things that has spontaneity."

Cameron covered everything from high school and college sports to professional sports. He has been with The Post since 1980.

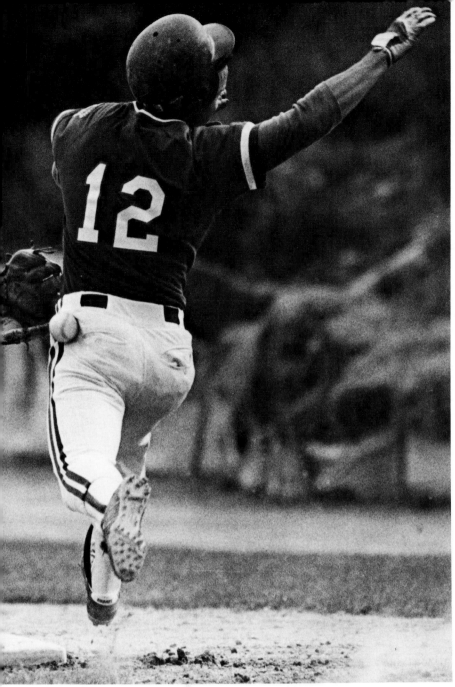

First base action on an errant throw from short stop caught the runner on his hip during a high school baseball game in Washington, D.C.

North Carolina State head basketball coach Jim Valvano celebrates the Wolfpack upset win in the Atlantic Coast Conference tourney with a traditional net-cutting.

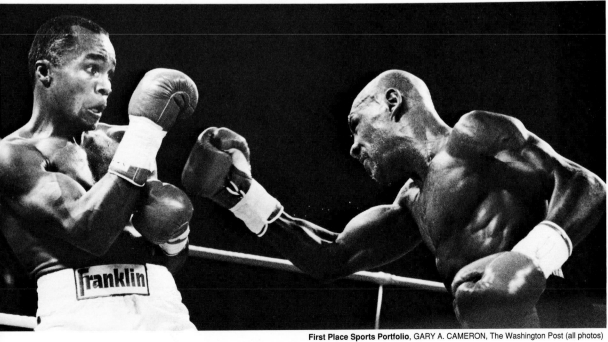

First Place Sports Portfolio, GARY A. CAMERON, The Washington Post (all photos)

Sugar Ray Leonard avoids a Marvin Hagler right during their April 6 match in Las Vegas. Leonard won an upset 12-round decision that oddsmakers thought impossible.

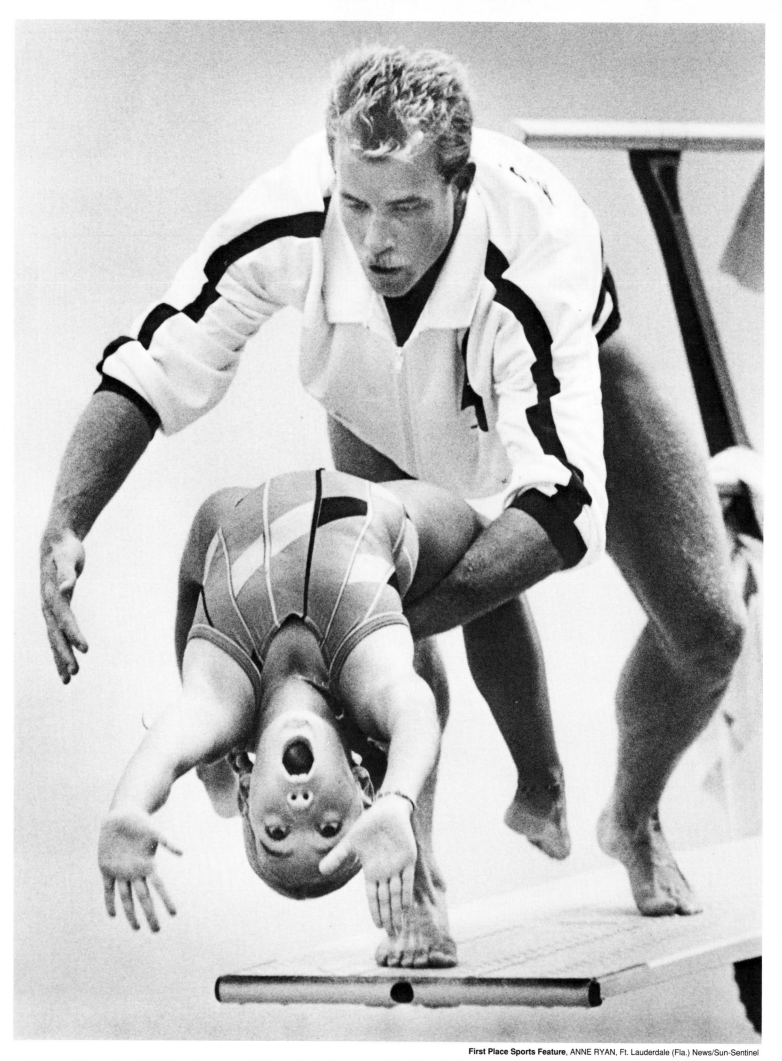

U.S. National 1-meter diving champion Doug Shaffer helps 10-year-old Allison Cammack try a lean-back dive. Cammack and other young divers were coached by Olympic medalists at an October diving clinic in Boca Raton, Fla.

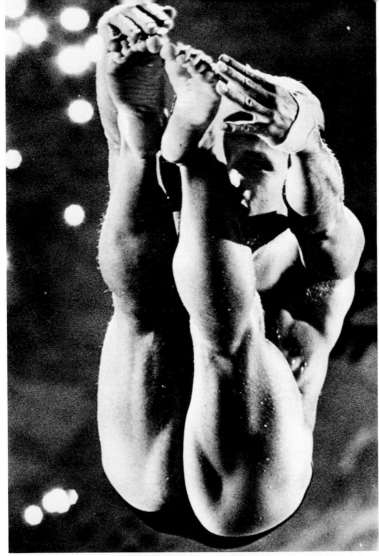

Diver Kent Ferguson practices before the indoor diving championships at the Louisiana State University indoor pool in Baton Rouge, La.

AE Magazine Sports, GERARD MICHAEL LODRIGUSS, The Philadelphia Inquirer (original in color)

U.S. swimmer Andy Gill is elated as his record time in the 100-meter backstroke is displayed on the scoreboard at the Pan-American Games.

Second Place Sports Portfolio, DAVID EULITT, University of Missouri-Columbia (original in color)

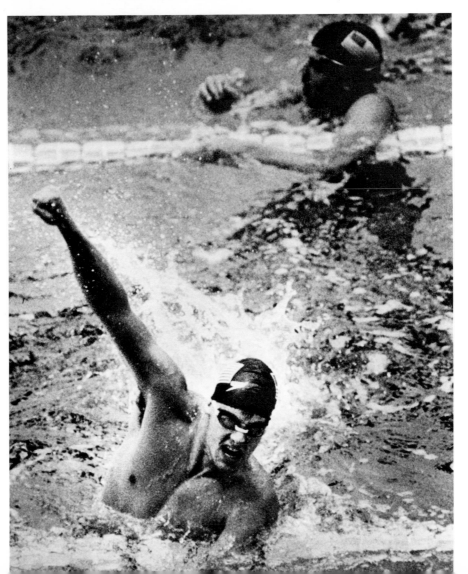

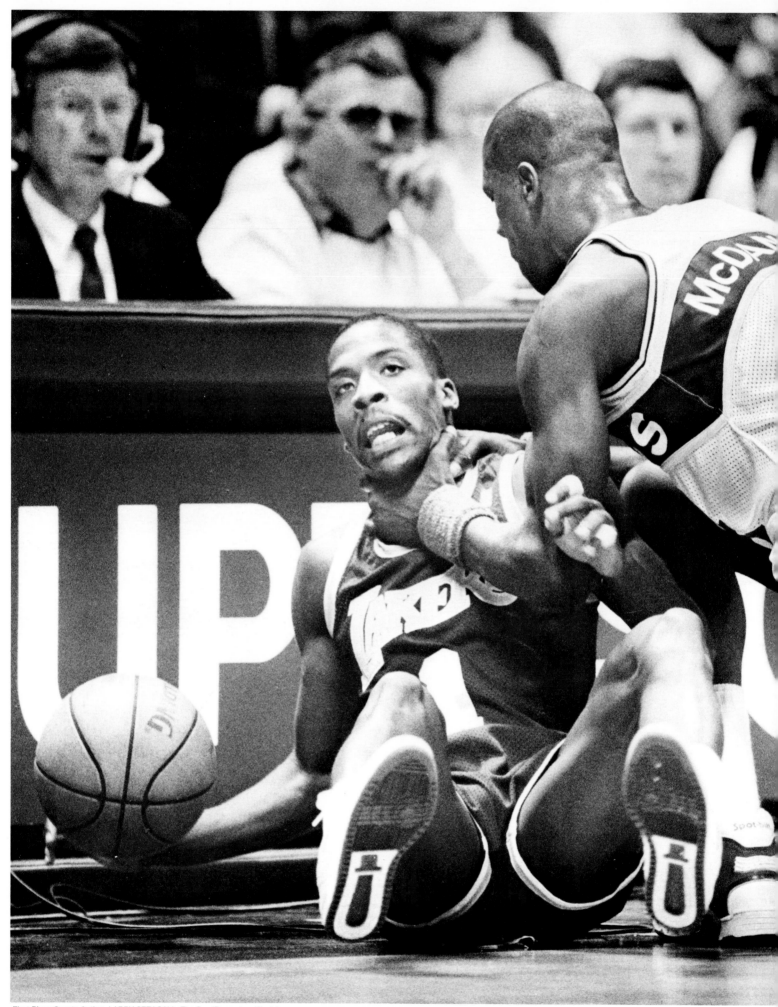

First Place Sports Action, LARRY STEAGALL, The Sun (Bremerton, Wash.)

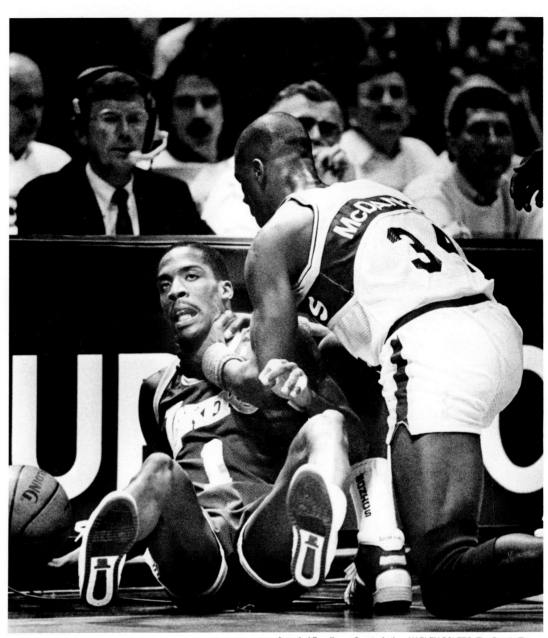

Seattle Supersonic Xavier McDaniel chokes Los Angeles Laker Wes Matthews during a scuffle after a battle for a loose ball in the Seattle Coliseum.

Judges take double look

All-but-indistinguishable pictures entered by two photographers in the POY competition. What's a set of judges to do?

That was the dilemma in the Newspaper Sports Action category for those who judged the first week of the competition.

"I think it's a hell of a picture," was one judge's comment.

Another judge replied, "Which one?"

"I don't see how you can choose between the two," offered a third judge.

But they did.

California Angels
second baseman
Mark McLemore
twists and strains
as he throws out
Jim Gantner of
the Milwaukee
Brewers at first
base. The Angels
won the game 4-3
in 12 innings at
Anaheim
Stadium.

PAUL CHINN, Los Angeles Herald Examiner

Award of Excellence Sports Portfolio, FRED COMEGYS, The News-Journal (Wilmington, Del.)

Raring to go, a
police horse
throws his rider
at an equestrian
competition in
Wilmington, Del.

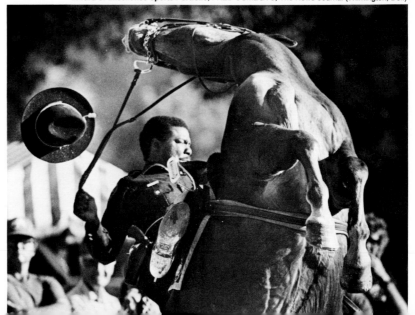

A Shawnee Mission North High School pole vaulter tries to clear the bar at the University of Kansas relays.

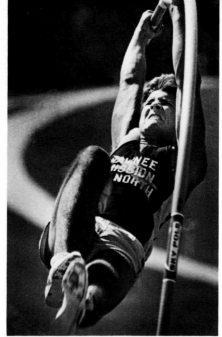

David Besteman of Wisconsin passes Paul Marchese (9) of New York and Andy Gabel of Illinois, who collided during a 500-meter speedskating heat at the Olympic Festival in Greensboro, N.C.

AE Sports Action, JEFF TUTTLE, The Herald (Jasper, Ind.)

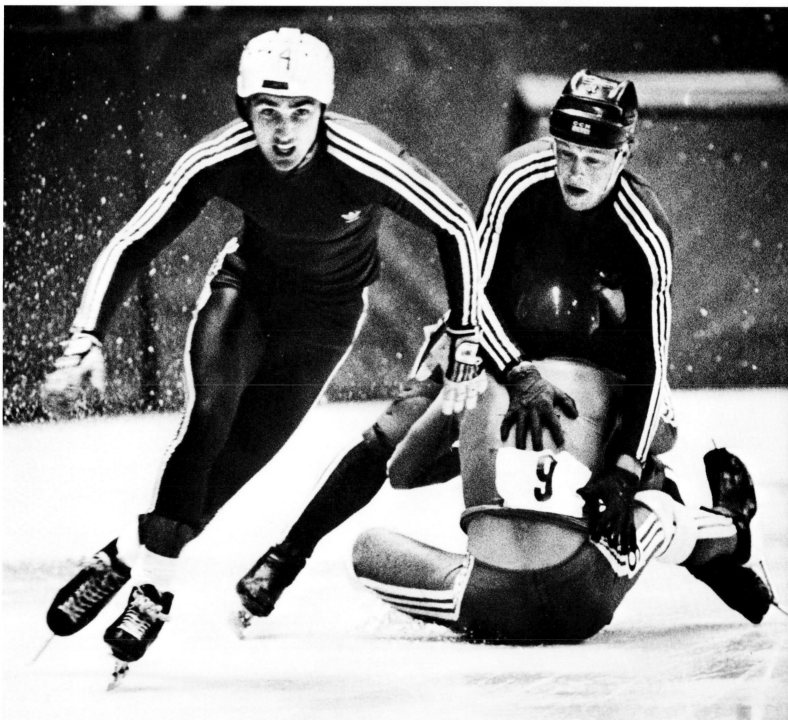

LOIS BERNSTEIN, The Virginian-Pilot and The Ledger-Star (Norfolk, Va.)

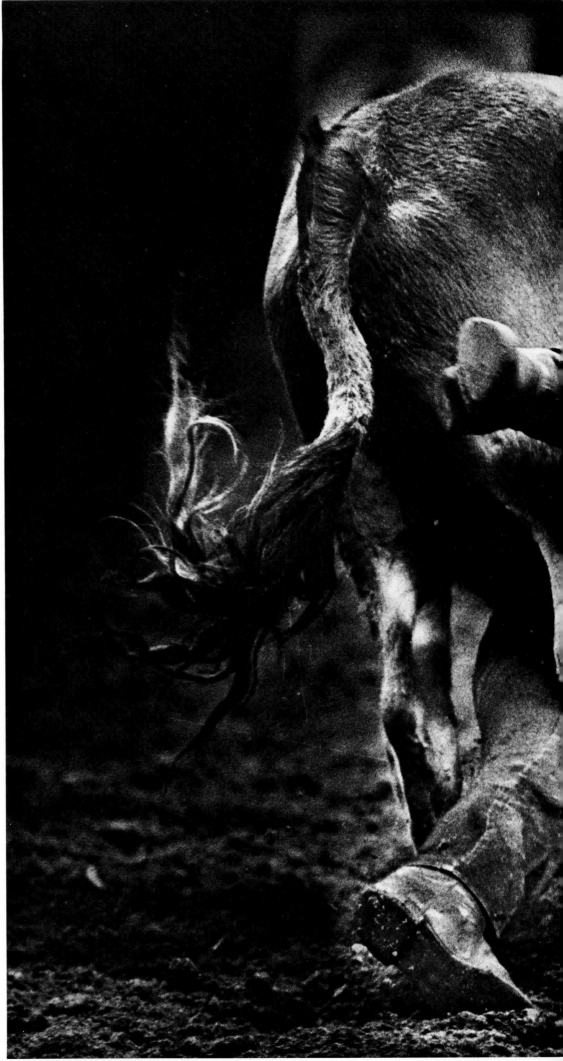

Butch Meyers wrestles a steer during the National Finals Rodeo in Las Vegas, Nev. The 43-year-old Welda, Kan., cowhand regained his composure and got the steer down.

Award of Excellence Sports Action, JEFF SCHEID, Las Vegas (Nev.) Review Journal

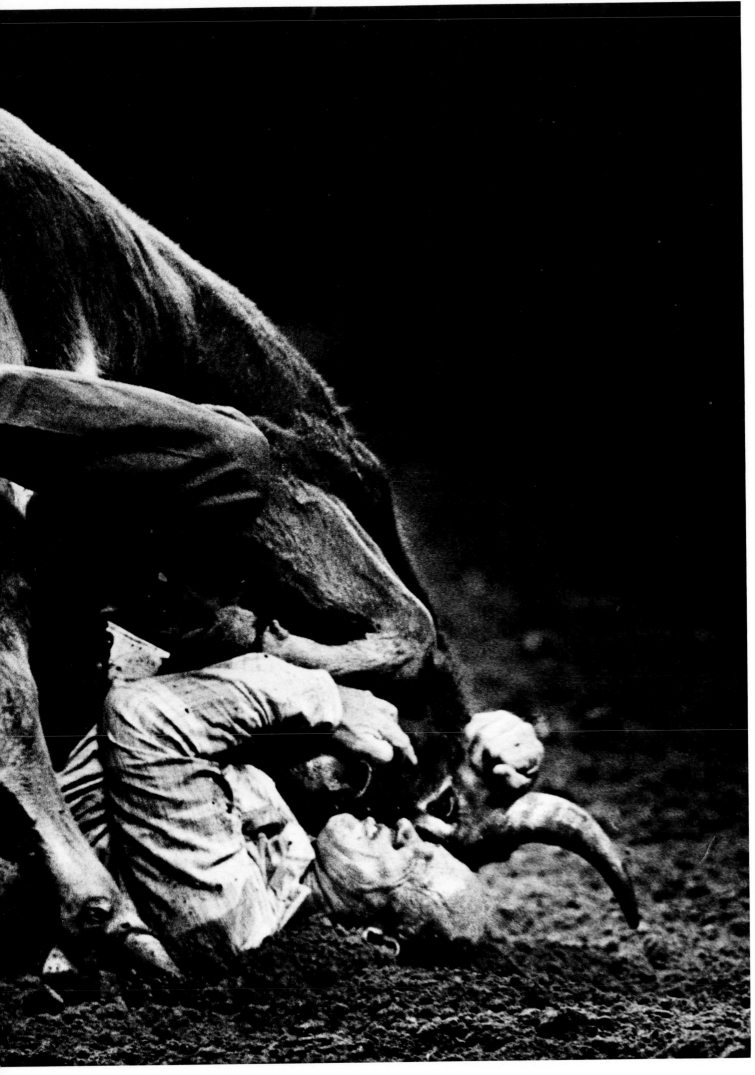

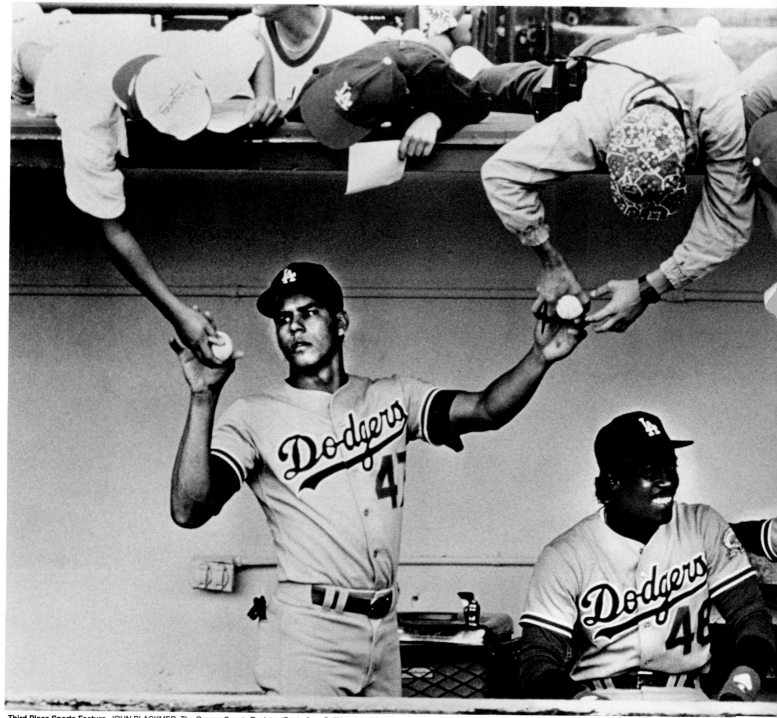

Third Place Sports Feature, JOHN BLACKMER, The Orange County Register (Santa Ana, Calif.) (original in color)

Spectators lean over a retaining wall to congratulate the gold medal ride of the U.S. team pursuit cycling team at the Major Taylor Velodrome at the Pan-American games in Indianapolis.

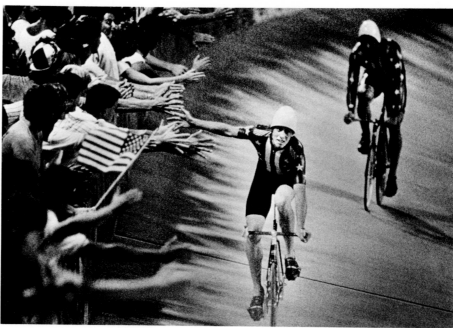

Second Place Sports Portfolio, DAVID EULITT, University of Missouri-Columbia (original in color)

Rookie outfielder Jose Gonzales, playing on the expanded L.A. Dodgers team roster during spring training, signs autographs before an exhibition game against the Baltimore Orioles in Miami.

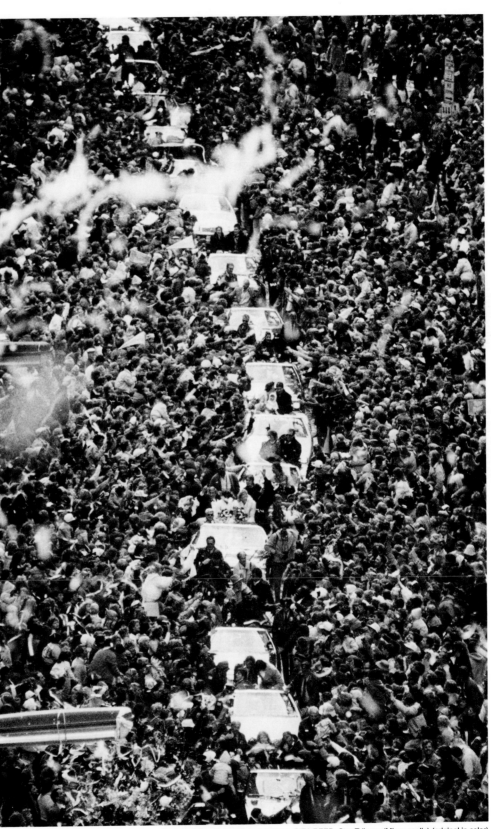

Half a million people jammd the streets of Minneapolis and St. Paul for a parade celebrating the Minnesota Twins' victory in the World Series.

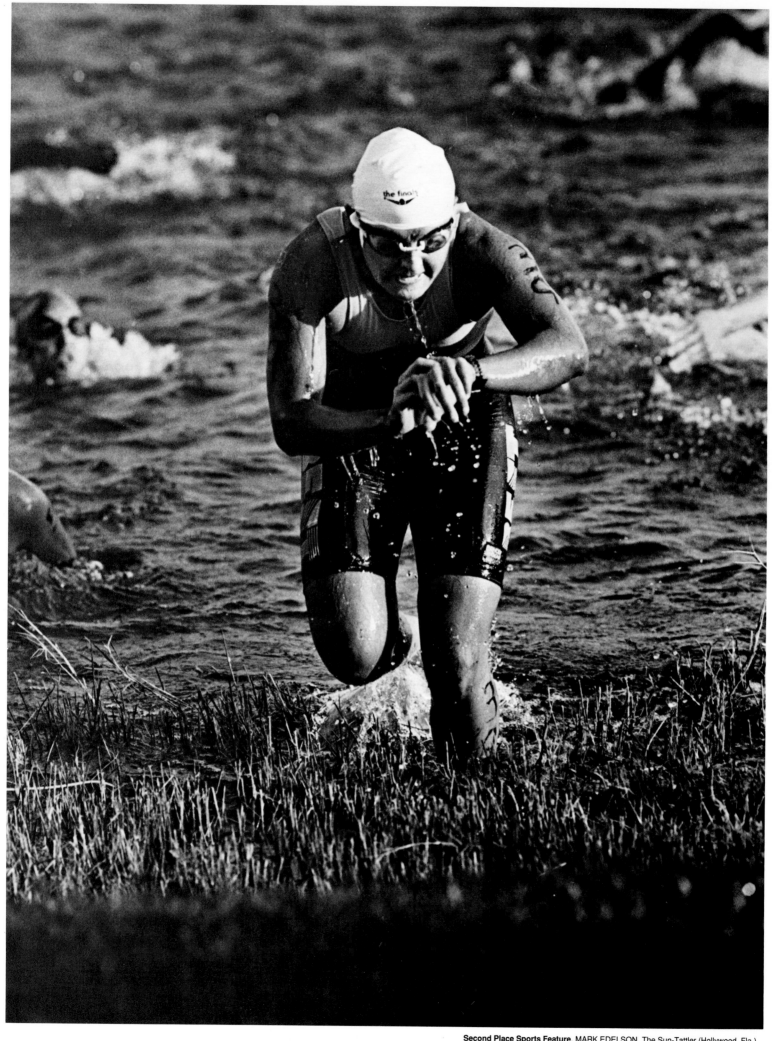

A racer checks his watch as he leaves the water and heads toward the bicycles in the Broward Sports Festival triathlon in Pembroke Pines, Fla.

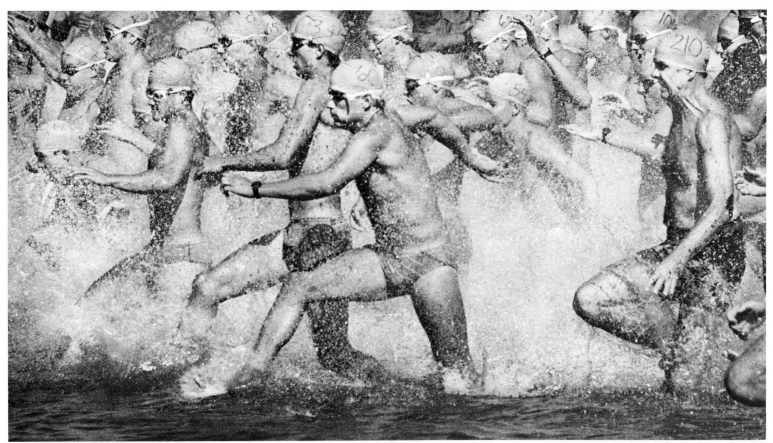

Swimmers race into the water during the first leg of the Big Creek Triathlon near Des Moines, Iowa.

Bogie Boker is thrown by a bucking bronco at the summer DuPage County Fair Rodeo in Illinois.

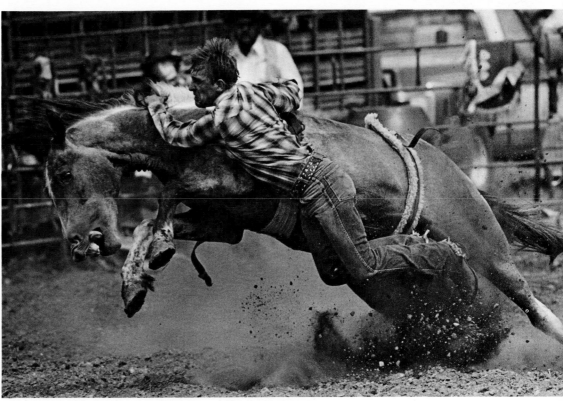

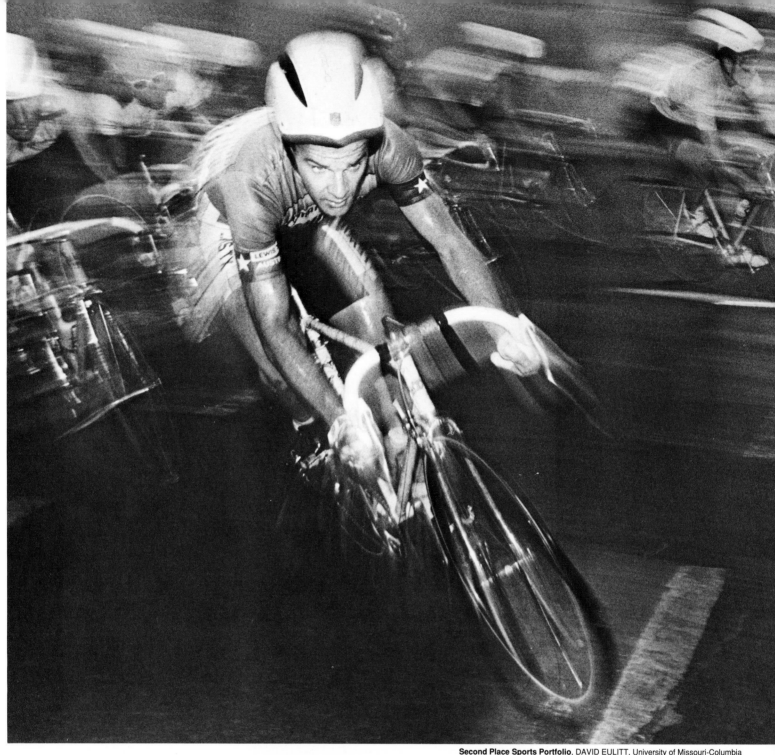

Second Place Sports Portfolio, DAVID EULITT, University of Missouri-Columbia

Bicyclists streak around a turn in the Mayor's Cup International Bike Race in Indianapolis. The national tournament holds races on the downtown streets of 21 cities.

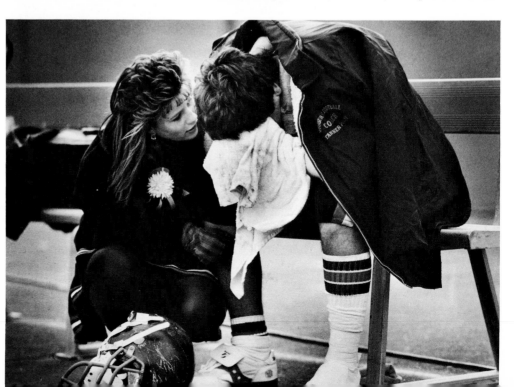

A cheerleader comforts a Woburn High School football player whose team lost a championship in Foxboro, Mass.

Second Place Newspaper Photographer of the Year, JOHN TLUMACKI, The Boston Globe

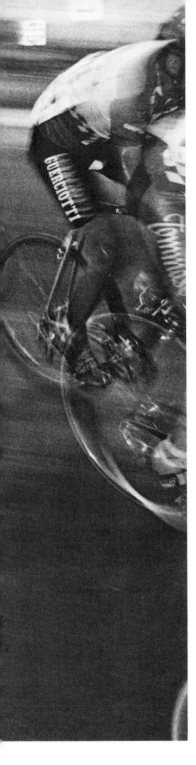

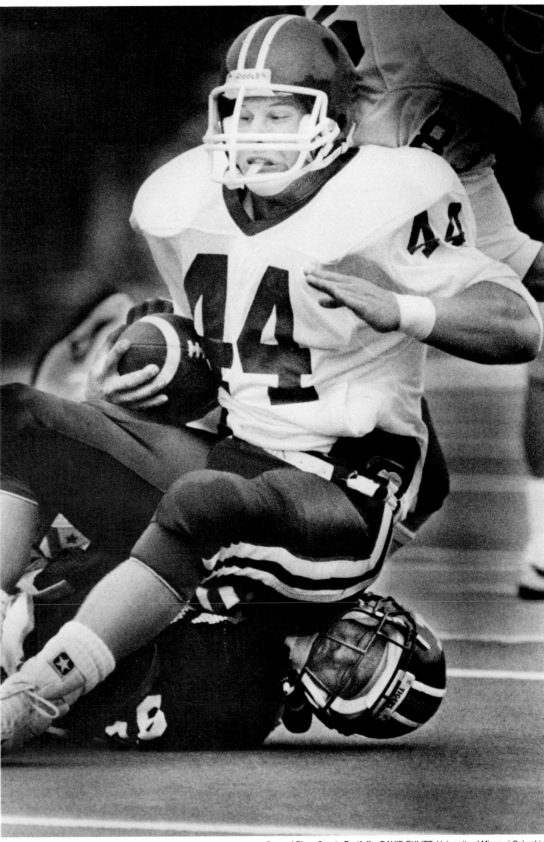

Kansas State University fullback Rick Lewis comes down hard on the head of Missouri safety Erik McMillan, who made the tackle on a short gain. Missouri came out on top in the contest, though, 34-10.

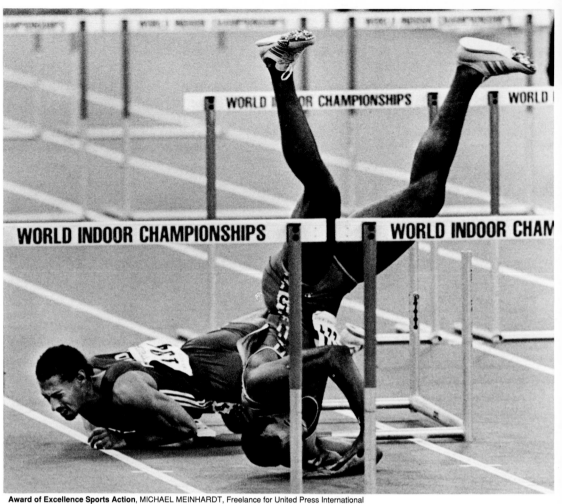

Award of Excellence Sports Action, MICHAEL MEINHARDT, Freelance for United Press International

Double trouble

When American Greg Foster and Canadian Mark McKoy, on the ground, tangled in the 60-meter hurdles final at the World Indoor Track and Field Championships in Indianapolis, both crashed to the track in pain. Foster had to be carried off the track. At an earlier semifinal race, Foster took away McKoy's world record in the event.

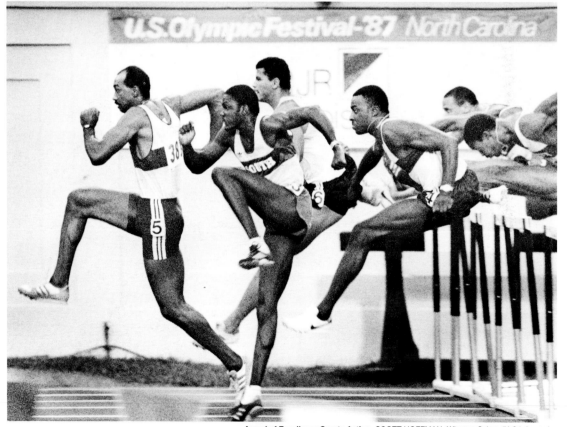

World-class hurdler Greg Foster leads a pack of competitors hot on his heels in the high hurdles at the Olympic Festival in North Carolina.

Award of Excellence Sports Action, SCOTT HOFFMAN, Winston-Salem (N.C.) Journal

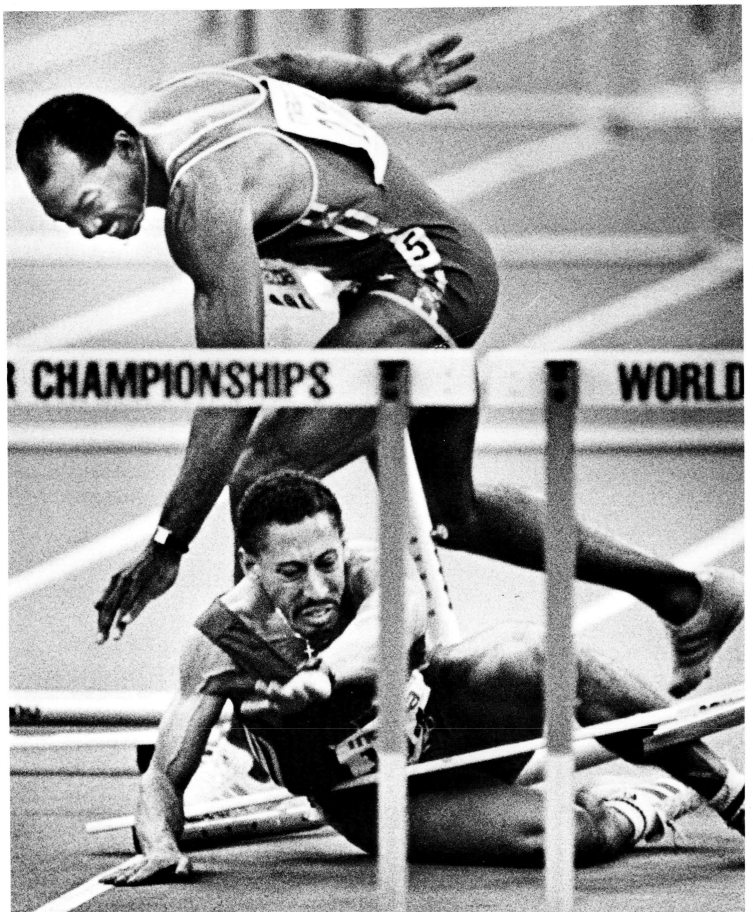

Award of Excellence Sports Portfolio, MIKE FENDER, The Indianapolis News

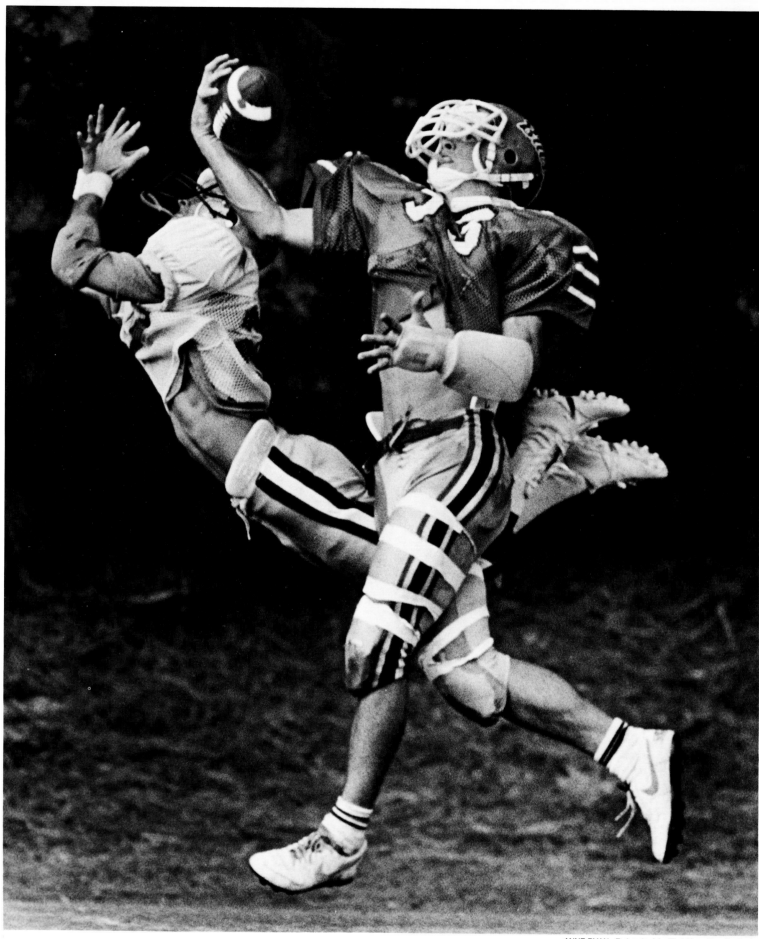

Benjamin High School's Rob Shurtleff gets his hands on a pass intended for opponent Trey Sizemore of Glades Day High School in Belle Glade, Fla. But it fell incomplete and Glades Day shut out Benjamin 25-0.

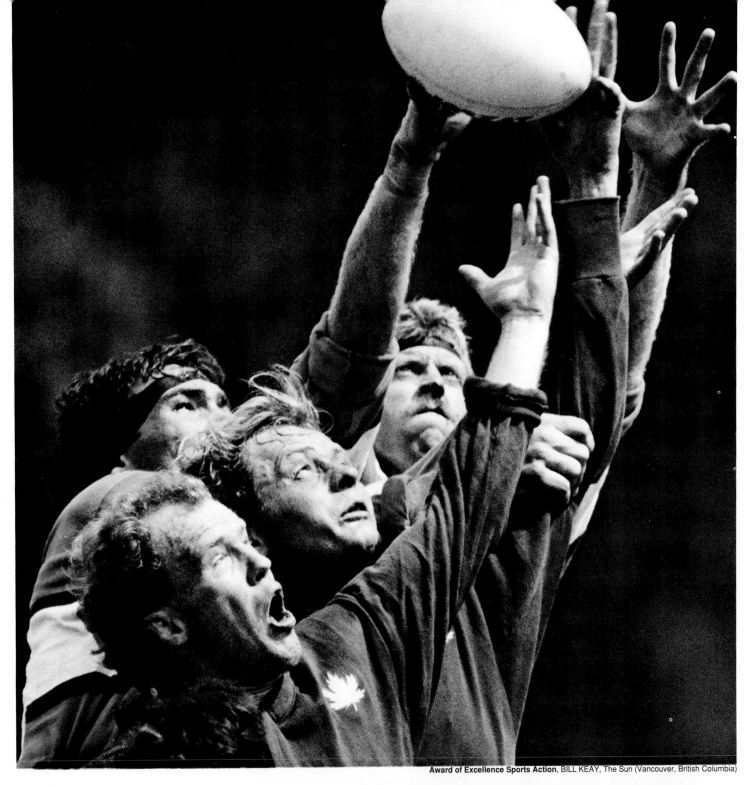

Rugby players reach for the top during a game between the United States and Canada at Brockton Oval in Vancouver, British Columbia.

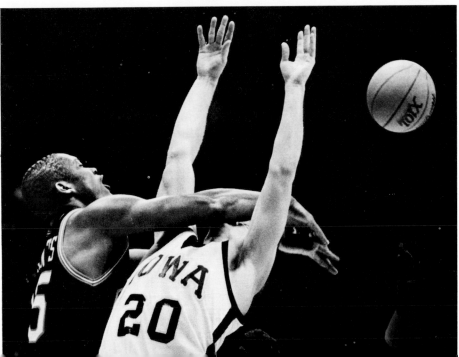

Purdue's Kevin McCants blocks a shot by Iowa's Jeff Moe (20) during a physical Big Ten match-up in Carver-Hawkeye Arena in Iowa City, Iowa.

RODNEY WHITE,
Iowa City (Iowa) Press-Citizen

Satanta's Sue
Sprenkle strains
to hand off the
baton to anchor
Elisa Stalker in
the prelims of the
girls' 2A relay at
the Kansas State
Track and Field
Meet in Wichita,
Kan.

**Second Place
Sports Action**,
GREGORY
DREZDZON,
The Wichita (Kan.)
Eagle-Beacon
(original in color)

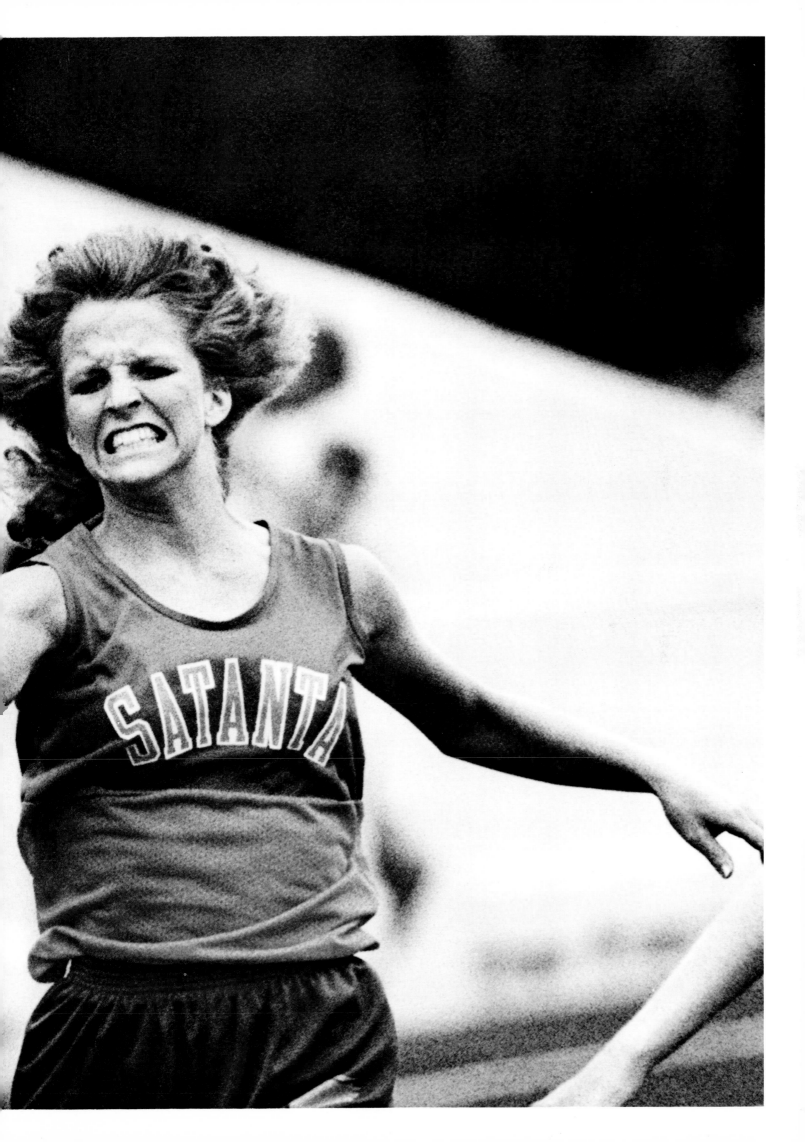

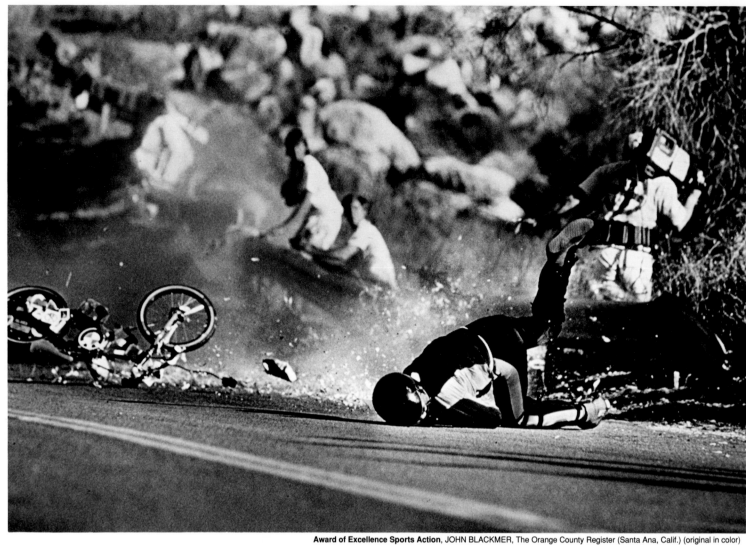

John Ficarra crashes while traveling at more than 60 mph during a gravity bike race in Palm Springs, Calif. The modified bikes, which have no pedals, reach speeds of 80-90 mph.

A hurdler tries to avoid landing on another racer who had an epileptic seizure and collapsed during the 300-meter intermediate hurdles in New Castle, Pa.

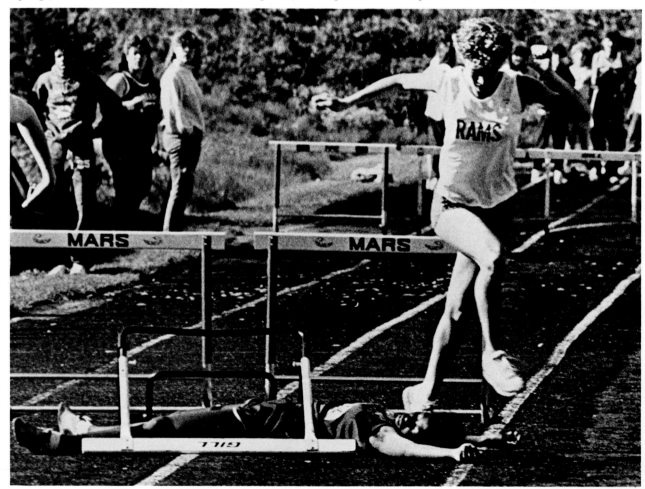

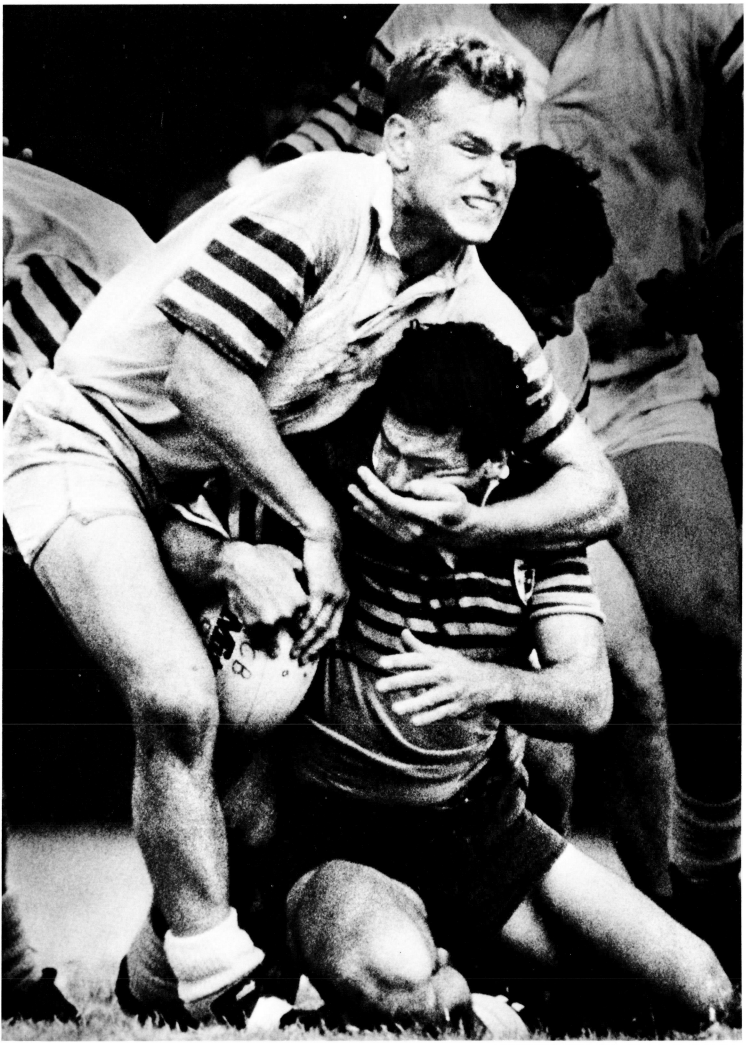

James Madison's Scott Gaejen, standing, puts the squeeze on Old Dominion's Scott Rogers during ODU's 12-0 victory in the college division of the Virginia State Rugby Championship.

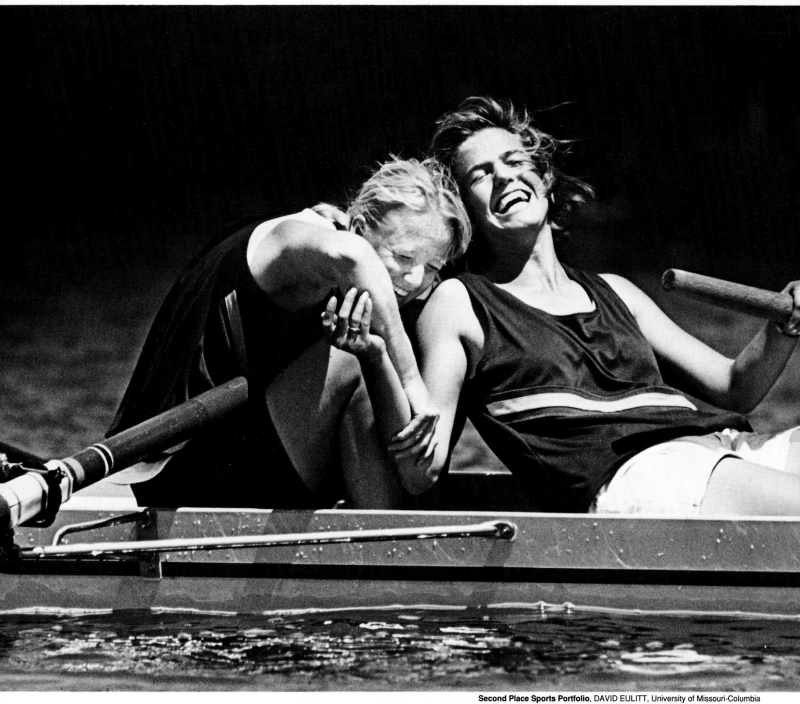

Kyrsten Abramson, right, and Green Lake teammate Meegan Amen celebrate their second place finish after a late comeback in the High School Eight's division at the 11th National Rowing Championships in Indianapolis in June.

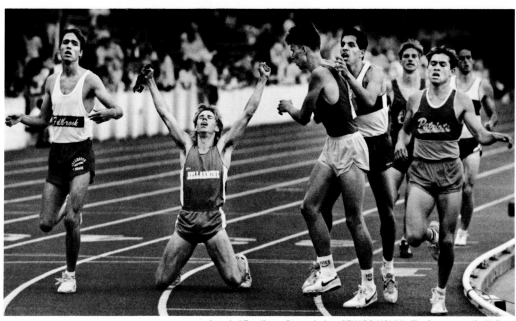

An exhausted Scott Robinson drops with raised fists after winning the men's 1600-meter run at the state track meet in Sacramento, Calif.

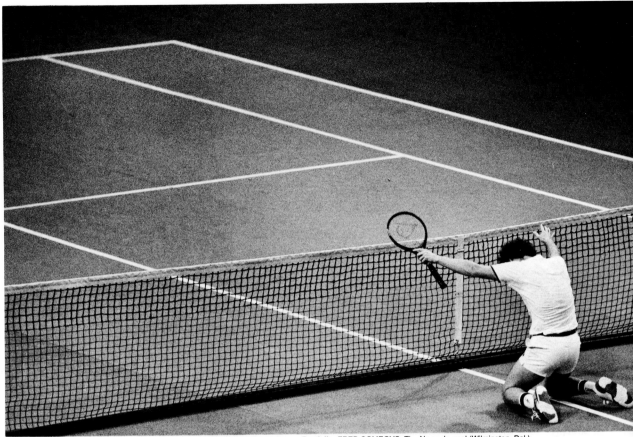

Award of Excellence Sports Portfolio, FRED COMEGYS, The News-Journal (Wilmington, Del.)

John McEnroe, trying for a comeback, drops to his knees and bows to Tim Mayotte at the Pro Indoor in Philadelphia after he missed a drop shot by Mayotte, who won the match.

Brazilian players celebrate their upset victory over the United States for the gold medal at the Pan-American Games in Indianapolis.

Third Place Sports Portfolio, ROBERT HANASHIRO, The Visalia (Calif.) Times-Delta (original in color)

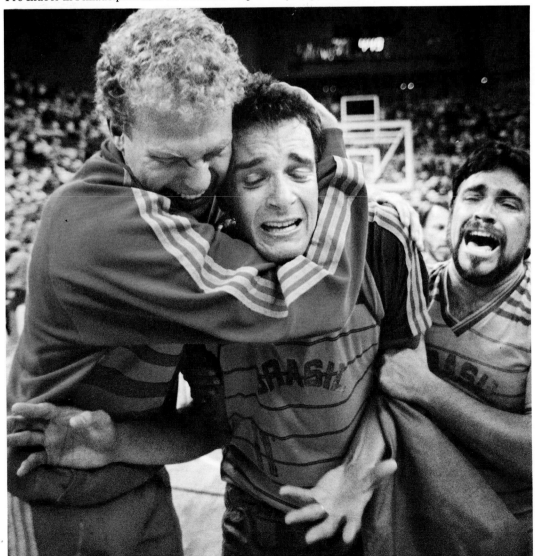

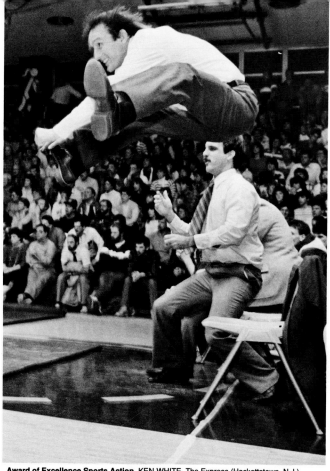

Phillipsburg, N.J., coach Rick Thompson's excitement goes sky high after his wrestler won a match.

Award of Excellence Sports Action, KEN WHITE, The Express (Hackettstown, N.J.)

Third Place Sports Portfolio, ROBERT HANASHIRO, The Visalia (Calif.) Times-Delta (original in color)

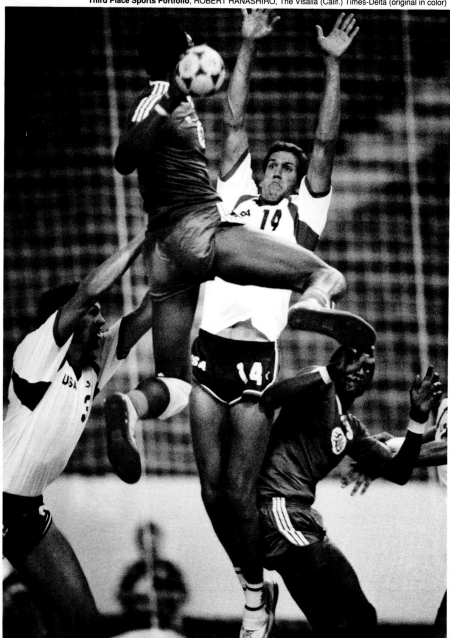

A Cuban team handball player leaps into the air, trying to make a shot past the outstretched arms of a U.S. player during the gold medal match at the Pan-American Games in Indianapolis.

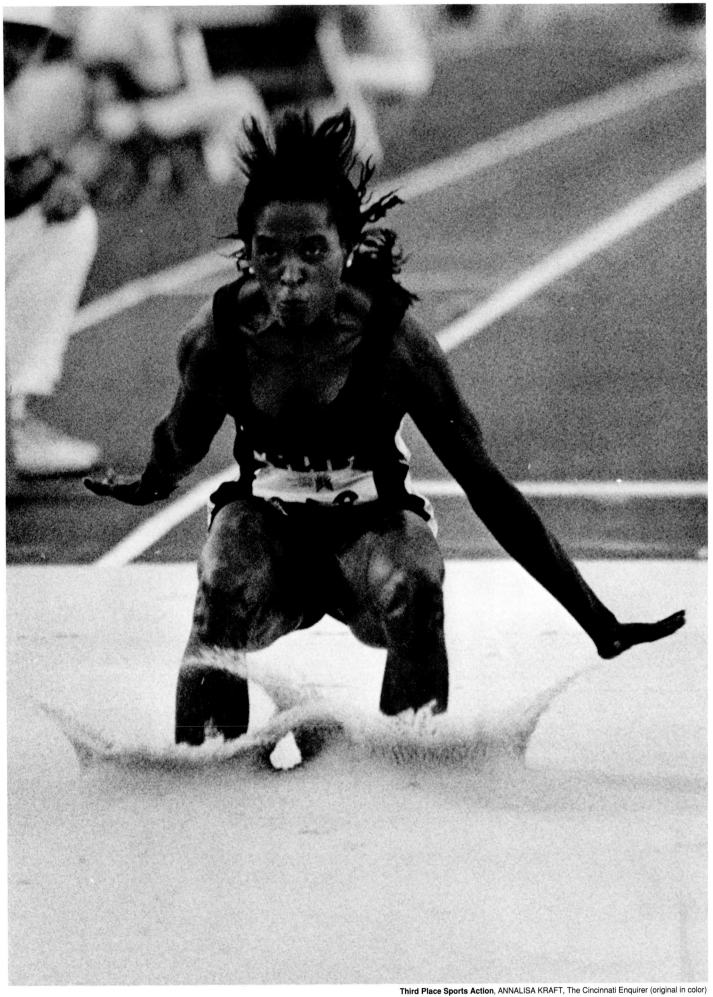

U.S. jumper Jennifer Innis takes a broad jump at the Pan-American Games in Indianapolis.

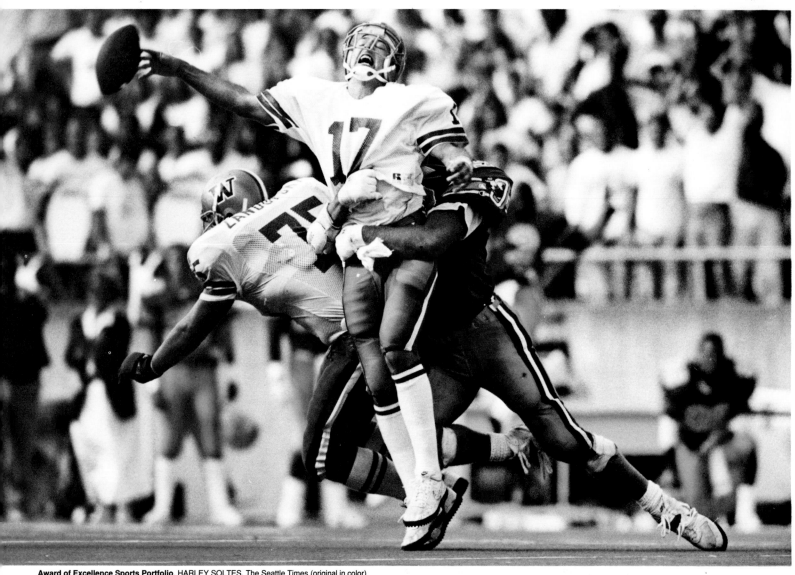

Award of Excellence Sports Portfolio, HARLEY SOLTES, The Seattle Times (original in color)

Heisman Trophy hopeful Chris Chandler of the University of Washington is decked by a University of Oregon linebacker.

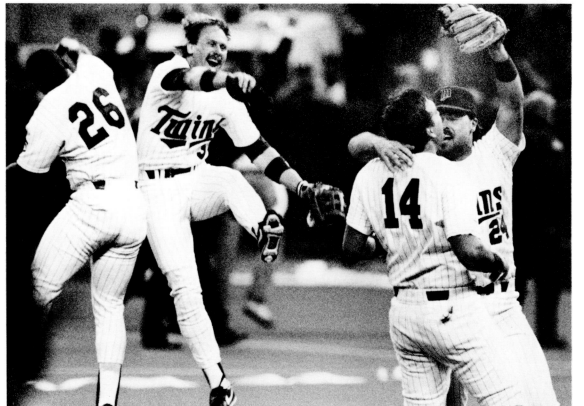

Minnesota Twins Al Newman (26) and Dan Gladden exchange "high fives" while teammates Kent Hrbek (14) and Steve Lombardozzi embrace after the Twins defeated the St. Louis Cardinals in Game 7 to capture the World Series in Minneapolis.

Award of Excellence Sports Action, GARY WEBER, Agence France-Presse (original in color)

Florida state high school diving champion Lara Woodman does a one and a half with a twist from the high dive springboard during practice in Miami.

**Award of Excellence
Sports Action**, JON KRAL,
The Miami Herald

Dennis Conner, and his crew sail the Stars and Stripes during a practice run the week before they raced — and beat — Kookaburra III for the America's Cup in Fremantle, Australia.

BOB BREIDENBACH The Providence (R.I.) Journal-Bulletin (oringinal in color)

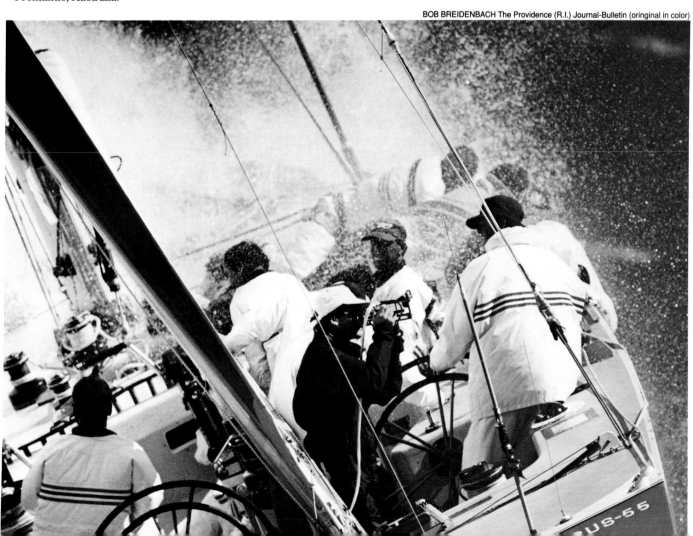

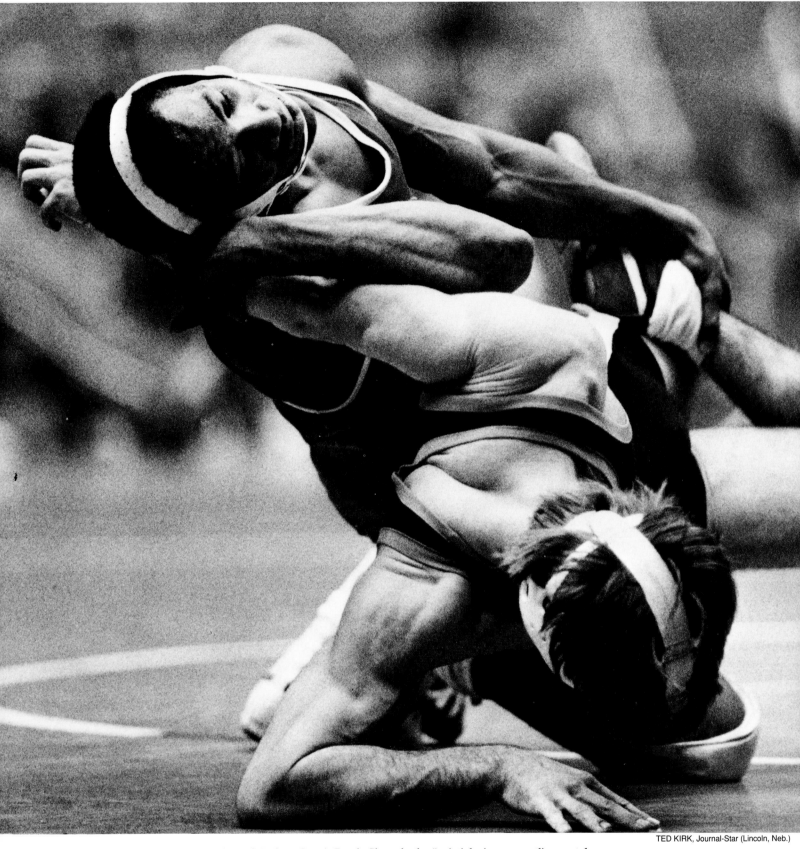

Nebraska's Wallace Dawkins, top, and South Dakota State's Randy Shaw do the "twist' during a wrestling match.

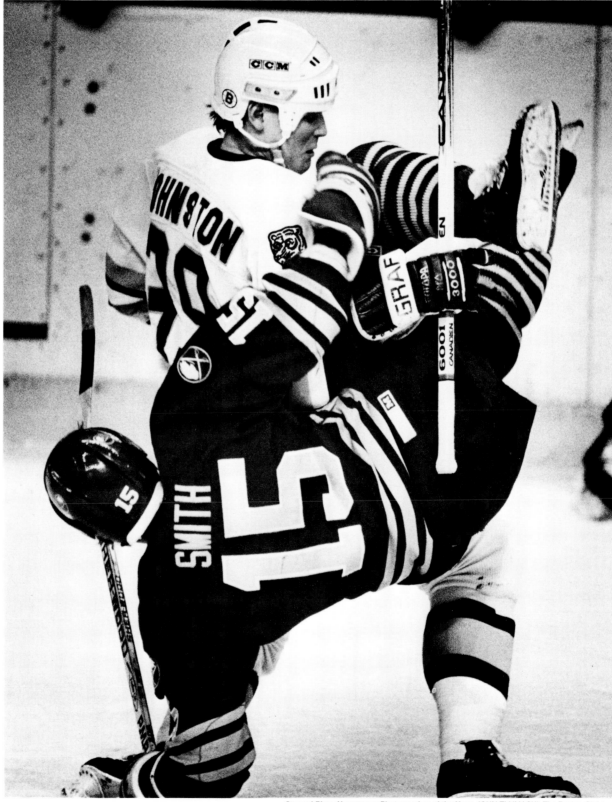

A Boston Bruins player trips up a Buffalo player as they tangle during game action.

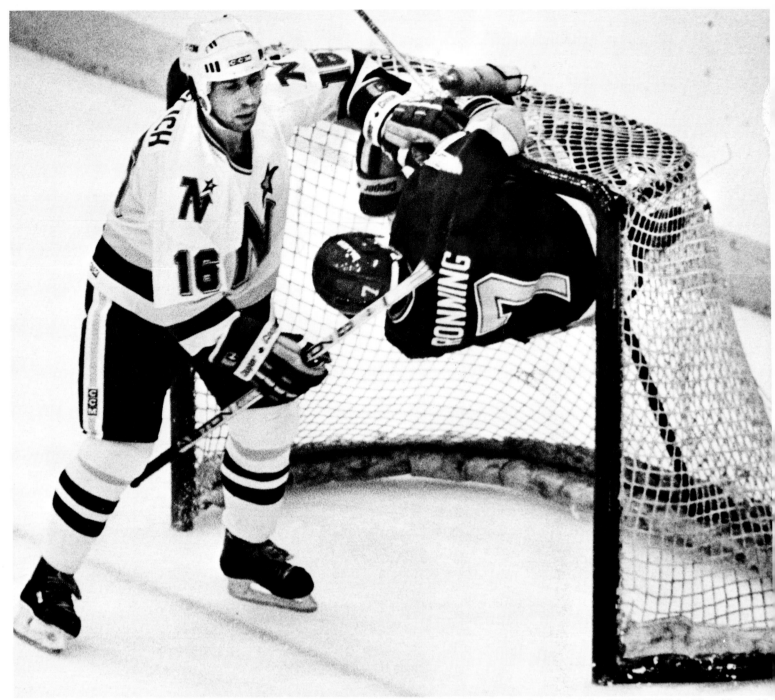

Award of Excellence Sports Action, MARLIN LEVISON, Star Tribune (Minneapolis)

Minnesota North Stars Mark Pavelich checks St. Louis Blues Cliff Ronning into the Blues' net.

Second Place Sports Portfolio, DAVID EULITT, University of Missouri-Columbia (original in color)

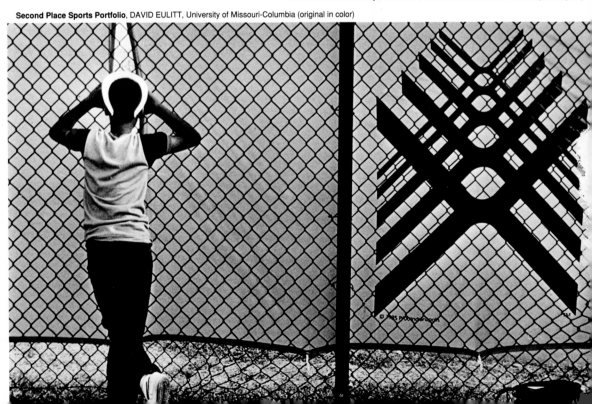

Divonne Banks, 11, peeks through the decorative banners to catch a glimpse of the sold-out track and field events in August at the Indiana University and Purdue University Indianapolis Track Stadium.

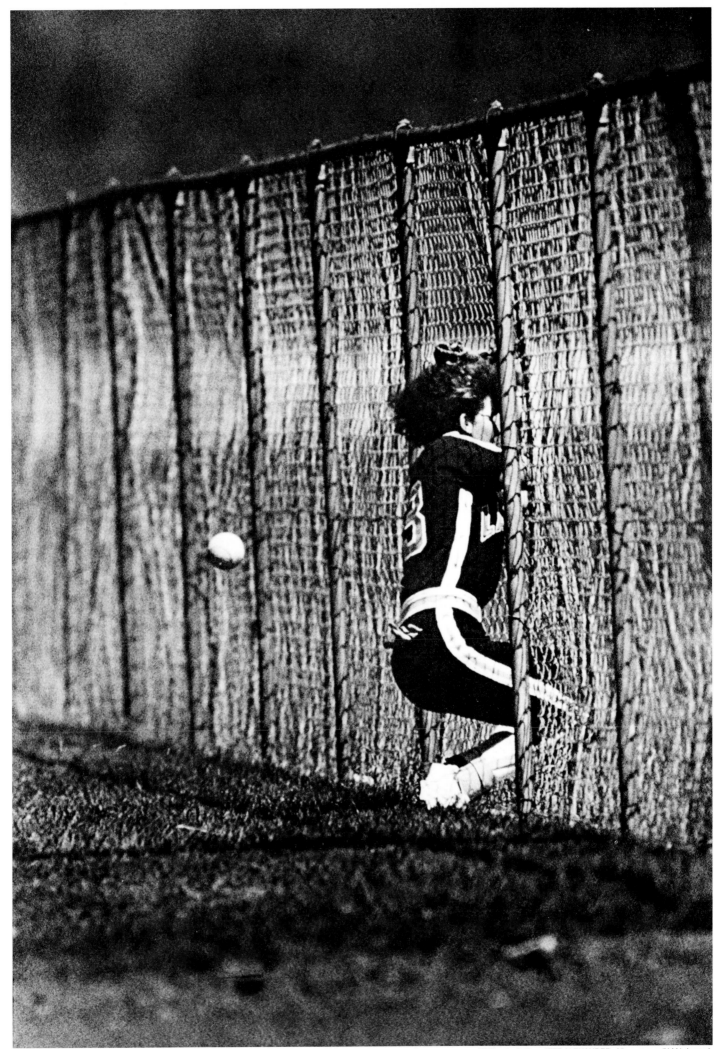

AE Sports Action, JEFF ALEXANDER, Albuquerque (N.M.) Journal

Courtney Jackson slams into the right field fence during a city softball championship game in Albuquerque, N.M. Although Jackson remained in the game, her team lost.

Year No. 45

A critical look at record POY

By Bill Kuykendall--Director of POY

Day one of week two, judges Bob Gilka, Alex MacLeod, Da
during judging of the editing division. POY entries were u

In 1943, when University of Missouri professor Cliff Edom started the 50 Print Exhibition (the earliest forerunner of POY), 60 photographers entered 223 photographs in news and feature categories. Three judges chose the winners in one day.

The 45th Annual Pictures of the Year contest, from which this book has been compiled, assembled more than 37,000 color and black and white transparencies, and more than 3,000 newspaper and magazine tearsheets from 1,995 editors and photographers. Eight judges labored ten hours a day for nine days to evaluate the 38 categories.

This contest, which could once be managed by Cliff and his wife, Vi, with a handful of student volunteers, now involves more than 120 paid and volunteer students and staff, 14 slide projectors, three dissolves, a computer, electronic voting, audio recording, PA equipment, and two separate judging arenas.

The 45th Annual Pictures of the Year Contest became the first POY to require two panels and nearly two full weeks of judging. This expansion came just in time to deal with a marked increase in entries that resulted, apparently, from the move from mounted print to slide entries two years ago.

Michael Waller of The Hartford Courant, who judged POY44, returned to help set the pace for this year's panel. Four of the judges—Bob Gilka, Carolyn Lee, Angus McDougall and Dave Peterson—viewed all categories. Waller and Bob Dannin served only on the panel that picked newspaper

division winners; Dave Harvey and Alex MacLeod served on the panel selecting editing, magazine and Canon Essayist awards.

The number of photographs, the number of tearsheets and the number of those who entered POY45 all represented an increase of 20 percent over POY44. This brings the National Press Photographer Association (NPPA) participating membership to nearly 25 percent.

Growth in newspaper photo entries is expected to level off. Indeed, if this doesn't happen, POY soon will become unmanageable within the time-frame it must be judged. Categories would have to be dropped or the contest subdivided into smaller competitions.

There appears to be room for expansion, however, within editing and magazine categories. These categories could double or triple without overburdening judges.

Recent POY changes also include the introduction of several new categories. The most successful has been Newspaper Sports Portfolio. Entries increased from 93 last year to 109. Magazine Sports Portfolio participation has been much weaker—only five entries. Judges gave no awards and suggested that, if quantity and quality didn't pick up soon, this category should be dropped.

Another new category (created last year) is One Week's Work. Though response was light—24 entries— judges agreed that this category should be continued because it rewards photographers

who put extra effort into everyday assignments, the bread and butter of our profession.

Less successful was the Best Use of Photos category for Zoned editions. There were only six entrants.

As with POY44, judges were distressed by the quality of food, fashion and editorial illustrations. They criticized the poor quality of ideas and execution. They favored food and fashion photos that were descriptive, and spoke emphatically against most that were visual puns.

Some judges opposed all photographic illustrations of editorial concepts through staged realistic scenes. They suggested credibility is the photojournalist's great virtue and to dilute this in the minds of readers undermines the general trustworthiness of documentary photos. Ironically, first place in Newspaper Editorial Illustration was awarded to a photo that appeared documentary in nature. It was only after judging the category and discussing it over lunch that the panelists brought all of their thoughts into focus.

Photo by Kurt Foss

Alan Harvey, Angus McDougall, Carolyn Lee and David Peterson, study a newspaper 20 percent over the previous year as 40,000 photographs and tearsheet were judged.

Then ensued a prolonged, public discussion. There was a strong unwillingness to rejudge the category, in part because many still felt this to be the best photo and because of a general resolve to never rejudge a category once awards have been given.

For the first time Newspaper Picture Editing awards were made both to teams and to individuals. The over-all number of editing entries was down. This year's total was 63, compared to 83 last year, but in POY45 there were 21 team entries compared with six in POY44.

The Best Use of Photos entries were allotted an unprecedented six hours for judging. The panel was directed to examine not only newspaper section fronts but also the use of photos on inside pages. They were asked to consider the use of local and wire photos, documentary versus photo illustration, the appropriateness of photos to the stories that they illustrated, the complementary relationship of captions and headlines, and the balance of news

and feature photos in each entry.

The POY staff agreed that this was the most thorough judging ever of these extremely significant categories.

Though total entries increased 20 percent and two new categories were added, the POY45 panel awarded only 265 prizes compared with 404 by the POY44 panel. Mike Waller, who helped judge all of that year's contest and the Newspaper Division of POY45, observed that the quality of entries seemed slightly better the previous year.

The POY45 judges were experienced, dedicated and diligent. They took their assignment (for which they received little more than room and board and the gratitude of the POY staff) seriously. They set a hard, defensible standard, applied it from the beginning and stuck to it.

As director of POY, I am grateful for the sacrifices made by each and for the guidance they have provided all of us through their thoughtful and consistently professional deliberations.

THE WINNERS

Newspaper Photographer of the Year

First: Bill Greene, The Boston Globe, front cover, p. 3, 6, 15, 126-129

Second: John Tlumacki, The Boston Globe p. 77, 173, 206, 223

Third: Melissa Farlow, The Pittsburgh Press p. 104, 144-148, 152, 153, 158, 159

Award of Excellence:
Carol Guzy, The Miami Herald p. 21, 22, 58, 114, 121, 154

Magazine Photographer of the Year

First: Anthony Suau, Black Star p. 21, 24-26, 82-85

Second: James L. Stanfield, National Geographic p. 29, 99, 163

Award of Excellence:
Nathan Benn, National Geographic p. 24-26

Canon Photo Essayist

Herman LeRoy Emmet, Freelance, "Fruit Tramps" p. 130-141

Newspaper Division

Spot News

First: David Murray, Jr., Ft. Lauderdale (Fla.) News/Sun Sentinel, "Haiti Election Results" p. 18
Second: Terry L. Way, United Press International, "Public Suicide — 3" p. 12
Third: Viorel Florescu, New York Newsday, "Election in Haiti" p. 18

Awards of Excellence:
Paul Aiken, The Virginian-Pilot and The Ledger-Star, "Knife Fight in Bleachers" p. 62
Brian Brainerd, The Denver Post, "SWAT Team Stalking" p. 66
Don Halasy, The New York Post, "Freeze or You're Dead" p. 65
Itsua Inouye, Associated Press, "Tear Gas"
John J. Lopinot, The Palm Beach Post (West Palm Beach, Fla.) "Death in Haiti" p. 20
Paul J. Milette, The Palm Beach Post (West Palm Beach, Fla.) "Nice Doggy"
Tim Reese, The Daily Sentinel (Rome, N.Y.), "Taking a Swing" p. 67
Terry L. Way, United Press International, "Public Suicide — 1" p. 12
Terry L. Way, United Press International, "Public Suicide — 2" p. 13
Joe Wrinn, Harvard University News Office (Cambridge, Mass.), "Speaker Attacked" p. 69
Joe Wrinn, Harvard University News Office (Cambridge, Mass.), "Attacker Restrained" p. 69

General News

First: Scott Takushi, The Seattle Times, "A Final Farewell" p. 28
Second: Cloe Poisson, The Hartford (Conn.) Courant, "Fiance's Funeral" p. 64
Third: Guy A. Reynolds, State-Times/Morning Advocate (Baton Rouge, La.), "Make-up for Debate" p. 52

Awards of Excellence:
Doug Atkins, Freelance for The Associated Press, "Golden Gate Bottleneck" p. 109
Chuck Bigger, Gazette Telegraph (Colorado Springs, Colo.), "Wild Horse Roundup" p. 97
Mary F. Calvert, San Francisco State University, "Klan March Protester"
Louis DeLuca, Dallas Times Herald, "AIDS Protest" p. 60
Martin E. Klimek, Freelance, "Bridgewalk"
Ed Kosmicki, Freelance for Agence France-Presse, "Schroeder Quits" p. 55
Robert A. Martin, The Freelance-Star (Fredericksburg, Va.), "Disagreement" p. 101
Kenneth Papaleo, The Rocky Mountain News (Denver), "Broken Hart" p. 54
Joanne Rathe, The Boston Globe, "War Widow" p. 76
Rita Reed, Star Tribune (Minneapolis), "Twins Mania" p. 203
John C. Tlumacki, The Boston Globe, "Refugees Wait" p. 77

Feature Picture

First: Keith A. Myers, The Kansas City (Mo.) Times, "AIDS in Prison" p. 58
Second: Marc Halevi, Freelance, "Child Inmate" p. 80
Third: Christine Cavanaugh, San Diego Union Tribune, "A Dollar ..." p. 33

Awards of Excellence:
Tony Bacewicz, The Hartford (Conn.) Courant, "Dash for Cover" p. 124
Curt Chandler, The (Cleveland) Plain Dealer, "Horsing Around" p. 108
Mark Fraser, The Hamilton (Ontario) Spectator, "Old Barber" p. 105
Melanie Stetson Freeman, The Christian Science Monitor, "Beggars" p. 78
Rob Goebel, The Indianapolis Star, "Gettin' Jump on News" p. 99
Barry Gray, The Burlington (Ontario) Spectator, "Morning Paper" p. 125
Catharine Krueger, The Sun-Tattler (Hollywood, Fla.), "Rearview/Frontview" p. 4
Gary Lawson, The News Press (Stillwater, Okla.), "View from Above" p. 173
Jose M. More, Chicago Tribune, "Snow Matter" p. 124
Gary Reyes, The Tribune (Oakland, Calif.), "Stage Fright" p. 120
Guy A. Reynolds, State-Times/Morning Advocate (Baton Rouge, La.), "Shaving with Hands Full" p. 123
Bonnie K. Weller, The Philadelphia Inquirer, "Amish Glow" p. 106
Barry L. Zecher, Intelligencer Journal (Lancaster, Pa.), "Crossing of Time" p. 164

Sports Action

First: Larry Steagall, The Sun (Bremerton, Wash.), "Stranglehold" p. 196
Second: Gregory Drezdzon, The Wichita (Kan.) Eagle-Beacon, "Handing Off" p. 212
Third: Annalisa Kraft, The Cincinnati Enquirer, "Pan Am Jump" p. 219

Awards of Excellence:
Jeff Alexander, Albuquerque (N.M) Journal, "Slam" p. 225
H. Rick Bamman, The Daily Journal (Wheaton, Ill.), "Tough Hombre" p. 205
John Blackmer, The Orange County Register (Santa Ana, Calif.), "BMX Gravity Bike Race" p. 214
Gary Fandel, The Des Moines (Iowa) Register, "Making a Splash" p. 205
Scott Hoffman, Winston-Salem (N.C.) Journal, "Tight Race" p. 208
Bill Keay, The Sun (Vancouver, British Columbia), "Weary Faces..." p. 211
Jon Kral, The Miami Herald, "Diver" p. 221
Thomas E. Landers, The Boston Globe, "Champs Punch"
Marlin Levison, Star Tribune (Minneapolis), "Checked Into the Net" p. 224
Bill Lyons, New Castle (Pa.) News, "Fallen Hurdler" p. 214
Michael Meinhardt, Freelance for United Press International, "Foster Flip" p. 208
Genaro Molina, The Sacramento (Calif.) Bee, "Exaltations" p. 216

Jeff Scheid, Las Vegas (Nev.) Review Journal, "Who's Dogging Who?" p. 200
Harley Soltes, The Seattle Times, "Choke" p. 197
Jeff Tuttle, The Herald (Jasper, Ind.), "Going Up" p. 199
Gary Weber, Agence France-Presse, "Jubilant Twins" p. 220
Ken White, The Express (Hackettstown, N.J.), "Ecstatic Coach" p. 218

Sports Feature

First: Anne Ryan, The Ft. Lauderdale (Fla.) News/Sun-Sentinel, "First Back Dive" p. 194
Second: Mark Edelson, The Sun-Tattler (Hollywood, Fla), "Time Out" p. 204
Third: John Blackmer, The Orange County Register (Santa Ana, Calif.), "The Rites of Springs" p. 202

Portrait/Personality

First: Sara Krulwich, The New York Times, "We've Lost the Baby" p. 14
Second: Carol Guzy, The Miami Herald, "General Namphy" p. 114
Third: Lucian Perkins, The Washington Post, "Visit to the Wall" p. 113

Awards of Excellence:
Michael Ewen, The Tallahassee (Fla.) Democrat, "I Have a Dream" p. 110
Bill Greene, The Boston Globe, "Cambodian Refugee" p. 2
Andrew Itkoff, The Miami Herald, "The Contender" p. 98
Jim Preston, The Philadelphia Inquirer, "Civilian Defense" p. 112
Kim Weimer, Freelance, "Mother Teresa" p. 110

Pictorial

First: Peter Tobia, The New Haven (Conn.) Register, "Lace and Flowers" p. 166
Second: Charles Ledford, The St. Petersburg (Fla.) Times, "Was It Worth It?" p. 102
Third: Wally Emerson, Freelance, "Snow Lot" p. 172

Awards of Excellence:
Daniel A. Anderson, The Orange County Register (Santa Ana, Calif.), "Paradise for a Blue Heron" p. 175
Charlaine Brown, The Orange County Register (Santa Ana, Calif.), "Deer Under Willow" p. 177
Pat Crowe, The News Journal (Wilmington, Del.), "Taking Off" p. 164
Bill Greene, The Boston Globe, "Wrap Around"
Carol Guzy, The Miami Herald, "Haiti Light"
Dan Marschka, Intelligencer Journal (Lancaster, Pa.), "Border Lines" p. 165
Ruben W. Perez, The Providence (R.I.) Journal-Bulletin, "Stairway to Heaven" p. 176
Don Preisler, The Washington Times, "Haitian Woman" p. 170
George Wilhelm, The Los Angeles Times, "Early Bird" p. 184

Food Illustration

First: Mary Circelli, Columbus (Ohio) Dispatch, "Mustards" p. 183
Second: Craig Trumbo, The Providence (R.I.) Journal-Bulletin, "Mmmm Mmmm Good" p. 186
Third: Mark B. Sluder, The Charlotte (N.C.) Observer, "Raw Oysters" p. 183

Awards of Excellence:
Nancy N. Andrews, The Freelance-Star (Fredericksburg, Va.), "Sweet Strawberries" p. 183
Lois Bernstein, The Virginian-Pilot and The Ledger-Star, "Pearl Onions" p. 187
Mary Kelley, The Kansas City (Mo.) Times, "Herbs" p. 186
J. Mark Poulsen, Albuquerque (N.M.) Journal, "Artichokes" p. 187
David Woo, The Dallas Morning News, "Red Fish" p. 186

Fashion Illustration

First: Vickie Lewis, Albuquerque (N.M.) Tribune, "Hats" p. 179
Second: Steve Harper, The Wichita (Kan.) Eagle-Beacon, "Lingerie and Innocence" p. 180
Third: David J. Phillip, The Denton (Texas) Record-Chronicle, "Graceful Beauty" p. 181

Awards of Excellence:
Don Ipock, The Kansas City (Mo.) Star, "Elegant Cat Stuff" p. 182
J. Mark Poulsen, Albuquerque (N.M.) Journal, "The Ghost of Christmas Presents" p. 182
Jim Sulley, The Staten Island (N.Y.) Advance, "Red Socks" p. 182
Nan Wintersteller, Ohio University (Athens, Ohio), "Shine Those Shades" p. 182
Steven Zerby, Star Tribune (Minneapolis), "High Tech Shades" p. 178

Editorial Illustration

First: V. Jane Windsor, University of Florida (Gainesville, Fla.), "The Communication Gap" p. 142
Second: Sig Bokalders, Freelance, "Oh Say Can You Shoot?" p. 142
Third: Geff Hinds, The News Tribune (Tacoma, Wash.), "Managing Meltdown" p. 142

News Picture Story

First: Jimi Lott, The Seattle Times, "Home Street Home" p. 34-41
Second: Manny Crisostomo, Detroit Free Press, "Too Young to Die" p. 46-47
Third: Janet Knott, The Boston Globe, "Election Violence" p. 22,23

Awards of Excellence:
Alan Berner, The Seattle Times, "Seattle's Homeless" p. 42
Steve Campbell, The Houston Chronicle, "Welcome Home" p. 112
Manny Crisostomo, Detroit Free Press, "Motown Crackdown" p. 48
Phillip Davies, New York Newsday, "Haitian Elections '87"

Judy Fidkowski, The Daily Southtown Economist (Chicago), "Council Wars" p. 53
Viorel Florescu, New York Newsday, "The Election in Haiti" p. 18
Brad Alan Graverson, The Daily Breeze (Torrance, Calif.), "Paul's Last Days" p. 60
Carol Guzy, The Miami Herald, "Haiti Elections" p. 21,22
Carol Halebian, Gamma/Liaison, "Execution in Haiti" p. 19
Keith A. Myers, The Kansas City (Mo.) Times, "AIDS in Prison: The Unseen Executioner" p. 58, 59
Steve Ringman, San Francisco Chronicle, "Black Monday" p. 15
Stephen Shames, The Philadelphia Inquirer, "Invisible Homeless" p. 42
John C. Tlumacki, The Boston Globe, "Uganda on the Edge" p. 77
Charles Trainor, Jr., The Miami Herald, "Prison Siege" p. 70-71, 72
Paul Vathis, The Associated Press, "State Treasurer Commits Suicide" p. 13
Terry L. Way, United Press International, "Public Suicide" p. 12,13
David Woo, The Dallas Morning News, "There Used to be a Town Here" p. 74

Feature Picture Story

First: Melissa Farlow, The Pittsburgh Press, "The Metamorphosis of Wendy Fraser" p. 144-148
Second: Bill Greene, The Boston Globe, "People of Flight" p. 2, 126-127
Third: Nicole Bengiveno, New York Daily News, "Homeless Hotel" p. 45, 107

Awards of Excellence:
Jim Hubbard, Image Concerns, "Ghetto Playground"
Jimi Lott, The Seattle Times, "A Cowboy Harvest" p. 177
Al Podgorski, Chicago Sun-Times, "Brother Bill's Brothers" p. 50-51
Gary Porter, The Milwaukee Journal, "Empty Cradles" p. 77

Sports Portfolio

First: Gary A. Cameron, The Washington Post p. 192-193
Second: David Eulitt, University of Missouri-Columbia p. 195, 202, 206, 207, 216, 224
Third: Robert Hanashiro, The Visalia (Calif.) Times-Delta p. 217, 218

Awards of Excellence:
Fred Comegys, The News-Journal (Wilmington, Del.) p. 198, 217
Mike Fender, The Indianapolis News p. 209
Harley Soltes, The Seattle Times p. 114, 197, 220

One Week's Work

First: Amy Davis, The Baltimore Sun p. 188-189
Second: Catharine Krueger, The Sun-Tattler (Hollywood, Fla.) p. 4
Third: Leland Holder, The Claremont (Calif.) Courier p. 122

Awards of Excellence:
Ronald Cortes, The News-Journal (Wilmington, Del.) p. 55
Angela Pancrazio, The Tribune (Oakland, Calif.) p. 123
William Snyder, The Dallas Morning News p. 66

Magazine Division

News or Documentary

First: Maggie Steber, J.B. Pictures for Newsweek, "Violent Legacy" p. 18
Second: James L. Stanfield, National Geographic, "Broken Hearts" p. 29
Third: Robert R. Mercer, Mercer Visual Communications, Inc., "Last Rites" p. 29

Awards of Excellence:
William Campbell, TIME, "Madonna of the Famine" p. 120
Greg Davis, TIME, "Rocky Road"
Bill Foley, TIME, "In Cold Blood"
Tom Haley, Sipa for TIME, "Striking Back"
Anthony Suau, Black Star, "Arrest" p. 84

Feature

First: Stephanie Maze, Freelance, "Honoring the High Priestess" p. 166
Second: Rick Smolan, A Day in the Life of the Soviet Union, "Cheating Cadet" p. 162
Third: Dilip Mehta, A Day in the Life of the Soviet Union, "Uncle Lenin" p. 162

Sports

Award of Excellence:
Gerard Michael Lodriguss, The Philadelphia Inquirer, "Form" p. 195

Portrait/Personality

First: Anthony Suau, Black Star, "Kim Young Sam" p. 26
Second: Dwan Feary, Freelance for The Virginian-Pilot and The Ledger-Star (Norfolk, Va.), "Faced with Nowhere to Go" p. 44
Third: Harry Benson, Freelance for LIFE, "Tammy and Jim" p. 30

Awards of Excellence:
Stephanie Maze, Freelance for National Geographic, "Saquiero of Serra Pelada" p. 163
James L. Stanfield, National Geographic, "Composer Witold Lutostawski"
James L. Stanfield, National Geographic, "The Chicken Lady" p. 163

Pictorial

First: Bob Thayer, The Providence (R.I.) Journal-Bulletin, "Geese in Blizzard" p. 168

Second: Neal Slavin, A Day in the Life of the Soviet Union, "Moscow Bath Swimmer" p. 81
Third: Frans Marten Lanting, Freelance, "Porpoise Surfacing" p. 81

Awards of Excellence:
Jodi Cobb, A Day in the Life of the Soviet Union, "Window Doll" p. 171
Richard Kozak, Insight, "Snow Fence"
Frans Marten Lanting, Freelance for American Express Departures, "Flamingos, Kenya" p. 174
Sarah Leen, A Day in the Life of Spain, "Spanish Moma" p. 167
Buck Miller, Sports Illustrated, "Wellington, New Zealand" p. 170
Anthony Suau, Black Star, "Color-Light Haiti"

Illustration

First: Gary S. Chapman, The Louisville (Ky.) Courier-Journal, "Seven Shapes" p. 178
Second: Caryn Levy, Sports Illustrated, "Jammin' Johnson" p. 190
Third: Gary S. Chapman, The Louisville (Ky.) Courier-Journal, "Deja Vu Fashion" p. 179

Science/Natural History

First: Jim Brandenburg, National Geographic, "Leaping Wolf" p. 90
Second: Jim Brandenburg, National Geographic, "Leader of the Pack" p. 92
Third: Frans Marten Lanting, Freelance, "Skua Attack, Falkland Island" p. 94

Awards of Excellence:
Natalie Fobes, The Seattle Times, "The Moment of Birth" p. 95
Bob Krist, Black Star, "Geothermal Spa" p. 95
Frans Marten Lanting, Freelance, "Albatross Couple, Falkland Island" p. 174
Frans Marten Lanting, Freelance, "Chameleon Striking, Madagascar" p. 96
Bianca Lavies, Freelance for National Geographic, "Snake Meets Mouse" p. 96
Bill Pierce, TIME, "Meissner Effect"

Picture Story

First: Jim Brandenburg, National Geographic, "Arctic Wolf" p. 86-93
Second: Nathan Benn, National Geographic, "Korean Revolution in the Streets" p. 24, 25, 26
Third: Randy Olson, The Pittsburgh Press Sunday Magazine, "Why Won't Jimmy go to School?" p. 149-151

Awards of Excellence:
Chris Cole, Newsweek, "Korea in Crisis"
Jean Bernard Diederich, Contact Press Images, "AIDS in Haiti"
Andrew Holbrooke, Freelance for Black Star, "Homeless in New York City" p. 32
Lynn Johnson, Black Star for LIFE, "Reconstructive Breast Surgery" p. 160-161
Karen Kasmauski, Freelance for National Geographic, "South Carolina's Sea Island People" p. 163
Frans Marten Lanting, Freelance for National Geographic, "Man and Nature in Madagascar" p. 94

Steve McCurry, National Geographic, "The Sahel" p. 163
Robert R. Mercer, Mercer Visual Communications, Inc., "The Only Way"
Alon Reininger, Contact Press Images, "AIDS in the USA" p. 56
April Saul, NPPA/Nikon Documentary Sabbatical Grant, "The Hmong in America" p. 155-157
Anthony Suau, Black Star, "Haitian Elections" p. 21
Anthony Suau, Black Star, "South Korea: A Historic Attempt" p. 24, 25

Sports Portfolio

The judges gave no awards in this category.

Editing Division

Best Use of Photographs by a Newspaper

Circulation Over 150,000

First: The Seattle Times

Second: The Virginian-Pilot and The Ledger-Star (Norfolk, Va.)

Third: The Hartford (Conn.) Courant

Award of Excellence:

The Commercial Appeal (Memphis, Tenn.)

Circulation 25,000 to 150,000

First: The Daily Breeze (Torrance, Calif.)

Awards of Excellence:

Reno (Nev.) Gazette-Journal
The Providence (R.I.) Journal-Bulletin
The Indianapolis News

Circulation Under 25,000

First: Journal Tribune (Biddeford, Maine)

Second: Green River Star (Green River, Wyo.)

Third: Jackson Hole Guide (Jackson Hole, Wyo.)

Award of Excellence:

The Herald (Jasper, Ind.)

First Place Best Use of Photographs by a Newspaper, Circulation over 150,000, **The Seattle Times**

First Place Best Use of Photographs by a Newspaper, Circulation over 150,000, **The Seattle Times**

Second Place Best Use of Photographs, Circulation over 150,000, **The Virginian-Pilot and The Ledger-Star (Norfolk, Va.)**

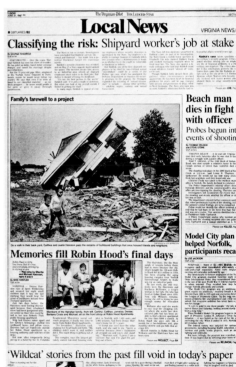

Second Place Best Use of Photographs, Circulation over 150,000, **The Virginian-Pilot and The Ledger-Star (Norfolk, Va.)**

Best Use of Photographs by a Newspaper

Zoned Edition

First: Neighbors, The Philadelphia Inquirer

Second: Neighborhoods, The Louisville (Ky.) Courier-Journal

Newspaper Picture Editing

Individual

(Picture Editor of the Year)

First: John Rumbach, The Herald (Jasper, Ind.)

Second: Dean Lindoerfer, El Paso (Texas) Herald-Post

Third: Steven Zerby, Star Tribune (Minneapols)

Award of Excellence:

J. Bruce Baumann, The Pittsburgh Press

Team

First: The Boston Globe

Second: The Seattle Times

Third: The Virginian-Pilot and The Ledger-Star (Norfolk, Va.)

Award of Excellence:

The Hartford (Conn.) Courant

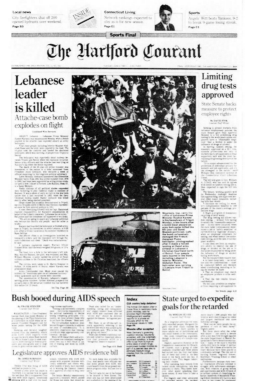

Third Place Best Use of Photographs by a Newspaper, Circulation over 150,000, **The Hartford (Conn.) Courant**

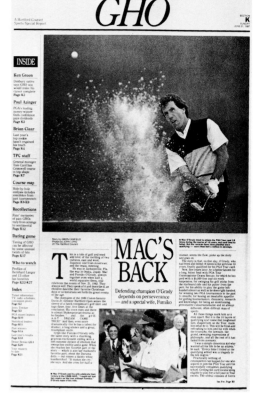

Third Place Best Use of Photographs by a Newspaper, Circulation over 150,000, **The Hartford (Conn.) Courant**

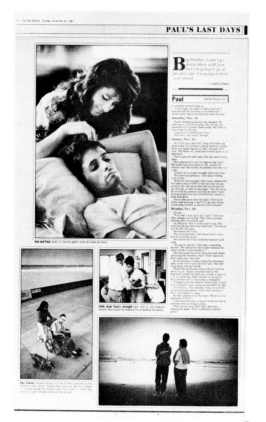

First Place Best Use of Photographs by a Newspaper, Circulation 25,000 to 150,000, **The Daily Breeze (Torrance, Calif.)**

First Place Best Use of Photographs by a Newspaper, Circulation Under 25,000, **Journal Tribune (Biddeford, Maine)**

First Place Picture Editor of the Year, JOHN RUMBACH, The Herald (Jasper, Ind.)

Second Place Picture Editor of the Year, DEAN LINDOERFER, El Paso (Texas) Herald-Post

Third Place Picture Editor of the Year, STEVE ZERBY, Star Tribune (Minneapolis)

First Place Newspaper Picture Editing (Team), **The Boston Globe**

Second Place Newspaper Picture Editing (Team), **The Seattle Times**

Third Place Newspaper Picture Editing (Team), **The Virginian-Pilot and The Ledger-Star (Norfolk, Va.)**

Best Use of Photographs by a Magazine

First: American Photographer

Second: National Geographic

Third: International Wildlife

Awards of Excellence:

LIFE
Missions USA
Sports Illustrated

Newspaper-Produced Magazine Picture Editing

First: David Griffin, Tom Gralish, Bert Fox, Larry Price, The Philadelphia Inquirer Sunday Magazine

Second: J. Bruce Baumann, The Pittsburgh Press Sunday Magazine

Third: Lesley A. Becker, Dallas Life Magazine (The Dallas Morning News)

Award of Excellence:

Greg Fisher, Charles Tuthill, The Commercial Appeal Mid-South Magazine (Memphis, Tenn.)

News Story

First: Donald R. Winslow, The Palm Beach Post (West Palm Beach, Fla.), "Opinion Page: Killing for Nothing"

Second: Robert Mayer, Ft. Lauderdale (Fla.) News/Sun Sentinel, "Page One: Panic on Wall Street"

Third: Randy Cox, The Hartford (Conn.) Courant, "Page One: Bridgeport Building Collapse"

Awards of Excellence:

Anestis Diakopoulos, Mike Delaney, Ann Peters, The Providence (R.I.) Journal-Bulletin, "City Edition: Fire Ravages Fall River Mill Complex"
Murray Koodish, The Commercial Appeal (Memphis, Tenn.), "Page One: Thousands Flee Area Floods"
Charlie Leight, The Arizona Daily Star (Tucson, Ariz.), "Pullout: John Paul Greets Devoted Detractors"
Mary Ann Nock, The Phoenix (Ariz.) Gazette, "Special Report: The Visit"
Team entry, The Hartford (Conn.) Courant, "Page One: Thousands Mourn Slain Patrolman"

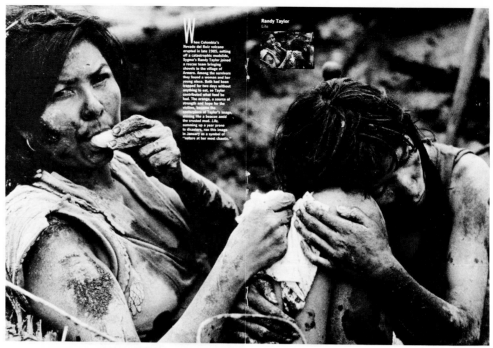

First Place Best Use of Photographs by a Magazine, **American Photographer**

Second Place Best Use of Photographs by a Magazine, **National Geographic**

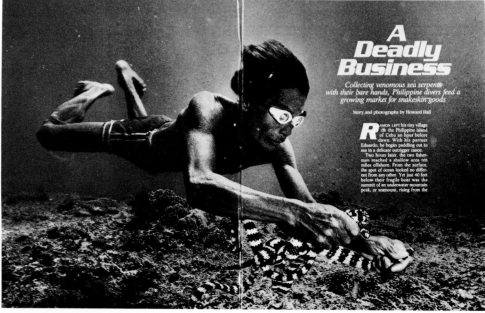

Third Place Best Use of Photographs by a Magazine, **International Wildlife**

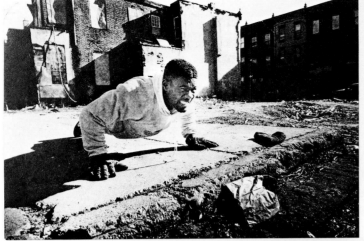

FIGHTING THE ODDS
BOXER 'KING' TUTT'S AMERICAN DREAM

Photography by ROB CLARK Jr.

Text by STEVE LOPEZ

GREG TUTT IS WALKING through a neighborhood that is going nowhere and taking everybody with it.

He walks past a corner house with broken windows, where four dudes sit on a porch in front of an open door.

Inside the house, trash is ankle-deep. A car rounds the corner recklessly enough to have nailed anybody who might have been crossing, and one of the occupants makes a contribution to the collection of trash on the streets. Even after the car is out of sight, the trash is still skidding along on the pavement, looking for a pothole the way a golf ball looks for the cup.

Greg Tutt plans to leave one day for Jersey, as soon as he becomes a millionaire. As he walks through the streets, everyone who sees him either waves, calls his name or comes up and shakes his hand.

continued on next page

AFTER A LONG RUN through Fairmount Park, 20-year-old Greg "King" Tutt finishes off his early-morning workout with pushups on a sidewalk at his Strawberry Mansion neighborhood. The routine is usually the same: run from 6:30 to 8, stretch and exercise, then stop in at the corner store to buy some oranges and to unwind. At night, Tutt unwraps his hands after an afternoon workout in the gym. For Tutt and hundreds like him, the sweat and the strain have a larger purpose: leaving poverty behind.

First Place Newspaper-produced Magazine Picture Editing, DAVID GRIFFIN, TOM GRALISH, BERT FOX, LARRY PRICE, The Philadelphia Inquirer Sunday Magazine

By Steve Twedt Photographed by Marlene Karas

MENDING THE FABRIC OF LIFE

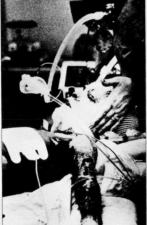

Cameron Smith, 9, is prepared for skin grafting at West Penn Hospital

Second Place Newspaper-produced Magazine Picture Editing, J.. BRUCE BAUMANN, The Pittsburgh Press Sunday Magazine

CONGO STREET

In the shadow of Fair Park, a neighborhood lives with the labels of the past

By Bill Minutaglio
Photography by Randy Eli Grothe

'This is where blacks had to stay,' says Sammie Clayton, sitting on her mother's porch at one end of the street. 'They didn't name any other block Congo, did they?'

Mama' Liz Plant sweeps the street in front of her house at least twice a week. Congo Street residents complain the city neglects the street except at fair time

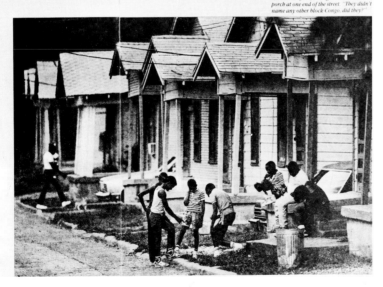

Third Place Newspaper-produced Magazine Picture Editing, LESLEY A. BECKER, Dallas Life Magazine (The Dallas Morning News)

Feature Story

First: David Griffin, The Philadelphia Inquirer Sunday Magazine, "The Invisible Homeless"

Second: Dean Lindoerfer, El Paso (Texas) Herald-Post, "El Paso's 10,000"

Third: Alex Burrows, The Virginian-Pilot and The Ledger-Star (Norfolk, Va.), "The Politics of Housing"

Awards of Excellence:

J. Bruce Baumann, The Pittsburgh Press, "The Last Day"
John C. Hansen, The Florida Times-Union (Jacksonville, Fla.), "Father Goose"
Bill Kelley III, The Virginian-Pilot and The Ledger-Star (Norfolk, Va.), "The Long Goodbye"
Dean Lindoerfer, El Paso (Texas) Herald-Post, "Third World Street Girls"
John Rumbach, The Herald (Jasper, Ind.), "Blind to Fear"
George Wedding, The Sacramento (Calif.) Bee Magazine, "Man With a Mission"
Steven Zerby, Star Tribune (Minneapolis), "The Hmong in America"

Sports Story

The judges gave no awards in this category.

Series or Special Section

First: Team entry, The Boston Globe, "Whisper of Stars"

Second: Team entry, The Boston Globe, "The People of Flight"

Third: Cole Porter, The Seattle Times, "Seattle's Homeless"

Fourth: Fred Nelson, Natalie Fobes, The Seattle Times, "The Saga of Salmon"

Awards of Excellence:

Greg Fisher, Tom DeFeo, Murray Koodish, The Commercial Appeal (Memphis, Tenn.), "China"
Kit C. King, The Spokesman-Review and Spokane Chronicle (Spokane, Wash.), "My Brother's Keeper"
Mary Ann Nock, The Phoenix (Ariz.) Gazette, "Almost a Marine"

INDEX

THANKS

Special thanks to the following for their help with production of the POY book in Norfolk and Virginia Beach, Va.:

Aldus PageMaker (TM) for donating the software for the production of the book

Chris Carr and Ohio Univeristy for donating the computer-layout and design software: AmperPage (TM)

Tim Cochran, Chris Keith, computer-layout assistants
Ray Gehman, Bill Kelley III, layout assistants
Sam Hundley, design advisor
Bill Pitzer, computer systems advisor

Alex Burrows Chris Holmes
Ginny Byrum Shannon Lynn
Cindy Dowdy Pam Royal
Denis Finley Martin Smith-Rodden
Jamie Francis William Tiernan
Mary Holiday Lui Kit Wong

Special thanks to the following for their help with the POY contest at the University of Missouri-Columbia (UMC):

Julie Ostrem, POY coordinator
Reggie Radniecki, David Rees, UMC photojournalism faculty members
Jim Jager, Mike Zerby, technical coordinators
Carol Pica, POY logistical coordinator
Ron Naeger, A-V technician
Daryl Moen, director, Mid-Career Professional Programs, UMC

John Cornell, NPPA president
Bill Hodge, NPPA vice-president

Jim Gordon, editor, News Photographer magazine
Randy Miller, NPPA liason

Buhl Optical, for loan of projection lenses
Canon, USA, Inc., corporate sponsor
Eastman-Kodak, for donations of slide carousels, projectors, dissolve units
National Geographic, for donation of Schneider lupes

Bill Marr, POY call for entries designer,
Nick Kelsh and Jay Anthony Bromfield,

Kelsh-Marr Studios
James Nachtwey, for photo on the call for entries

POY entry loggers:

Wendi Brown
Matt Campbell
Amelia Kunhardt
Lisa Powell
Devon Ravine
Richard Romero
Tim Steeg
Ashley Williams

UMC Photojournalism Students (caption readers, dissolve unit operators, projector operators, slide sleevers):

Christine Anderson	Robert DeGuire	Jim Howard	Robert Milfeld	Tammy Sickal
Kathryn Anderson	Spencer Dickey	Dave Howe	Mitzi Neuhaus	Ian Sights
Dawn Andres	Marcus Donner	Neil Hubbard	Geoff Newton	Nancy Smith
Beth Bader	Steve Dowell	Benedict Hughes	Gale Nie	Sunee Srinitiwongsakul
Joel Beeson	Garth Dowling	Katherine Jones	Laura O'Brien	Barry Tice
Marc Bering	Paula Duncan	Jay Karr	Lori Padzensky	John Torno
Laura Bourgeois	David Eaheart	Jim Kelly	Luci Pemoni	Kris Trahnstrom
Bill Brandt	Sean Farrell	Larry Klemme	Chris Pickens	Lora Trapp
Michael Brown	Nancy Fitzgerald	Amy Kohl	Anne Raup	Brian Trompeter
Bonnie Butler	Kurt Foss	Pat Krohn	Cheryl Reed	Minnie Two Shoes
A.J. Cancelada	Jason Gertzen	Lisa Luigs	Terri Rieke	Piet Van Lier
Cathy Caruthers	Eric Haase	Larry Lund	Jim Rintoul	Todd Winge
Jerry Casey	Barbara Hass	Ben Manheimer	Brad Rupert	Cynthia Youree
Emmanuel Chu	Diana Heil	Robert McAdoo	Chris Schifferer	
Jim Davenport	Brad Hohenstreet	Nalin Meegama	Akwi Seo	

Students from other colleges and universities:

Central State University (Edmond, Okla.)- - Alondra Butts, Danette Intrieri, Greg Stell, Keith Wolfe

Middle Tennessee State University (Murfreesboro, Tenn.)- - Frank (Sandy) Campbell, Darrien Caughorn

Western Kentucky University (Bowling Green, Ky.)- - James Borchuck, Tim Broekema, Robert Bruck, Royce Vibbert

University of Montana (Missoula, Mont.)- - Scott Crandell

University of Texas-Austin- - Allen Brook, John McConnico

University of Wisconsin-Stevens Point- - Larry Mishkar